1967

A COMPLETE
ROCK MUSIC HISTORY
OF THE SUMMER OF LOVE

HARVEY KUBERNIK

STERLING
New York

STERLING
New York

An Imprint of Sterling Publishing Co., Inc.
1166 Avenue of the Americas
New York, NY 10036

ISBN 978-1-4549-2052-6

Distributed in Canada by Sterling Publishing Co., Inc.
c/o Canadian Manda Group, 664 Annette Street
Toronto, Ontario, Canada M6S 2C8
Distributed in the United Kingdom by GMC Distribution Services
Castle Place, 166 High Street, Lewes, East Sussex, England BN7 1XU
Distributed in Australia by NewSouth Books
45 Beach Street, Coogee, NSW 2034, Australia

For information about custom editions, special sales, and premium and corporate purchases, please contact Sterling Special Sales at 800-805-5489 or specialsales@sterlingpublishing.com.

Manufactured in China

2 4 6 8 10 9 7 5 3 1

www.sterlingpublishing.com

Design by Phil Yarnall and Allison Meierding

Picture Credits and additional credits are on pages 255–64

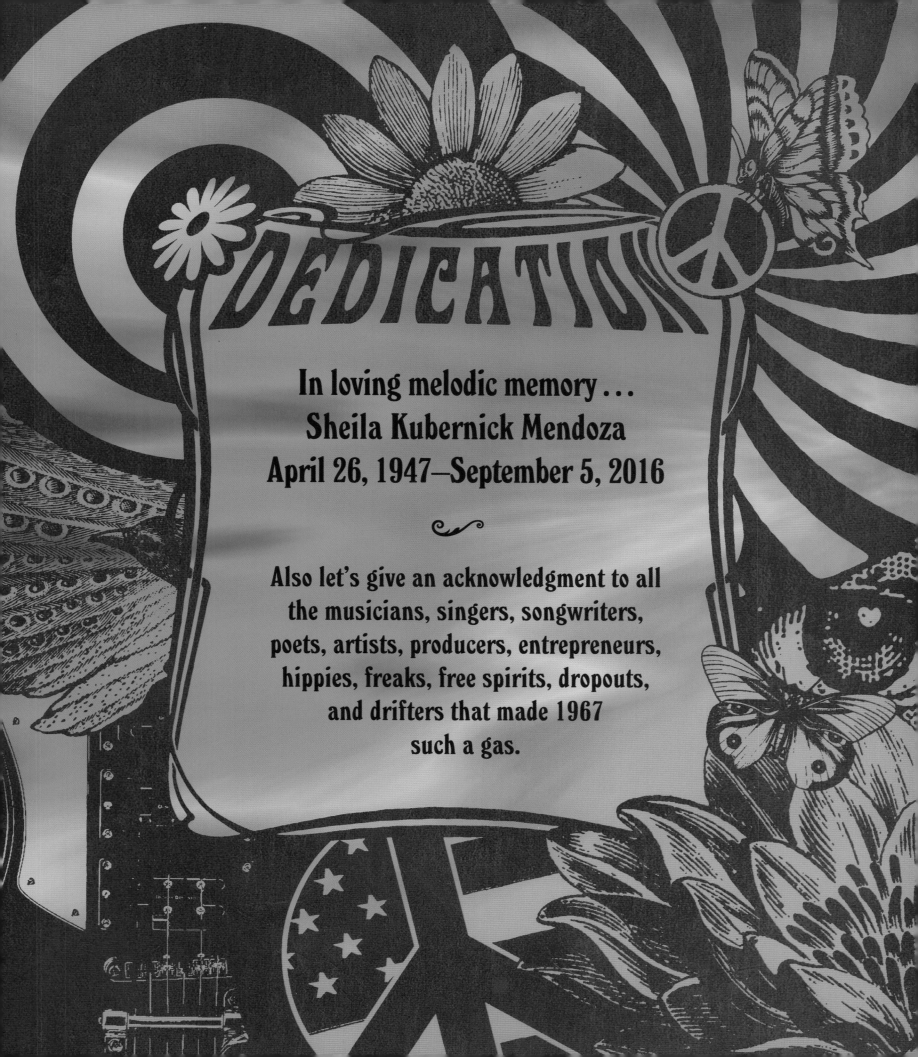

DEDICATION

In loving melodic memory . . .
Sheila Kubernick Mendoza
April 26, 1947–September 5, 2016

Also let's give an acknowledgment to all
the musicians, singers, songwriters,
poets, artists, producers, entrepreneurs,
hippies, freaks, free spirits, dropouts,
and drifters that made 1967
such a gas.

contents

BETWEEN THE LINES

The vibe, energy, and fierce determination of counterculture freethinkers and impact players who disputed authority in 1967 helped shape an alternative environment that changed the fabric of pop culture in America and across the globe. Little did most realize what was just around every corner that inspiring year. Unexpected detours happened; there wasn't competition in the air but collaboration everywhere, even under the largely suspicious and uninformed media glare monitoring the vibrant and unified scene.

Many musicians, artists, actors, designers, and writers delivered information and guidance that led to sonic freedom and self-awareness expeditions, along with innovative trailblazing approaches that still resonate fifty years on. During 1967, the "fear clinic" establishment watched as the relationship between music and radio airwaves, as well as the seekers, the anti-establishment individuals, the self-proclaimed tribes, the first believers, and the uninitiated young became situational, instructional, spiritual, and, later, statistical.

From 1957 to 1963, my family and I lived in Culver City near MGM Studios, where *The Twilight Zone* was taped (1959–1964). The show made a huge impression on me and looking back, it seems the world in 1967 was actually becoming a twilight zone for many people. 1967's Summer of Love was a tipping point for a whole lot of folks in various parts of the United States who had been feeling that the dominant culture and the dominant philosophy and the dominant way of understanding the individual's place in society and the world were ideas that were no longer useful, no longer working, no longer functional—we needed new ideas.

The cosmic flash points were in California—Venice, Los Angeles, Hollywood, San Francisco, Berkeley, Palo Alto, Monterey—where it all started; Detroit; New York City; Melbourne and Sydney in Australia; and Toronto and London.

What happened first in California on the West Coast still echoes around the universe.

This is a book of challenge, fate, change, trust, and achievement. It isn't a feasibility study, term paper, academic thesis, distorted-reality forensic analysis, or retrospective montage on the hippie dream.

During that revealing Summer of Love, exploration of destiny, identity, and newfound community engagement, I was in Hollywood "Walking on Sunset" and then "Bumpin' on Sunset." And, around the luxury of silence, like you, I continue to hear, view, cherish, play, and embrace the merit-based deep soul masterstrokes of the many accomplishments that constantly surround us and are not bound by history.

Harvey Kubernik
Los Angeles, California

Young man painted with colorful art and the word "PEACE" at a love-in at Elysian Park in Los Angeles; image by Henry Diltz, June 4, 1967.

1966 WAS (ALSO) A VERY GOOD YEAR

Week after week, the AM airwaves scintillated to the sound of Bob Lind's "Elusive Butterfly" and the lilting caress of Left Banke's "Pretty Ballerina."

The proud black voices of both Motown and Stax Records found, for the first time, a level playing field on the mainstream dial and were regularly heard around town in L.A. and Hollywood.

Bob Dylan turned the Beatles on to Arthur Rimbaud, to the pursuit of an authentic authorial voice that pushed pop music into the realm of aesthetics.

1966 saw tectonic shifts in other mass media as well. Film director/auteur Roger Corman unleashed *The Wild Angels*—hard-asses on Harleys®—in an attempt to capture some rock 'n' roll bad boy bravado on the big screen. Marlon Brando had, thirteen years earlier, donned leather in search of something/anything to rebel against in *The Wild One*; Corman revivified the malcontent thread in the form of squealing hot wheels, bodacious mamas, and a loud, corrosive soundtrack.

Corman revealed that at its core, the "youthquake" could be marshaled to produce healthy dividends for capitalist enterprises.

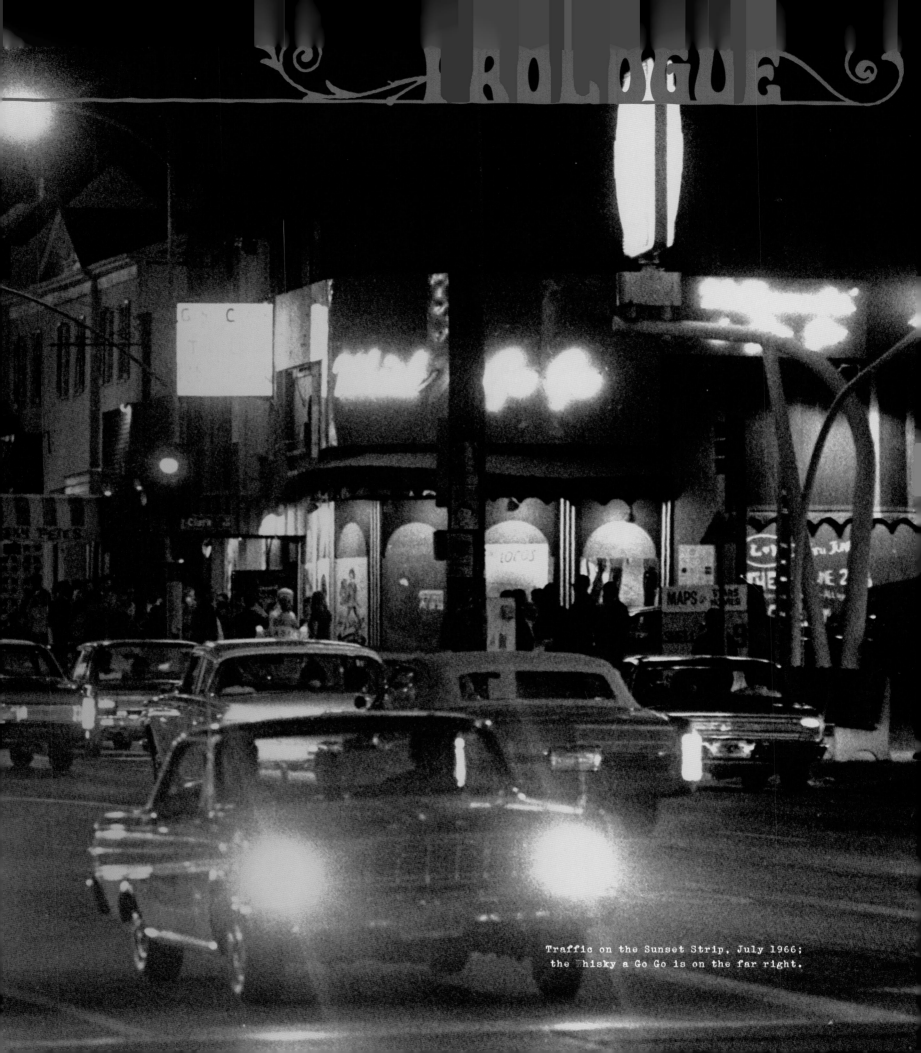

Traffic on the Sunset Strip, July 1966;
the Whisky a Go Go is on the far right.

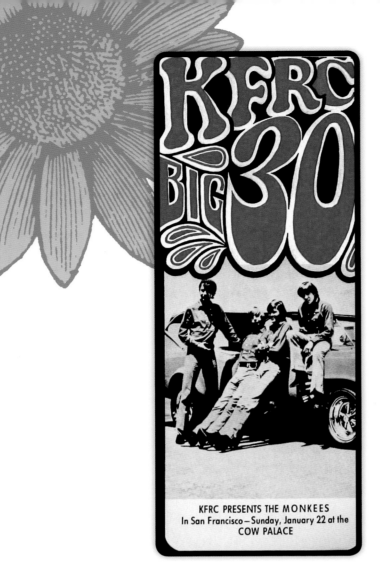

KFRC PRESENTS THE MONKEES
In San Francisco—Sunday, January 22 at the
COW PALACE

The Monkees premiered on national television on September 12 under an avalanche of public and industry interest. The show's producers corralled a savvy group of songwriters and session musicians to instill the music with character, mirroring their good sense to cast some genuine talent as the wittily engaging group. Further, the TV series' weekly stories about the escapades of a struggling L.A. rock band operated at the edge of network acceptance, imbuing the proceedings with just enough subversion to delight *Mad Magazine*'s Alfred E. Neuman, poster boy for juvenile delinquents from coast to coast.

What was also becoming clear was that all these roiling cultural currents were flowing into California, that heart of lightness, a tomorrowland stage irresistible to any self-styled free spirit.

California's allure was noted in *Look* magazine, which first pointed its snooty Manhattanite gaze west in 1962, suggesting "California is a window into the future."

By June 1966, an entire issue was dedicated to the Golden Bear State. "A new game with new rules," boldly declared the cover. "Its turned-on people have set out on a surprising, risk-filled adventure that could change your life."

And for many, it did exactly that. This was, after all, the Space Age, and Southern California in particular played host to the nascent aerospace industry, which, when not busy devising the eve of destruction—Thor and Titan, Atlas and Minuteman missiles—was realizing Kennedy's directive to put a man on the moon by decade's end.

And there, lurking, like Calypso, was L.A., its sparkling Herculean sky cloaked under a noxious ocher stain, warning prospectors that all that glitters may not be gold.

KENNETH KUBERNIK

music journalist/editor,
jazz keyboardist, producer

"The British poet Philip Larkin famously observed that sexual intercourse began in 1963, around the time of the Beatles' first LP. Larkin, who came of age during the [Second World] war, was renowned for his love of Ellington, fine claret, and choosing his words with the precision of a thoracic surgeon. But even he couldn't pare away the taint of envy in his drollery, fully cognizant that the sixties were charting a new, boldly disruptive direction—and not just in music and mating.

"Those hordes of young people parading along the sidewalks of suddenly swinging London, packing the coffee houses in Greenwich Village, carousing on the Sunset Strip, heading to North Beach and the Haight, were turning their collective backs on the certitudes of class, politics, race, and religion that defined their parents' generation. Young women, emboldened by the pill, by the rousing effrontery of feminism, were equally unsparing in their demands. It was all too much for a moldy fig like Larkin. 'Too late for me,' he lamented, 'too late for me.'

"By 1966, the clamor had compacted itself into a rash of provocative slogans, some merrily benign, others as drearily dogmatic as the scriptures they were meant to challenge. 'Down With the Establishment,' 'Don't Trust Anyone Over 30,' 'Drop Acid Not Bombs,' and the evergreen 'Make Love Not War.'

"Anti-war marches, civil rights protests, student sit-ins—they all had harrowing consequences; you could serve some serious jail time or get shot at with result. Muhammad Ali danced on this volcanic ledge with his incendiary protest against the draft.

"Across American suburbia, parents watched in dismay as their precious sons and daughters fell under the spell of that menace to society, the Rolling Stones, as well as Jefferson Airplane and the Grateful Dead.

"It was the inescapable sound of music which riled and captivated young and old, the car radio a battlefield. Anyone born after World War II eagerly decrypted the scrunch of screeching guitars, pounding beats, the rumpled refrains of adenoidal singers as code from the revolutionary front, while the adults retreated to the alpaca comforts of Andy Williams and Perry Como."

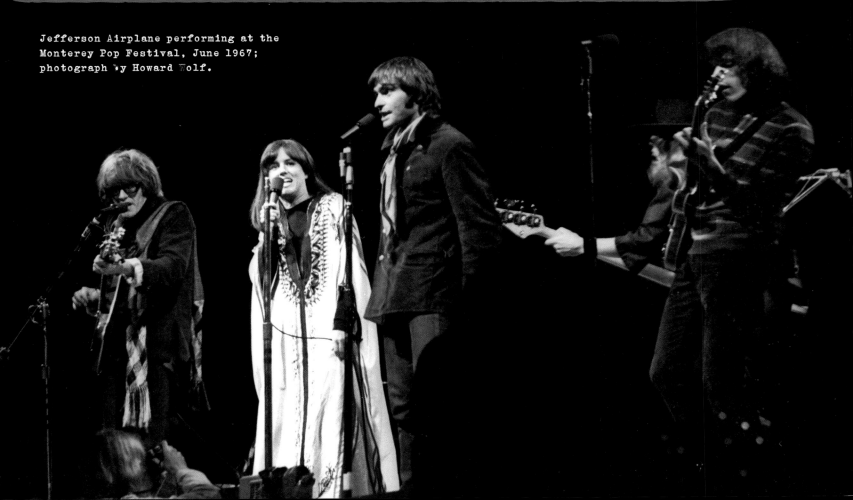

Jefferson Airplane performing at the Monterey Pop Festival, June 1967; photograph by Howard Wolf.

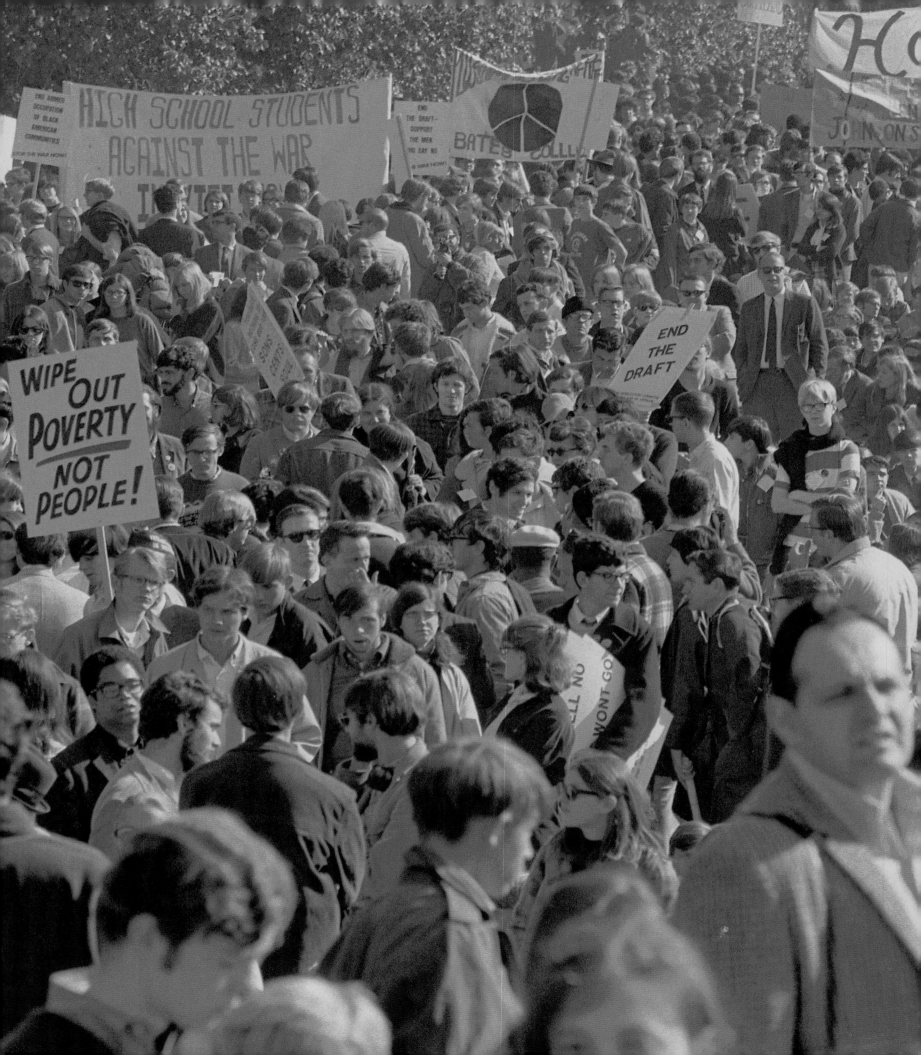

ROGER STEFFENS

actor, poet, photographer,
reggae archivist

"In the early sixties, the magazines *Look*, *Life*, the *Saturday Evening Post*, and *Collier's* did issues about the Golden State of California, where all the women were blonde and all the boys drove woodies and carried surfboards. That's where the hippest people came, and that's where the beatniks gravitated to.

"Then when beatniks turned into hippies, it was on. There was a mystique about San Francisco even more than [about] Hollywood and Los Angeles. Those cities were well documented, partially owing to constant show business coverage. And there had always been a beat scene in Southern California going back to the forties and fifties in Laurel Canyon, Venice, and Topanga Canyon.

"In contrast, the Haight-Ashbury [San Francisco] style [was] long hair. There were fringe jackets and leather. It was a time of such incredible expression in every level of one's being.

"The hip people and the Diggers' collective in San Francisco were also determined not to be defined by sensationalistic outside television and newspapers.

"The Diggers were doing something wonderful: They were feeding homeless people. They had the Free Store. Come and take it. . . .

"Hollywood, Los Angeles, and San Francisco were destiny spots for musicians. Many things birthed in these cities were then shared across the United States and the world. The Summer of Love spread from the West. . . . 1967 was a turning point for the world."

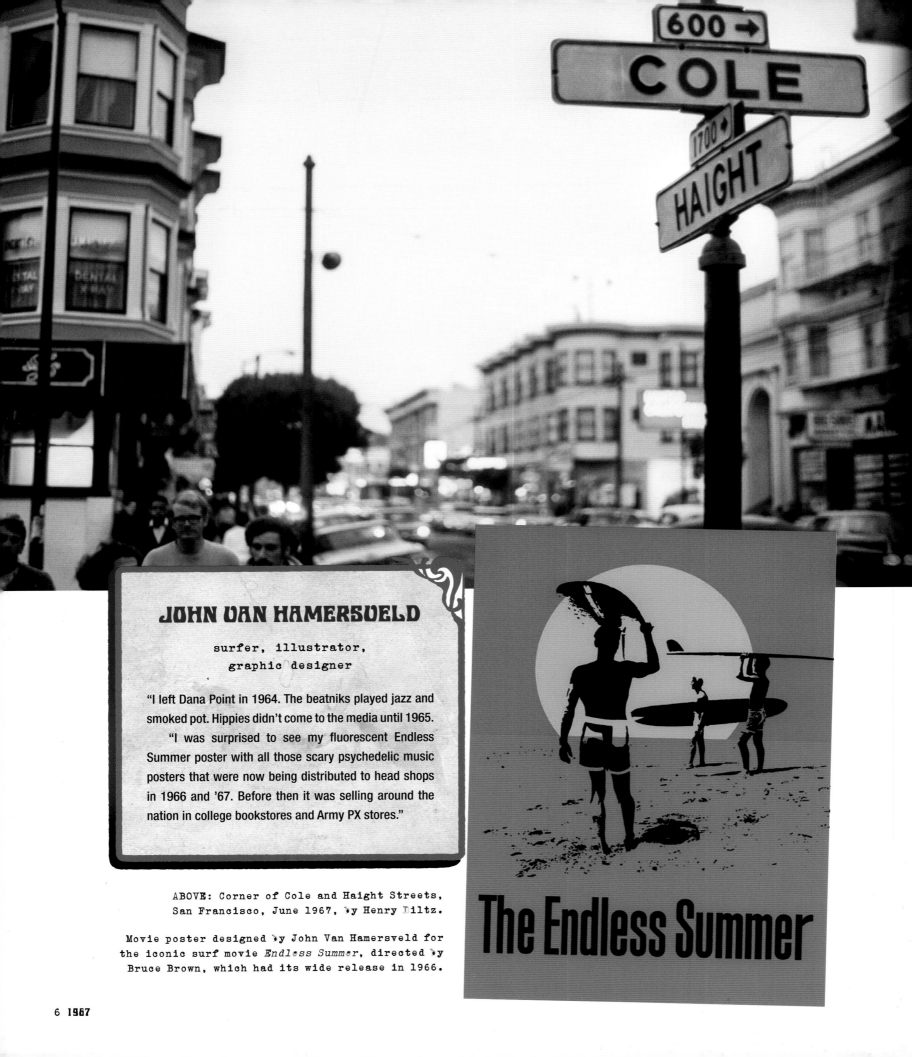

JOHN VAN HAMERSVELD

surfer, illustrator, graphic designer

"I left Dana Point in 1964. The beatniks played jazz and smoked pot. Hippies didn't come to the media until 1965.

"I was surprised to see my fluorescent Endless Summer poster with all those scary psychedelic music posters that were now being distributed to head shops in 1966 and '67. Before then it was selling around the nation in college bookstores and Army PX stores."

ABOVE: Corner of Cole and Haight Streets, San Francisco, June 1967, by Henry Diltz.

Movie poster designed by John Van Hamersveld for the iconic surf movie *Endless Summer*, directed by Bruce Brown, which had its wide release in 1966.

"In Los Angeles all the superficiality is right on the surface and depth is beneath the surface. In San Francisco it's just the opposite."

—JAMES CUSHING, RADIO HOST, KEBF 97.3 FM "THE ROCK"

Nothing quite defines a city like its rivalry with another city's baseball team. By 1967, no two teams lived to loathe each other quite like the flashy Los Angeles Dodgers and the cold, wind-swept San Francisco Giants and their death zone, Candlestick Park. Both cities traded barbs with pleasure: L.A., that plastic-fantastic escape into empty celebrity; Frisco (the much-hated abbreviation), a repository for freaks, misfits, and hippies (!)—every kid in need of a haircut and a job. Bay Area bands were soon traipsing through Hollywood while cutting tracks on Sunset. We locals savored the hypocrisy.

As cocksure as a bantamweight, jut-jawed, T-squared, singer Marty Balin was a compact ball of bravado whose gentle, amber-and-yellow voice was as expressive as a Stan Getz solo. Balin provided the perfect counterpoint to the regal iciness of both Signe Toly Anderson—Jefferson Airplane's original vocalist—and replacement Grace Slick, lifting the band to rock greatness. Though Ms. Slick, the most bewitching of sixties music icons, received an understandably disproportionate amount of the media's attention, it was Balin's steely presence that guided the band through turbulent takeoffs and the occasional crash landing.

Raised in the Bay Area, singer Martyn Jerel Buchwald recorded the 45 rpm "I Specialize in Love" backed with "You Are the One" for Challenge Records in Hollywood in 1962. Guitarists Glen Campbell and Barney Kessel, vibes player Milt Jackson, bassist Red Callender, and the Blossoms vocal group backed him for the session date at United Western Recorders on Sunset Boulevard. He was subsequently given the name Marty Balin by the label.

He returned to San Francisco and joined the Town Criers while learning his craft in the burgeoning folk music movement before turning electric, echoing the journey of another celebrated folk renegade, Bob Dylan. Like Dylan, Marty encountered resistance from club and venue owners and potential booking agents because he wanted to perform original materials/songs and not sing cover versions of contemporary hits on the radio, but he remained undeterred.

Marty Balin, co-founder and co-lead singer of Jefferson Airplane, 1967, in a photograph by Tom Gundelfinger O'Neal.

> **"We went into it our normal selves. . . . Getting to the heart of the matter, the point is, if you find something that makes you joyful, take note of it. Amplify it if you can. Tell other people about it. That's what San Francisco was about. Both musically, idealistically, metaphorically, and every other way. That's what we did here."**
>
> —PAUL KANTNER, JEFFERSON AIRPLANE

Balin took matters into his own hands, opening the Matrix club on Fillmore Street in a former pizza parlor on August 13, 1965. The room soon became a showcase for the explosion of new talent converging in San Francisco: Balin's newly created Jefferson Airplane (which he'd formed with Paul Kantner in a bar called the Drinking Gourd—"he was the first guy I picked for the band and he was the first guy who taught me how to roll a joint," Balin explained), the Warlocks (soon to be the Grateful Dead), Big Brother & the Holding Company (with Janis Joplin), and Quicksilver Messenger Service.

All these bands, along with countless others, helped to redefine the direction pop music was taking; Balin not only opened a door, he also took the stage and made it his own.

Also flying in Balin and Kantner's Airplane were guitarist Jorma Kaukonen, bassist Jack Casady, and second vocalist Signe Toly Anderson.

MARTY BALIN

singer/songwriter, Jefferson Airplane

"I think San Francisco was full of all these people who were talented, and who were expressing themselves . . . or playing music, and I think San Francisco has a lot to do with that. I don't know if it's the geomagnetic forces of the earth and the ocean, but something went on there. It's a lot different than the rest of the world. I saw all the great writers and poets. This is a world before 1967 and the Summer of Love. It started with the beatniks, poets, and City Lights bookstore in North Beach.

"As a solo performer in 1964, '65, I started to use a 12-string guitar with a pickup on it and wanted to use drums. I had played the hungry i nightclub, the Purple Onion, the Jazz Workshop as [part of] a folk-band group. I went back to get some jobs, and no one would hire me because I was too loud. So after being turned down by everybody, I was playing a folk club."

JEFFERSON AIRPLANE "COME UP THE YEARS"·RCA LOVES YOU

LEFT: A promo piece for the song "Come Up the Years," from Jefferson Airplane's debut album, *Jefferson Airplane Takes Off*, released August 1966.

PAUL KANTNER

singer/songwriter, guitarist,
Jefferson Airplane

"Jefferson Airplane had the fortune or misfortune of discovering Fender® Twin Reverb amps and LSD in the same week while in college. . . ."

"We were in a place that encouraged and nourished that kind of thinking and still does to this day, and we took full advantage of it. We weren't up on soapboxes complaining like the Berkeley people. . . . We need those people too. Those people are very valuable. But that's not what we did. Our message was subtler. There was a message there, but we didn't blare it out. We just tried to show by example what you could get away with, basically. We tried to propose a real alternate quantum. And did. Enjoying our day. And that's all we tried to put across."

JACK CASADY

bass guitarist, Jefferson Airplane

"Signe Anderson was a real sweetheart with a terrific contralto voice coming from a solid folk background. Listen to how she made the three-part harmonies of *Jefferson Airplane Takes Off* sound so thick, her wonderful tone between Paul's and Marty's."

BELOW: Jefferson Airplane c. 1966, with, from left to right, Paul Kantner, Alexander "Skip" Spence, Marty Balin, Signe Toly Anderson, Jorma Kaukonen, and Jack Casady.

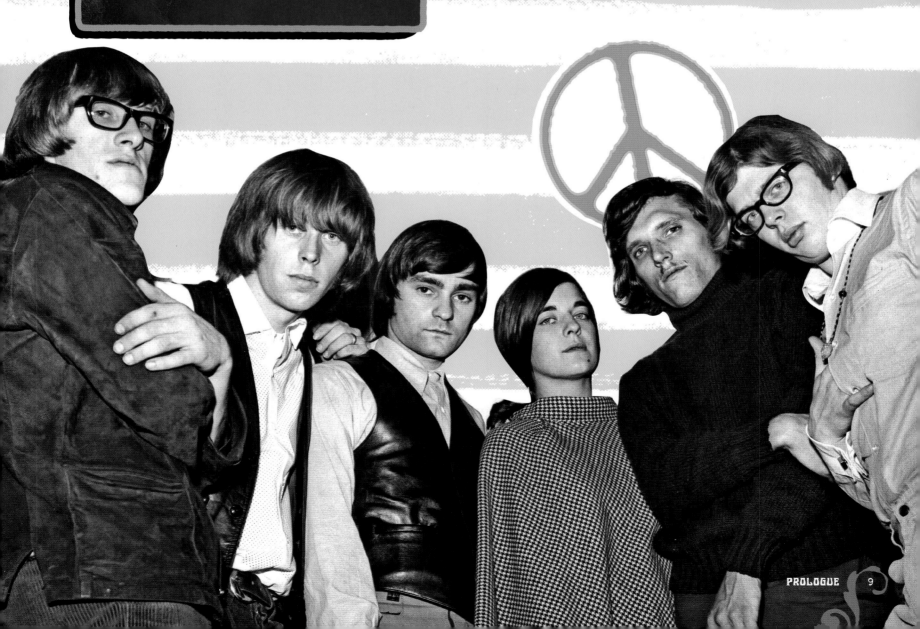

The mercurial Dr. Timothy Leary. The onetime West Point cadet turned Harvard psychologist—resplendent in academic tweeds and establishment crew cut—matriculated through the sixties as the hippie beau ideal of peace, love, and psychedelicized spirituality. Leary was the *Playboy* interview in its December 1966 issue. His epoch-defining mantra—"turn on, tune in, drop out" (uttered for the first time during San Francisco's Human Be-In in January 1967)—caught the zeitgeist's frontal edge with the marketing moxie of a Madison Avenue campaign.

Timothy Leary photographed in the office of his house in Millrook, New York, c. 1966.

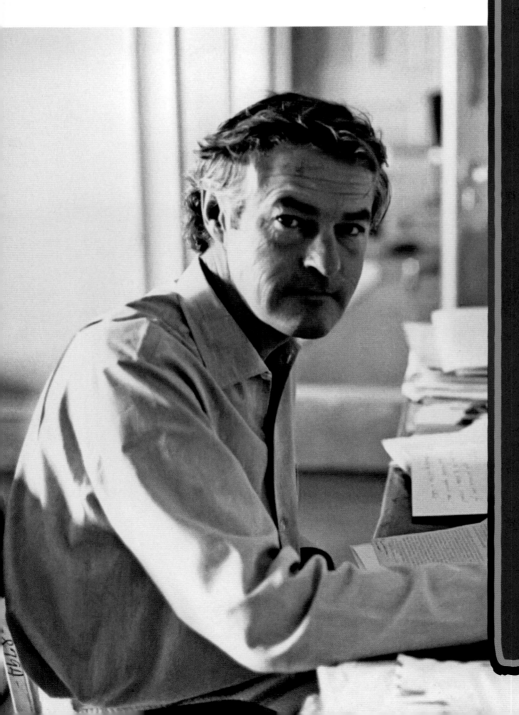

TIMOTHY LEARY

psychologist

"In the early sixties, [research] . . . led us to see that sound and music were very important. So, right from the beginning, music was also the idea of talking on tape. I belong to the first generation where we had [magnetic] wire. And when I did my graduate studies, we were using wire recording. . . . I go way back with the electric technology. Now, singing in the earliest, earliest stuff we did, we would use a repetition of certain words . . . 'cause that's the standard Hindu, Tibetan, Buddhist thing . . . the Mantra. . . . Buy the Buddha in seven delicious karmic colors. Purity. The very basis of those religions is sound, chanting, and vibrating. L.A. is where the migrants and the mutants and the future people come, the end point of terrestrial migration."

KENNETH KUBERNIK

"Leary's involvement with LSD began with scholarly rigor; it soon (de)evolved into a badge of honor shared with artists, musicians, writers, and a confederation of mischief-makers hell-bent on finding nirvana in a sugar cube.

"In retrospect, the psychedelic movement spearheaded by Leary reads like a scene from one of Jack Webb's *Dragnet* television episodes: acid-head 'Blue Boy' dispenses 'trip tickets' to unsuspecting teens eager to fly 'trans-love airlines,' who crash and burn in a dastardly kaleidoscopic hue. Aside from the snickering silliness of Jack Webb's loopy fears, LSD was a genuinely serious object of inquiry."

ROBERT GREENFIELD

"One of the aims of the book I wrote about Timothy Leary [*Timothy Leary: A Biography*, 2006] was to dispel the myth that he had created around himself. It is also the story of a very dysfunctional individual who I think actually caused more damage than he did good. Although Tim did effect real social change, he did so with disastrous consequences for many other people."

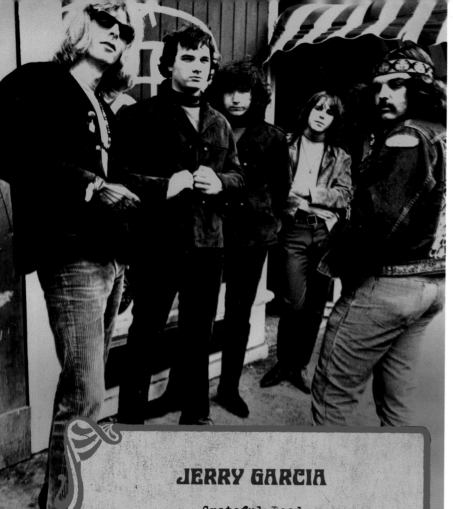

There were many precursors in both 1965 and 1966 that led directly to the international interest and media attention focused on the events of 1967 and the Summer of Love—including Jefferson Airplane's headlining dance concert in October 1965 at the Longshoremen's Hall on Fisherman's Wharf in San Francisco.

In January 1966, the Trips Festival was also held at the Longshoremen's Hall. The three-day happening (January 21–23) was produced and organized by composer and visual artist Ramon Sender; writer Stewart Brand and his partner, Zach Stewart; and novelist Ken Kesey in conjunction with the Merry Pranksters, his group of psychedelic compatriots, including sound-system pioneer Ken Babbs.

Thousands of people, including many volunteers, tried the LSD-spiked punch. (The Merry Pranksters had begun organizing "Acid Test" parties in California in late 1965, often in conjunction with music festivals like this one.) The Grateful Dead, Jefferson Airplane, Big Brother & the Holding Company, the Great Society, and the Charlatans gave performances that were enhanced by mind-altering light-show installations.

JERRY GARCIA

Grateful Dead

"When the Acid Tests were happening, I personally felt, 'In three months from now, the whole world will be involved in this.' So, as far as I'm concerned, it's been slow and disappointing. Why isn't this paradise already? [Laughs.] My personal feeling has been one of waiting around. One of the things you could say about all the bands that came from San Francisco at that period of time was that none of them were very much alike. I think that the world has changed. I can't say how or why, but I also think it's affected everything. Just all the interest in things like ecology. All the interest in the sense of personal freedom."

ABOVE: The Grateful Dead in San Francisco, c. 1966. From left to right: Phil Lesh, Bill Kreutzmann, Jerry Garcia, Bob Weir, and Ron "Pigpen" McKernan. Music journalist and author Robert Greenfield notes: "The Grateful Dead in America were part of the Haight-Ashbury scene and a part of a social movement. Jerry was so different. He was completely working-class but became a self-created icon and legend. He was a genius musician and an extraordinary human being, and I have great love and respect for him."

CAROL SCHOFIELD

MsMusic Productions record-label owner

"It was a new world. The San Francisco dawning of the pre–Summer of Love experience, Longshoresmen's Hall, the Fillmore Auditorium, and the Avalon Ballroom.... The vibe was fresh and exciting, and there really was magic in the air. As for the Haight Street experience, we would hang out on doorsteps drinking shared wine or sharing a few puffs of smoke along the walk up and down the Haight. Free love did occur regularly, and wandering over to Golden Gate Park to make out on occasion would be nice.... [It] was a time I will always remember and a part of me I cherish."

The cover of *Look* magazine's September 20, 1966, issue declared that it was an investigation of "Youth '66—The Open Generation

> Their new morality
> Conversations parents never hear
> Early sex and early marriage
> London's cutting edge
> Russia's cool Communists"

On October 6, 1966, LSD became illegal in California; it was federally banned in the entire United States on October 24, 1968.

Ronald Reagan was elected governor of California on November 8, 1966.

Bill Graham, the son of Russian-Jewish emigrants to Berlin, was born Wulf Wolodia Grajonca in 1931. His father died soon after "Wolfgang" was born and his mother later died in Auschwitz. Graham was able to escape the horrors of war-torn Europe; in 1939 he sailed with other young Holocaust refugees to New York, where he reinvented himself as a street-savvy bon vivant, as agile on his feet as he was sharp of tongue. In other words, a survivor.

In 1965, he demonstrated his entrepreneurial flair by staging a series of benefit concerts in San Francisco, which quickly morphed into an unprecedented career as the most successful, if highly contentious, concert promoter in the history of rock music. Graham's name was synonymous with state-of-the-art production values, lavish attention to the performers' every want and need, and, above all else, seeing to the well-being of his paying customers.

All these attributes were on display as early as 1966, when he transformed a dilapidated theater in the funky Fillmore district into the most revered platform for introducing new music to the rock 'n' roll mainstream.

TOP RIGHT: Bill Graham, late 1967, photographed by Baron Wolman.

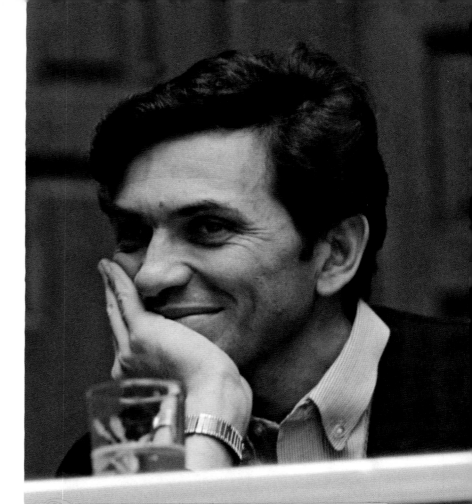

BILL GRAHAM

promoter

"I met Jerry [Garcia] in 1965. He was doing the Acid Tests. I thought he and his entire band were from another planet. I was very disturbed at those first parties because—and there's a lot of differences in opinion—grown-ups as well as kids were testing their metabolism. I was producing theater in San Francisco at that time, where the group was still the Warlocks, doing benefits involving these groups. I got to know him later on."

"In 1966, '67, there was all sorts of music going on. That became that because of what we did in San Francisco and encouraged Bill Graham. He really had all those strange combinations of acts on the bill. We didn't think of them as opening acts. We just thought of them as other acts that are really good. We encouraged Bill to book them."

–PAUL KANTNER

MARTY BALIN

"Bill Graham was running [as business manager] the Mime Troupe when we went over there to rehearse, and I remembered him. He was sitting in the office, and I looked at him and remembered him auditioning for this play, *Guys and Dolls*. And he got fired after a big fight with the director. I was a dancer in the show. So I went into the office. And he asked me what I was doing. 'I'm just playing original music. I just want to do that.' And we started talking and I said, 'Why don't you put on a benefit for your Mime Troupe and we'll play it and see what happens?' And Bill put on a benefit for the group's legal defense fund. They were lined up around the block on November 6, 1965. Lawrence Ferlinghetti, the Fugs, John Handy, and Jefferson Airplane.

"I then asked, 'Hey Bill. Why don't you get a place and we can play often?' So he went and got the Fillmore. We played a show with the Russian poet Andrei Voznesensky. And boom! History was made."

BILL GRAHAM

"There is something that the Grateful Dead always had in common from the beginning, and something hardly spoken about in the media after all these years. The San Francisco bands, starting with the Dead, always went to the gigs with the intention of putting it out there. It was the lack of professionalism at the beginning that made that possible. It wasn't that the contract said forty-five minutes and 'that's what we've got to play.'

"They were the first one who asked to play longer. They wanted to extend the relationship between the audience and themselves."

"He cared about the audience. Bill's obsession was 'the kids,' as he called them. He wanted to put on the best show possible for both the artist and the kids. The thing that Bill lived for was the moment in the show when 'the get-off' would happen. He was like Ziegfeld in that his primary concern was always the show. Despite also being obsessed with the money, he had a real political and social consciousness. Since he's gone, we don't see the great rock benefits anymore. We don't see rock being used as a force to raise enormous amounts of money for good causes."

–ROBERT GREENFIELD, MUSIC JOURNALIST AND AUTHOR

GRACE SLICK

singer/songwriter, Jefferson Airplane

The audience and the bands were not that separate. In other words, a large amount of the audience was the other bands at the time. So it was casual, and not that separated. As a rock 'n' roll force I mostly liked Bill's energy. Both physical and mental. He was able to keep an awful lot of balls in the air. He could organize and do business, whereas most of us were on the artistic side, which is a positive thing, but also we would not have been able to deal effectively, I don't think. Which he did. And without that, we would not have had what we did—a venue to express ourselves."

ABE JACOB

sound engineer

"Bill Graham was a very dynamic individual. And he had a terrific personality. Sometimes it wasn't the personality you wanted to deal with. But his philosophy was always for the audience. He would do anything he did for the band and for the artist as long as they gave a performance to the audience. 'Cause he said, 'Bands are for management and agents. Everybody else has somebody representing them. I'm here to represent the audience,' he told me one night."

OPPOSITE: Jefferson Airplane performing on June 10, 1967 at the KFRC Fantasy Fair and Magic Mountain Music Festival, on Mount Tamalpais, Marin County, California; photograph by Helie Robertson.

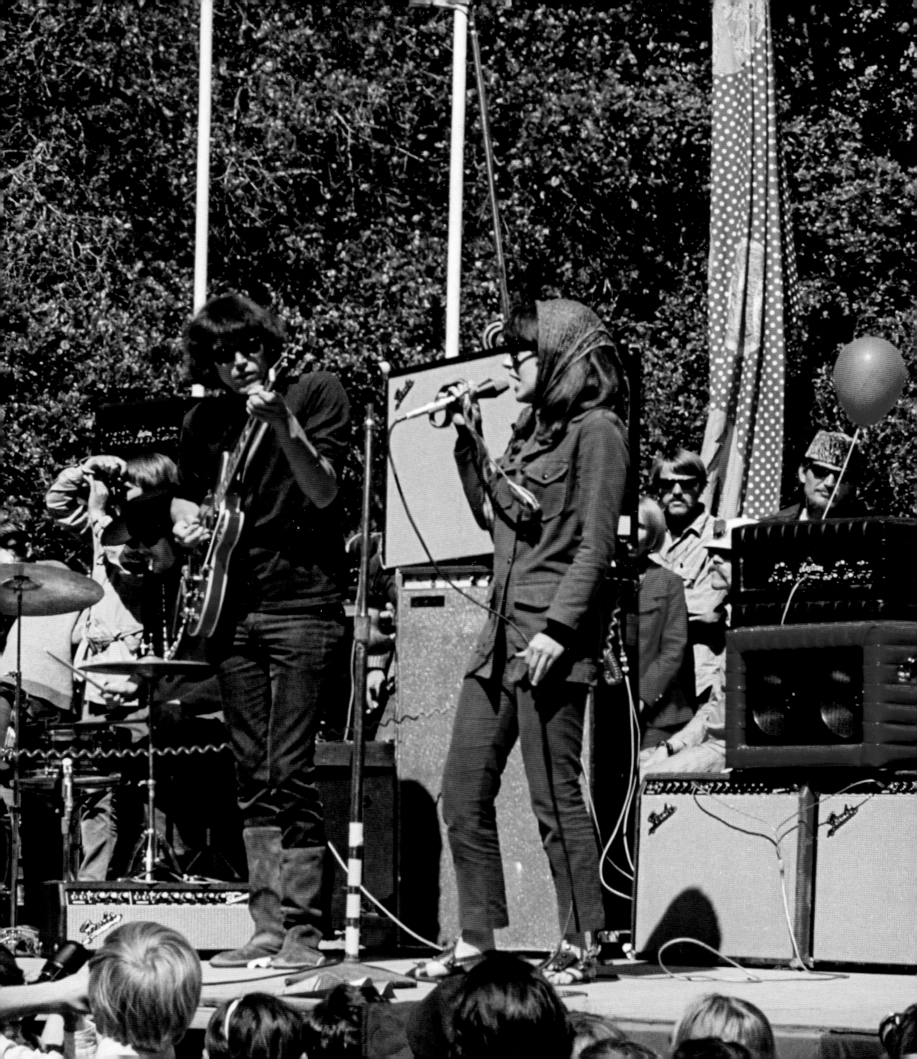

Chet Helms—long and lanky, with his signature beard that looked as coarse and scraggy as the sagebrush of his native Texas—had, along with New York transplant Bill Graham, become one of the premiere concert promoters of the mushrooming (figuratively and literally) Bay Area music scene.

He had arrived in San Francisco in 1962. He settled into a local hippie commune, the Family Dog, in 1966. Helms repurposed their charitable efforts into a savvy business enterprise, booking the Avalon Ballroom and the Haight Theatre with the ecstatic sounds of the Grateful Dead, Jefferson Airplane, Country Joe, and, most significantly, Big Brother & the Holding Company. He not only held (briefly) a management position with the latter but also introduced them to another Texas hell-raiser, singer Janis Joplin, whose uncomforting

Southern wail and captivating stage presence elevated the band to the brink of greatness. Family Dog hosted events every other weekend while rival promoter Graham promoted acts during the other alternating weekends. Eventually the two promoters would be at odds. It was a constant contrast in styles and smiles. Chet Helms and Bill Graham had different views on money and business, but they were both pulse points in presenting music that reached across the globe.

ABOVE: Human Be-in, 1967, Golden Gate Park, San Francisco, photograph by Henry Diltz.

OPPOSITE: Chet Helms, 1967, photographed by Tom Gundelfinger O'Neal.

"It was just a handshake agreement that we would do shows on alternate weekends. [Graham's] concern was just being able to produce that many events. Part of it was that other than the Airplane, he really didn't know the bands. He wasn't part of the street and social and party scene, and John [Carpenter] and I were fairly central to that. We did about four shows over a three-month period."

—CHET HELMS, PROMOTER,
FAMILY DOG PRODUCTIONS

PAUL KANTNER

"The reason that people came to the Fillmore was not the band. People came to the Fillmore much like a harvest festival. The same reason they came to the Human Be-In [in Golden Gate Park, San Francisco, January 14, 1967]. To be there. And if there were good bands playing, that was an added plus. But not many people were coming as fans of the band. . . .

"I always mention everything was possible. And plausible, even. And we got away with it all. More or less. Mostly. You went to the park, the Fillmore, and later the Monterey International Pop Festival, to get absorbed in the whole whatever it was going on."

MARTY BALIN

"Chet Helms was more of a hippie-type guy. And Bill Graham came out from New York and had the New York moxie. He was a totally different cat."

ABE JACOB

"With Chet Helms it was 'All for the people.' He never received the notoriety or the popularity or the world-wide renown that Bill Graham did. With Chet and with Bill, it was about having audiences."

The Beat Roots of the Summer of Love

When asked why the West Coast became the catalyst for the cultural revolution of 1967, Roger Steffens explains: "To understand the power of San Francisco in the sixties, you have to go back to the fifties. That's when Allen Ginsberg first read *Howl*. That's where the beatniks were headed. That was Jack Kerouac's destination when he and Neal Cassady made their mad drive across the country."

Allen Ginsberg recalls San Francisco's music and poetry scene in the mid-1950s: "[Charles] Mingus was involved with [poets] Kenneth Rexroth and Kenneth Patchen. And Fantasy Records [in San Francisco] documented some of that. The Cellar in San Francisco. By that time, I didn't know how to handle it, so I never did much of that myself, 'cause I was more funky, old-fashioned blues. I couldn't cut the mustard with free jazz.

"By the time I got around to getting on the radio, it was actually an AM station in Chicago with Studs Terkel; recorded the complete reading of *Howl* in Chicago, later used for Fantasy Records. It was broadcast censored . . . in '59. KPFA in the Bay Area then started broadcasting my stuff in San Francisco, a Pacifica station. Fantasy put out *Howl* and that got around."

New York–born film director and photographer Jerry Schatzberg describes the synergy between jazz, poetry, and rock: "The 1967 Summer of Love. The period was such a special time. I mean, it started in the fifties with the beat generation, 52nd Street jazz. The poets, Ginsberg, [Lawrence] Ferlinghetti were talking to the people. Listen to the rock music in the early and mid-sixties. It was really about the people. It was the revolution of saying, 'We're not getting into what we did yesterday. We want to do something different.'

"I think that just crept into the music. And of course, maybe the Beatles and all that music coming. It wasn't exclusively America. It really started in London, England, where the music was coming through differently. It all started with our own rhythm and blues. It took the French to tell us that we started jazz, you know.

"I was very close with all the English photographers. People who were in my business. But everybody was into music and art. The UK photographers of 1966 album covers, along with myself, were seen in 1967 by everyone."

ABOVE: Jerry Schatzberg, self-portrait, 1964.

ABOVE: Roger Steffens: "I took a photo of Allen Ginsberg at a private party of poets and students. He was scheduled to read poetry at Marquette University, but his performance was unceremoniously canceled because he had allegedly taken his clothes off at a reading at Columbia University the week before. And I was his replacement. Milwaukee, Wisconsin. February '67."

"When I was at Stanford, on the weekends I would drive up to the city and go to North Beach and hear the beat poets. But it was so out of my world. I was a real gung-ho, high-achieving, Jewish upwardly mobile graduate student and they scared the shit out of me."

—RAM DASS, SPIRITUAL LEADER

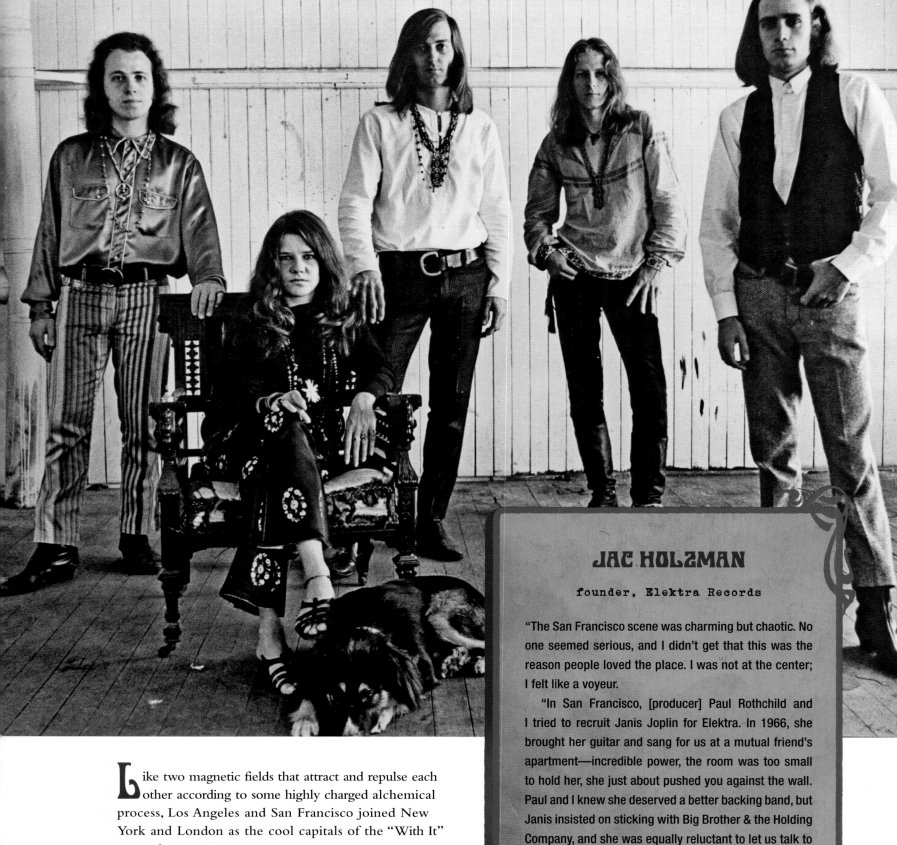

Like two magnetic fields that attract and repulse each other according to some highly charged alchemical process, Los Angeles and San Francisco joined New York and London as the cool capitals of the "With It" generation.

ABOVE: Janis Joplin with Big Brother & the Holding Company, photograph c. 1966.

JAC HOLZMAN

founder, Elektra Records

"The San Francisco scene was charming but chaotic. No one seemed serious, and I didn't get that this was the reason people loved the place. I was not at the center; I felt like a voyeur.

"In San Francisco, [producer] Paul Rothchild and I tried to recruit Janis Joplin for Elektra. In 1966, she brought her guitar and sang for us at a mutual friend's apartment—incredible power, the room was too small to hold her, she just about pushed you against the wall. Paul and I knew she deserved a better backing band, but Janis insisted on sticking with Big Brother & the Holding Company, and she was equally reluctant to let us talk to her record label about buying out her contract.

"L.A. was where I finally found what I was looking for. The time was the summer of 1966, and the place was the Sunset Strip, which had suddenly morphed before everyone's astonished eyes into the hippie navel of the universe."

KENNETH KUBERNIK

"L.A. is the 'industry' town: power, money, access—fightin' words to the Bay Area's counterculture, which celebrates its grungy iconoclasm as a thrusting middle-finger at anything phony or, in the current parlance, plastic. The media revel in the North/South divide and high-profile feuds make for good copy. But even the most ardent outliers can be bought . . . depending upon the deal.

"By the end of 1966, most of San Francisco's leading musical lights had sold their souls to the major record labels, settling in at exclusive Hollywood recording studios while dope dealers proffered their finest wares and young girls, as ripe as navel oranges glistening in the San Fernando sunshine, waited to be picked. It was tawdry—sex, drugs, and rock 'n' roll—but the temptation to ambitious young men of any philosophical stripe was irresistible. Even Timothy Leary settled in Laurel Canyon, not immune to its garden of earthly delights."

JOEL SELVIN

music journalist and author

"The San Francisco scene was this little cauldron of insurrection. The Jefferson Airplane had their debut album in 1966. The Dead's first album would come out in March '67, and you can refer to all kind of accounts for what sort of craziness went behind the concoction of that. The deal was just beyond any concept of corporate responsibility, and it granted them full creative control.

"The idea of this kind of music being even reflected in the mainstream media was foreign at that time. *Life* magazine caught up with it the next year. This all happened off their radar at that time.

"It was smart, but the San Francisco bands were so insular and they were not part of anything outside of their very peculiar LSD philosophical world. None of these people were show business professionals.

"A lot of these people looked at Los Angeles as sort of a basement to San Francisco. [Laughs.] Some of them had been in Los Angeles, Hollywood, or Venice before. We're talking 1962 to 1965, and the cultural distinctions between Los Angeles and San Francisco were quite prominent.

"I mean, you knew where those minds were in those days. And everything the San Franciscans represented was quite at odds with what was going on in Hollywood. And both camps were very suspicious of each other. However, there was, for lack of a better word, a beatnik highway. And it had stops out at the beach, and there were characters who flowed in and out of both these things.

"The music industry was in Hollywood. In San Francisco, there was only one recording studio, Coast Recorders; there is a film of Vince Guaraldi recording there and you can tell how backward it is. The biggest record label was Tom Donahue's Autumn, and he sold it to Warner Bros. And [Warner/Reprise executive] Joe Smith had already signed the Dead before the Monterey festival. He had seen them in San Francisco."

"San Francisco is 49 square miles surrounded by reality."

—PAUL KANTNER

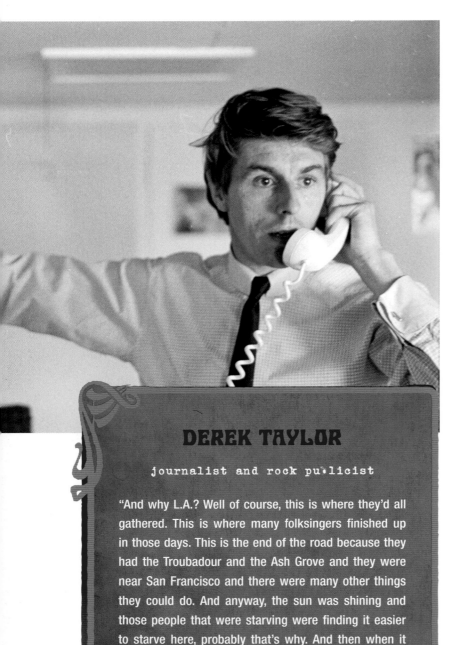

DEREK TAYLOR

journalist and rock publicist

"And why L.A.? Well of course, this is where they'd all gathered. This is where many folksingers finished up in those days. This is the end of the road because they had the Troubadour and the Ash Grove and they were near San Francisco and there were many other things they could do. And anyway, the sun was shining and those people that were starving were finding it easier to starve here, probably that's why. And then when it got what San Francisco would call glossy and shiny and over-commercialized, San Francisco said, 'We'll make our own music now; we are ready. And we won't have any of that L.A. nonsense.'

"Except that they do come down to L.A., I notice, for big advances from the capitalistic record companies. But it happens when it happens, if the right people meet at the right time."

Light, in all its prismatic permutations, became the leitmotif of the counterculture itself; to become "one with," to be "bathed in," to "see" the light, was the glorious end of the phantasmagorical journey. And music, sweet music, would prove a boon companion.

Chet Helms and Bill Graham introduced light shows to the wayfaring audiences at the Avalon Ballroom and the Fillmore Auditorium; globules from the electromagnetic spectrum shape-shifted like the Greek god Proteus, as buzzing guitars, drooling organs, and lulling, atavistic beats enticed both viewers and listeners.

In very early 1967, Bill Ham and Light Sound Dimension made their first public appearance at the San Francisco Museum of Modern Art. Alfred Frankenstein, in the *San Francisco Chronicle* in February 1967, described the audio and visual collaboration as an "exciting experiment in light and sound. . . . The technique is highly improvisational . . . no obvious effort was made to synchronize visual and aural effect but no such effort was needed. The two always go together no matter what."

Light shows quickly became de rigueur at any bohemian gathering accented by the consumption of psychedelics. Art installations, poetry readings, even car shows—hey, that new convertible looks bitchin' when you're trippin'—were buoyed by the presence of a drop cloth enlivened by the visual intrigues of light manipulators. It was all of a piece—sound and visuals melting into a Daliesque escape in time.

LEFT: Derek Taylor, August 1965, in Hollywood; photograph by Jim Dickson.

RIGHT: Paul Kantner, 1967, photographed by Tom Gundelfinger O'Neal.

MARTY BALIN

"Jefferson Airplane had a traveling light show on stage, a visual component. The light show was important. There were times we played in a museum and the light show would be the main thing, and they would turn the lights out on us on stage so that we would be in shadow so they could just concentrate on the light show. 'Cause it was getting talked about more than anything else at the time."

PAUL KANTNER

"As far as San Francisco being suspect of L.A. and Hollywood people, we always tried to get above that if possible as a general rule. People didn't like the Doors. 'Cause they were from L.A. [Laughs.] I rejected the suspicions of L.A. as a general rule. I thoroughly enjoyed L.A. and New York. I could make myself comfortable in either one of those cities. I liked San Francisco a lot.

"So many things were going on, you didn't take that kind of notice of them. You just assumed that was going on. 'All right!'— and go with it. We didn't analyze it. We didn't think to wonder about it. It was just another thing that was going on along with the music, the clothes, the bookstores, the poets, the artists; there was a plethora of things and you did not have time basically to take it all in. It existed. It's part of a whole.

"In San Francisco we had no restrictions. We never thought about being in an independent record label for cred. It came to us. All we had to do was roll with it. I liken it to white-water rafting. There was so much going on, you didn't worry about what was around the next curve. Or what are you going to do on the third curve. 'Cause you are right in the river."

BILL HAM

pioneering light artist and designer

"I arrived in San Francisco in 1959. It has always been a city of art. The light show was conceived here. I was a painter. San Francisco is the best place in the world. It's on the coast. We're linked to that other side of the world. I think there is something to do with magic. The other important element that can't be overlooked is the change in drugs. In the fifties, the painters in New York and everybody going back to Paris . . . the change in drugs was from alcohol to marijuana. And then early awareness of peyote. See, California is blessed. We're north of Mexico. Peyote came next, and then, the chemist . . . Dr. Albert Hofmann and LSD.

"I will just say, without the Avalon and the Fillmore and the light shows that turned two no-fixed-seating and no-stage-lighting bare funky ballrooms into psychedelic events, sixties San Francisco bands [would] have had a much different national impact most likely.

"It is seldom noted that the . . . unlike later with the Fillmore East seating, the original Family Dog dances in San Francisco were very related to participants dancing.

"I don't like to claim to be the only one of anything, but I was a major force in making up the original version. It was what turned out to be appropriate.

"I didn't see the music and light show at the Avalon with Chet Helms as church. I saw it as art. The ballroom was a real ballroom with a dance floor, but purple drapes and mirrors. Pretty funky. I explained to Chet we would have to get a screen up. And could not project on the mirrors or drape. And there was no stage lighting at the Avalon.

"In fact, there was barely any house lighting. And so I was the light. We used the balcony to project from on a table with projectors. And as a result I had exactly what I wanted. I had no limitations or restrictions.

"The light show made a major difference on all levels, and the fact that it completely surrounded and enveloped everybody, including the band, the floor, the people, and the walls.

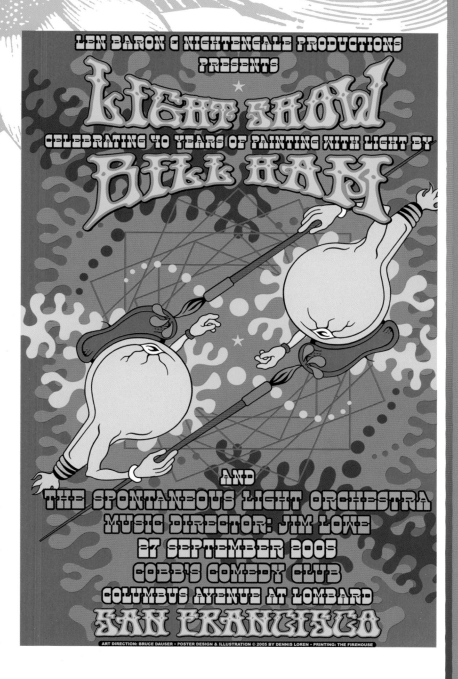

LEN BARON & NIGHTENGALE PRODUCTIONS
PRESENTS
LIGHT SHOW
CELEBRATING 40 YEARS OF PAINTING WITH LIGHT BY
BILL HAM
AND
THE SPONTANEOUS LIGHT ORCHESTRA
MUSIC DIRECTOR: JIM LOWE
27 SEPTEMBER 2005
COBB'S COMEDY CLUB
COLUMBUS AVENUE AT LOMBARD
SAN FRANCISCO

ART DIRECTION: BRUCE DAUSER • POSTER DESIGN & ILLUSTRATION © 2005 BY DENNIS LOREN • PRINTING: THE FIREHOUSE

OPPOSITE: Roger Steffens in a 1967 performance of his popular one-man show, *Poetry for People Who Hate Poetry*, which featured dramatic readings of living American poets, including Gregory Corso and Lawrence Ferlinghetti.

ABOVE: A poster by noted visual artist and graphic designer Dennis Loren for a light show in San Francisco celebrating Bill Ham, 2005.

DENNIS LOREN

graphic designer and art director

"Albert Neiman and his partner—the late Bruce Dauser—had a shop in the Haight-Ashbury that sold light-show supplies and other types of lighting. They worked a lot with the people that ran the Straight Theater on Haight Street.

"Bill Ham and his LSD [Light Sound Dimension] were there at the beginning. Many others would follow; you can see their names on all of the Avalon and Fillmore posters. Light shows in San Francisco were as numerous as bands in those days. They had clever names like the Deadly Nightshade, Ibis Alchemical Company, the Holy See, Glen McKay's Headlights, and Single Wing Turquoise Bird, who did shows in Venice and Los Angeles. Several light shows even traveled on tour with bands such as Jefferson Airplane. They wanted bands to have the whole ballroom experience."

ROGER STEFFENS

"I started doing psychedelic poetry readings in very early 1967 when I commissioned two St. Louis–based artists, Tom and Pam Linehan, to create a series of vibrant abstract slides to illustrate 10 poems by e e cummings. They were made of household soaps and powders, chemicals, food coloring and other liquids, and they were truly stunning.

"Imagine kids in Catholic high schools in the Chicago-Milwaukee region in 1967, coming to a 9 a.m. English class and having *me* show up, red beard, handlebar mustache, wild eight-foot-long red and bronze scarf (which I used as a prop), reading Corso and doing Lord Buckley–esque interpretations of Julius Caesar! Then showing Fillmore-quality psychedelic slides as I spoke cummings's words. I made a couple of hundred bucks a day that year, *huge* money for someone who had been interning at the Milwaukee Repertory Theater for $41.52 a week!"

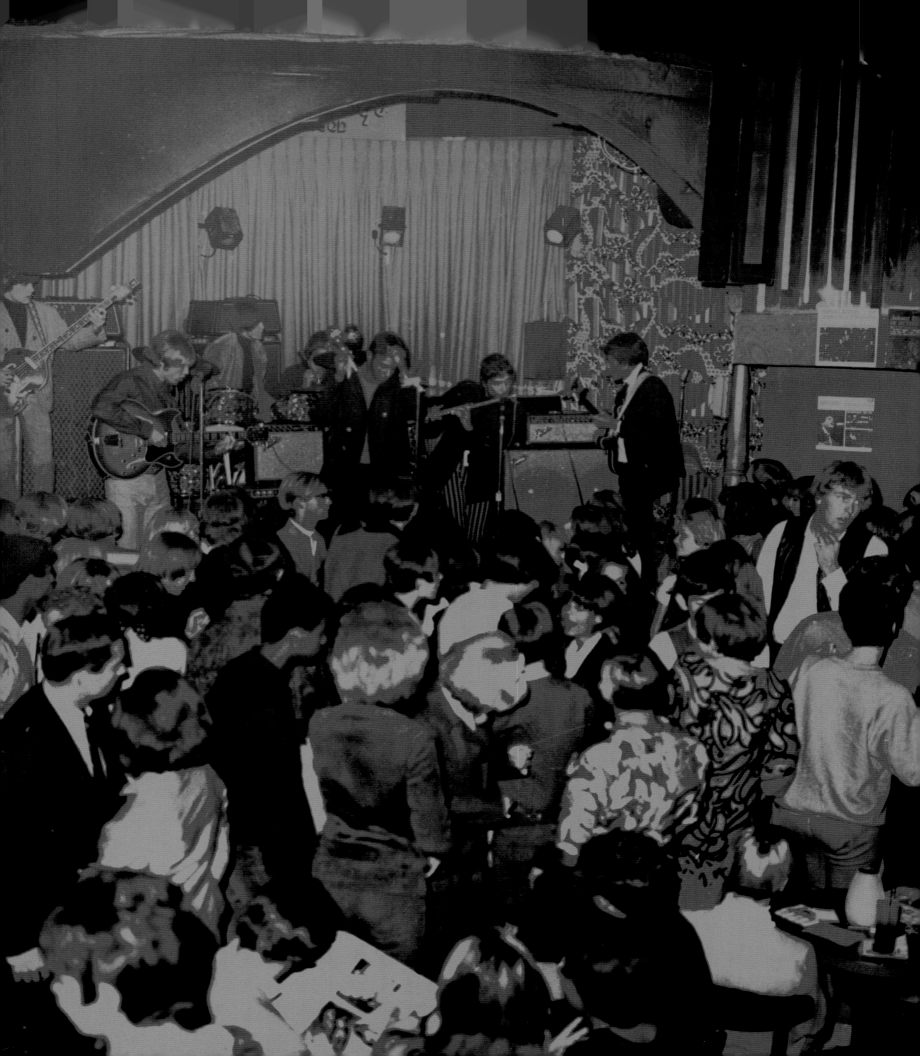

ABOARD THE FRIGATE

Janus, the guardian god of doors and beginnings, had his work cut out for him as 1967 dawned. The decade had been whirring at a dizzying pace; ruptures in politics, in popular culture, and in the very fabric of societal consensus had induced an electrical charge whose outlets remained scarily ungrounded. The year prior concluded with a collective breath-taking, having exhausted itself like a hurricane over land's edge. Even the Beatles retreated to the nurturing womb of Abbey Road, freed from the frenzy of renown that had made their lives a living hell.

The Who's Pete Townshend addressed this sense of restive watching and waiting in a January 14, 1967, interview with England's *Melody Maker.* Asked about the Beatles' sabbatical from the hurly-burly of superstardom, he said: "I'm a bit disappointed they're not still making records. If they are, then I wish they'd hurry up. They are basically my main source of inspiration—and everybody else's for that matter."

Like nature, pop music abhors a vacuum. As the Beatles relaxed their grip, a profusion of bands raced to occupy the high ground. Psychedelia began to ferment in the music of the Move, the Who, and especially an American expat in London, Jimi Hendrix, a onetime Army paratrooper turned wind-crying bluesman, a conjurer of magical portents on his electric guitar.

On January 3, 1967, Ronald Reagan was sworn in as governor of California.

OPPOSITE: The Band Love performing at the Whisky a Go Go in Hollywood, January 6 or 7, 1967.

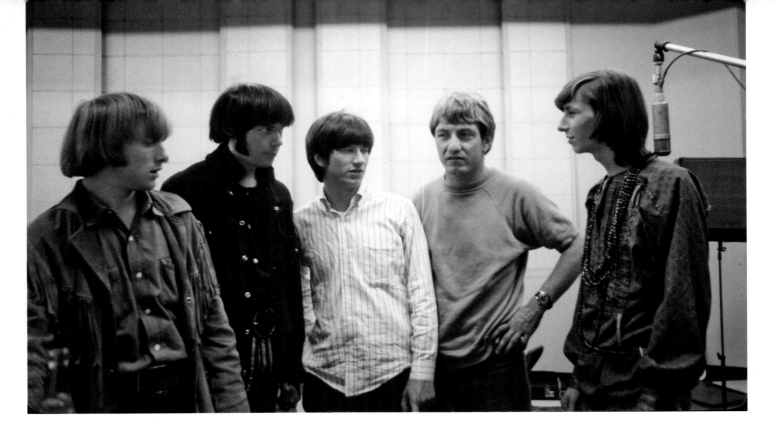

The Doors debuted their self-titled first album on January 4, 1967, excavating a sound drawn from the louche posturing of Rive Gauche symbolists and the blackened swagger of Chicago's South Side, hometown of Doors keyboardist Ray Manzarek. Although it arrived with a virtual whimper, it would prove to be the wildly prevalent dark heart of the summer of '67—and "Light My Fire" the most played song of the summer.

A billboard of their cover appeared on Sunset Boulevard peering down over the city of angels; Jim Morrison loomed like an imperious outlaw, wanted dead or alive. Posses of lost boys and girls swarmed along the Strip, converging around the Whisky, the Trip, the London Fog, outposts branded by the particular war whoops of the groups in residence, be they Love, the Doors, or Buffalo Springfield.

Time magazine's iconic "Man of the Year" was announced in its issue of January 6, 1967. It was not an individual but a generation: "Twenty-five and Under."

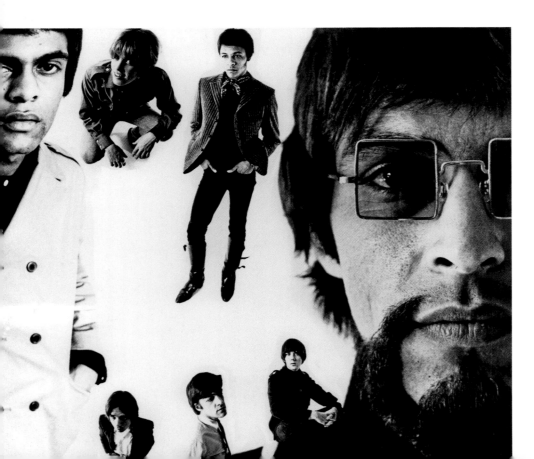

ABOVE: Buffalo Springfield photographed at Gold Star Studios in Hollywood, c. June 1966, by Henry Diltz.

LEFT: A collage of Love by photographer Guy Webster, with images from his 1966 photo shoot of the band in Beverly Hills for their album *Da Capo*.

OPPOSITE: Be-in, Golden Gate Park, San Francisco, January 1967; photograph by Henry Diltz.

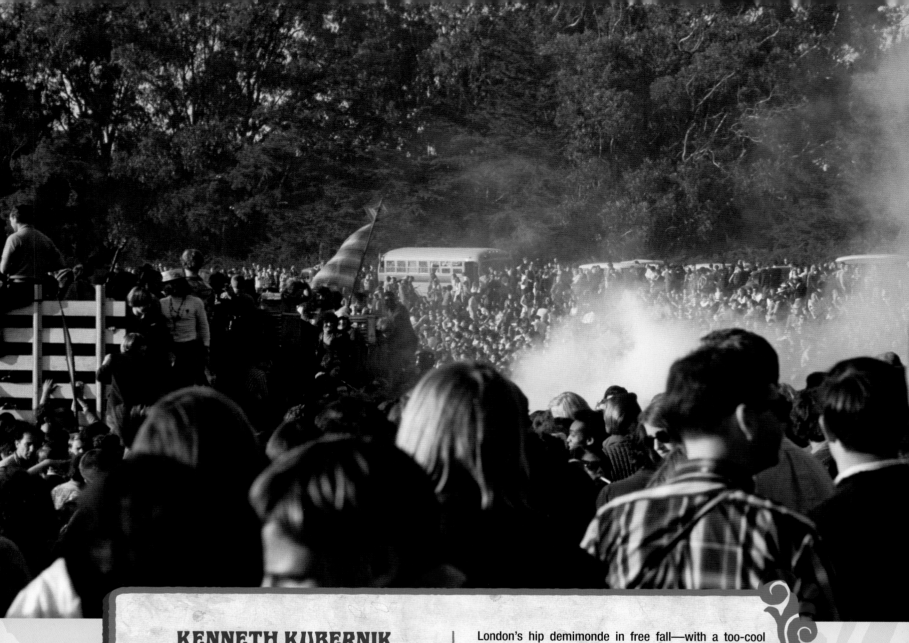

KENNETH KUBERNIK

"The 'riot' on the Sunset Strip [the first of a series of protests over a new 10:00 p.m. curfew and loitering law there that took place on November 12, 1966] was not exactly Little Big Horn, but it scared the daylights out of the locals. L.A.'s blue line stood at the ready to protect and serve, their boots jacked, their gazes impenetrable. Ronald Reagan, California's governor-elect, was more than happy to unleash his Praetorian Guard.

"In San Francisco, the hippies received a more salutary reception. Golden Gate Park hosted a 'happening,' a micro-community celebrating the tenets of peace, love, and LSD as the discordant thrum of rock music blared out into the purple haze.

"Step inside a cinema and the trip persisted; Antonioni's *Blow-Up* [December 1966], a sensorial examination of

London's hip demimonde in free fall—with a too-cool cameo from the Yardbirds featuring Jeff Beck and Jimmy Page!—reflected the psychic toll on the revolutionary impulse. Francois Truffaut's cool, cerebral *Fahrenheit 451* [November 1966] provided a sobering counterpoint, an essay on indulgence leading to a totalitarian state.

"January also offered up the inaugural edition of a little gridiron horseplay that would, in time, metastasize into a kind of pathological obsession. On Sunday the fifteenth, Los Angeles's Memorial Coliseum played host to the first NFL–AFL World Championship Game, televised on both NBC and CBS. This minor contretemps between the Green Bay Packers and the Kansas City Chiefs drew a middling crowd and middling ratings. But given enough hype and the need to distract the American public from the cascading uncertainties engulfing it, the outcomes would soon become, well, super."

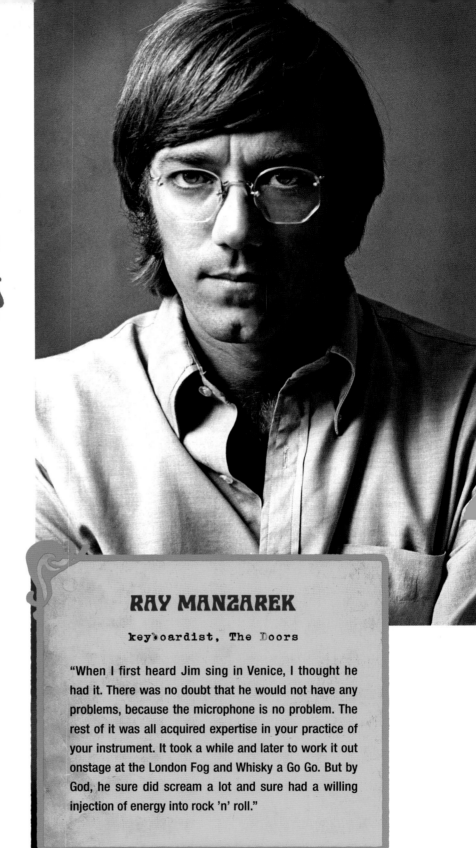

Jim Morrison's voice had a silky unworldliness punctuated by guttural animal spasms that reigned over a carnival honky-tonk of keyboards, slide guitar, and jazz-like acute drums that was at once ghostly and ecstatic, where dread and dreams met at the crossroads of unconsciousness and subterranean slumber.

PAUL BODY

drummer, writer, poet

"I saw the Doors at my former high school, Monrovia. I didn't have a ticket since I wasn't a student. So after talking to their guitarist Robby Krieger, he had me carry his guitar into the auditorium. I think they only did three songs. 'Break On Through' they did twice."

JOHN DENSMORE

drummer, The Doors

"'Break On Through' was so percussive. When we were recording and locked in, I was in it. We were just so in it. We were lost. Playing live, there were big sections on 'The End' when we would vamp, and Jim would throw in anything. And then, 'Oh yeah? I'll throw that back at you. Check this out.'"

RAY MANZAREK

keyboardist, The Doors

"When I first heard Jim sing in Venice, I thought he had it. There was no doubt that he would not have any problems, because the microphone is no problem. The rest of it was all acquired expertise in your practice of your instrument. It took a while and later to work it out onstage at the London Fog and Whisky a Go Go. But by God, he sure did scream a lot and sure had a willing injection of energy into rock 'n' roll."

TOP RIGHT: Portrait of Ray Manzarek, by Guy Webster, late 1966, Beverly Hills.

OPPOSITE: A publicity photo of the Doors from 1966, by Guy Webster.

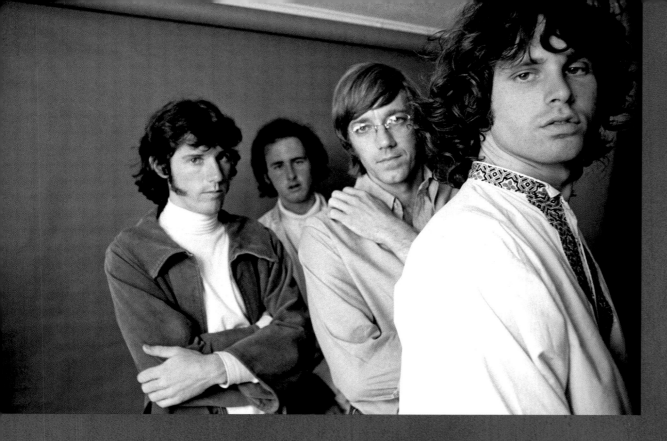

"I knew Jim was a great poet. . . . See, that's why we put the band together in the first place. It was going to be poetry together with rock 'n' roll. Not like poetry and jazz. Or like it, it was poetry and jazz from the fifties, except we were doing poetry and rock 'n' roll. And our version of rock 'n' roll was whatever you could bring to the table. Robby, bring your flamenco guitar; Robby, bring that bottleneck guitar, bring that sitar tuning. John, bring your marching drums and your snares and your four-on-the-floor. Ray, bring your classical training and your blues training and your jazz training. Jim, bring your Southern gothic poetry, your Arthur Rimbaud poetry. It all works in rock 'n' roll."

—RAY MANZAREK

"In San Francisco [we played] first at the Fillmore, where we kinda scared everybody, and then at the Avalon Ballroom; I could tell they liked us, we were the underbelly.

"You forget, in the Summer of Love, there is the Vietnam War on everyone's mind. San Francisco was quiet. They stared at us like we were from Mars. We knew that was making an impact."

—JOHN DENSMORE

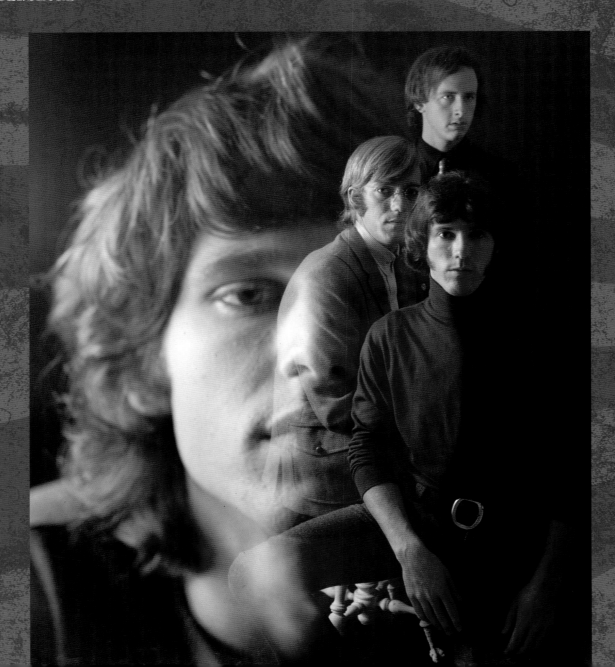

JAC HOLZMAN

founder, Elektra Records

"My relationship with producer Paul Rothchild started in 1963. Paul and I discussed how far we should take 'em. He said, 'Well, why don't we take them to 80 percent of concert pitch and let them come in the studio.' I said, 'That sounds great to me.' So that's what we did.

"But the whole Elektra Records label was me looking for something that I hadn't heard before. Or something that I had heard but it had a new face on it or it felt intrinsically different to me. . . .

"Before the [Doors] album was released, I phoned Bill Graham in San Francisco and pleaded with him to book the Doors for the Fillmore before they broke wide. Selling him an unknown band was not going to be easy. After a heavy pitch, Bill agreed but extracted one option for a repeat date within six months of the first booking—and both gigs for scale, hardly enough to cover the airfares. I gulped hard but agreed. San Francisco was the heart of spacey, rebellious rock 'n' roll, and the Doors had to be seen there."

On January 6, 1967, the Fillmore Auditorium booked the Young Rascals, Sopwith Camel, and the Doors.

OPPOSITE: An outtake from Guy Webster's photo shoot for the Doors' eponymous first album of 1966.

BELOW: A publicity photo of Jim Morrison from late 1966, by Guy Webster.

ROB HILL

writer and editor of *MG* magazine

"Bookended by the psychedelic throwdown 'Break On Through' and the eleven-minute existential opera 'The End,' the Doors' music was for the nighttime; music meant to send you off into a carnival dreamland of deserts, endless midnights, whisky and acid wildernesses, and cinematic verse. It was different—and strange."

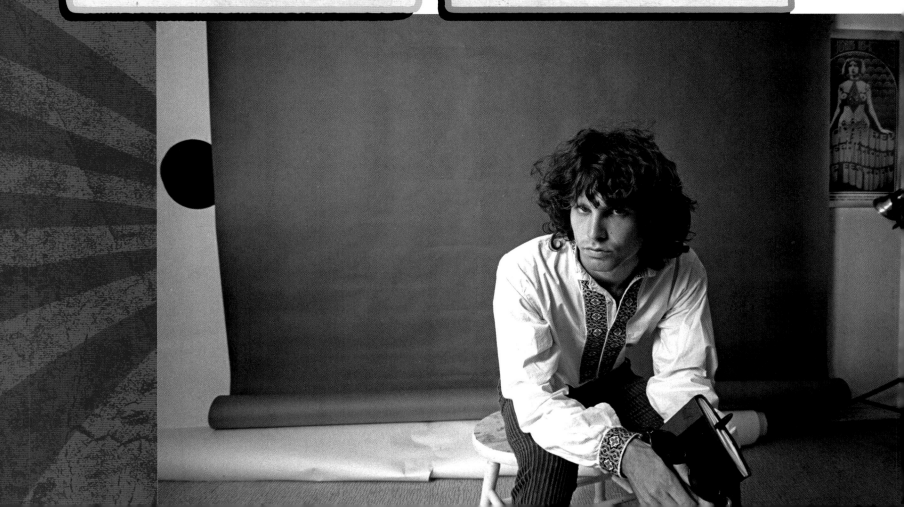

The era was flush with sensual overload. Buried within that thicket of sociological jibber-jabber was a clear message: Feed your head!

By 1967, San Francisco had become the epicenter of a youthquake that seemingly knew no boundaries.

A press release issued by the organizers of the Human Be-In of January 14 stated:

> Berkeley political activists and the love generation of the Haight-Ashbury will join together with the members of the new nation who will be coming from every state in the nation, every tribe of the young (the emerging soul of the nation) to powwow, celebrate, and prophesy the epoch of liberation, love, peace, compassion, and unity of mankind. The night of bruited fear of the American-eagle breast-body is over. Hang your fear at the door and join the future. If you do not believe, please wipe your eyes and see.

Gavin Arthur, grandson of the twenty-first U.S. president, Chester A. Arthur, was the Bay Area's leading astrologer, and he observed that the auguries pointed toward January 14 as the day of celebration.

January 14, 1967. Human Be-In: A Gathering of the Tribes at the Polo Grounds, Golden Gate Park. Promptly at noon, beat poet Gary Snyder blew on a conch shell to signal that the gates of delirium were open for business.

The crowd numbered 20,000 to 30,000 love-beaded sojourners, tripping on visions both real and (chemically) imagined. The speakers were Jerry Rubin, Richard Alpert (Ram Dass), Dick Gregory, Allen Ginsberg, Lenore Kandel, Lawrence Ferlinghetti, Michael McClure, and Timothy Leary.

Bands including Jefferson Airplane, the Grateful Dead, Big Brother & the Holding Company, and Quicksilver Messenger Service supplied the electric music.

Beverly Hills–born artist Michael Bowen produced and coordinated the Be-In. Bowen was the art director of the *San Francisco Oracle*, an underground newspaper edited by Allen Cohen that was published from September 1966 to February 1968, distributed by the Underground Press Syndicate.

The event poster was designed by Rick Griffin, former staff artist at *Surfer* magazine (who would become a seminal rock poster and album designer of the psychedelic movement).

Among those in attendance were James Rado and Gerome Ragni. The duo, inspired by the freedom and lifestyles, would immediately write the lyrics and book to *Hair: The American Tribal Love-Rock Musical* with composer Galt MacDermot; it would debut in New York in October 1967.

BARRY MILES

author and journalist

"The beginnings of the British scene very much reflected the different backgrounds to the youth revolt.

"The British scene was always more political and grounded in the Campaign For Nuclear Disarmament and anarchist theory. The American one was always the cult of the individual, self-development, hedonistic. . . .

"There were plenty of people around. It's just that the British scene was leaderless. We didn't have all those alpha males that the Americans had: Chet Helms, Bill Graham, Jerry Rubin, Abbie Hoffman, Paul Krassner, Tim Leary, Allen [Ginsberg]. No one was regarded as a leader or even spokesman, or wanted to be."

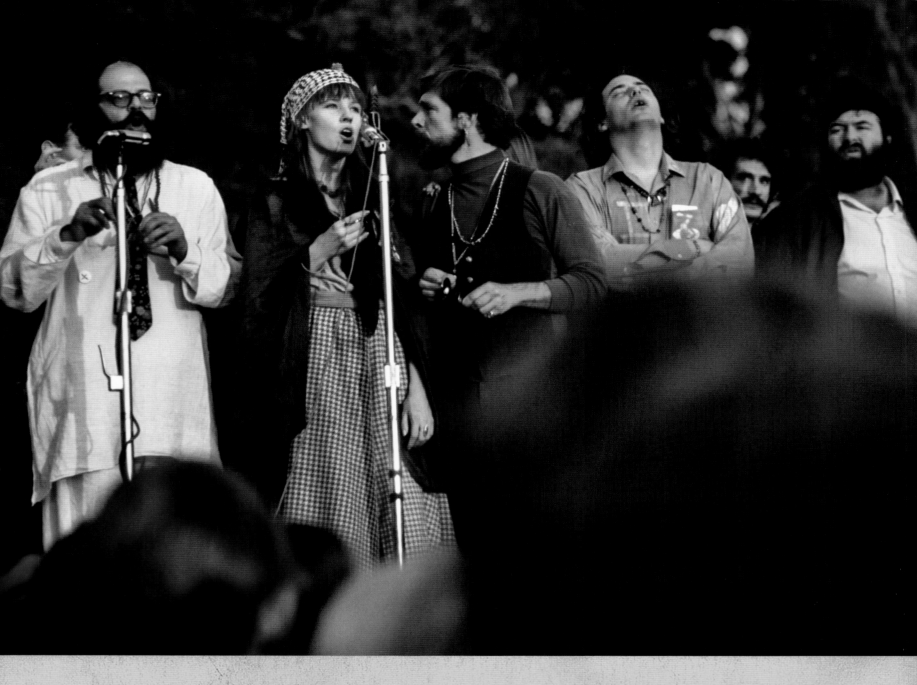

"The '67 Be-In in San Francisco was the coming attraction for Woodstock. It was a large gathering of people who came together just to share love, their arts, stories, music, and poetry. It helped ignite unity by involving **LSD**. Newspapers and magazines were doing cover stories about acid and even whole issues were devoted to LSD, such as *Life*."

— ROGER STEFFENS

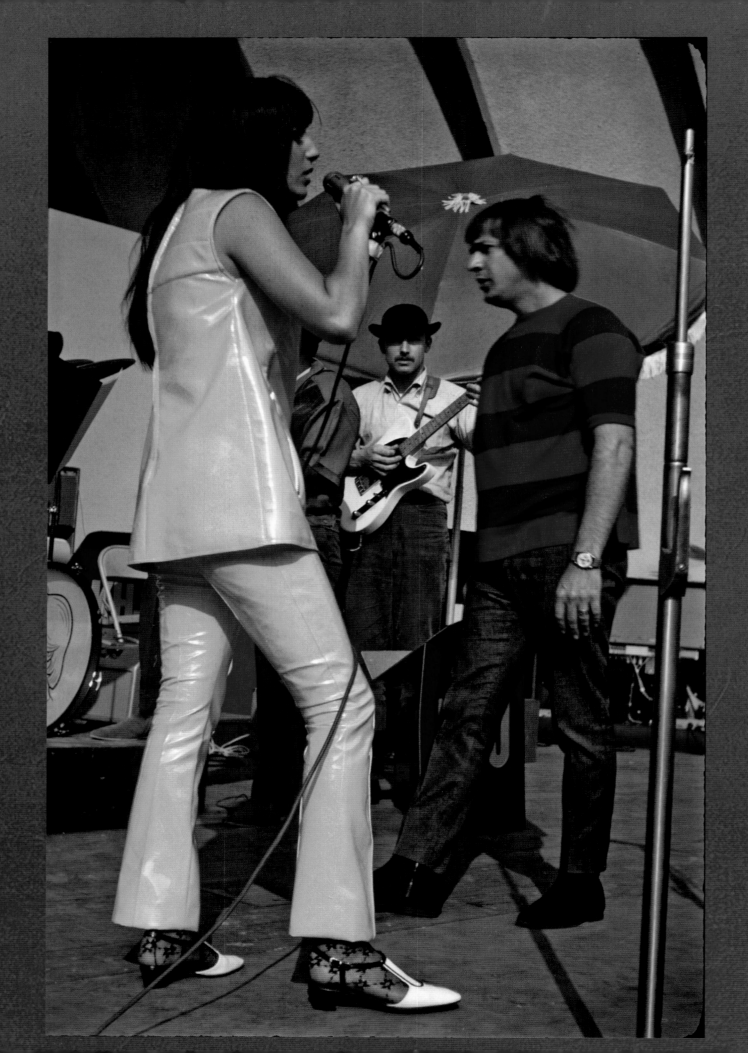

Sonny and Cher's "The Beat Goes On," which was released as a single in late December 1966 on Atlantic Records (backed with "Love Don't Come"), reached the No. 6 slot on the *Billboard* Hot 100 on January 14, 1967, while the Human Be-In was in full swing.

KHJ'S "BOSS 30" RECORDS IN SOUTHERN CALIFORNIA!

ISSUE NO. 79—PREVIEWED JANUARY 4, 1967

Last Week	This Week	TITLE	ARTIST	LABEL	Weeks On Boss 30
(1)	1.	I'M A BELIEVER/ (I'm Not Your) STEPPIN' STONE	The Monkees	Colgems	6
(2)	2.	SNOOPY Vs. THE RED BARON	The Royal Guardsmen	Laurie	6
(5)	3.	TELL IT LIKE IT IS	Aaron Neville	Parlo	4
(4)	4.	PUSHIN' TOO HARD	The Seeds	GNP	8
(3)	5.	WEDDING BELL BLUES	Laura Nyro	Verve	6
(8)	6.	GEORGY GIRL	The Seekers	Capitol	3
(13)	7.	STANDING IN THE SHADOWS OF LOVE	The Four Tops	Motown	5
(16)	8.	FULL MEASURE	The Lovin' Spoonful	Kama Sutra	5
(18)	9.	SINGLE GIRL	Sandy Posey	MGM	5
(6)	10.	BORN FREE	Matt Monro	Capitol	9
(7)	11.	THERE'S GOT TO BE A WORD!	The Innocence	Kama Sutra	6
(9)	12.	HELP ME GIRL	Eric Burdon & The Animals	MGM	7
(22)	13.	KNIGHT IN RUSTY ARMOUR	Peter & Gordon	Capitol	3
(11)	14.	KNOCK ON WOOD	Eddie Floyd	Stax	8
(21)	15.	HELLO HELLO	The Sopwith "Camel"	Kama Sutra	4
(29)	16.	FOR WHAT IT'S WORTH	The Buffalo Springfield	Atco	2
(12)	17.	SUGAR TOWN	Nancy Sinatra	Reprise	5
(10)	18.	WINCHESTER CATHEDRAL	The New Vaudeville Band	Fontana	12
(24)	19.	WORDS OF LOVE	The Mamas & The Papas	Dunhill	4
(25)	20.	WACK WACK	The Young-Holt Trio	Brunswick	3
(30)	21.	THE BEAT GOES ON	Sonny & Cher	Atco	2
(17)	22.	I NEED SOMEBODY	? & The Mysterians	Cameo	7
(23)	23.	GOOD THING	Paul Revere & The Raiders	Columbia	6
(26)	24.	TELL IT TO THE RAIN	The 4 Seasons	Philips	3
(HB)	25.	98.6	Keith	Mercury	1
(27)	26.	IT MAY BE WINTER OUTSIDE	Felice Taylor	Mustang	3
(HB)	27.	PRETTY BALLERINA	The Left Banke	Smash	1
(HB)	28.	I'VE PASSED THIS WAY BEFORE	Jimmy Ruffin	Soul	1
(—)	29.	KIND OF A DRAG	The Buckinghams	USA	1
(HB)	30.	NIKI HOEKY	P. J. Proby	Liberty	1

THE POPULARITY OF RECORDS LISTED HEREIN IS THE OPINION OF KHJ BASED ON ITS SURVEY OF RECORD SALES IN SOUTHERN CALIFORNIA CORRELATED WITH LISTENER REQUESTS.

OPPOSITE: Sonny and Cher doing a soundcheck at the Hollywood Bowl, April 2, 1966, before a benefit concert organized by KHJ-AM for the Braille Institute of America; guitarist Don Peake is in the background. Photograph by Henry Diltz.

ABOVE: The top thirty songs on KHJ "Boss" Records the week of January 4, 1967; "The Beat Goes On" is at #21.

DANIEL WEIZMANN

author and journalist

"The Beat Goes On"—sung at Sonny Bono's funeral and inscribed on his tombstone—is famous mostly for its syncopated Carol Kaye bass riff . . . go-go music for the fruggers [the Frug was a mid-1960s dance].

"But it's really one of the decade's true lyrical masterpieces. It's a vivid Polaroid® snapshot of a society in furious transition, precisely at the moment of greatest instability. The flux from all sides acts like concurrent riptides—sexual mores unravel from Charleston to the miniskirt, while the Ma and Pa General Store is plowed over to make way for late-era capitalist supermarts, and technology fuel-injects daily life from baseball to war. The Old America is done for, and the change is dizzying, 'all happening at once,' Whitman-style.

"Embedded in the song is also a gentle irony—*the beat going on* of course implies that the basics remain. And yet, the forceful, almost military march of the groove thunders back again and again, implying that, this time around, the change might be cataclysmic, a hypnotic progress that can't be reversed—an all-out cash-out to youth. Teenybopper is now king—but the question is, will this new leader be benevolent or tyrannical? The song's real genius is that it refuses to answer. But there may be a hint in the song's final image, a bum begging for a dime."

RODNEY BINGENHEIMER

radio host, KROQ 106.7 FM, "Rodney on the Roq"

"Ahmet Ertegun was around the Sonny and Cher session dates. It took me a couple of years to figure out he was the Atlantic Records guy. Ahmet would never intrude. Cher would sit on his lap. It took me a while to learn he had the checkbook. Ahmet grooved on the music. He did seem older than everybody. He was scouting talent. Ahmet wasn't a snob. He was very approachable."

DENNIS LOREN

"You see, when I arrived in San Francisco in 1967, I felt like I had died and gone to heaven. I have loved art and music since I was a small child, and San Francisco had an abundance of both. Beautiful posters, handbills, and flyers kept me informed as to all of the things happening in the city.

"Bill Graham watched everything that the Family Dog and Chet Helms did for their concerts and did the same and became more famous for doing it. Graham's first shows were benefits for the San Francisco Mime Troupe, who he was the business manager for; his first posters looked more like the old-style boxing posters of the fifties and early sixties.

"Wes Wilson really did the first psychedelic poster designs for the Family Dog shows at both the Fillmore and Avalon Ballroom. When Graham took over the Fillmore space, Chet moved to the Avalon. Soon after Helms, Graham had Wes design his posters as well. Like Wilson's posters, Bill Ham also started doing light for the Family Dog.

"Most of the early Family Dog people were at the Charlatans' Red Dog shows in Virginia City. In the summer of 1965, when they came back to San Francisco, they wanted to keep the party going. Alton Kelley, Ellen Harmon, Luria Castell, Jack Tolle, and others started the first Family Dog dance-concerts at Longshoremen's Hall, even before Chet Helms—who had been managing Big Brother & the Holding Company—came on board. Like Jim Gurley from Big Brother, Stanley Mouse, Ellen Harmon and Jack Tolle came from Detroit. Kelley did several of those early Family Dog posters and he would later work with Stanley Mouse on Avalon Ballroom posters.

"I haunted art galleries in both North Beach and on Sutter Street. Also, I frequently went to the Jazz Workshop, Coffee and Confusion (where, according to Chet Helms, Janis Joplin got her first gig), and the Coffee Gallery. They were all located in North Beach, and then there was Cedar Alley (South of Market), the Blue Unicorn Coffeehouse (near the Haight-Ashbury district), and the Straight Theater on Haight Street."

Another seismic event in 1967 took place on January 29 at the Avalon Ballroom in San Francisco: The Mantra-Rock Dance, a charitable event organized by followers of the International Society for Krishna Consciousness, or the Hare Krishna movement. The Grateful Dead, Big Brother & the Holding Company, Moby Grape, Allen Ginsberg, and the society's founder, the guru A. C. Bhaktivedanta Swami Prabhupada, were among those who appeared.

BELOW: Dennis Loren at a store called the Black Angel in the Mission District of San Francisco, late 1967.

OPPOSITE: The poster for the Mantra-Rock Dance at the Avalon Ballroom, January 29, designed by Harvey W. Cohen.

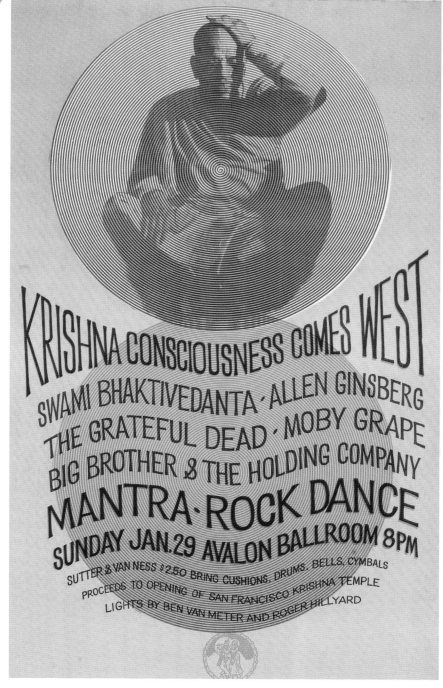

KRISHNA CONSCIOUSNESS COMES WEST
SWAMI BHAKTIVEDANTA · ALLEN GINSBERG
THE GRATEFUL DEAD · MOBY GRAPE
BIG BROTHER & THE HOLDING COMPANY
MANTRA·ROCK DANCE
SUNDAY JAN. 29 AVALON BALLROOM 8PM
SUTTER & VAN NESS $2.50 BRING CUSHIONS, DRUMS, BELLS, CYMBALS
PROCEEDS TO OPENING OF SAN FRANCISCO KRISHNA TEMPLE
LIGHTS BY BEN VAN METER AND ROGER HILLYARD

"I spent a lot of time at the Fillmore and the Avalon. I did a couple of shows with the Grateful Dead, but it wasn't the right setting for my thing. Because the audience, no matter how sweet they were, basically came to have a rock concert experience.

"I was at parties with the Grateful Dead, and after the concerts we would all be laying around. . . . What I loved was that these experiences were community and ritual of a very high order. Where people felt safe to be open and very uninhibited and there was a sweetness about it all."

—RAM DASS

MOJO MEN / CHOCOLATE / LOVE / WATCH BAND

Sparta Advertising Club
San Jose, California

© Copyright 1967

BIG ABE'S BIRTHDAY PARTY • SANTA CLARA COUNTY FAIRGROUNDS • SATURDAY, FEBRUARY 11, 1967 • 8:30 P.M. • $2.50

HEARING A NEW FREQUENCY

The power of television to shape the popular cultural discourse is, for good or for bad, irrefutable. Television's ability to bring the immediacy of an unfolding event into our lives—be it a calamitous overseas conflict or goofball entertainment—was so potent that the Vietnam War was dubbed the "living room war" by *New Yorker* critic Michael Arlen in 1965. In 1967, it was getting harder to discern exactly where those tragicomic threads deviated. And yet for every vacuous Bob Hope special that aired (the presence of Ann-Margret notwithstanding), a tiny act of sedition slipped through the network censors.

OPPOSITE: A poster by Jim Michaelson, created for Dave Schiller's rock concert at the Santa Clara Fairgrounds, San Jose, February 11, 1967. The concert—billed as "Big Abe's 158th Birthday Party" in celebration of President Abraham Lincoln (born February 12, 1809)—featured the Mojo Men, Love, and Chocolate Watchband.

On February 5, *The Smothers Brothers Comedy Hour* premiered on CBS-TV from Television City in Hollywood. Jim Nabors and Ed Sullivan were among the featured guests. Billed as ostensibly another white-bread variety show, it quickly metabolized into a scathing bully pulpit, satirizing the political establishment with reckless glee while giving voice to some of the most strident voices in pop music. The Turtles, Buffalo Springfield, Jefferson Airplane, Judy Collins, the Association, the Buckinghams, the Hollies, the Who (detonating "My Generation") were all touchstone artists addressing the young people's crusade. Pete Seeger's rendition of "Waist Deep in the Big Muddy," a hand grenade thrown at the Johnson Administration, pushed the network's buttons until they popped. A lot of huffing and puffing ensued, but the wolf at the door was stifled . . . for the nonce.

BELOW: From left to right: Tom Smothers, guest Pete Seeger, and Dick Smothers, performing on *The Smothers Brothers* show, September 1967.

DENNY BRUCE

record producer, A&R

"The [*Smothers Brothers*] program arrived in early '67. It was mandatory viewing on a Sunday night. It's all we had. A show where pop and provocative rock acts were given slots, much like *Ed Sullivan*. The hosts, Tom and Dick from the South Bay, were folk music veterans and they did the best they could against censorship suggested or imposed on them by the network."

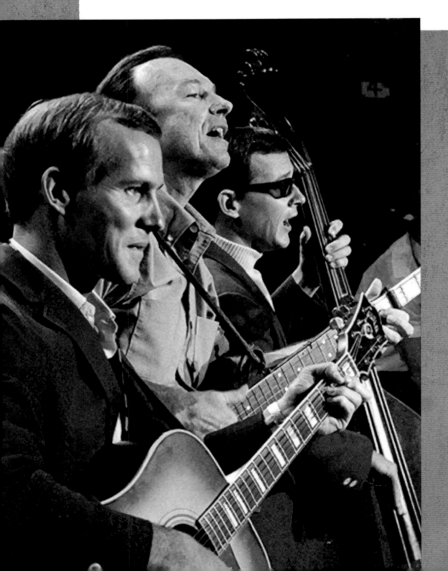

"[The Smothers Brothers's] slot was FM radio to television. Historians will always remember their groundbreaking show. They stuck a figurative middle finger up at middle America."

—ROGER STEFFENS

"Dr. Timothy Leary said in his book *The Politics of Ecstasy*, the Monkees brought long hair into the living room. It made it OK to be a hippie, have long hair, and wear bell-bottoms. It did not mean you were a criminal, a dope-smoking fiend commie pervert. That's what happened."

–MICKY DOLENZ, THE MONKEES

Meanwhile, the Monkees dominated the airwaves that February with the No. 1 single in England ("I'm a Believer") and the No. 1 album in America (*More of the Monkees*).

ABOVE: A still from *The Monkees* show, photographed by Henry Diltz in 1967; from left to right: Peter Tork, Micky Dolenz, Michael Nesmith, and Davy Jones.

BELOW: Micky Dolenz in Chicago, 1967, photographed by Henry Diltz.

It is no small irony that an act by an imperious government agency did more to stoke the fires of the sixties music revolution than any amount of rubber-lipped posing or feel-good festival revelry.

In 1965, the Federal Communications Commission (FCC) mandated that radio stations could no longer maintain their AM and FM broadcasts with identical programming.

Virtually overnight, the long-neglected FM bandwidth, distinguished by its superior stereo sound, became a haven for jazz and classical artists who were the immediate beneficiaries of this surprisingly well-received directive. But it was in the world of pop music that the change was most artfully felt.

AM broadcasters had become ravenous in their pursuit of tighter playlists; Top 40 became Top 30, and then Top 20, as the economics of the radio business drove a numbing conformity across the dial. It was big business.

In 1964, seventeen-year-olds were the preeminent demographic in the country, and their appetite for music generated more cash flow than either the sports or movie industries. As their tastes matured, the music grew increasingly ambitious.

Photo of the AM/FM dial by Henry Diltz taken while in a car at the 1968 Miami Pop Festival.

TIMOTHY LEARY

"I had always been just fascinated and obsessed with music as a kid. I was [from the] first generation of kids that had radio to listen to late at night. . . . so it's been music all the way. We were futurizing. What's the next thing? What's coming? And many of the people knew that. The consumer would tell you, 'Hey, we want more stereo.'

"Yeah, everybody knew about it, we're talking about a culture, you know. . . . People are sharing this information. And [I] give a tremendous amount of credit to pirate radio and new radio, and all those around the Bay Area; suddenly every city had its counterculture radio. Boy! Free radio. 'SPREAD THAT WORD.'"

ROGER STEFFENS

"Potent RKO (Radio Networks) AM radio stations were already in place. FM rock radio emerged in 1966 and was really blaring in '67. That year you had a revolution in radio. Before that, it's hard to imagine that, except for a few effete hi-fi snobs and opera and classical music lovers, hardly anyone ever listened to FM radio. First of all, it cost so much to have an FM set, and there were hardly any FM stations, and whatever there were, they were invariably straight and uptight."

FRED CATERO

record producer and engineer

"I was a staff engineer for Columbia Records in the sixties. The arrival of FM radio in 1967 didn't change Columbia, but the demographics of FM radio changed the label and who was listening. Because FM is ideal for high fidelity. It was much clearer, so you could hear the subtleties of his voice. As a human organism, we rely a lot on the subtleties, and FM was able to transmit that—especially if you were listening on headphones or a good system—whereas AM was limited in its ability to transmit that feel."

"KMPX [FM, San Francisco] with Tom Donahue just revolutionized the airwaves, and then his work spread to the Los Angeles area on KPPC and later KMET. It was the most amazing radio. Entire albums on shifts, coupled with live concerts that had just occurred."

—ROGER STEFFENS

The joint Northern and Southern California collective radio vision ignited trends in music awareness nationwide.

In very late 1967, KPPC-FM in Pasadena, located in the basement of a Presbyterian church, initiated a new policy. Tom Donahue was now overseeing the station and even made an attempt (unsuccessfully) to change the longtime call letters of KPPC to KHIP.

By January 1968, the station continued on the air with Donahue, B. Mitchel Reed, Les Carter, Ed Mitchell, and Don Hall. In '68 the staff would add Ted Alvy (aka "Cosmos Topper") and the "Obscene" Steven Clean.

DENNIS LOREN

"A Detroiter—Larry Miller—started the whole underground FM radio thing on February 1, 1967, on KMPX-FM (San Francisco), and not Tom 'Big Daddy' Donahue like some would have people believe.

"Miller had the midnight-to-6:00 a.m. slot on that station, and was the first to play folk rock on a station that usually played religious, classical, and ethnic music programs. Having the midnight shift, Miller was free to play whatever he wanted, and as folk rock morphed into psychedelic music, so did his free-form style become popular with the original hippies and young people. Donahue was an AM jock who saw the writing on the wall and offered station owners to make this underground rock format 24/7. Later there was a palace coup and many of those jocks started KSAN [FM]."

A poster for the underground folk rock Larry Miller show on KMPX-FM.

ROGER STEFFENS

"KMPX in San Francisco was the city's fabled first underground radio station, and when the staff went on strike not long after, many of the DJs went on to found KSAN under the leadership of program director Tom Donahue.

"Bob Postal served on both stations, and his broadcasts were among the most widely focused, mixing folk music with deep blues, long-form rock, jazz, tapes of live shows, and fascinating anecdotes about the musicians he helped to gain more mainstream exposure. Anything went, as long as it was good.

"The one thing about FM radio, a lot of the DJs did not back-announce song titles. And that was a mortal sin in radio. I had a radio show in New York in 1961. Babatunde Olatunji, the Nigerian "Drums of Passion" man, was my first guest. I was always taught that you must tell people what you played in reverse order. And so I was hearing songs in 1967, and not knowing the actual titles or albums. I heard a lot of Frank Zappa without knowing it was Zappa."

JOE SMITH

Warner/Reprise executive

"And then Tom Donohue started FM radio up there [San Francisco] because there was this station that programmed Chinese. He offered to take it over, and the first day he's on the air, and anybody who listened to that frequency the day before was not prepared when he played a Grateful Dead record and the phones went berserk."

Portrait of pioneering DJ and program director Tom "Big Daddy" Donahue, by Baron Wolman.

XERB MIGHTY 1090

50,000 WATTS

FULL TIME 24 HOURS

THE SOUL MONSTER
ALL OVER LOS ANGELES

ABOVE: Ad for XERB "Mighty"-FM 1090, c. 1967.

RAM DASS

"I remember doing *The Long John Nebel Show* [on WNBC] in New York midnight to 5:00 a.m. with Timothy Leary. . . .

"That show was more focused on psychedelics in those days, and there was more 'flower child' mentality, more 'Wow!' In the sixties, a lot of people called who were high on something and it was like, 'We're all out here together.' It was like we were tripping together.

"We're on a journey together, and I'll be as honest as I can about my trip and you can do whatever you want to do, but I'm going to create the space where it's safe to be very vulnerable. That's about drugs, sexuality, about politics, everything."

MARSHALL CHESS

record producer

"XERB [AM, in Baja California, Mexico], the R&B and blues station, always played Chess Records. And their signal reached all of California. When FM radio hit, that was a whole other thing. FM radio was a godsend for the blues. The DJs would put your albums right on! They'd talk with you and smoke joints right on the air! . . .

"Those were the great days. . . . When everyone took LSD to watch the Grateful Dead. I've been at the Fillmore West sitting on the floor.

"What happened to me was that I was part of that sex, drugs, and rock 'n' roll generation. And it blew my mind. Bill Graham was the greatest [for] the blues artists of that era like B. B. King and Muddy Waters. It blew our mind. Of course it was a fantastic thing. We loved it. And we never thought that [white] kids would constantly support and buy our records. It was a total fantasy."

KBLA Radio 1500
the "iN 30" RECORDS

APRIL 18, 1966

HARRY NEWMAN
6AM - 9AM

VIC GEE
Midnight 'til Dawn

WILLIAM F. WILLIAMS
9AM - 12 Noon

HARVEY MILLER
9PM - 12 Midnight

ROGER CHRISTIAN
12 Noon - 3 PM

DAVE DIAMOND
3PM - 6PM

BOB DAYTON
6PM - 9PM

Meet the KBLA iNtertainers!

KBLA-FM 1500 card; Dave Diamond is featured on the bottom row, center.

DAVE DIAMOND

disc jockey

"I had eighteen months at AM radio station KBLA from very late 1965 until mid-June '67 and could play whatever I wanted. I had a weekly Sunday night show on KBLA-AM in 1966 and '67, *Stones City*. Three hours of the Rolling Stones on an AM station. The Stones recorded in Hollywood at RCA from 1964 to 1967.

"I played the Rainy Daze's 'Acapulco Gold' and would spin long LP tracks: 'Up in Her Room' by the Seeds and 'Revelation' from Love. I previewed Buffalo Springfield's 'For What It's Worth.' I was friends with their drummer, Dewey Martin.

"In June 1967, KBLA changed their format to country. I ended my show with the Doors' 'The End.'"

DENNY BRUCE

"I loved KPPC-FM. I couldn't be more happy to not play my own records and be able to enjoy somebody who put some thought into doing a show.

"I had heard KMPX and then KSAN in San Francisco and was delighted to hear whole albums spun and announcements for local music gigs. What I really enjoyed about 1967 radio in California were the DJs who would track a rock or blues song, programming the original and a cover version."

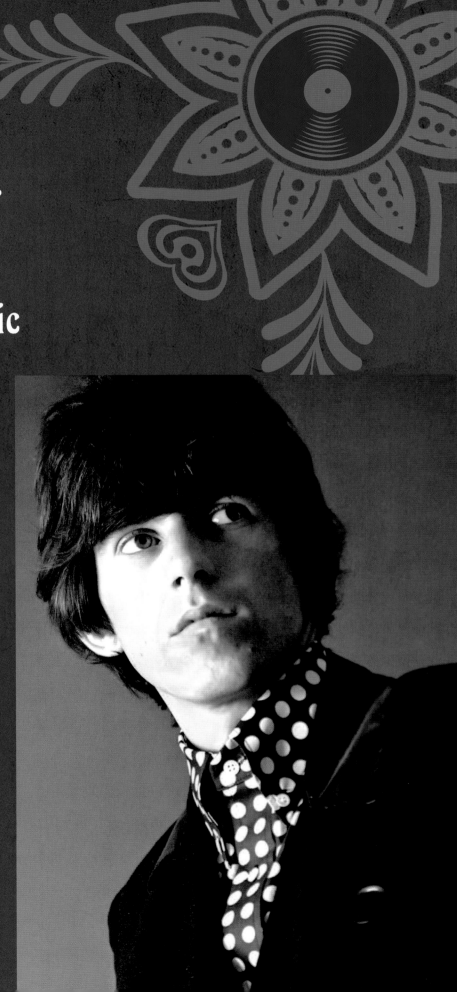

"The room is good if you know what you're doing. Use as few microphones as possible. The whole idea when you play music is to fill the room with sound. Because a band is several people playing something. And somewhere in the air of the room, that sound has to gather in one spot. And you have to find that spot."

–KEITH RICHARDS, THE ROLLING STONES

Portrait of Keith Richards
by Guy Webster, March 1966.

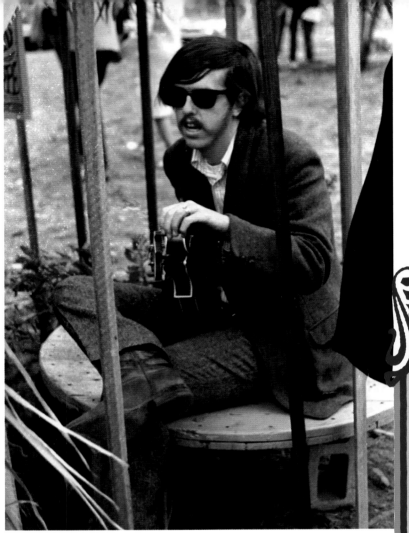

Chris Darrow, multi-instrumentalist and one of the founding members of the Los Angeles–based psychedelic folk and blues band Kaleidoscope, recalls the band's experiences with underground FM radio in California.

LEFT: Chris Darrow of Kaleidoscope, photographed at a be-in by Pam Lauesen, c. 1967

CHRIS DARROW

multi-instrumentalist, Kaleidoscope

"When I was in the Kaleidoscope in 1967, we were getting our first album, *Side Trips*, played on the radio. . . . Not on AM radio, but on FM. With the coming of the West Coast sound and psychedelic music, an alternative form of delivery was established and FM 'underground' radio became the norm for us hippies, whose music was coming from the other side of the tracks.

"In those days, FM was an occasional jazz station, a religious program, or talk radio. AM was what everyone had in their homes and cars at the time. That's where the money was, Top 40 and all those commercials. But free-form FM radio had a big edge in sound quality, and there were virtually no commercials. Our station was KPPC-FM, located in Pasadena, and the DJs played whatever they wanted, for as long as they wanted to, often playing an album from beginning to end, with no break.

"I was friends with both B. Mitchel Reed and the Obscene Steven Clean, who were both DJs on KPPC. Our producer, Barry Friedman [later known as Frazier Mohawk], and I went to BMR's house in Laurel Canyon one day to listen to a fourth-generation pre-release bootleg cassette of the Beatles' *Sgt. Pepper's Lonely Hearts Club Band*. Underground all the way!

"Our band often did radio interviews at underground FM stations in California, and there was usually pot being smoked somewhere in the building. Those were the days!"

JAC HOLZMAN

"From its elementary beginnings several years earlier, by 1967 FM had broadly embraced rock formats.

"FM DJs were knowledgeable and trusted. FM took the place of the listening booth in old record stores and gave the fan an accurate sense of what they could expect from the complete, shrink-wrapped, 12-inch LP.

"The Doors's 'Light My Fire' was so successful on FM that it accelerated acceptance of the track on AM radio, which combined gave Elektra its first No. 1 million-selling single.

"All hail the FM DJs! They were essential partners in the impact radio made on the astute listener."

The Next Phase in Underground Music

LuxuriaMusic.com DJ Gary Schneider, who also owns and operates Open Mynd Collectibles in Rialto, California, spent the first six months of 1967 on the East Coast in Massachusetts, and then relocated to the Los Angeles area, where he remains a resident, in June for the Summer of Love. Here he recounts stories of the music and radio scene in early 1967:

"1967 was an extension of 1966! 1967 was and could only be the next phase of rock music! Garage bands of '66 progressed and experimented for the better. . . . The rough edges were still there, but the overall sound was more melodic and better produced. The Electric Prunes' 'Get Me to the World on Time,' the follow-up to 'I Had Too Much to Dream (Last Night),' was in rotation. During 1967, the Chocolate Watchband from the San Jose area had a regional hit in California with 'Are You Gonna Be There (At the Love-In).'

"Even AM radio was in a mood change by '67, [including] KFRC in San Francisco, KHJ in Hollywood, and KRLA in Pasadena.

"KBLA in Burbank, California, was quick to change their format to not only Top 40 but also album cuts and 'underground' local groups for airplay. Dave Diamond, Humble Harve, and 'Emperor' Bob Hudson were introducing the 'heavy' L.A. sounds of the day. Love, the Doors, the Strawberry Alarm Clock, the Misunderstood, and the Knack.

"Even KFWB with B. Mitchel Reed, who would go on to one of the premiere underground FM stations, KPPC, and KMET, was showcasing the Who's *A Quick One* on his afternoon shows."

KPFK-FM, the Pacifica outlet, noncommercial station in North Hollywood, had numerous rock music programs and regularly announced Summer of Love live music shows. College radio in L.A. also provided a platform for *The Underground Airbag*, broadcast from the campus on the University of Southern California.

Paul Body, early 1966,
Monrovia, California.

PAUL BODY

"Underground radio, which was like religion, it saved us KPPC, I used to hang around there, even drove Tom Donahue's Olds Toronado to LAX to deliver some tapes heading for the city.

"At PCC [Pasadena City College], best part of the day was the drive home listening to KRLA real loud and listening to KBLA at night. Life is a lot more serious now. KGFJ was rocking some cool stuff. KGFJ played the best soul music around."

KGFJ-FM 1230
promotional piece.

GARY SCHNEIDER

"The big cities weren't the only ones to change. Even smaller markets had hip radio stations! Outside of Chicago, a suburb in Illinois had WNWC-FM in Arlington Heights, and in Detroit, WABX-FM. The independent markets were emulating and even expanding on some of the ideas the big-wigs were trying out. It was a magical time for radio. The 1967 sounds of the Summer of Love were spun the whole year.

"Radio was the main communicating device we teenagers used to keep up with the changing trends in music. Not all of us could afford buying all the teenzines or records hitting the shelves daily or weekly. We tuned in extensively all through the sixties, but 1967 was one of those years you couldn't miss out on what the current sound was. Everything changed from week to week. Since FM was emerging in '67, you had to reinvest in a transistor with that extra band."

Notice for a birthday concert at the Village Theater in New York, sponsored by WOR-FM 98.7 in New York, June 1967.

Los Angeles wasn't the only place going through changes. In New York, Murray the K [Murray Kaufman], Scott Muni, and Bill "Rosko" Mercer on WOR-FM were experimenting with and expanding their format as early as October 1966! By 1967, they were in full swing as New York's underground sound.

The Summer of Love sounds were also on playlists at WBAI-FM, the noncommercial station in New York. Bob Fast had a shift, and in late fall of '67, "Rosko" Mercer joined WNEW-FM when they changed direction. Alison Steele, "the Nightbird," was on staff as well.

EMPEROR ROSKO

disc jockey, Radio Caroline

"When I was on Radio Caroline, it was reaching 15 million listeners. I was playing 90 percent soul and R&B. I loved Stax, Motown, Chess. Other guys were playing the Who, the Beatles, and the Rolling Stones. But I was known for playing black music.

"The DJs I heard on the radio in Los Angeles were an influence. 'Emperor' Bob Hudson and Bill 'Rosko' Mercer. And 'Magnificent' Montague on KGFJ. I loved XERB and Wolfman Jack. I stole from the best of them and made it into me. [Laughs.]

"Growing up in Los Angeles in the fifties and early sixties, I briefly went to University High School. I brought some of my love for R&B back to England and Europe. I would fly back to L.A. and go to all the record stores down in Watts. I'd go through the bins and I would come back to England with hundreds of 45s, and try to explain to customs at the airport what a pirate radio DJ was doing with 250 singles. When they caught me, that was very interesting. They thought I was opening a store in England. 'No! I'm a DJ!'

"And, I would play both sides of the record, which a lot of people thought was kind of weird. You never know what you're gonna find on the flip side. I've turned a couple of B-sides into Top 10 hits in England.

"Anything that was anti-establishment, I was all for it. I loved the Doors. They were California and represented, to me, L.A. They were unique. It's so nice when you have something that cultures out of Los Angeles. They made great and mesmerizing music."

Carlos Santana, in his 2014 autobiography *The Universal Tone*, wrote that for him, "the Summer of Love was also the summer of decisions." The enlightened musician might have been referring to judgments being made by open-minded program directors in 1967 at radio stations in North America and England. These included airplay decisions that gave American and British bands initial exposure.

RIGHT: Portrait of Andrew Loog Oldham, manager and producer of the Rolling Stones (1963–67), by Guy Webster, March 1966.

KEITH ALTHAM

music journalist and press agent

"The Brits were very fashionable, weren't they? Not the flavor of the month but maybe the flavor of the year. And the Beatles, having knocked down the door, there was kind of a surge of groups, bands, and artists that were mirroring and monitoring their success and following in their wake.

"FM radio was big in 1967. Pirate radio in the UK in '67 was sort of our FM radio. Pirate radio station Radio Caroline [started in 1964 by Ronan O'Rahilly] shattered the BBC Radio monopoly.

"The BBC until then had a stranglehold on everything that was played. If you weren't played on the BBC, you didn't get exposure. They had the monopoly. You had Radio Luxembourg for about an hour between six and seven o'clock at night before another station would cut in so you couldn't actually hear the music anymore. So that's what we were subjected to.

"And then somebody saw the gap in the market and went to the offshore ship and actually played without being restricted by the government's punitive laws on radio and broadcasting. And that was when we started to hear more independently minded voices, independently produced records, and it came about through pirate radio."

ANDREW LOOG OLDHAM

record producer and manager, author, radio host

"The times were changing. FM radio and [BBC Radio 1 DJ] John Peel and pirate radio, plus the continuing flow of drugs and disposable income, changed the focus seemingly from the 45 rpm to the long-play record as a way of presenting an act as opposed to a single. It all became much more expensive and, in truth, I was and remain a song and a singles man.

"If we had not had pirate radio I might not have had a hit with Marianne Faithfull's 'As Tears Go By.' The BBC would not touch it—they said Marianne could not sing. Mind you, that's what they'd said about Mick Jagger a year earlier when the Rolling Stones failed their BBC live audition. They said, 'The singer cannot sing.' The BBC was the enemy, a limp-wristed arm of the government trying to keep kids on a rationed musical diet of trad jazz and skiffle."

HOLLAND-DOZIER-HOLLAND

"Bernadette" is the magnificent 1967 song recorded by the Four Tops for the Detroit-based Motown Records label. The hit single was written, composed, and produced by the Motown production team of Brian Holland, Lamont Dozier, and Eddie Holland. Their influential tenure at Motown was from 1962 to 1967. Composers Dozier and Brian Holland produced the songs and Eddie Holland penned the lyrics and arranged the singers.

"H-D-H was absolutely brilliant," Berry Gordy Jr. notes. "The three of them were different and they all complemented each other. Eddie did mostly vocals. Brian, I thought, was the most talented, creative person. He was my protégé for many years. I thought Lamont was also a good writer, and he was good on backgrounds."

BELOW: The Four Tops performing on *The Ed Sullivan Show*, January 30, 1966.

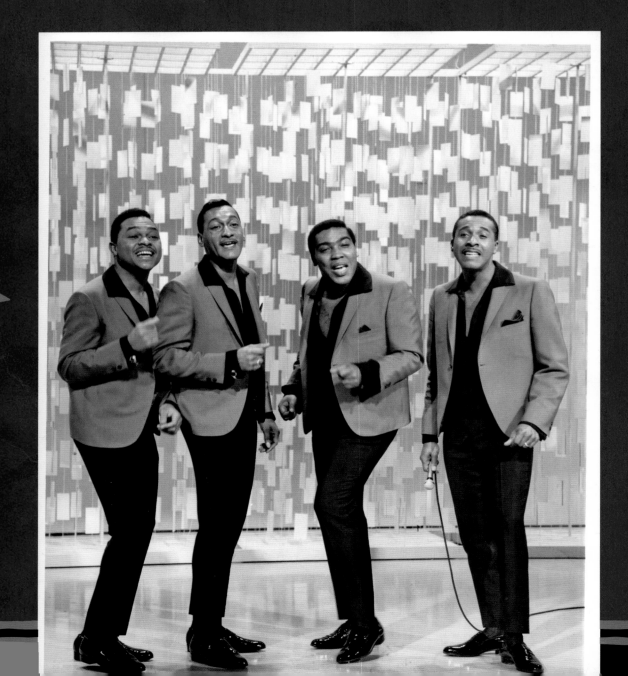

There was likely an FM or AM radio dial in the car, maybe an 8-track tape player (still in its infancy), but it was usually you, alone or with friends, and the LP in your bedroom. Home entertainment centers, stereo components, and the introduction of headphones were all part of the 1967 sound experience.

By '67, lots of people owned television sets and were now getting their first color TV models, somewhat owing to the success of the *Batman* and *The Monkees* television series. These color sets were the first expansion of the home entertainment system for teens and young people beyond their first turntable.

The popularization of stereo headphones—which were first invented by John C. Koss of Milwaukee in 1958—now made it possible to have a more intimate relationship with music. More important, headphones emphasized the paradox that popular music, produced and marketed for public consumption, could be experienced privately.

JAMES CUSHING

radio host, "James Cushing's
Jazz Classics," KEBF-FM

"[With headphones] you could really investigate sound between your ears. Guitar parts. Vocal panning. Of course, stereo sound made a big difference here too. Stereo LPs cost a dollar more in 1967, but stereo added a whole other dimension to the discovery. . .

"FM radio proved that we are not alone. That there were live people who could talk to me in my own home. In my own room. Who at the same time could function in this larger, more exciting culture where adults had the great, grand permission to be who they really were.

"Jefferson Airplane was not the fantasy. The fantasy was the Harvard School. [A] 1940s way of living in the world. The reality was a lot closer to Jerry Garcia. The reality was a lot closer to Grace Slick and John Lennon. The reality was that I was going to go to U.C. Santa Cruz, which would ultimately house the Grateful Dead's archives. FM radio showed me and others there were new voices and choices available."

"Poet William Blake said, 'One thought fills immensity.' In the headphone experience, the music becomes the one thought."
—JAMES CUSHING

The Rolling Stones' *Between the Buttons* LP was issued stateside on February 11, 1967. Keith Altham, in the January 14, 1967, *New Musical Express*, hailed this constant Spring and Summer of Love turntable companion:

"Andrew Oldham has produced an album richer than ever before in terms of variation of pace, sound and excitement—the Stones send the mind reeling and limbs wheeling."

BELOW: The Rolling Stones' lineup, March 1966, featured, from left to right: Keith Richards, Mick Jagger, Bill Wyman, Charlie Watts, and Brian Jones (foreground). Photograph by Guy Webster.

OPPOSITE: Keith Richards and Andrew Loog Oldham, 1967. Photograph by Jerry Schatzberg.

ANDREW LOOG OLDHAM

"The songs were just brilliant, only eclipsed by the idea that the Beatles, Ray Davies, and, coming up through the ranks, Pete Townshend, wrote better. The media and the BBC would just not accept what damn fine writers Mick and Keith had turned into. Wonderful social commentaries that had their roots somewhere between vaudeville and the BBC World Service.

"I'm not just talking about the obvious: 'Satisfaction,' 'Paint It, Black.' I'm talking 'She Smiled Sweetly,' 'Connection,' 'All Sold Out,' 'Back Street Girl.' The laconic comments, the posed rancor, Mick and Keith's songs at that time cut right through the picket fence and into the very life of then.

"I'd better stop now, or Keith, if he reads this, might be reaching for the vomit bag."

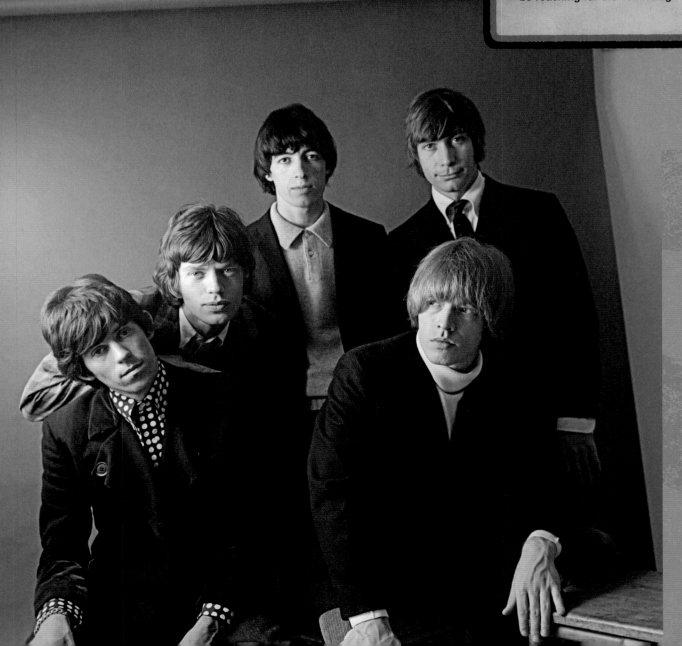

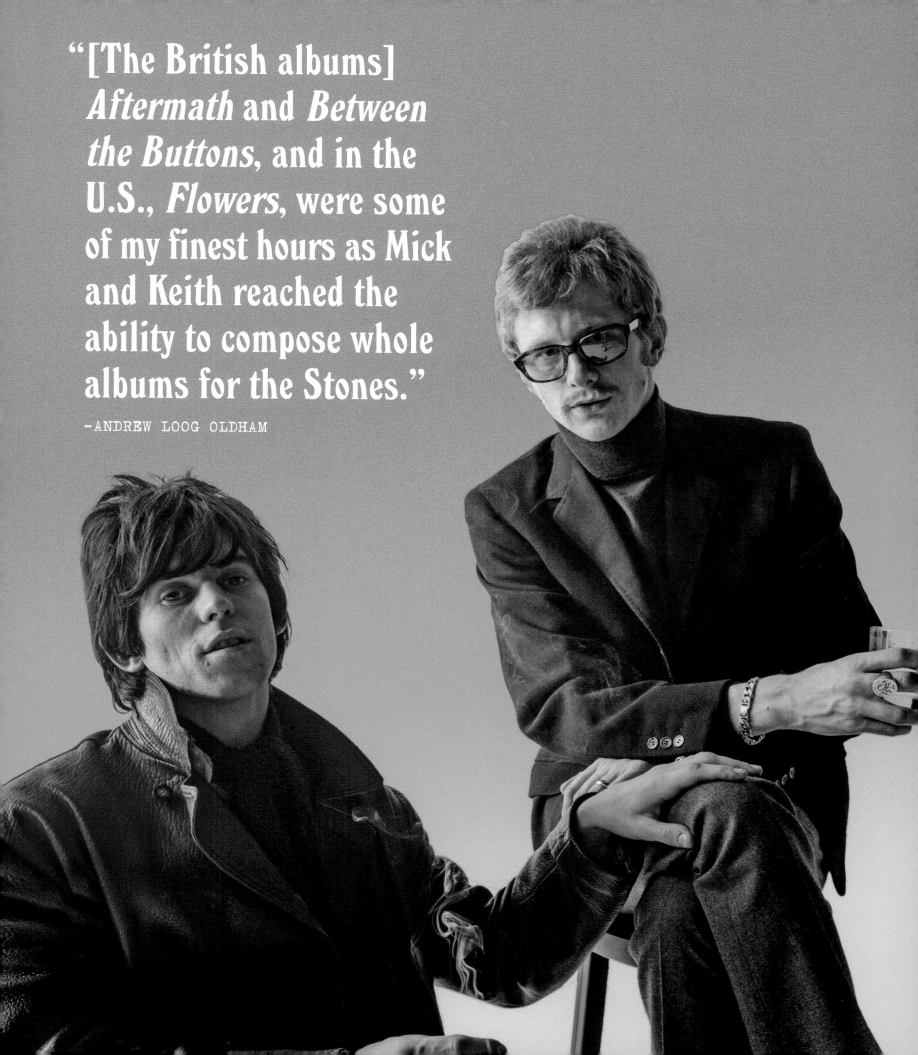

"[The British albums] *Aftermath* and *Between the Buttons*, and in the U.S., *Flowers*, were some of my finest hours as Mick and Keith reached the ability to compose whole albums for the Stones."

—ANDREW LOOG OLDHAM

In Between the Buttons

Kenneth Kubernik

"The image is indelible: December's wicked children, led by a dissolute blonde rogue, peer wearily into the lubricious lens of photographer Gered Mankowitz. It's an early winter morning in the waning days of 1966. After another exhausting all-nighter at Olympic Studios in Barnes, London, the Rolling Stones had piled into producer Andrew Loog Oldham's 'Roller' and motored to Primrose Hill. The cover shot for their forthcoming album, *Between the Buttons*, beckoned, but no one was keen on posing at the surly gates of dawn.

"What resulted—five haunted souls edging fitfully into focus—not only captured the elastic quality of the music contained within, it provided a snapshot of entropy in action, the British pop aesthetic regenerating like Doctor Who from its effervescent go-go prose to something more elliptically poetic. 'Swinging London' was cracking up, and no group of cultural outliers understood this better than the Stones.

"The group convened at Olympic in November to complete tracks begun at RCA Studios in Hollywood back in August. *Between the Buttons* was released to the ravenous eyes and ears of a restive audience on the cusp of a complete psychedelic makeover. If the music sounded then (and now) like an inebriated

pastiche, it came by its hazy lassitude honestly.

"Physically—if not spiritually—spent, they relied on their finely honed instinct for delivering brilliant moments: the cross-fire buzz-saw guitars on 'Miss Amanda Jones'; the gravelly bass throb juxtaposed to pianist Ian Stewart's barrelhouse revelry on 'My Obsession'; Brian Jones's plaintive recorder counterpoint to the slap-dash funk groove on 'All Sold Out.'

"Throughout the music, keyboards figure as prominently as the magical 'weave' of guitars that had defined the Stones sound. Foreshadowing Procol Harum and the Band, the robust interplay of piano, organ, and other mysterious embellishments lent the songs a distinct sonic signature. Herein, the gimlet-eyed contributions of the Stones's other 'sixth man,' Jack Nitzsche, must be acknowledged. Nitzsche, whose rococo musings on harpsichord had distinguished such vital Stones tracks as 'Play With Fire' and 'Lady Jane,' provided impertinent detail to songs in desperate need of some panache.

"*Buttons* is littered with the drips and drabs from whatever was hip, was charting, or catching fire along taste-making Portobello Road. 'Who's Been Sleeping Here?' is pure leopard-skin, pillbox Dylan; Jagger practically sniggers his line

readings and Brian wheezes on the harp, while Keith picks some tasty blues filigrees as though auditioning for Bob's Newport electric band.

"The album concludes with the whimsical throwaway 'Something Happened to Me Yesterday.' Many bands at the time were trafficking in English music-hall send-ups; the Kinks, in particular, had been dishing out such musical caprice as 'Dedicated Follower of Fashion,' to some acclaim. Similarly, the Bonzo Dog Band and the New Vaudeville Band (who were chart-topping with 'Winchester Cathedral' at the time the Stones were recording) were make some joyful noise with their cheeky hijacking of the tradition, deploying trombones and tubas like mad hatters in some Carrollian cock-up.

"Ultimately, *Between the Buttons* is a minor work. At its best, though, it tolls with the stately grace of Big Ben, christening an instant when the Pop Aristocracy bestrode King's Road, in search of a crown to fit their station, the boys resplendent in their military brocade and attendant whiskers, the girls aglow in Yardley cosmetics and Courrèges white boots."

OPPOSITE: Outtake from *Between the Buttons* album cover photo shoot, by Gered Mankowitz.

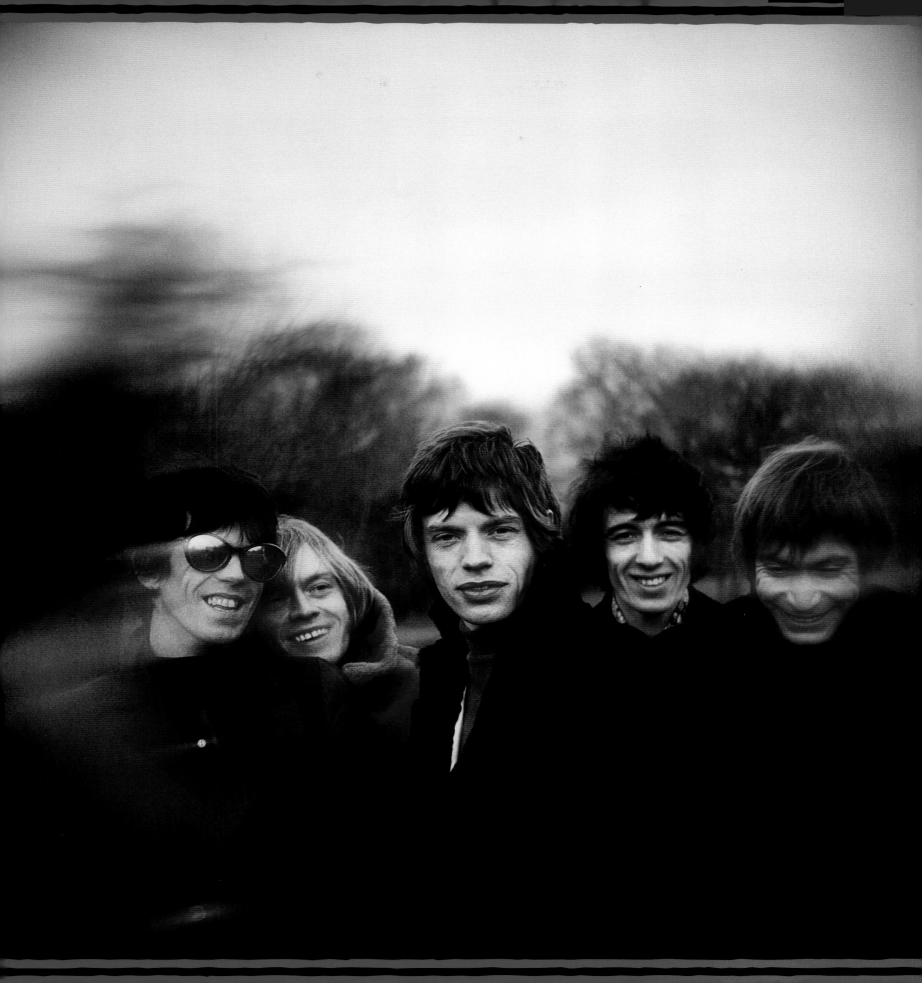

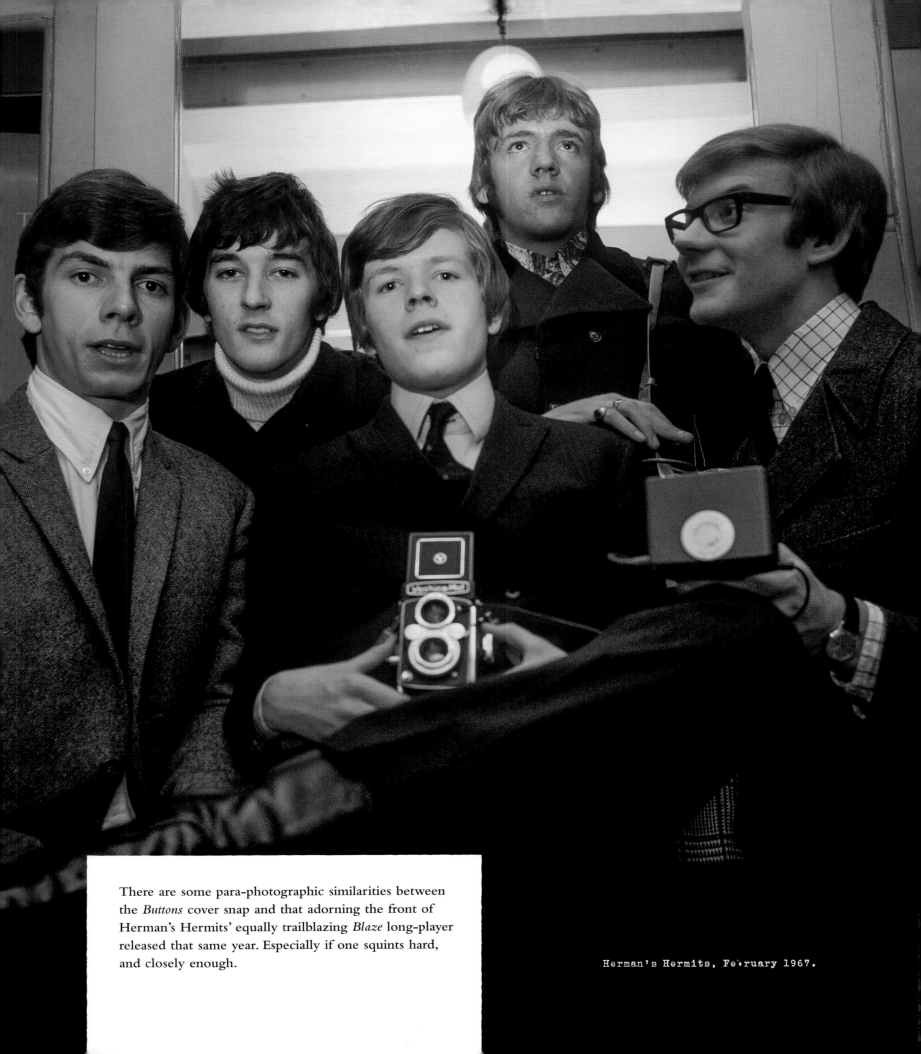

There are some para-photographic similarities between the *Buttons* cover snap and that adorning the front of Herman's Hermits' equally trailblazing *Blaze* long-player released that same year. Especially if one squints hard, and closely enough.

Herman's Hermits, February 1967.

GARY PIG GOLD

singer-songwriter,
record producer, author

"As with most of the original British Invaders, 1967 proved a final American fling of sorts for Herman's Hermits. Already replaced on most teen bedroom walls by fellow Mancunian Davy Jones, Peter Noone—though remarkably still only nineteen years of age at the time—wisely followed mentor/producer Mickie Most's advice to begin maturing things somewhat, especially musically speaking.

"So came the majestic 'There's a Kind of Hush,' a Les Reed/Geoff Stephens composition that had debuted on the 1966 New Vaudeville Band *Winchester Cathedral* LP and was actually covered first by Franklin, Ohio's kiddie-popping Gary and the Hornets. But it was the Hermits' lush, heartfelt, yet still somehow not *too* sticky rendition that reached No. 4 on *Billboard*'s March 25, 1967, Hot 100, right there behind 'Penny Lane'—the last time Herman and Co. hit the U.S. Top 10."

ANDREW LOOG OLDHAM

"Mickie Most was bar none the most versatile and successful British record producer of the sixties. George Martin had the Beatles, I had the Stones, Shel Talmy had the Who and the Kinks—all self-contained acts. Mickie spotted great talent—Herman's Hermits, the Animals—and he matched them with great songs, again and again and again.

"Mickie Most and Peter Noone. These two guys had a great run together and nailed down that American affection for British song and vaudeville, which survives from Bob Hope to . . . Michael Flatley.

"Mickie Most was a great songsniffer, one of the best. 'I'm into Something Good' and 'There's a Kind of Hush' are great records. And then there was his run with Donovan. [Most produced Donovan's 'Epistle to Dippy,' a U.S. chart hit in 1967. 'Preachin' Love' was the poptastic B-side.] The yard went on forever . . ."

"Mickie found John Paul Jones, who first came along as an arranger and bass player. He wasn't going to be a Hermit. He was going to write the [chord] charts. Graham Gouldman [of 10cc] wrote 'No Milk Today.' It was a pure Manchester song about the place, and it's about things we could see every minute that we were in Manchester. You know, the milk delivery and the terraced houses on the hillside."

-PETER NOONE, VOCALIST, HERMAN'S HERMITS

JAMES CUSHING

"From the opening Fender Twin Reverb shimmer on 'The Dolphins,' we know we're in the presence of a wise and richly informed soul whose vision of 'folk-rock' has nothing to do with anyone else's, and who sings with the voice of an authentic American wanderer. Alan Wilson, the doomed genius of Canned Heat, adds lonely blues harmonica to the deep pessimism of 'That's the Bag I'm In,' but the album is mostly a palimpsest of chiming guitars and Neil's uniquely commanding, sexy baritone, which rivals both Tim Buckley's and Jim Morrison's for irresistibility.

"Neil wrote 'Candy Man' for Roy Orbison, and Neil's voice is one of the few in rock on that [same] level of expressiveness, especially on the heartbreaking version of 'Faretheewell (Fred's Tune).' The best-known song on the album, of course, is 'Everybody's Talkin',' made famous years later by Harry Nilsson—but Neil's understated masculine arrangement offers a more intimate perspective. Neil made another album that year, *Sessions*, with upright bass, four acoustic guitars, and a looseness only equaled by Dylan's Basement sessions—of which Neil could not have been aware."

Given its luminous music and its beneath-the-shadows status, *Fred Neil*, by the American folk rock artist of the same name, released in February 1967, may be the most egregiously overlooked and underrated LP of that watershed year.

BELOW: Fred Neil in the Capitol Records studio, Hollywood, 1967.

On the Byrd's fourth Columbia release—the Gary Usher–produced *Younger Than Yesterday*, recorded in December 1966 and out in February—the Byrds were a four-piece band and a known quantity; the jingle-jangle of Roger McGuinn's electric twelve-string was no longer a new sound, and "folk-rock" was already yesterday's genre.

"So You Want to Be a Rock 'n' Roll Star" has a glorious gift of a solo turn from South African jazz trumpeter Hugh Masakela; Chris Hillman plants the seeds of country-rock fusion with his "Time Between" and "The Girl With No Name"; and has David Crosby ever written a lovelier melody than "Everybody's Been Burned"?

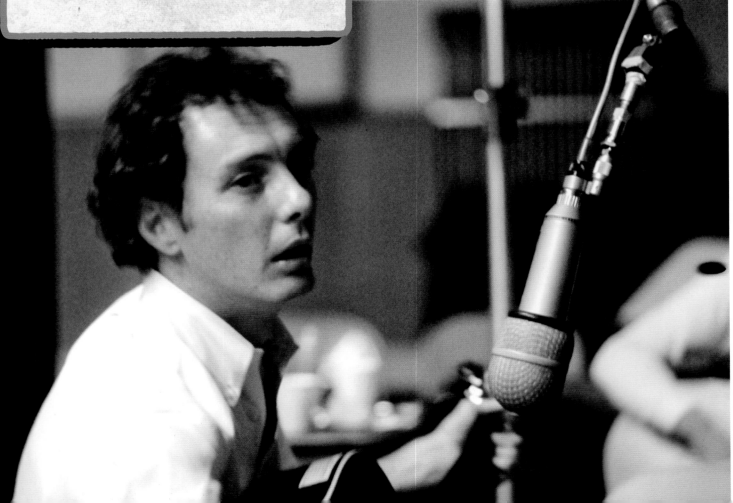

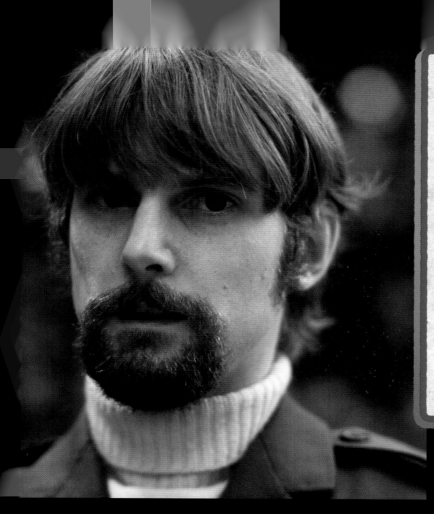

ROGER MCGUINN

lead singer and guitarist, the Byrds

"We had some good times writing songs. Chris Hillman played us 'Have You Seen Her Face' in the studio and we cut it. Chris Hillman is a very gifted musician. The way he transitioned from mandolin to bass was amazing in a very short time. I don't know if he was completely influenced by [Paul] McCartney, but he had this melodic thing, I guess more from being a lead player. He incorporated a lot of leads into his bass playing. . . .

"David Crosby is an incredible singer for harmonies, and he's written some wonderful songs as well. A good songwriter. I also really appreciated his rhythm guitar work. I thought he had a great command of the rhythm part of it and also of finding interesting chords and progressions."

Clockwise from top left: the Byrds' Roger McGuinn, Chris Hillman, and David Crosby; photographs by Henry Diltz, 1966–67.

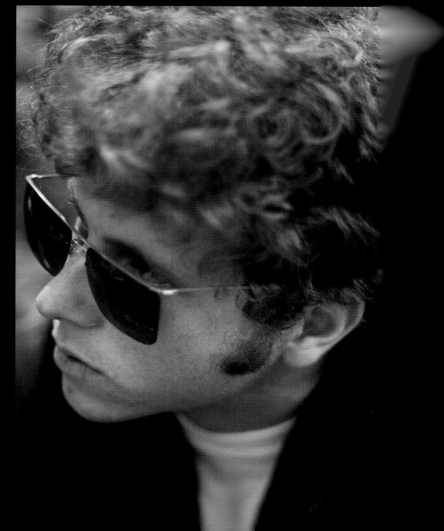

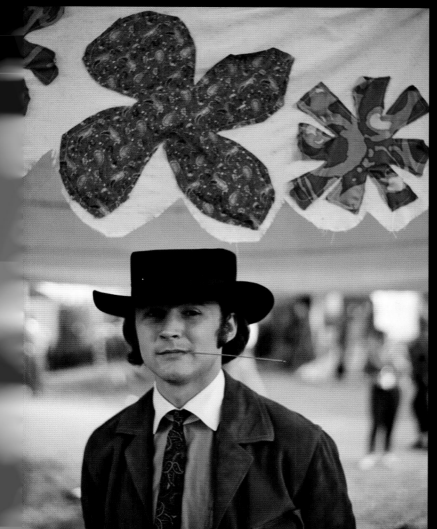

Jefferson Airplane's second album, *Surrealistic Pillow*, arrived on February 1, 1967. Landing like a giant's step, it put the world on notice that evocative songwriting, stellar musicianship, and a lysergically enhanced attitude could not only top the charts but also incite a revolution (sort of).

With its two hit singles, "Somebody to Love" and the immortal "White Rabbit," *Surrealistic Pillow* was a slickly sensual, folk-rocking affair, boldly announcing that San Francisco had game and that this was just the tip of the spear.

What Grace brought to the band, vocally and as a songwriter, is a sense of exploration. She loved Miles Davis's *Sketches of Spain* album and listened to it fifty times without stopping and wrote "White Rabbit."

Jefferson Airplane's repertoire got longer and more expansive. Many of the songs on this album are done very similarly to the way they were recorded in the studio. However, you get the feeling the characters could go into a place or newly discovered sound pocket at any time. There's a sense of something mysterious about *Surrealistic Pillow*. Something that is both highly constructed and yet enormously flexible.

"Marty and I worked 'Today' up together. We wrote several things in those days. He'd bring a piece and I'd bring a piece and we'd put them together and weave them. And they fell together in the studio. Jerry Garcia played on it."

—PAUL KANTNER

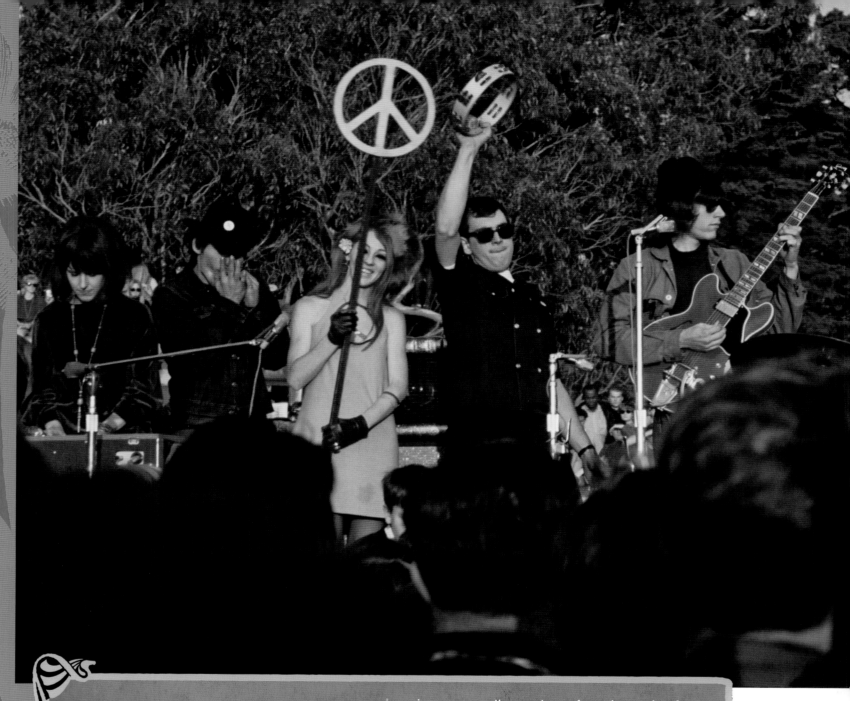

CELESTE GOYER

writer and poet

"The music showed another way to be, more specifically another way to be a woman outside of traditional female roles. In 1967 there were many powerful female singers across the spectrum of popular music—from Aretha to Lesley Gore to Janis. I think the unique thing about this new culture was that it took the adolescent "no" that rejects your parents' values and turned it into a "yes." Yes, there is a better way to live. Your parents do not have the last word. Grace Slick has the last word."

ABOVE: Jefferson Airplane, at the Human Be-In; Golden Gate Park, San Francisco, January 14, 1967; photograph by Henry Diltz.

MARTY BALIN

"In the Airplane somebody might give me a chord change and make something out of it and write a song to it. How can I sing to this? What kind of melody would I put to it? I get the idea where I'm going. Over the years I learned to get out of my way and let the words come. I don't try to write it. I just try to transcribe what I hear in my head.

"'Comin' Back to Me' just happened. I left the RCA studios in Hollywood and went back to the motel. I ran into Paul Butterfield, and they had this joint and gave it to me. 'Smoke this, Marty. It's the best stuff you'll ever smoke.' [Laughs.] So I did. And I was in my room, and I tell you, I couldn't find my legs. I got up and went to the guitar. Bam! In five minutes that song came out.

"So I ran back to the studio, the session pretty much ended, they were cleaning up. Jerry Garcia was there, Grace, and Jack Casady. And I said, 'Hey guys. Play this with me.' And I told the second engineer to turn on the tape, and we did one take and that was it. And I didn't think any more of it. Because you couldn't play it live because it was so soft. I didn't have any idea about that song lasting that long.

"I loved that RCA studio in Hollywood. We had a lot of studio time. The label would pull us off the road and say, 'We need a new album.' The engineers were great. Al and Richie Schmitt were great people."

JAMES CUSHING

"You have Marty Balin, initially a folk singer with a high-pitched voice, and this pleading and desperate, hysterical, almost feminized tone. And then Grace Slick, with a lower voice, and her tone that is very severe. So, you have a pleading man and a severe woman. And those are two different sides. And never overlook Paul Kantner in the combined vocal harmony department, songwriting, or his occasional lead vocal expedition.

"Paul is a fine rhythm guitar player along with the background duties within the Marty and Grace show. Spencer Dryden is a terrific drummer for this group. Guitarist Jorma is using the wah-wah pedal in a very creative way.

"And bassist Jack Casady. We've never heard anything like this in pop music. The closest being Jack Bruce in Cream. Both created deep and dark bass lines.

"Marty Balin is still very much the dominant voice in the band. But now, paired with Grace Slick, Jefferson Airplane go from an interesting and promising folkie act to something unique. Slick brings lyrical and sexual menace to the platform. It's psychedelic chamber music."

OPPOSITE: Jefferson Airplane on *The Ed Sullivan Show*, September 29, 1968.

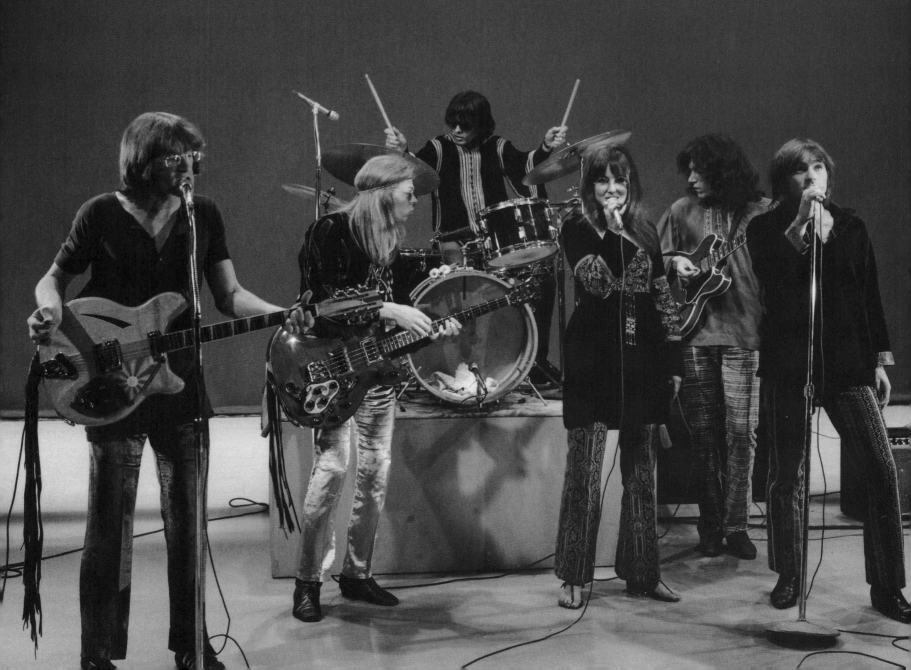

"On our first U.S. tour we were in cities where all the kids came in prom gowns and tuxedos. Then we came back to Iowa a year later and they were having nude love-ins and everybody had their faces painted."

—PAUL KANTNER

THE RAMIFI-CATIONS OF INVOLVEMENT

Aretha Franklin's career was going nowhere. Her recordings for Columbia Records were tepid, uninvolving performances of material that was at cross-purposes with her unique talents. A woman born and bred in the black church—her father, the Rev. C. L. Franklin, was the preeminent Baptist preacher in post-war Detroit—she was desperate to find musical and spiritual respect. She found it upon signing with Atlantic Records and its legendary producer, Jerry Wexler.

Her first album for them, *I Never Loved a Man the Way I Love You*, came out in March 1967. The title song, Aretha's first million-selling record, was recorded in a small Southern town—Muscle Shoals, Alabama.

Lazing by the mighty Tennessee River, Muscle Shoals offered up little more than a bus stop, a hotel, and all the whiskey and bourbon you could handle. Rick Hall, a brusque, plainspoken man who ate fools for breakfast, built and ran the studio; he could take it apart and put it back together again the way a teenage boy knows his first car—from the guts up. He had a talented bunch of good ol' boys playing on all the records he produced: David Hood on bass, Roger Hawkins on drums, Barry Beckett on keyboards, and Jimmy Johnson on guitar. Known collectively as the Muscle Shoals Rhythm Session—and after 1974 as "the Swampers," after Lynyrd Skynyrd included the nickname in their hit "Sweet Home Alabama"—they were the Southern counterpart to L.A.'s Wrecking Crew and Motown's Funk Brothers.

OPPOSITE: Interior of a recording studio at the famed Muscle Shoals, in Alabama, photographed by Carol M. Highsmith in 2010.

These guys could lay it down like a slather of butch wax. Ms. Franklin was, unsurprisingly, wary at their first meeting. The session was stalled; no one could find the right groove. Then, Spooner Oldham, a wily multipurpose pro, sat down behind a funky beige Wurlitzer electric piano—the same model played by Ray Charles on "What'd I Say"—and picked out a soulful plagal cadence, the IV–I "Amen" chordal resolution so common in black spirituals. Suddenly it

was there, and the band, with Aretha riding them hard from the acoustic piano, delivered the imperishable performance. The song was cut in under twenty minutes.

Nothing more perfectly captured the air of improbability, the hope of possibilities coursing through that fraught time, than this unlikely marriage of North and South, black and white. Music has the power to move mountains; on this day in the old Confederacy, a more perfect union was realized.

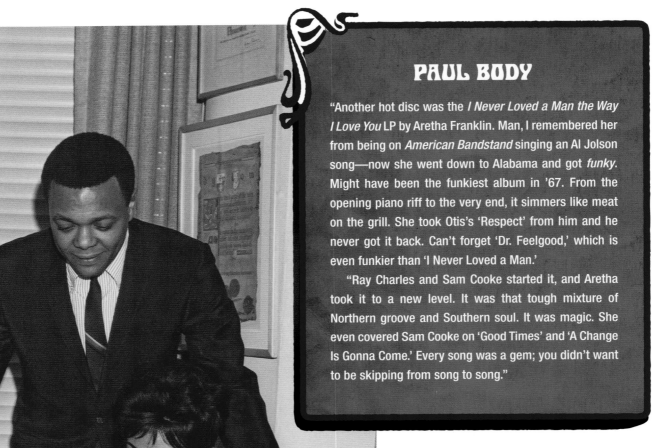

PAUL BODY

"Another hot disc was the *I Never Loved a Man the Way I Love You* LP by Aretha Franklin. Man, I remembered her from being on *American Bandstand* singing an Al Jolson song—now she went down to Alabama and got *funky*. Might have been the funkiest album in '67. From the opening piano riff to the very end, it simmers like meat on the grill. She took Otis's 'Respect' from him and he never got it back. Can't forget 'Dr. Feelgood,' which is even funkier than 'I Never Loved a Man.'

"Ray Charles and Sam Cooke started it, and Aretha took it to a new level. It was that tough mixture of Northern groove and Southern soul. It was magic. She even covered Sam Cooke on 'Good Times' and 'A Change Is Gonna Come.' Every song was a gem; you didn't want to be skipping from song to song."

Aretha Franklin signs her contract with Atlantic Records in New York City, November 21, 1966; Jerry Wexler (left) and Ted White, Aretha's husband and manager (center), look on.

In early March, the *Berkeley Barb* weekly started a rumor in the Bay Area about banana peels having hallucinogenic properties; in L.A., the Seeds had just harvested "Mr. Farmer" as a single on the GNP Crescendo Records label.

Like the Doors' Ray Manzarek, the Seeds' Daryl Hooper defined his band's sound with a creeping, tingly keyboard texture that lifted them out of the garage and onto the concert stage. Shorn of the baroque, richly improvised figures that characterized Manzarek's playing, Hopper, on songs like "Mr. Farmer" and "Pushin' Too Hard," delivered deft, punchy, four-bar phrases on his Wurlitzer electric piano, providing an effective counterpunch to the aptly named Jan Savage's stinging lead guitar lines. The Seeds didn't rock so much as they crackled.

RIGHT: Cover of the Seeds' single "Mr. Farmer," backed with "Up in Her Room," released in 1967.

KIRK SILSBEE

music journalist

"In their prime—1965 to 1968—the Seeds crystallized a crucial moment. They innovated a driving, attitude-laden rock that almost defined the Sunset Strip explosion. Songs like 'Pushin' Too Hard,' 'Can't Seem to Make You Mine,' 'Mr. Farmer,' and 'Trip Maker' melded psychedelia, rock, and blues with an undercurrent of punk and goth. Future *Star Wars* director/producer George Lucas, in his 1967 student film at USC, *The Emperor*, profiling KRLA DJ 'Emperor' Bob Hudson, placed the Seeds' 'Rollin' Machine' in the soundtrack at the top of his movie.

"It was a keyboard-driven band that used sinister minor chords, a development that presaged the Doors. Sky Saxon's sneering, slack-jawed vocals marked him as one of the early punks. Along with Arthur Lee of Love, Sean Bonniwell of the Music Machine, and the Chocolate Watchband's Dave Aguilar, he was one of the best of the post-Jagger/pre-Morrison singers."

"Of all the 'Nuggetarian' bands that came to psychedelic light in the Gar Age, the Seeds brought rock back to its most hypnotic elementals."

—LENNY KAYE, PATTI SMITH GROUP AND MUSIC HISTORIAN

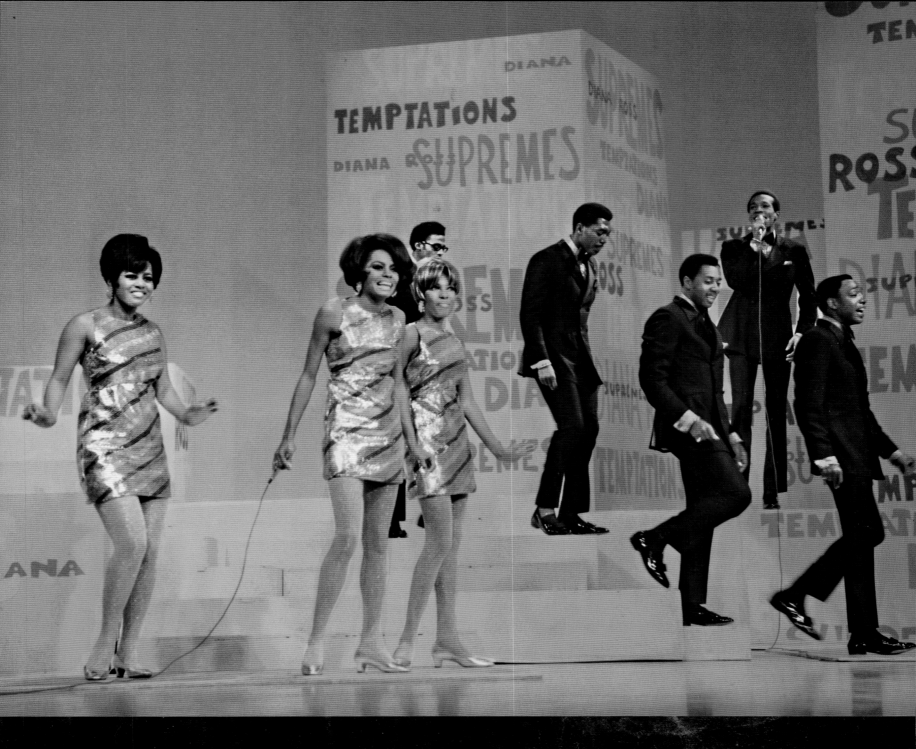

"The Holland, Dozier, and Holland production-and-song-writing team on Motown was phenomenal. They came up with hit after hit. They started a thing. They had a lock on the Supremes."

—BERRY GORDY JR.

ABOVE: The Supremes and the Temptations
performing on *The Ed Sullivan Show,*
November 19, 1967.

Farther east in Detroit, the Supremes and Motown Records were riding high on the charts with "Love Is Here and Now You're Gone," which hit the top of the Billboard chart on March 11, 1967.

MARY WILSON

The Supremes

"Berry Gordy was an innovator, and he knew talent when he saw it.

"He only accepted the best. He allowed people to create on their own. He allowed the producers to really inspire each other. Any new female group coming up will definitely try and take something from the Supremes. It was like we were the model for music. The Motown sound was the model.

"One thing I remember Berry said that had something to do with it: 'This is the sound of young America. There is no time on it. I want to make this music where everyone in the world can listen to it and enjoy it. We're singing from our guts. I want to make music that everyone around the world can enjoy.' And that's what he did.

"I have to give credit to Berry for putting us with Holland, Dozier, and Holland. Because previously, we were the 'No Hit' Supremes for a long time. Berry said, 'I can see that you are really serious, so I'm gonna put you with my top writing team, H-D-H.' So it was their music, their direction."

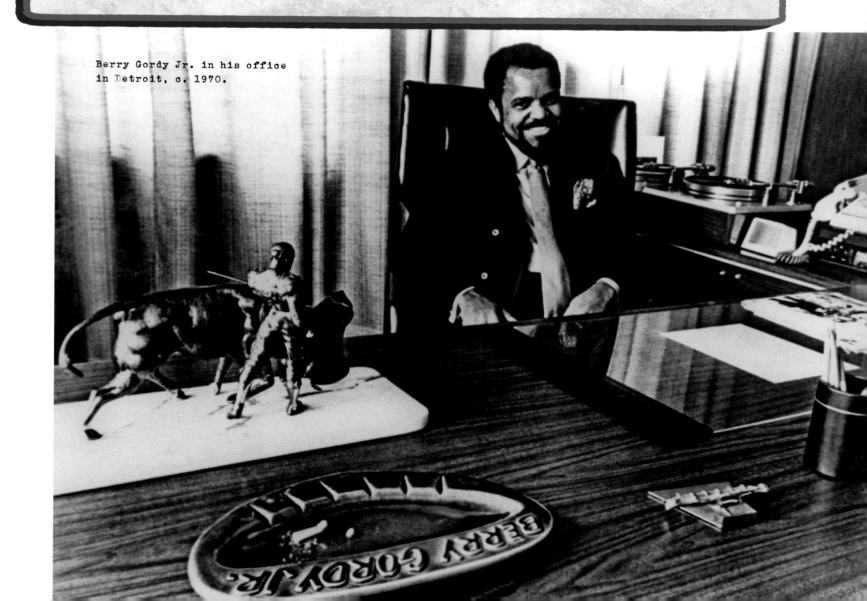

Berry Gordy Jr. in his office in Detroit, c. 1970.

The *Velvet Underground & Nico* LP was released after delays in the second week in March. In 1966, the group had played at the Trip on Sunset Boulevard.

At the insistence of sponsor/mentor Andy Warhol, Nico sang on three songs on their debut LP. Sessions were recorded at Scepter Studios in New York City in spring 1966, with some re-recordings at TTG Studios in Hollywood with producer Tom Wilson.

It's a very non-1967 record in terms of its refusal of blues-based rock and its denial of hippie transcendence, much more New York City than Laurel Canyon/Haight-Ashbury.

LOU REED

Velvet Underground

In 1989, the Velvet Underground's chief songwriter, vocalist, and guitarist Lou Reed, discussed the group with writer Roy Trakin: "Andy Warhol used to say to me, it's the work. The work is the whole thing. And to me, that's been coming to grips with the technology of the studio and, as a writer, coming to grips with writing. Which means discipline and focus.

"All I'm doing is telling these kind of little stories from a biased point of view. I'm the one choosing the words. I'm the one setting up the situations. I'm the one who makes the character take a left-hand turn and there's a train. But I'm also the one who can make it funny.

"I like the way language works and playing with words. I was an English major in college [Syracuse University]. I love the way guys like Raymond Chandler and Delmore Schwartz wrote dialogue. I always thought my best stuff sounded like someone speaking directly to you in conversation."

LEFT: Portrait of German Warhol star Nico (née Christa Päffgen), in Monterey, California, 1967, by Guy Webster.

OPPOSITE: Marquee for a show at the Trip club on Sunset Boulevard, May 1966, advertising the Velvet Underground & Nico, and the MFQ (Modern Folk Quintet). Photograph by Henry Diltz.

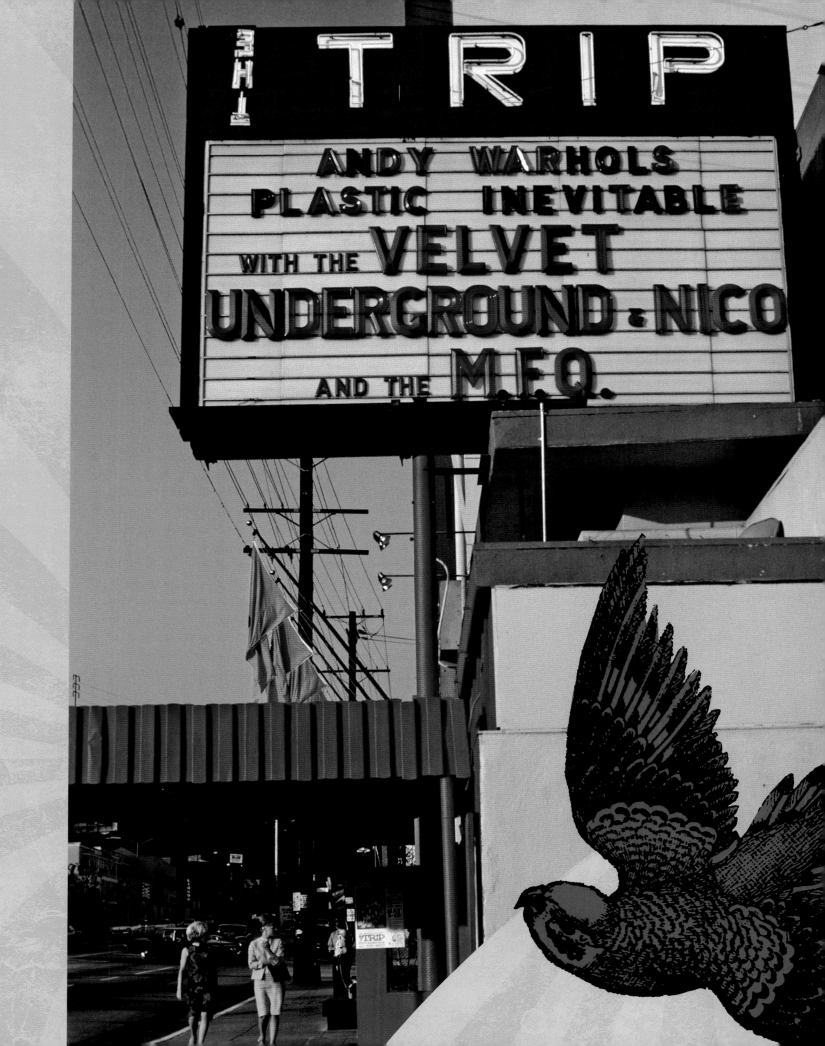

The Grateful Dead's self-titled first LP, on Warner Bros., recorded in Hollywood at RCA studios, then shipped to the rack jobbers and retail outlets in mid-March.

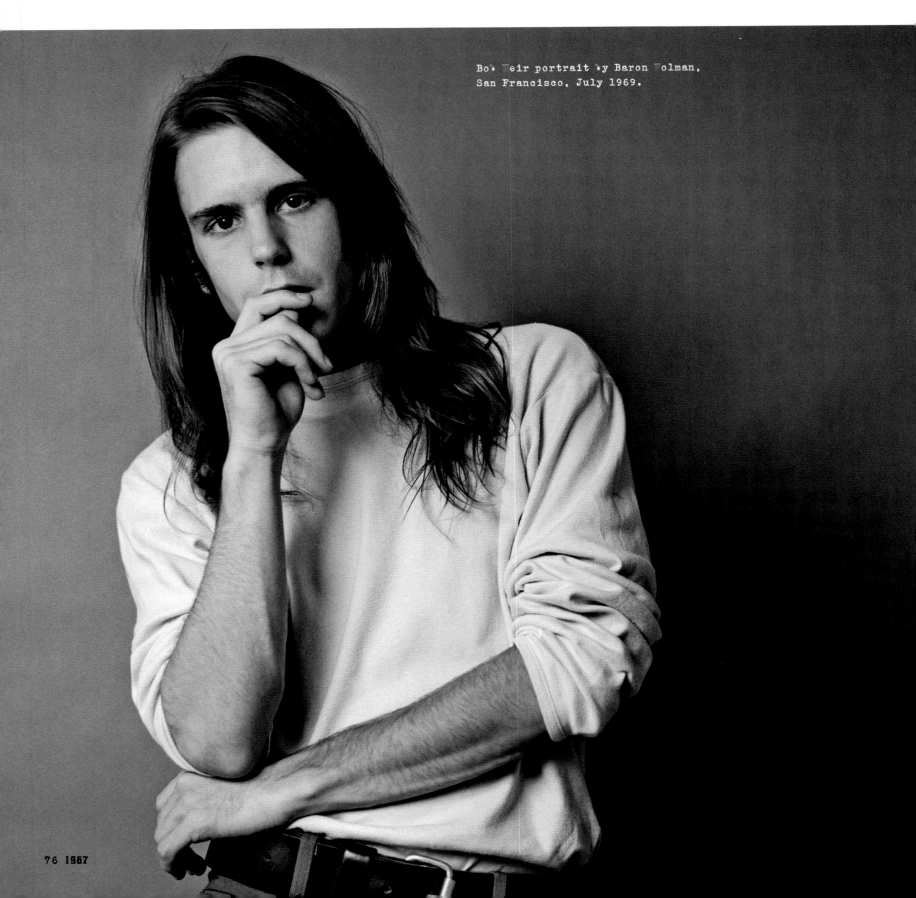

JERRY GARCIA

The Grateful Dead

"My band is a band that could best be described as consonance and harmony. . . . In the Grateful Dead, it's a situation in which almost no two people have the same conception musically, which makes it harder. Nobody gets their way. However, what we all respect about that situation is that there is a potential of a larger central viewpoint which none of us, individually, are capable of perceiving, but which we all add to because of the diversity and the conflict.

"[Bob] Weir and I are a little further apart musically and conceptually, but we're close on other levels and so forth. It expands and contracts. It also has to do with a thing of allowing each person to have their personal space. We don't tell each other what to do.

"I think, because our relationship is part of the family concept, that comes into play at this point. We're involved even if we don't want to be. We're involved in a large number of people who know each other and it stays that way whether we work or not. It's still there, and we're living in the same world together. In that sense it is inescapable. I don't think anyone fears any particular change. Our feeling about the Grateful Dead is that we respect it for what it can be at its best, rather than have to be a second-rate version of itself. We would just as soon not do it. We'd dump it. The thing is that we can disengage, and also, if we want to, we can engage. And I think having that option is a must."

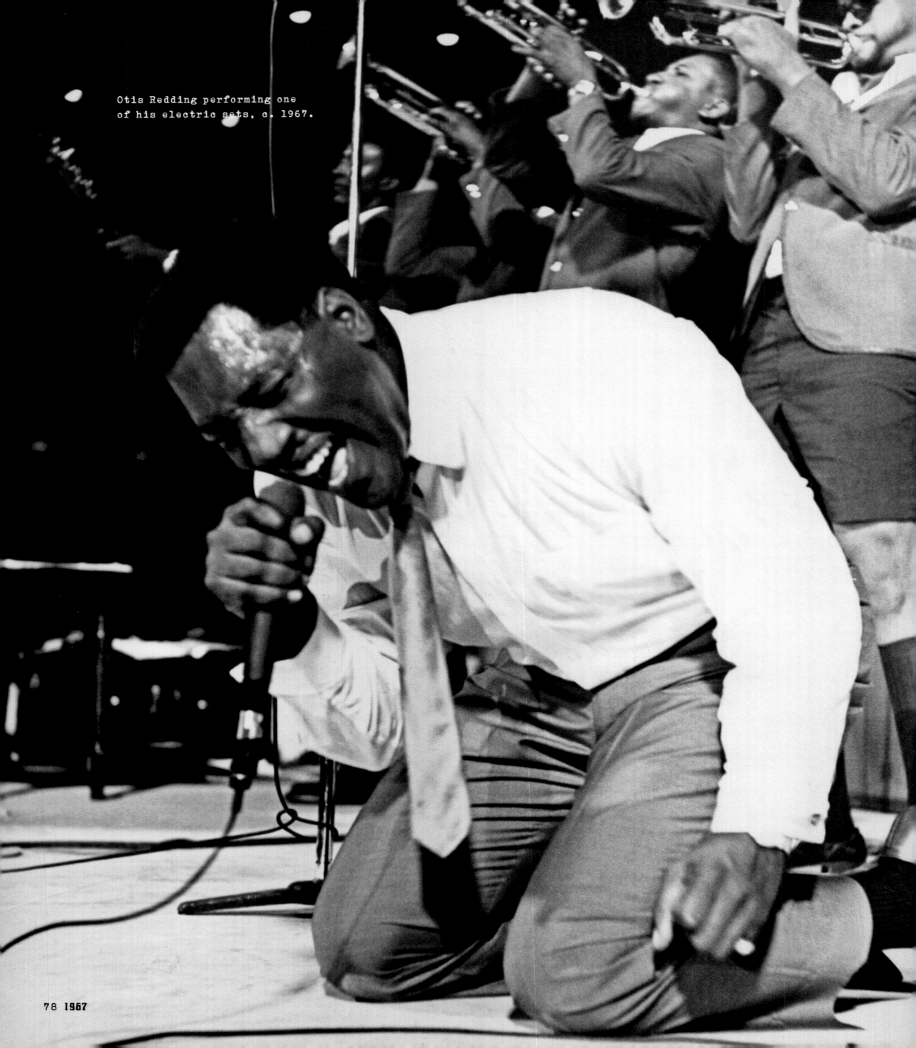

Otis Redding performing one of his electric sets, c. 1967.

While most everyone attuned to the pop zeitgeist was running wild through the clouds, chasing butterflies and moonbeams, there remained a solid block of soul-stirrers staying true to their rhythm and blues roots. Such forceful singers as Wilson Pickett, Joe Tex, and Sam & Dave continued to chart during the height of "Flower Power." But no one shook the stage with the same titanic presence as Otis Redding.

MARTY BALIN

"In 1966, and '67, and all through Jefferson Airplane, we did my tune 'It's No Secret.' I originally wrote it with Otis Redding in mind. It was for him but he was writing a lot of his own material then. In fact, I was the guy who took the record of Otis's 'These Arms of Mine' to Bill Graham. 'Hire this guy—I want to see him!' And Bill Graham did. December of 1966."

"Otis Redding was like a panther on stage. A black Adonis. The most extraordinary talent I have ever seen, presented, and known."

—BILL GRAHAM

Otis and Normie

Australian music journalist Ritchie Yorke remembers a particularly powerful performance in England: "I had the pleasure of attending an Otis Redding performance at Tiles club on Oxford Street, London, in October 1966, along with Australia's reigning king of pop, Normie Rowe. We were endeavoring to get Normie launched in the British market.

"Normie had specialized in covering various U.S. R&B classics that had not been granted the privilege of being accorded radio airplay in Australia, due to racist programming policies. Normie's hits included his versions of 'Pride and Joy,' 'Tell Him I'm Not Home' and 'Que Sera, Sera' (covering the High Keys' workout on the Doris Day movie track).

"I wanted Normie to see real R&B delivered by an originator. Supporting Otis on the night was Chris Farlowe, who was enjoying UK chart success with his version of the Jagger-Richards chestnut 'Out of Time.'

"Otis was sensational, delivering an unforgettable set that remains clear in my memory some fifty years later."

Time and again, British musicians commented during their initial visits to the States that they were "only playing your music back to you," amazed at our seeming ignorance of the fertile black American music culture that so thoroughly informed the beat band invasion.

In the spring of '67, Stax Records of Memphis, Tennessee, along with its sister label Volt, brought its high-stepping revue of soul and R&B artists to Europe for the legendary Stax/Volt tour.

Backed by the agile styling of Hammond organ maestro Booker T. Jones and his accompanists, the M.G.'s—the shark-skinned Steve Cropper on guitar, Donald "Duck" Dunn on bass, and Al Jackson Jr. on drums—soul-stirrers Otis Redding, Sam & Dave, and others made their fans want to "shake." And they did.

In England, the musicians inflaming the passions of the *Ready, Steady, Go!* crowd, who viewed these artists with the same sense of apocalyptic fervor as seen in the audience at the Beatles' appearance on *The Ed Sullivan Show*.

RIGHT: A Sam & Dave recording session at Stax Records in Memphis, 1967; from left to right: drummer Al Jackson, pianist/composer Isaac Hayes, songwriter David Porter, singer Sam Moore, trumpeter Wayne Jackson, bassist Donald "Duck" Dunn, singer Dave Prater, guitarist Steve Cropper, and sousaphone player Booker T. Jones.

WAYNE JACKSON

The Mar-Keys and the Memphis Horns

"[I recall that] Jim Stewart of Stax told Otis in England, 'We're recording this, Otis, so we need to get into the groove of Stax.' And Otis said, 'Fuck you. This is my show and I'm gonna leave these people out of breath.' And that's what he did.

"He ignored Jim completely. It was his way to keep the fire under their feet. I don't think he had more confidence. I don't think he could have had any more confidence if he tried. He was just an exuberant, wonderful guy. He brought all of that to the stage with him. Sam & Dave tried to cut him every night. They tried to blow him out of the water, but they never did. They were as strong as nine acres of garlic, but Otis was ten acres of garlic!"

"Booker T. Jones is a musical genius. Otis always brought a great contribution to all the sessions he was on. He was educated. Steve Cropper invented a style of guitar where the little guitar parts were singular. He played licks that became part of the song. The horns were part of the song. Without us they would not have been the same.

"Al Jackson was a joy to watch. He was the most fun drummer I ever was around. He was just the best drummer you ever heard and the best drummer you ever saw. He was a great musician. Musicians are not in competition. No one in that band was in competition. We were one thing.

"We were there to support and glorify Otis Redding. And we did that. We were there to respect, glorify, and hold the singer up to glory. Whether it be Otis, Eddie Floyd, or Sam & Dave. We did that. That was our job and we loved it and did it good. Everybody in that band had his position. Like Duck Dunn. Have you ever seen anybody work that hard on bass? It makes my hands cramp up."

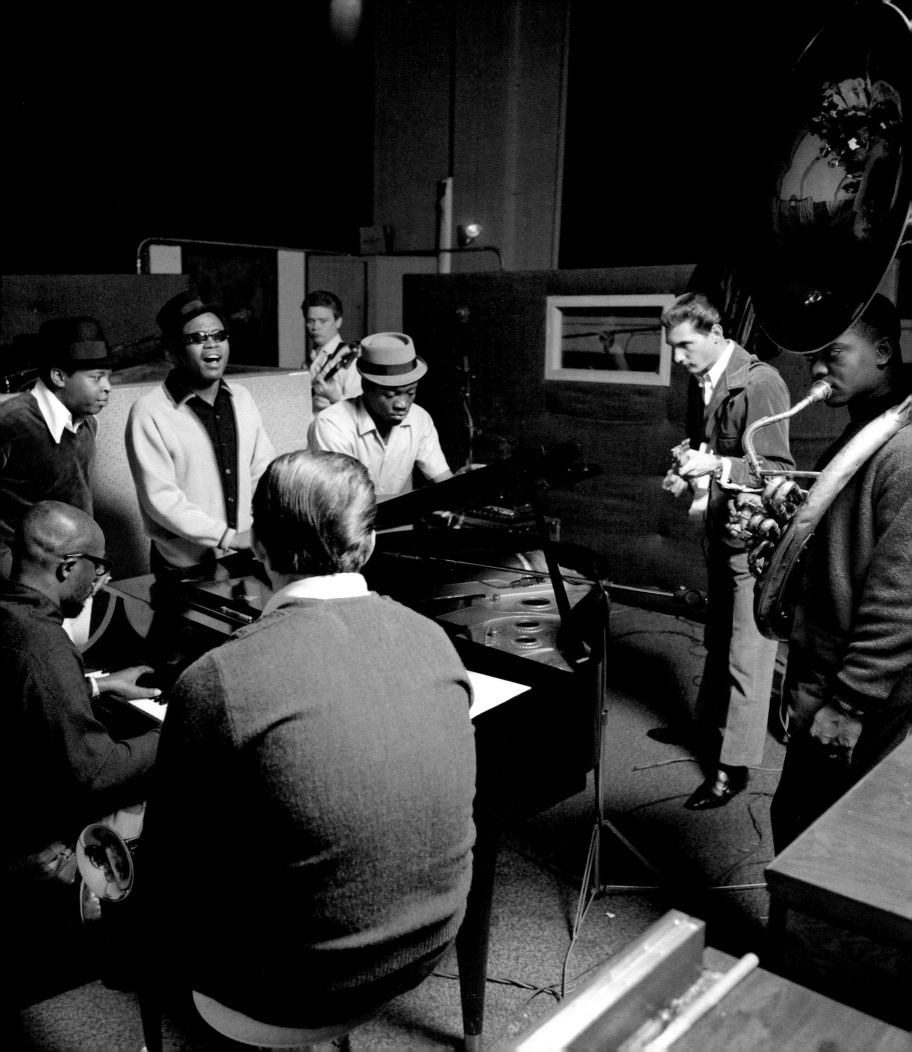

The emcee for the Stax/Volt tour of Europe in 1967 was Emperor Rosko. He is heard introducing Otis Redding on the singer's legendary *Live in Europe* (1967) album, recorded at the Olympia in Paris on March 21, 1967.

EMPEROR ROSKO

"It's one of the outstanding albums of all time. I worked with the Stax group. We sat down the first day and told the guys I would be introducing them. I'm this brash, untested guy. 'How do we make this cool?'

"I talked to Booker and Steve Cropper, Duck Dunn, and Al Jackson of the M.G.'s, and told them to riff while I was out there. So there was no real dead air. They kind of liked that idea. We hit it off. I brought them on stage. . . . Otis would stomp in his show. He had this fantastic voice. I would sit there with my mouth open at the side of the stage. I watched him for six weeks! I would have dinner with him every night. He'd grin and would look at me and his eyes would twinkle.

"And let's not short-change Sam & Dave. And we took a fifteen-minute break after they came on. They just tore the place up. Amazing. Booker T. and the M.G.'s were just magic. And it was magic music in a magic era."

STEVE CROPPER

Booker T. and the M.G.'s

"Everything Otis touched, he made it his own, like Sam Cooke's 'Shake.' All of those things, you listen to them, and it's sort of like a great actor, like if Gene Hackman takes a part, or if James Stewart takes a part, they become that character. And at the time you watched it, you became part of them. You know what I'm saying? You don't think about somebody else doing it.

"Everybody came home from England with a whole different opinion about themselves. I mean, if I remember, we were treated like the Beatles over there. . . . We were treated more like royalty and with respect in England. It was amazing. Hundreds of people trying to touch us. They used to have to line bodyguards up so we could get from the stage to the bus. We'd never seen that before. That was something unheard of, especially in the States.

"It changed everybody's egos. And things started happening, and all of a sudden, the whole aura around Stax started changing because everybody all of a sudden wanted to be an individual. They didn't want to work as a team anymore, and I was fighting for the team. I fought for that team big time. To me it was like the greatest basketball team that ever came together. When they went into the studio together, magic things happened. And they won. And winning was to have a hit record. A hit single on the charts."

"Otis put out vibes when he performed. Like a lion stalking through the jungle."

—EMPEROR ROSKO

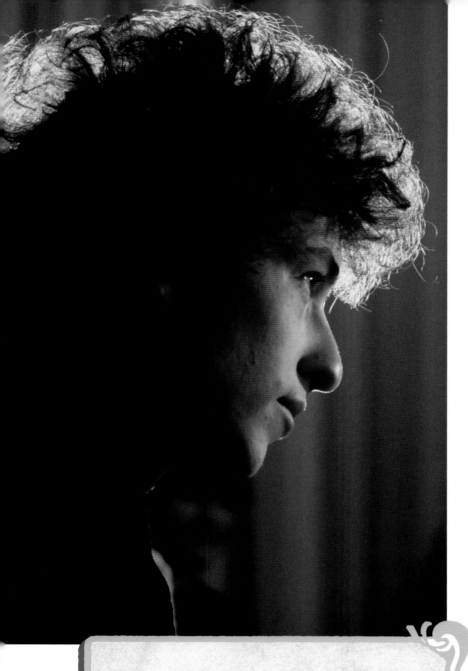

Bob Dylan had a Billboard Top 20 album in 1967: *Bob Dylan's Greatest Hits*, released March 27, with nine songs culled from six long players plus "Positively 4th Street," which until then was available only on a 45-rpm single.

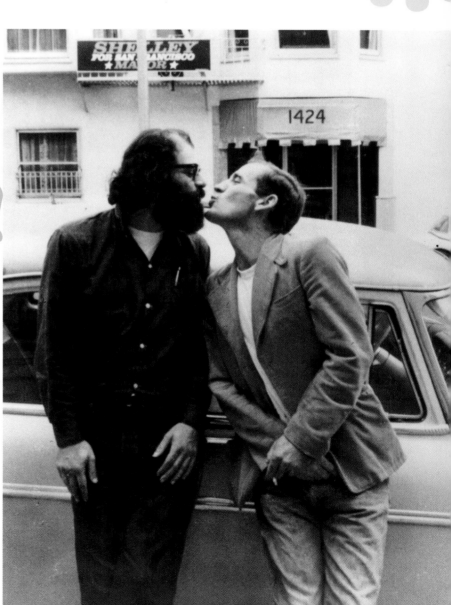

ALLEN GINSBERG

poet

"I don't think I would have been singing if it wasn't for younger Dylan. I mean, he turned me on to actually singing. I remember the moment it was. It was a concert with Happy Traum that I went to and saw in Greenwich Village. I suddenly started to write my own lyrics, instead of [singing poetry by William] Blake. Dylan's words were so beautiful. The first time I heard them I wept.

"I had come back from India, and at a welcome home party, Charley Plymell, a poet I liked a lot in Bolinas, played me Dylan singing 'Masters of War' from *Freewheelin' Bob Dylan*, and I actually burst into tears. It was a sense that the torch had been passed to another generation."

Before ever taking out the long player and putting it on the turntable, you knew a whole new paradigm was in play. Nowadays the *Sgt. Pepper*'s album cover has become iconic in its own right.

DANIEL WEIZMANN

"The album cover for *Sgt. Pepper's Lonely Hearts Club Band*, taken in London on March 30, 1967, was more important and more revolutionary than the music. It was the declaration of nothing less than a new religion—the Church of Pop Culture. That image and the feelings it evokes in people is the secret reason this LP tops most best-of lists, not the great songs. In one photo flash, they made believers out of all of us.

"*Revolver* and its cover were austere, black and white—the Beatles as grown-ups. Eleanor Rigby died in the Christian church and no one was saved. The girl who knew what it was like to be dead made you feel like you'd never been born. Listeners were instructed to surrender to the void. *Revolver* was kitchen-sink drama and cinema verité.

"By contrast, *Sgt. Pepper*'s was utopian, ironic, dreamlike, sophisticated but also cartoony—a pop art shrine, screaming with color.

"Like Warhol's harshly vibrant movie star portraits with their religious connotations, the fake, costumed group on a bandstand was both ersatz and transcendent at the same time, a post-mod challenge. It was as if they were saying—*We are the leaders of a new sensibility. But don't forget that we're an act, an image, a fabrication.* All this, years before Ziggy.

"Also important to note: The ye olde time shtick of a Lonely Hearts Club Band was no random disguise. It neatly matched the rising sixties' music hall/vaudeville revival exemplified by shows like *Laugh-In* and *Beyond the Fringe*, and musicians from "Winchester Cathedral," Ian Whitcomb, and the Kinks, to Brian Wilson's *Smile* experiments, San Francisco's Charlatans, and others. To paraphrase [media theorist] Marshall McLuhan, the sixties drove into the future looking in a rearview mirror.

"But even more revealing than the Beatles' getups is the choice of the attentive 'audience members' on the cover. This crowd is our collective and unconscious understanding of the word 'culture' in all its very *different*, contradictory permutations—Karl Marx and Marlon Brando, W. C. Fields and H. G. Wells, Sri Paramahansa Yogananda and Dion DiMucci. As well as Lenny Bruce and Wallace Berman. And it's as if they're also saying—*All this stuff we modern people share, high or low, East or West, it is all one.* This is pop art about pop art, with LSD's spirit of kaleidoscopic agglomeration.

"Because of Lennon's remarks, Jesus had to go. Hitler and Gandhi also didn't make the cut as originally intended. But the most telling audience members that do appear are, of course, the wax Mop Tops. Here in the Church of Pop Culture, fake real and real fake stand side by side. There's something joyous about it and freeing. And these wax Beatles also send another message, maybe the most important one of all—*We are in the crowd, right alongside you.*"

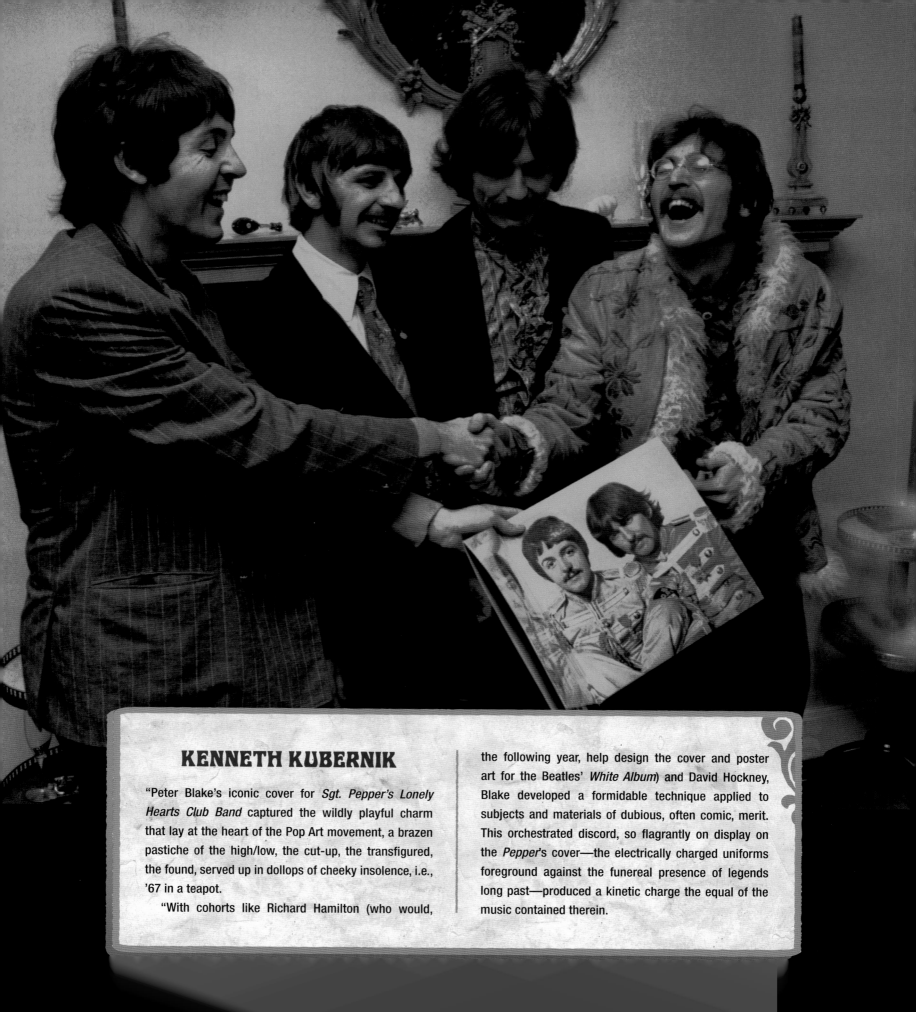

KENNETH KUBERNIK

"Peter Blake's iconic cover for *Sgt. Pepper's Lonely Hearts Club Band* captured the wildly playful charm that lay at the heart of the Pop Art movement, a brazen pastiche of the high/low, the cut-up, the transfigured, the found, served up in dollops of cheeky insolence, i.e., '67 in a teapot.

"With cohorts like Richard Hamilton (who would, the following year, help design the cover and poster art for the Beatles' *White Album*) and David Hockney, Blake developed a formidable technique applied to subjects and materials of dubious, often comic, merit. This orchestrated discord, so flagrantly on display on the *Pepper*'s cover—the electrically charged uniforms foreground against the funereal presence of legends long past—produced a kinetic charge the equal of the music contained therein.

The early 1960s heralded the rise of "New Journalism." This lively pastiche of first-person narrative and mindful, immersive reportage provided the next generation of writers and music critics with a fresh vantage point, as revelatory as the music and art of the time.

Several wordsmiths and newspaper reporters described Easter Sunday of 1967 in Los Angeles at Elysian Park, where the emerging Summer of Love Angeleno counterculture had been fully on display at a joyous Love-In. Music groups providing the environmental graphic were the Daily Flash, the Peanut Butter Conspiracy, the Factory, the Steve Miller Blues Band, Clear Light, the Rainy Daze, the West Coast Pop Art Experimental Band, and the groundbreaking comedy troupe Firesign Theatre. Troupe member and KPFK-FM radio host Peter Bergman first coined the term "love-in."

Initially, hippies received more scorn than the beatniks from a decade earlier: because there were more hippies. And because they were more visible, and hence easier to point out and castigate. And because the beatnik thing was much more concentrated in a small number of urban areas.

The truly groovy daytime gathering was attended by an estimated ten thousand people, with relatively few arrests or security issues considering the size of the crowd.

BELOW LEFT: A poster for the Elysian Park love-in by noted artist Gary Grimshaw.

BELOW OPPOSITE: Musicians and dancers at the Easter Sunday love-in at Elysian Park, March 26, 1967; photograph by Guy Webster.

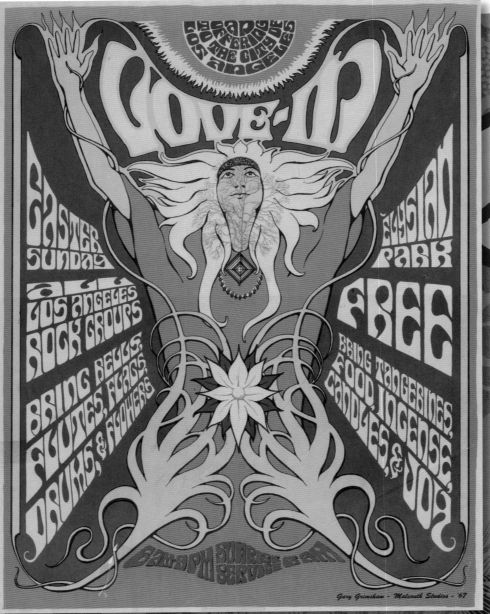

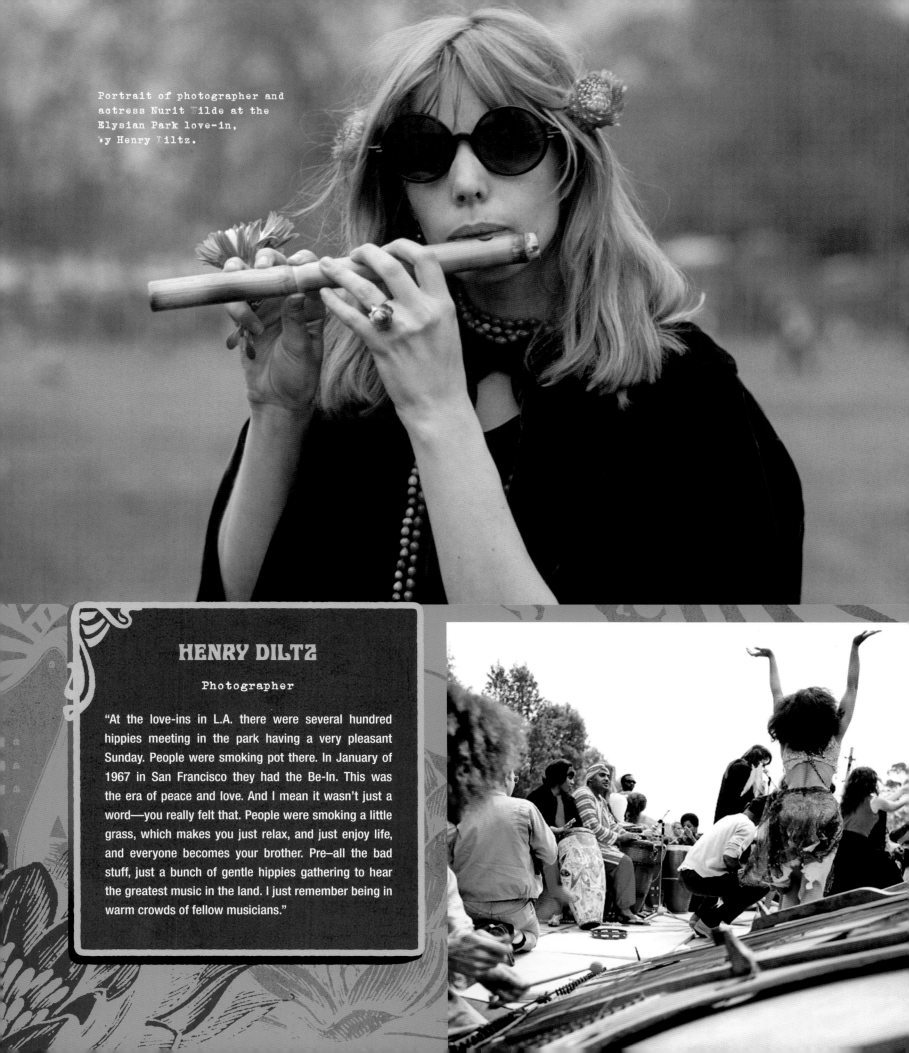

Portrait of photographer and
actress Nurit Wilde at the
Elysian Park love-in,
by Henry Diltz.

HENRY DILTZ

Photographer

"At the love-ins in L.A. there were several hundred hippies meeting in the park having a very pleasant Sunday. People were smoking pot there. In January of 1967 in San Francisco they had the Be-In. This was the era of peace and love. And I mean it wasn't just a word—you really felt that. People were smoking a little grass, which makes you just relax, and just enjoy life, and everyone becomes your brother. Pre—all the bad stuff, just a bunch of gentle hippies gathering to hear the greatest music in the land. I just remember being in warm crowds of fellow musicians."

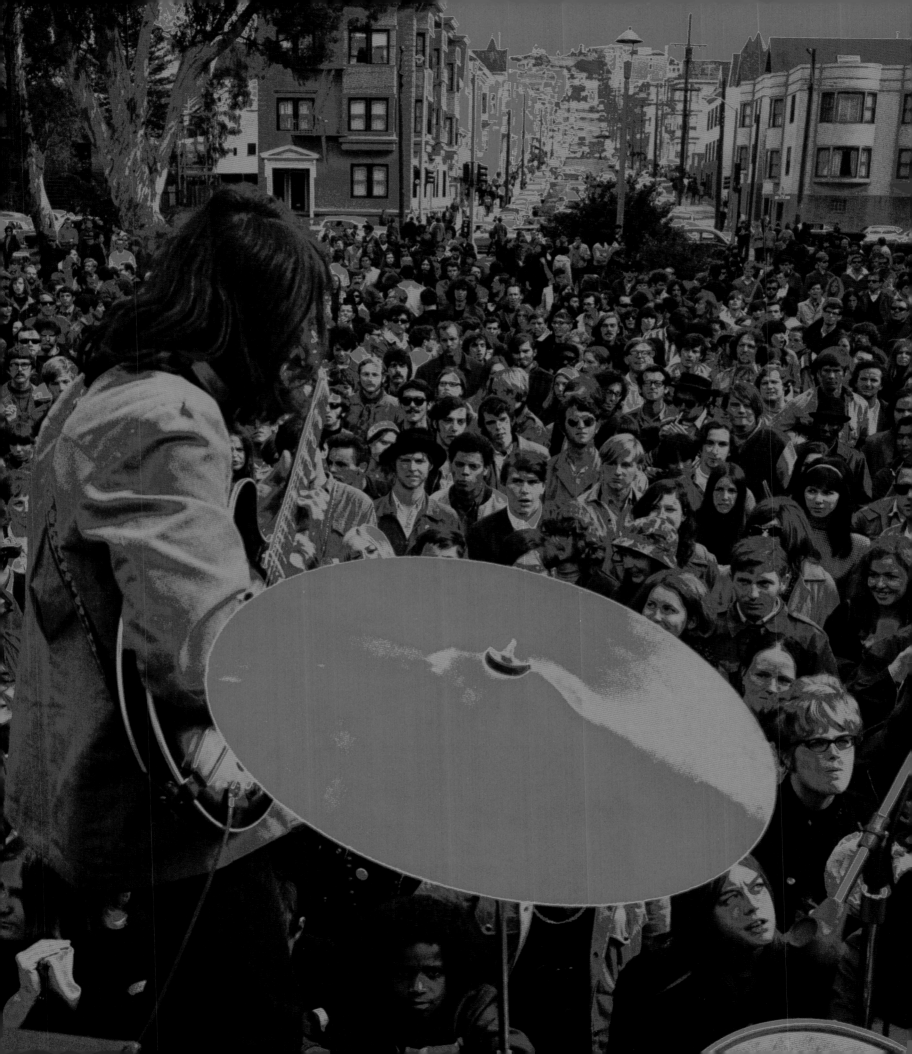

COOL CLARITY

On April 15, two antiwar marches organized by the Spring Mobilization to End the War in Vietnam were held simultaneously in New York City and San Francisco. An estimated 125,000 protestors in New York, including Martin Luther King Jr., and 75,000 in San Francisco, made it the largest antiwar demonstration in the United States up to that time.

Meanwhile, in Hollywood, a new music spot called the Kaleidoscope opened for a few weeks in mid-April at Ciro's nightclub, on Sunset Boulevard in Hollywood. The floating psychedelic dance club was operated by John Hartmann and Skip Taylor (Canned Heat's managers at the time, who both went on to major careers in the music industry) and their associate Gary Essert (who later founded and helmed the L.A. Filmex Festival).

OPPOSITE: Concert at an antiwar march organized by the Spring Mobilization to End the War, in San Francisco, April 15, 1967.

JOHN HARTMANN

music agent, manager, record executive

"Skip Taylor and I were agents and left William Morris because they wouldn't let us open a San Francisco office once we saw what was going on there in 1966. And we said, 'Let's rent a house, sign up all these acts that are gonna be huge. Because if we did, we can make it way bigger if we become a manager.' And that was when we started the Kaleidoscope club.

"In April of 1967 we brought the Jefferson Airplane, the Grateful Dead, and Canned Heat together on the same bill at a Kaleidoscope show.

"We also supported the idea . . . of bringing San Francisco bands to Los Angeles first. Skip and I were focused on the Kaleidoscope. The truth was, we stayed away from alcohol . . . and we charged $2.50 at the door so anybody could get in. And we probably didn't have the capacity to succeed with the cost of the artists that we were bringing in."

The trio presented events around Hollywood with Jefferson Airplane, the Grateful Dead, the Peanut Butter Conspiracy, the Doors, Canned Heat, and the West Coast Pop Art Experimental Band. The operation found a more permanent home in 1968 at the Earl Carroll Theatre on Sunset. The team remodeled the building, which was across the street from the famed Hollywood Palladium, with a new sound system and a 360-degree light show.

That spring, scientists and media reported that LSD could cause chromosome damage, a claim that is still debated today.

Also in April, the Mamas & the Papas released the single "Creeque Alley," which got initial airplay and first sales in the L.A. market in spring and then hit the Top 5 hit parade by Memorial Day.

MICHELLE PHILLIPS

vocalist, the Mamas & the Papas

"John [Phillips] and Lou [Adler] really thought alike. And they were an incredible force together. People would not say no to the two of them. They knew how to get what they wanted. It's wonderful. I think people should always get what they want; it's just a matter of knowing how to get it. John was a real chameleon and could be anyone you wanted him to be. He was very intuitive and knew exactly who you wanted him to be. And that's who he would be. He could be the businessman, the rock 'n' roller, the folk guy, the jazz guy."

LEFT: A round poster advertising three Kaleidoscope shows in L.A., April 14–16, 1967.

OPPOSITE: The Mamas & the Papas, photographed by Henry Diltz in 1967.

"Cass was always the biggest star on the stage. You could not take that spotlight off of her. Because she was always so funny and so engaging. And she talked to the audience and she would make them laugh. That was her expertise and forte. She was extremely entertaining."

—MICHELLE PHILLIPS

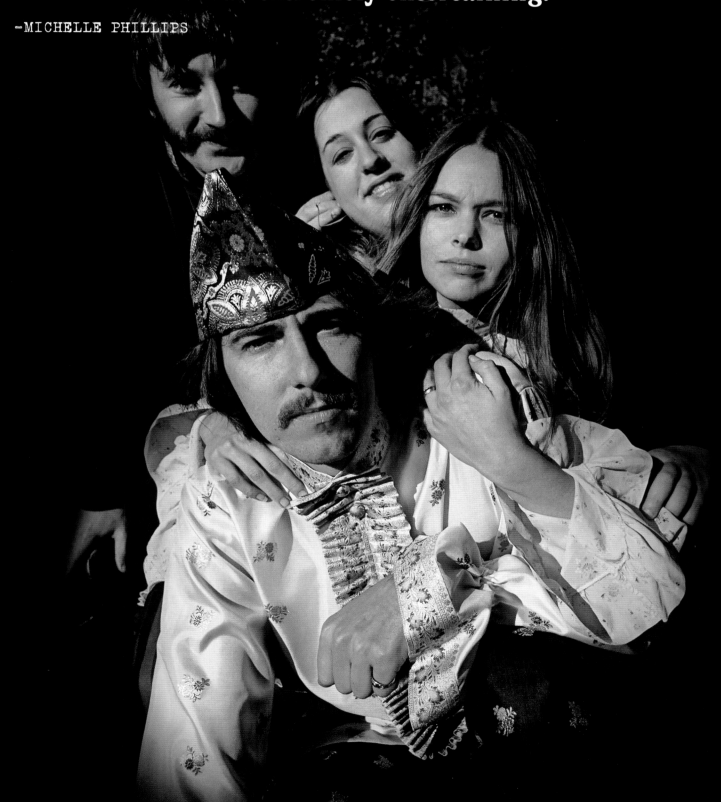

Howard Kaylan is destined to be remembered for singing the Turtles' 1967 smash hit "Happy Together." The Turtles performed it on *American Bandstand* on April 1, when it was in its second week at No. 1 on the *Billboard Hot 100*. In 1999, the recording, which garnered more than five million radio plays, was selected by BMI as one of the top fifty songs of the twentieth century.

On April 25, 1967, *Inside Pop: The Rock Revolution*, a CBS television news special, was broadcast. The historic program was filmed in November 1966 and was hosted by legendary composer, conductor, and author Leonard Bernstein. He touted the music of the Beatles, Bob Dylan, the Association, the Monkees, the Byrds, and Tim Buckley, and conducted revealing interviews with Roger McGuinn, Peter Noone, and Frank Zappa. Also televised were Brian Wilson debuting a poignant recital of "Surf's Up" on piano, Graham Nash performing "Bus Stop," and a stirring performance of "Society's Child" from Janis Ian.

Throughout the month of April, the album *Tim Hardin 2*, and Hardin's 1966 composition "If I Were a Carpenter," received national FM radio attention. Curtis Hanson, director of such films as *L.A. Confidential*, *8 Mile*, and *The Wonder Boys*, noted that "[Tim Hardin's] 'Reason to Believe' from *Tim Hardin 1* was on my *Wonder Boys* soundtrack because we were dealing with a story that is about fiction, redemption, reinforcement.

HOWARD KAYLAN

The Turtles

"I knew 'Happy Together,' written by Garry Bonner and Alan Gordon, was going to be a big hit. We honed and developed it over months on the road. Wonderful fate. It was a luxury and it's appreciated. I've never had the luxury to take something on the road for eight months and work it, rework it, and just fine-tune it. I didn't know 'Happy Together' would be that *huge* of a hit or an anthem. We did it on *The Ed Sullivan Show* in May 1967."

And, by the way, Tim Hardin is a tragic wonder boy. [He] was so talented, but because of the combination of his bad luck and bad drugs, people forgot he wrote these amazing songs and had a wonderful voice that spoke his own words so well."

ABOVE: The Turtles performing "Happy Together" on *The Ed Sullivan Show*, with Howard Kaylan on vocals, May 14, 1967.

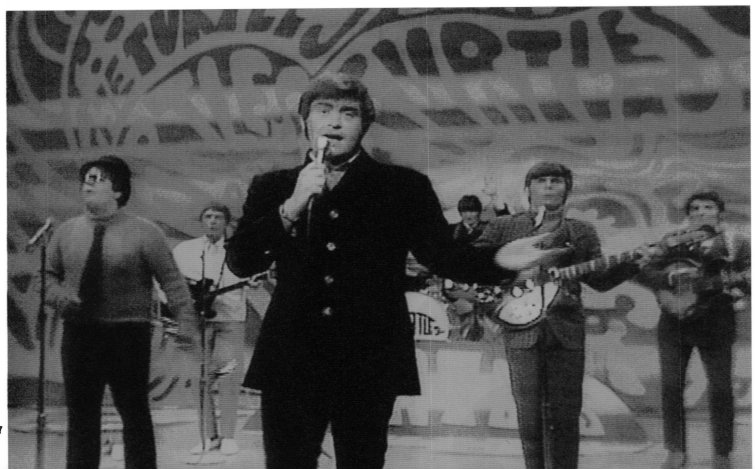

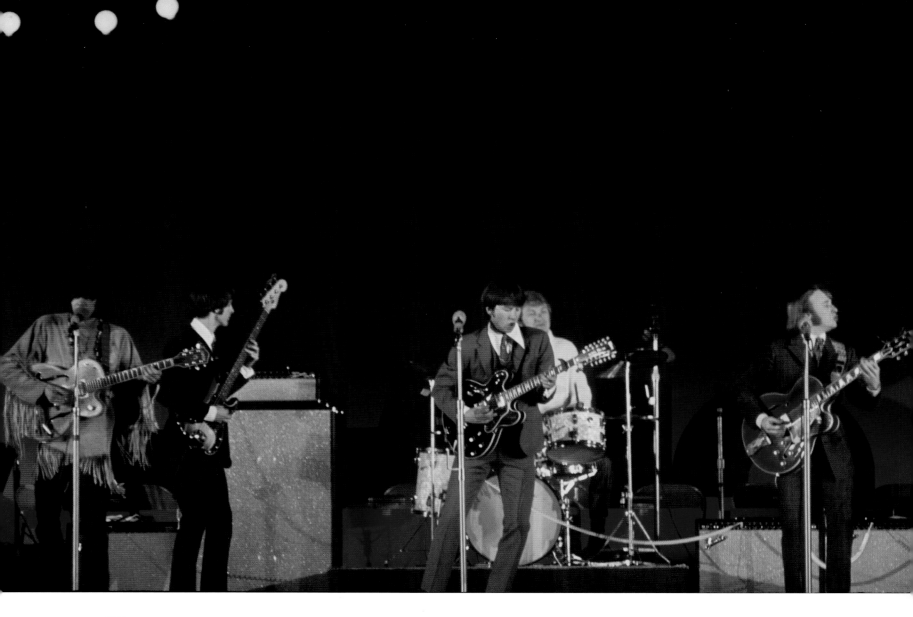

A landmark evening in 1967 was the April 29, 1967, 93/KHJ Appreciation concert at the Hollywood Bowl with the Seeds, Buffalo Springfield, Johnny Rivers, the 5th Dimension, Brenda Holloway, and the Supremes. Proceeds established a Motown scholarship for musical excellence. All tickets were 93 cents.

In 1966, Beat Generation light and key hippie-scene figure Lenore Kandel had her first book of poetry, *The Love Book*, deemed pornographic after the police in San Francisco raided both the Psychedelic Shop on Haight Street and City Lights Books, where it was being sold. All copies were confiscated on the grounds that Kandel had violated state obscenity codes.

Kandel had earlier appeared on stage at the January San Francisco Be-In and read a poem from her work.

A benefit for her was staged in Hollywood on April 30, 1967, at the Hullabaloo on Sunset Boulevard, sponsored by radio station KBLA, the *Los Angeles Free Press*, and the Omnibus Coffee House. Two shows were held by the Freedom of Expression Committee to collect funds to help with legal fees for defending Kandel's *The Love Book*—then being sold at the Free Press bookstore—and to also permit singing in coffeehouses.

A San Francisco jury had previously declared her book obscene and lacking any redeeming social value. The court decision was eventually overturned after the Hollywood benefit, which featured Clear Light, the Factory, UFO, Peanut Butter Conspiracy, Hearts & Flowers, Taj Mahal, the Poor, Biff Rose, Hamilton Streetcar, Barry McGuire, and others. Elliot Mintz of KPFK-FM was the emcee.

ABOVE: Buffalo Springfield performing at the KHJ Appreciation concert at the Hollywood Bowl, April 29, 1967.

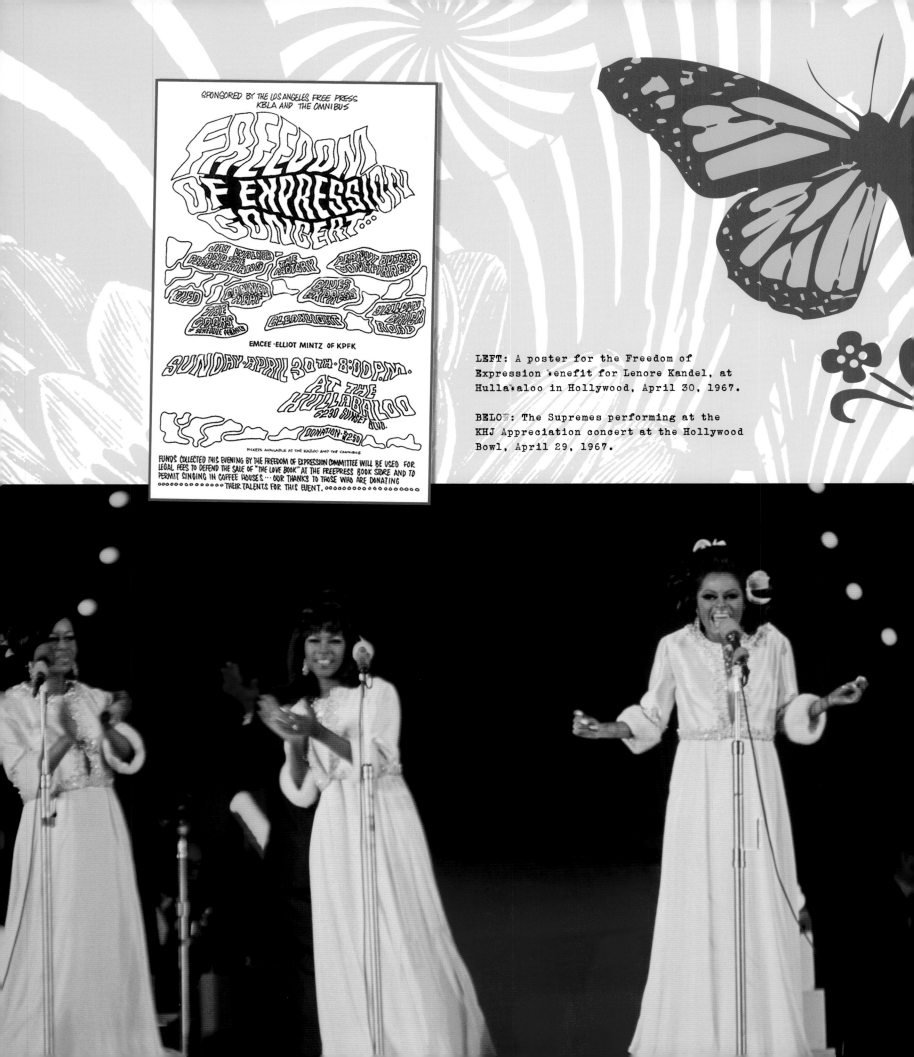

SPONSORED BY THE LOS ANGELES FREE PRESS
KBLA AND THE OMNIBUS

FREEDOM OF EXPRESSION CONCERT...

JAY WALKER AND THE PEDESTRIANS · THE FACTORY · PEANUT BUTTER CONSPIRACY
RED · CANNED HEAT · BLUES EXPRESS
THE SEEDS OF SCHEDULE PERMITS · CLEARLIGHT · YELLOW BRICK ROAD

EMCEE · ELLIOT MINTZ OF KPFK

SUNDAY · APRIL 30TH · 8:00 P.M.
AT THE HULLABALOO
6230 SUNSET BLVD.

DONATION $2.50

TICKETS AVAILABLE AT THE KAJOO AND THE OMNIBUS

FUNDS COLLECTED THIS EVENING BY THE FREEDOM OF EXPRESSION COMMITTEE WILL BE USED FOR
LEGAL FEES TO DEFEND THE SALE OF "THE LOVE BOOK" AT THE FREEPRESS BOOK STORE AND TO
PERMIT SINGING IN COFFEE HOUSES ··· OUR THANKS TO THOSE WHO ARE DONATING
ooooooooooooooo THEIR TALENTS FOR THIS EVENT. ooooooooooooooooo

LEFT: A poster for the Freedom of Expression benefit for Lenore Kandel, at Hullabaloo in Hollywood, April 30, 1967.

BELOW: The Supremes performing at the KHJ Appreciation concert at the Hollywood Bowl, April 29, 1967.

Not to be out-flowered by the American hippies, the Brits mounted their own saturnalia. It was on Saturday, April 29, that London's hip underground newspaper, the *International Times*, presented the 14-Hour Technicolor Dream concert at the fabled Alexandra Palace, a Victorian grandiosity known locally as "Ally Pally." Priced at one pound per "punter," the happening drew between 5,000 and 8,000 stargazers, spacing out to the groovy sounds of Soft Machine, the Crazy World of Arthur Brown, and the Syd Barrett–led Pink Floyd. The event's press release promised "a night out of time. On entry, everyone will be asked to change the time on their watches and the night of happenings will then evolve. Every sense will be expanded."

ABOVE: The Alexandra Palace, or "Ally Pally," in North London, which held the 14-Hour Technicolor Dream concert on April 29, 1967.

BARRY MILES

"There were forty-two acts—some of them were theater troupes or poets. I remember the Flies pissing over the audience—a decade before punk. I did stop to watch the full set of the Pink Floyd at dawn and that was truly remarkable. It was the Royal Albert Hall poetry reading in June '65 that really started the scene. That was when people looked around and thought, and said, 'Wow, there's thousands of us!'"

The Summer of Love Down Under

In '67, the West Coast–birthed Summer of Love message also reached across the Pacific Ocean to the land of Oz. Audio signals sent from Hollywood recording studios, residing on the American hit parade, garnered initial radio airplay in a country that now had a budding relationship with the Association's "Cherish," Buffalo Springfield's "For What It's Worth (Stop, Hey What's That Sound)," Love's "She Comes in Colors," the Electric Prunes' "I Had Too Much to Dream (Last Night)," the Mamas & the Papas' "Words of Love," the Music Machine's "Talk Talk," and Paul Revere & the Raiders' "Good Thing."

Michael MacDonald, journalist and author, remembers the universality of the music coming from America as it hit the airwaves in his native Melbourne that year: "Melbourne in 1967—I was just a suburban kid who still listened to a transistor radio, but a kid who knew there was something in the air that was all about change. It went far beyond the Beatles wearing granny glasses and goofy clothes—a whole new sound was coming from the West Coast, and it caught on in Australia. Maybe for me it was hearing Johnny Rivers singing 'Summer Rain' for the first time, which perhaps ushered in the Doors and Eric Burdon's New Animals.

The Beach Boys' 'Good Vibrations' received heavy airplay, and many Aussie bands paid attention—their hair grew longer and they began to experiment with their sound and songwriting. The Summer of Love had arrived in Australia.

"This was against the backdrop of the war in Vietnam and an Australian government who conscripted young men to fight in a conflict unpopular with its people.

"In 1967, Eric Burdon's New Animals toured Australia and drummer Barry Jenkins was bashed by police in Melbourne. Most of us wanted a Summer of Love but knew there would be resistance. Naturally we embraced the music. Scott McKenzie may have sung about wearing flowers in your hair when you came to San Francisco, but us

"Radio began to feature less British Invasion bands and play more sounds from San Francisco and Los Angeles. We embraced the new music and a new rock scene began to evolve in Australia——we never looked back."

—MICHAEL MacDONALD, JOURNALIST AND AUTHOR

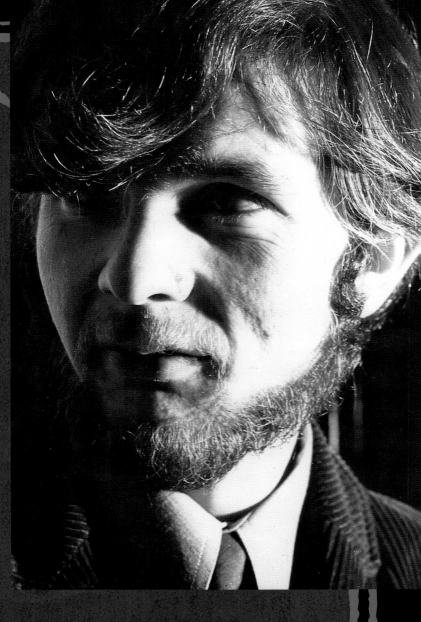

Aussies knew John Phillips lyrics had something universal about them—soon the hippie movement emerged in pockets of Melbourne and Sydney.

"Radio began to feature less British Invasion bands and play more sounds from San Francisco and Los Angeles. We embraced the new music and a new rock scene began to evolve in Australia—we never looked back."

A musician and journalist from Australia who founded that country's first import rock record store, David N. Pepperell was in his early twenties during the Summer of Love: "Psychedelic music was very popular in Melbourne and Sydney in 1967—'The Ballad of You and Me and Pooneil' from Jefferson Airplane even topped the Sydney Singles chart!

"There wasn't much acid around but lots of marijuana from Indonesia and Thailand, and a number of bands were playing psychedelic style, including the James Taylor Move—with later Sky superstar Kevin Peek on guitar—whose 'Magic Eyes' was pure psychedelia. The Procession had a hit with an a cappella ballad called 'Anthem,' the Wild Cherries freaked out with 'Krome Plated Yabby,' and 'Undecided' by the Masters Apprentices showed the psych/prog path they would take in the future. On the flower power scene, a band called 18th Century Quartet had a hit with a piece of Stones-style baroque pop called 'Rachael.'

"Long hair had been de rigueur for hip males since the Beatles tour in 1964, but by 1967, Indian shirts and sandals started to appear, as well as tie-dyed T-shirts in a plethora of colors, and beads and bangles were everywhere—and on girls too! Incense was in every house, sometimes to cover the smell of dope but often just to go with the carpets on the wall and the December '67 advance posters of the cover of the next Jimi Hendrix album, *Axis: Bold as Love*.

"The first Pop Festival/Gathering was not held until 1970, at Ourimbah in New South Wales, but strobe and police lights, as part of a light show featuring projected color slides, were appearing at all the clubs and big hall dances by 1967."

ABOVE: David Pepperell, c. 1967; photograph by Robert Westfield.

SOUND AND VISION WITH A MISSION

The commercial success of the sounds of 1967 was a grand announcement that the old order had passed and a new order had arisen. There was a fundamental change in the way that music was going to function for its listeners and audience: Musically, songs embodied more depth and complexity; and in terms of content, they began to make more of a difference politically and socially.

One of the most anticipated albums released in May was Country Joe and the Fish's *Electric Music for the Mind and Body*. *Playboy* magazine heralded it as a "fine collection of originals." KEBF-FM radio host James Cushing describes it as "acid folk music. And pastoral ballads with plenty of psychedelic elements. The first track is a talking blues song called 'Flying High,' which refers to a hitch-hiking trip when the driver turned Country Joe McDonald onto some marijuana. There are songs about Grace Slick and Janis Joplin. There's great understanding of the feminine."

OPPOSITE: A "birthday" card for KHJ 93-AM "Boss" radio in L.A., celebrating their second year, photographed in May 1967 by Henry Diltz.

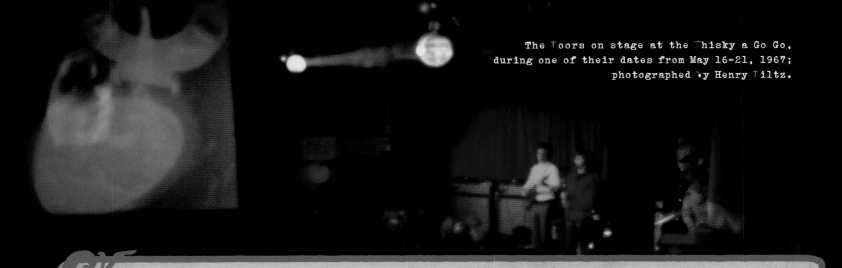

RAY MANZAREK

"I didn't grow up with reefer madness and paranoia. I was a musician. I initially knew it from guys who were jazz musicians and smoked it. Then, all of a sudden, it makes its appearance in the world of the sixties, you know. 'Holy cow! It's like everyone is smoking a joint now.' It's like no big deal at all. A common occurrence. . . . But don't forget it's 1967, and the potheads were aware. That's what was so great about marijuana opening the doors of perception—along, of course, with LSD.

"Marijuana makes you aware that you are on a planet. It's God's good green earth and you've got to take care of God's good clean earth. In 1967, ecology was very, very big. We were all trying to save the planet. The sun was the supreme energy."

JOHN DENSMORE

"In 1967, we were naïve, but felt, 'We're changing the world.' . . . And, actually, it was just seeds being planted which are blooming and will bloom a hundred years from now. Civil rights, feminism, peace movement, ecology, Native American rights, all that was planted.

"I remember poet Gary Snyder on a cable TV show, and they were trying to pin him down: 'You're an ecological poet. You must be very depressed by the way the ecology environment is going and beaten up.' He replied, 'I'm not gonna buy that. Maybe it will be two hundred years before big blooms come out from the seeds.'"

JAMES CUSHING

"Marijuana was part of the fabric in 1967. The baby boomers were the first generation of people who spent hours looking at a television screen, which projected images that were there purely for our pleasure. And now, here is a drug, marijuana, that supposedly produces a sense of euphoria. And our generation essentially asked, 'What? You mean, after creating a world of pleasures for us, there are certain pleasures you say we can't have?' I hope I'm not reducing the hippie movement, but I think there was a purely hedonistic dimension to it, which was a structural weakness because it made it very vulnerable to corporate exploitation."

On May 12, Jimi Hendrix released his debut album, *Are You Experienced*, issued by Warner Bros./Reprise Records in the United States. That evening in London, Pink Floyd give their first quadraphonic-sound concert at Queen Elizabeth Hall.

"First of all, I don't want people to get the idea it's a collection of freak-out material. I've written songs for teenyboppers like 'Can You See Me' and blues things; 'Manic Depression' is so ugly you can feel it. It's a collection of free feeling and imagination. Imagination is very important. The States are still very conservative; maybe the West Coast would be easier to break than New York—you can play louder on the West Coast. I like things the Mamas and Papas are doing."

—HENDRIX, SPEAKING WITH REPORTER KEITH ALTHAM IN THE MAY 13 ISSUE OF THE UK'S *NEW MUSICAL EXPRESS*, DISCUSSING HIS DEBUT PLATTER

Jimi Hendrix performing at the Hollywood Bowl, August 18, 1967, photographed by Guy Webster.

By 1967, the Rascals—formed in New Jersey in 1965 and signed by Ahmet Ertegun at Atlantic the same year—had become one of the most influential and artistically important American bands in rock 'n' roll. Felix Cavaliere, Eddie Brigati, Gene Cornish, and Dino Danelli created a musical brew of blue-eyed soul that permeated their Top 10 singles, including "How Can I Be Sure," "Come On Up," "You Better Run," "I've Been Lonely Too Long," "Good Lovin'," and their May '67 No. 1 hit, "Groovin'."

OPPOSITE: The Young Rascals (as they were known until 1968) performing on *The Ed Sullivan Show*, June 4, 1967.

KIRK SILSBEE

One word applies to Atlantic Records CEO Ahmet Ertegun in the 1960s: *visionary*. The label was founded on rhythm and blues and soul but he could see that the future lay elsewhere. He shrewdly signed pop and rock artists who would generate big chart hits: Sonny and Cher, the Rascals, Buffalo Springfield. Ertegun later added Dusty Springfield, Iron Butterfly, Led Zeppelin, and the Allman Brothers to Atlantic's roster. But he didn't neglect his black artists: Atlantic maintained a healthy jazz profile, and through a distribution deal with Stax brought Memphis soul into the pop mainstream.

"Ahmet was no stranger to Hollywood. His brother Nesuhi, considered Atlantic's font of taste and sophistication, graduated from and later taught at UCLA. Ahmet was a presence at Gold Star Studio when the Springfield recorded, while Otis Redding's live 1966 album at Whisky cross-pollinated Hollywood with Memphis, briefly but significantly."

"'Groovin'' began as a demo. We had some studio time, and we recorded the track. There was no guitar, no organ or drums on it. Dino [Danelli] played conga. I played the tambourine and later on the harmonica on the stereo version. Felix played the piano. I went to overdub the bass and couldn't get that Latino feel we wanted. And the engineer at the time, Chris Huston, suggested Chuck Rainey from King Curtis."

—GENE CORNISH, GUITARIST, THE RASCALS

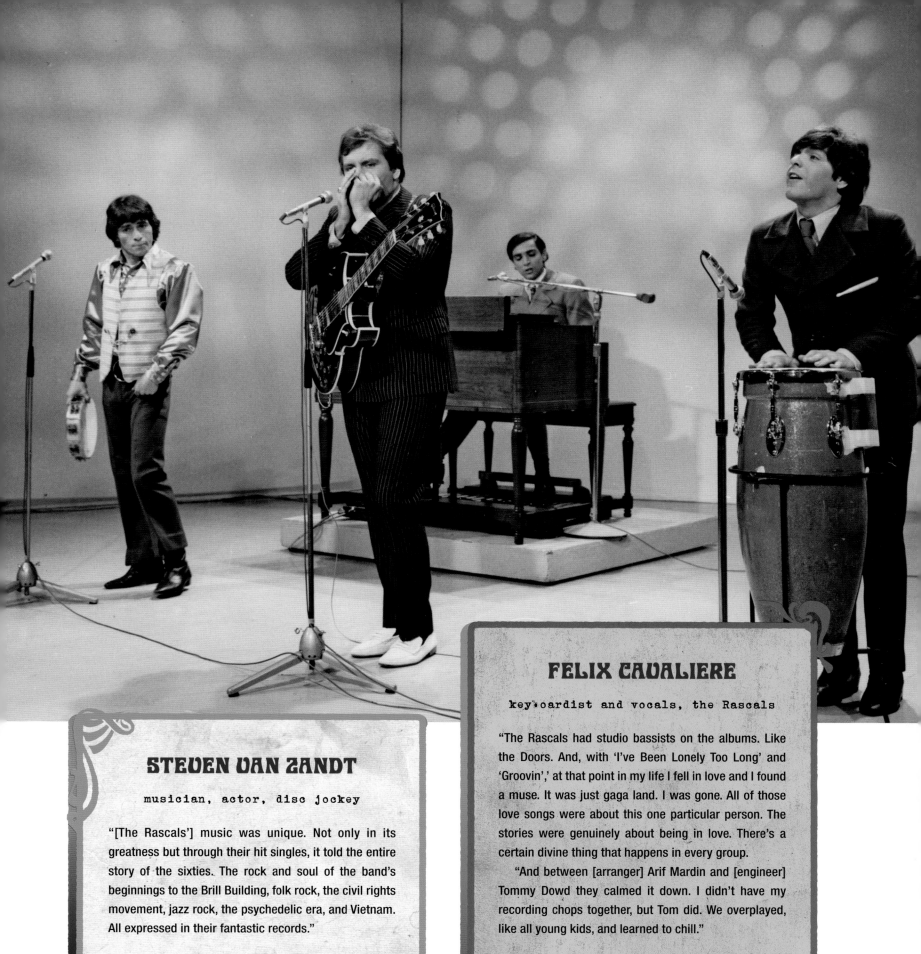

STEVEN VAN ZANDT

musician, actor, disc jockey

"[The Rascals'] music was unique. Not only in its greatness but through their hit singles, it told the entire story of the sixties. The rock and soul of the band's beginnings to the Brill Building, folk rock, the civil rights movement, jazz rock, the psychedelic era, and Vietnam. All expressed in their fantastic records."

FELIX CAVALIERE

keyboardist and vocals, the Rascals

"The Rascals had studio bassists on the albums. Like the Doors. And, with 'I've Been Lonely Too Long' and 'Groovin',' at that point in my life I fell in love and I found a muse. It was just gaga land. I was gone. All of those love songs were about this one particular person. The stories were genuinely about being in love. There's a certain divine thing that happens in every group.

"And between [arranger] Arif Mardin and [engineer] Tommy Dowd they calmed it down. I didn't have my recording chops together, but Tom did. We overplayed, like all young kids, and learned to chill."

Dont Look Back

Bob Dylan wasn't touring in 1967, due to a July 1966 motorcycle accident outside of Woodstock. However, filmmaker D. A. Pennebaker's Bob Dylan documentary *Dont Look Back*, shot in Britain during 1965, was officially released and theatrically screened for the first time on May 17 in San Francisco.

"You could never have that film made today," Pennebaker says. "Management wouldn't allow it.

There was no myth or legend yet. It was so incredible. Dylan had such an amazing kind of mercurial sense that translated to people.

"In 1965 I would look through my lenses and the words would drop on the music. I was just amazed at how anybody could produce that kind of electricity. To me that was what art was about.

"In 1967, in San Francisco, we opened *Dont Look Back* at the Presidio Theatre. Then in Los Angeles and Hollywood. There's always a delay between the people at the gates and the public.

"My partner, Ricky [Leacock], and I came [to San Francisco] and I was so pleased we had gotten it into a theater. It played in San Francisco for almost a year in 16mm. Then New York came around four months later when it showed at the 34th Street East. The company didn't even have to run ads."

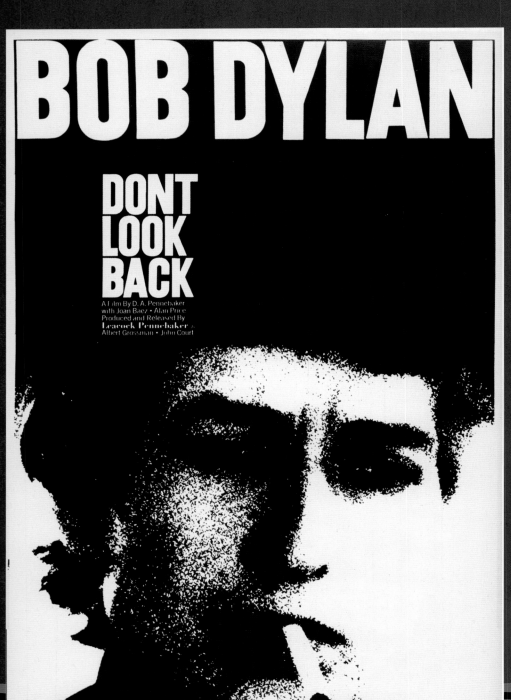

The arresting poster for D. A. Pennebaker's documentary on Bob Dylan, *Dont Look Back*, released in May 1967.

On May 30, 1967, Jefferson Airplane headlined a benefit for the Haight-Ashbury Legal Organization at Winterland Ballroom. Paul Kantner discussed Jefferson Airplane's humanitarian efforts with Jeff Tamarkin, author of the book *Got a Revolution! The Turbulent Flight of Jefferson Airplane*: "There was a great romantic ideal of taking care of 'the people.' We had that naïve hope that we were champions of the poor and dispossessed, being somewhat poor and dispossessed ourselves. There was a Robin Hood–like capacity there. All you had to do was go out and play and make a large amount of money for somebody who really needed it."

The last week of May was the delivery date of the highly anticipated Mothers of Invention *Absolutely Free* LP. Produced by Frank Zappa and Tom Wilson, it did quite well commercially, considering its musical complexity, reaching No. 41 in the *Billboard* charts.

Frank Zappa had moved to New York City in April 1967, and he and Gail Sloatman would be married there in September. The Mothers played a long residence at the Garrick Theater on Bleecker Street in New York's Greenwich Village, which helped shape their musical direction for many years. It was also where Ian Underwood (woodwinds, keyboards) joined the band that July, becoming an influential part of Zappa's music through 1973.

RIGHT: Frank Zappa and his wife, Gail Sloatman, at their house in Echo Park, Los Angeles, 1967.

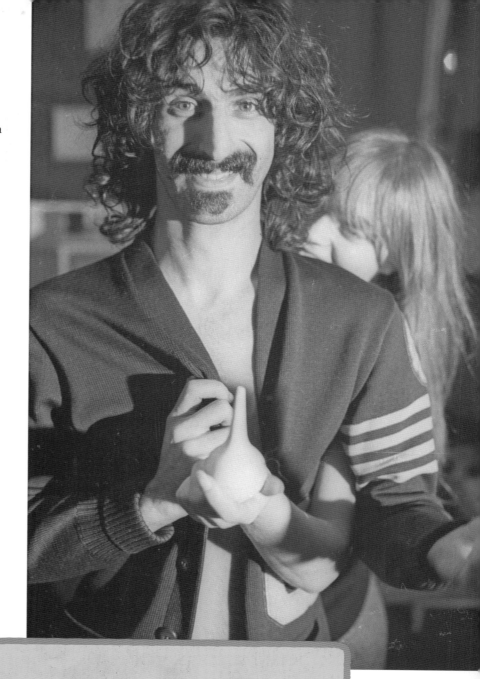

GENE AGUILERA

author, music historian,
record producer

"When I was in junior high school, my friend Gary tapped me on the shoulder and said, 'Hey, hurry and get your dad to take you to White Front. There's this double album, *Freak Out!*, by these guys called the Mothers of Invention. They look crazy and I think they made a big mistake on the tag—it only says $1.99.' This was my introduction to Frank Zappa and the Mothers.

"I don't think there were too many thirteen-year-olds in East L.A. devouring *Freak Out!* on their record players like I was in 1966.

"Then in the spring of 1967, Zappa unleashed the Mothers' second LP, *Absolutely Free*, to an unsuspecting world, with an album cover that looked like an underground *Los Angeles Free Press* ad.

"The first thing I did was check to see if Roy Estrada, their Chicano bass player, was still in the band (yes, thank God!). And this time around, Zappa took me from the greasy doo-wop slabs of El Monte Legion Stadium to riot-central Pandora's Box on the Sunset Strip. *Absolutely Free* was a biting satire on straitlaced America ('Brown Shoes Don't Make It'), phony hippies ('Plastic People'), and vegetable fetishism ('Call Any Vegetable'), all tied together in little musical vignettes. I still listen to it, and yes, my neighbors still talk to me."

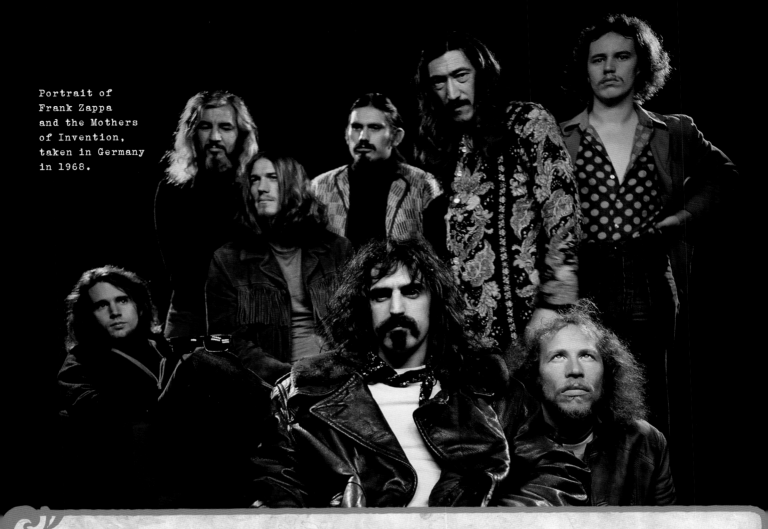

Portrait of Frank Zappa and the Mothers of Invention, taken in Germany in 1968.

ALAN G. WATTS

music aficionado and neuroscientist

"Musically, *Absolutely Free* was a way more sophisticated record than *Freak Out!* Many interesting musical quotes, from Stravinsky to the Supremes. Zappa was able to add Billy Mundi, a second drummer, Bunk Gardner, and Don Preston to the Mothers late in 1966, which made the band an eight-piece. More versatile than the *Freak Out!* band, which meant they could tackle more complex pieces. Zappa organized the album as an oratorio.

"In my opinion, *Absolutely Free* is entirely a 1966 album. It was recorded during four sessions in mid-November—Verve-MGM Records wouldn't pay for more—and was slated for release in early January 1967. But the release was pushed to May 1967 because of arguments with the label about censoring the printed 'libretto' that was supposed to accompany the album.

"Thinking about Zappa's musical development, 1967 was a critical year for him. He recorded all of *We're Only in It for the Money*, *Lumpy Gravy*, and the first bits of *Cruising with Ruben & the Jets*.

"*Lumpy Gravy* was his first solo album, and in some respects his most important music to date. It was released in its original non-libretto form in August of 1967, but quickly withdrawn after a lawsuit from Verve-MGM.

"For me, *We're Only in It for the Money* is way more important for 1967 than *Absolutely Free*. San Francisco, hippies, LSD, 1967 run through the entire album. Take a look at the lyrics, particularly 'Who Needs the Peace Corps?,' 'Concentration Moon,' 'Flower Punk,' and 'Take Your Clothes Off When You Dance.' . . .

"*We're Only in It for the Money* was recorded in Hollywood at TTG Studios in February and July through September at Mayfair Studios, New York City, with final mixing in October 1967 at Apostolic Studios, New York City. *Sgt. Pepper*'s was released June 1967.

"Like *Absolutely Free*, the release of *We're Only in It for the Money* was delayed because of censorship issues, and of course the famous cover (apparently Paul McCartney was OK with the Zappa cover, but the lawyers weren't), which delayed the release for four or five months. The *Sgt. Pepper*'s parody was eventually placed on the inside of the gatefold, out of harm's way. *We're Only in It for the Money* came out in March 1968, but in my opinion, you can't discuss 1967 without mentioning this album—far more relevant for the year than *Absolutely Free*."

JAMES CUSHING

"In high school a friend of mine used 'Brown Shoes Don't Make It' as a routine just to annoy people. *Absolutely Free* is massively brilliant. The satire of Zappa in the 1966–1968 recordings . . . is that the hippies are just as un-free as everybody else. And in case you didn't get it, his next album, out in early '68, *We're Only in It for the Money*, has a parody of *Sgt. Pepper*'s on the back and the front. Which basically calls bullshit on the whole thing. But does so in a way that is so brilliant that I sometimes think of that album as part of a trilogy along with *Sgt. Pepper*'s and *Magical Mystery Tour*.

"Frank Zappa was not oriented toward pleasure. Hippie culture was oriented toward pleasure. This man's deepest pleasure was in hard, disciplined work.

"The '67 music became more political, both in the literal sense, with bands like Country Joe and the Fish calling out President Johnson, and figuratively, with Jefferson Airplane, Love, and Frank Zappa's Mothers of Invention as models for the possibility of life outside of the capitalist rat race."

Remembering Zappa

As a drummer, Denny Bruce worked with Frank Zappa in the developmental stages of the Mothers. He rehearsed with Zappa for a few months in 1965 and did a couple of shows, including one at the Brave New World in Los Angeles. He first met Zappa at Zappa's California courtyard apartment in Echo Park:

"Zappa had records that filled up his bathtub. These are the records that informed his albums. The discs are his touchstones. Every record was there for a reason. He couldn't live without them.

"I was always proud of everything he ever did. I'm honored that I knew him. I made him laugh and he liked all my ideas, the Frank Zappa who I knew in the 1965 to 1967 period. He would have the ability to process all the information going on around him. I don't mean reading or listening to music. I just mean focusing on conversations he might have had.

"I had been to San Francisco in 1966 and crashed in somebody's pad. When I woke up there were twenty people. I just described the scene to him, and later that day, from my conversation, that cat was able to turn 'We're going up to Frisco,' from our dialogue, into 'Flower Punk,' an anti-hippie song.

"Zappa worked very hard. That guy, in my mind, with coffee and cigarettes, put in 24/7. I know he enjoyed working all night because it was quiet. Very intelligent. Deep-rooted, he knew he was ugly and had to outwork the other guy. That was his genius.

"And it made sense that he would put out an album in '67, *Absolutely Free*. Because he was. Not paying attention to convention and the grin and grip stuff you have to do to get your product out. It all was like water rolling off a duck's back. 'Cause he did look freaky without trying. OK?"

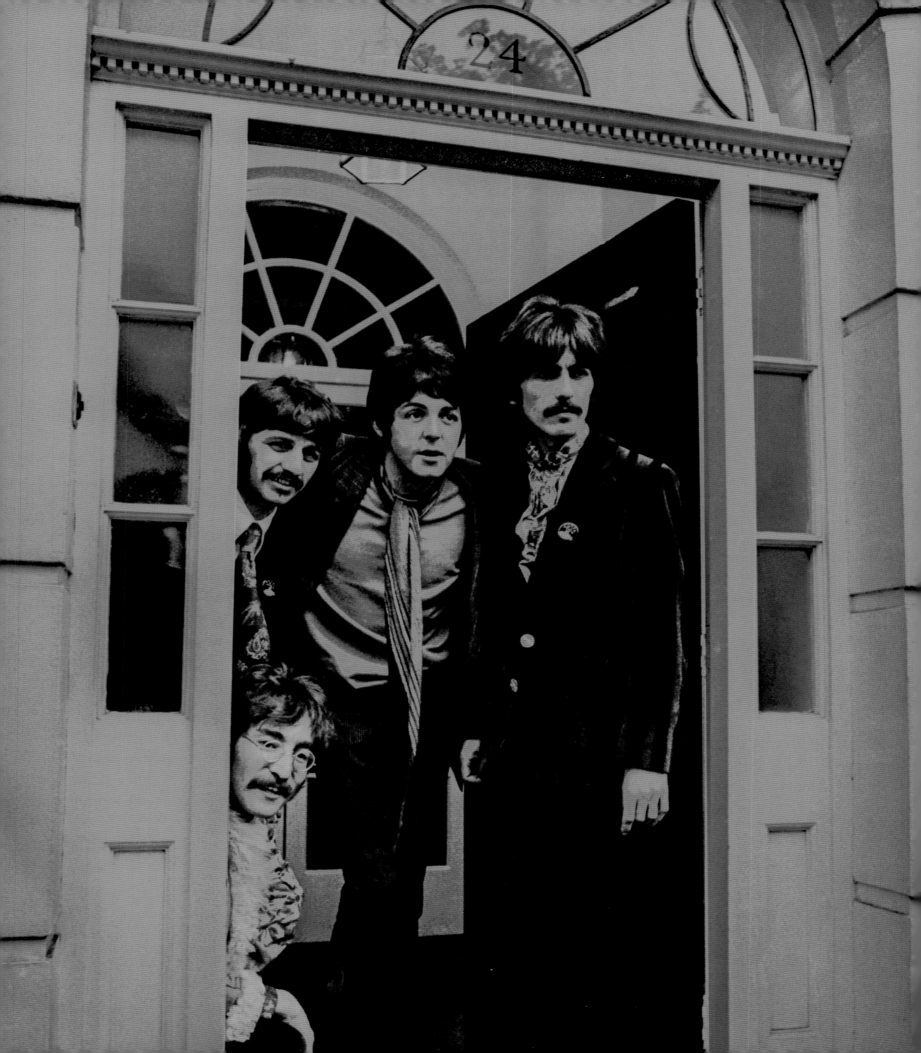

STAX OF WAX

Having ensconced themselves in the salutary confines of Abbey Road Studios in London, the Beatles spent the winter and spring of '67 concocting their next album. Expectations, needless to say, ran high; in fact, the entire pop music world was holding its collective breath, waiting for not only musical, but also spiritual guidance.

The Fabs had long since graduated from teen dreams into the mythic realm of Arthurian knights, living legends whose every utterance (watch what you say about Jesus, John) and every fashion choice ("Oh, look, Paul's grown a mustache, Lennon's wearing National Health specs!") was deconstructed for some deeper meaning.

Sgt. Pepper's Lonely Hearts Club Band landed on June 1 with the force of the Magna Carta, the template against which all subsequent music would be weighed and judged. Andrew Loog Oldham recalled it as "the second coming of the audio Christ."

The Byrds' Roger McGuinn "loved *Sgt. Pepper's* and thought it was a brilliant album.

The Byrds loved everything the Beatles did. They were our heroes. They could do no wrong as far as we were concerned. *Sgt. Pepper's* was just incredible. I may have liked some of their earlier stuff a little better, but I did like the production values of *Sgt. Pepper's* and the fact that it all kind of ran together and had a theme, a story."

OPPOSITE: The Beatles in the doorway of their manager Brian Epstein's house in London, for the press launch of *Sgt. Pepper's Lonely Hearts Club Band*, May 19, 1967

JOHN DENSMORE

"We were starting our second album, *Strange Days*, when our engineer, Bruce Botnick, got an advance copy of *Sgt. Pepper's* before it was released and played it for us. Oh, what a challenge . . .

"[On] *Strange Days*, we were definitely more into experimental because of hearing that album, but we didn't want to do horns and strings . . . it was so wild. Ringo did four hundred pounds of overdubs on that album.

"We weren't in competition with the Beatles. When I think competition, it's sonic competition. Lennon and McCartney then were more semitraditional songwriters, and we were West Coast acidheads. But sonically, we were challenged, and started to do backward piano tracks. 'The recording studio is the fifth door. Let's experiment.' That's what *Sgt. Pepper's* did. We didn't try and copy Lennon and McCartney."

RAM DASS

"I loved the Beatles' music. . . . Music is a vehicle for moving consciousness, and humor is a vehicle for moving consciousness. And the combination of that. It was not hard rock. It was soft rock. It was John Lennon's love. It was that quality of that space."

SHEL TALMY

record producer

"In *New Musical Express* or *Melody Maker*, I was the 1967 record producer of the year. I thought *Sgt. Pepper's* was brilliant. Psychedelic or not, it had form as far as I was concerned. Maybe they went a little overboard with the psychedelic stuff. The songs were great. What they did was a little too long for me. If there was a great song that went five minutes, that's cool. Even six, maybe, at a stretch. But I still subscribe to the fact that if you're gonna hear a great song, you're gonna pretty much know it in the first eight bars. And then it continues to develop; three to four minutes is about the right amount of time for it."

BOBBY ROGERS

vocalist, the Miracles

"Once when we [the Miracles] were in England, in 1963, this guy came up to me in a small little club and said, 'Are you with the Isley Brothers?' When I told him I was in the Miracles, he nearly flipped out.

"He said his name was George and he was in a group named the Beatles. We used to party with all the groups. You know, music travels in sort of a cycle.

"Marvin [Gaye] was listening to everything that was around. Beatles, Stones, pop, jazz. You know that *Sgt. Pepper's* LP? It was always on Marvin's turntable."

A California ad for the Muntz Stereo-Pak 4-track tape of the *Sgt. Pepper's* album.

"It came out and suddenly music went from black-and-white to color to 3-D."

—PAUL BODY

"In the sixties I was a fan of the Beatles. I bought *Sgt. Pepper's* in India. I heard a lot of music on the BBC in India, and was brought up on classical sounds . . . Mozart, Vivaldi, Beethoven, [and] Indian classical music: Ravi Shankar, Ali Akbar Khan.

"*Sgt. Pepper's* was the right thing at the right time. It was an interesting time, when people were kind of playing with drugs a little bit, the hallucinogenics, and causing some drastic mind shifts in people.

"I was in medical school at the time *Sgt. Pepper's* came out. A friend of mine actually had gone on a scholarship to England and brought back two copies of *Sgt. Pepper's*, one for me and one for himself. And shortly after that, the Beatles arrived in Rishikesh, India, in 1968."

—DEEPAK CHOPRA, AUTHOR, COFOUNDER, CHOPRA CENTER FOR WELLBEING

ABOVE: Guitarist Peter Lewis of Moby Grape,
Shrine Exposition Hall, Los Angeles, 1967;
photograph by Heather Harris.

One other long-player was in the shop racks on that same June 1 date. It certainly didn't soar up the charts but did signal the arrival of twenty-year-old David Bowie. His self-titled album, on the Deram label, was produced by Mike Vernon and engineered by Gus Dudgeon at Decca Studios.

Instructions to UK music retailers and vendors were to file the album in the racks under Pop Music, Baroque Pop, and Music Hall.

The first week of June also delivered the long-anticipated debut album from Moby Grape, consisting of Peter Lewis (guitar), Jerry Miller (guitar), Bob Mosley (bass), Don Stevenson (drums), and co-founder Skip Spence (guitar).

Playboy magazine hailed *Moby Grape* as "strong both vocally and musically," adding, "'Omaha' is a psychedelic classic."

The Grape, although heralded as part of "The San Francisco Sound" (whatever that was), was a mixture of Los Angeles, San Diego, San Francisco, and Seattle musicians. It was basically built around Skip Spence, the original Jefferson Airplane drummer and songwriter of "My Best Friend" and "Blues from an Airplane," who was returning to guitar—his main instrument.

In June, Jefferson Airplane was the musical guest on Dick Clark's *American Bandstand*. The outfit lip-synched to "Somebody to Love" and "White Rabbit."

Host Clark did a brief chat with Paul Kantner during band introductions. Dick was curious as to whether the parents of America should be concerned now that groups like Jefferson Airplane were arriving. Paul replied, "I think so. Their children are doing things that they don't understand."

"When we played live at the Fillmore or the Avalon, there was a bond and a chemistry with the audience. We did structured songs, not free-form jams, but three-minute versions with a couple of guitar solos and a few endings. We had a couple of songs that we stretched out on—'Dark Magic,' and on the ending of 'Hey Grandma.'"

—BOB MOSLEY, BASS GUITARIST, MOBY GRAPE

Like an off-Broadway production not quite ready for the Great White Way, the KFRC (Mt. Tam) Fantasy Fair and Magic Mountain Music Festival arrived the weekend before the Monterey International Pop Festival. KFRC, the San Francisco–based AM 610 radio station, sponsored a 1967 promotion on top of the mountain in Mount Tamalpais State Park in Marin County, at the four thousand–seat Sidney B. Cushing Memorial Amphitheatre.

The Stanley Mouse–designed poster announced, for a two-dollar ticket price, performances from Canned Heat, the Doors, the Seeds, the Byrds with Hugh Masekela, Penny Nichols, Kaleidoscope, Jefferson Airplane, the Grass Roots, the 5th Dimension, the Chocolate Watchband, Country Joe and the Fish, the Merry-Go-Round, Roger Collins, Blues Magoos, Every Mother's Son, Wilson Pickett, the Mojo Men, the 13th Floor Elevators, Smokey & His Sister, Dionne Warwick, the Sparrow, P. F. Sloan, the New Salvation Army Banned, Loading Zone, Sons of Champlin, the Steve Miller Blues Band, Captain Beefheart and the Magic Band, the Mystery Trend, the Lamp of Childhood, and Tim Buckley.

This Summer of Love benchmark was the brainchild of producer Tom Rounds, the program director at KFRC who coordinated the two-day Northern California afternoon delight.

The June 10–11 schedule included everything from the sublime (Jim Morrison in full lizard king persona) to the ridiculously early (Captain Beefheart's 10:30 a.m. [!] set).

Everyone imbibed deeply from the sun-sweetened air, redolent of peace and love, gloriously unaware that they were attending the very first pop music festival.

LEFT: Singer-songwriter Tim Buckley at the Magic Mountain Music Festival held on Mount Tamalpais in Marin County, California, from June 10 to 11, 1967. The festival, which kicked off the Summer of Love, was one of the first large rock festivals ever held.; photograph by Henry Diltz.

ABOVE: Berkeley poet Jerry Burns on Mount Tamalpais during the Magic Mountain Music Festival.

TOM ROUNDS

program director, KFRC,
and festival organizer

"The original idea for Mt. Tam goes back to the Rolling Stones concert in the Cow Palace. And we're watching the security guys pick up teenage girls and throw them back into the arena. I was program director of KFRC, who was a sponsor of the concert. [I thought to myself] 'You know what? We've got to do something outside in nature.'

"A few weeks later I went down to L.A. to visit KHJ program director Ron Jacobs, and we went to the Renaissance Pleasure Faire. The whole idea was to have wandering musicians—minstrels—and the site was Mt. Tam.

"We had a charity arrangement with the Hunter's Point Child Care Center. We were approached because there had been riots the year before I got to San Francisco. And the whole area was on the mend. San Francisco was a very R&B town. So that was very important for us, to program according to that constituency. The Economic Opportunity Council approached us, which I think was a federal initiative after the Watts riots in 1965, to do some kind of an event to raise money.

"There were some groups who wouldn't perform because we were a commercial station. One manager felt we were exploiting the music. And we had a very close relationship with Bill Graham, who was a big advertiser on the radio station. We were the number one station.

"The first day of the festival, we got there at 6:30 a.m. and the sun was coming up. We were above the clouds. So that made it almost a mystical experience coming out of that overcast and the bright sunshine. It was where the term 'festival vibes' came up.

"The thing is, just about everybody listened to KFRC, and it had enormous shares. It was very popular, and FM had not quite happened. So between the radio station and word of mouth, it was easy."

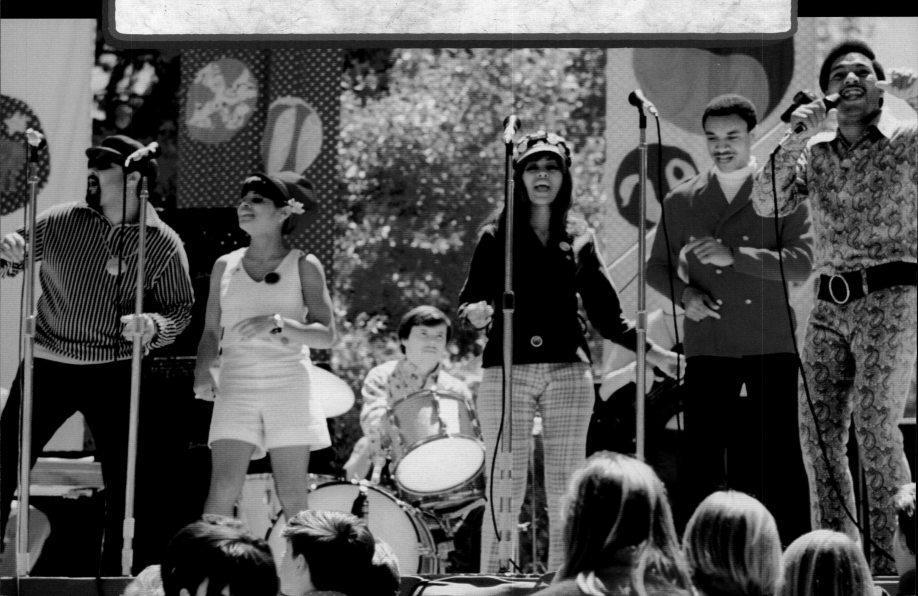

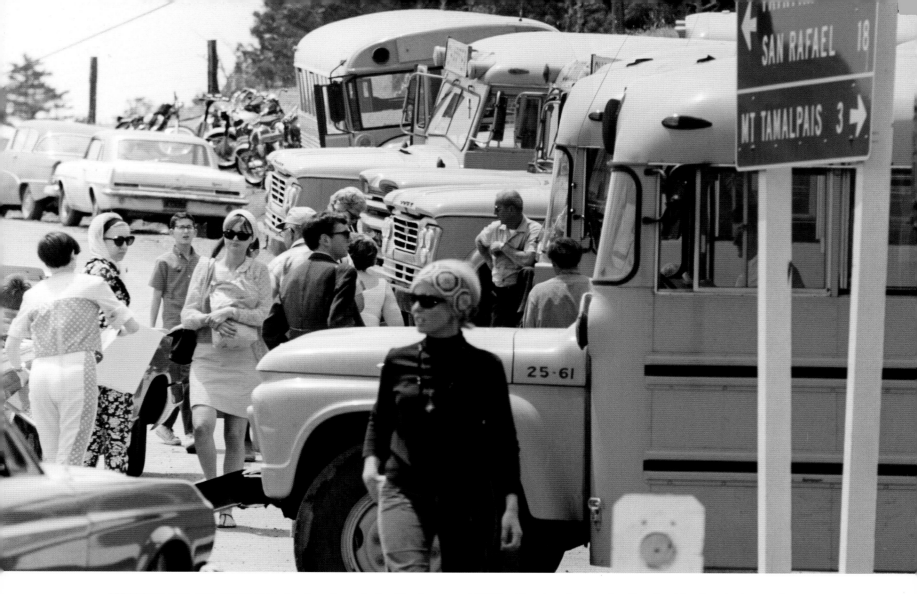

OPPOSITE: The 5th Dimension performing at the Magic Mountain Music Festival; photograph by Helie Robertson.

ABOVE: Charter buses to the festival; photograph by Henry Diltz.

"The logistics of the whole thing were bewildering, you know. Busing everybody up [on Trans Love Bus Lines] from the parking areas to the goddamn Mt. Tam amphitheater. It definitely is an uncredited little historic moment, and it reflected the music scene of the time fairly well. Jim Morrison and the Doors. There was nothing more rock in June 1967."

–JOEL SELVIN

JANN WENNER

co-founder and publisher,
Rolling Stone magazine

"It was kind of an odd thing for a radio promotion. KFRC, right? This seemed like the oddest thing for a Top 40 radio station to do except for it was San Francisco. Top 40 radio was a little different, you know. KFRC and Tom Rounds. Radio station KYA had always been a little different. It was a tight scene with Tom Donahue.

"When FM radio began, a lot of those guys came from AM radio. So they were AM radio jocks who were . . . very attuned to what was going on in the so-called underground scene. It kind of crossed over a lot. There wasn't that huge divide that existed in Los Angeles or New York, in the bigger markets."

MEL LAWRENCE

technical advisor,
Magic Mountain Music Festival

"I worked at the festival and saw the new world at Mt. Tam. I then really saw it 130 miles away the next week at Monterey. I thought it was recognition that you weren't alone, you know. That there was this group consciousness that you didn't know of before these festivals. Just to know how people have to operate with huge crowds of people. How to operate in circumstances with a show going on. That continuity of those who were production people."

TOP: The Doors' electric performance at the festival; photograph by Helie Robertson.

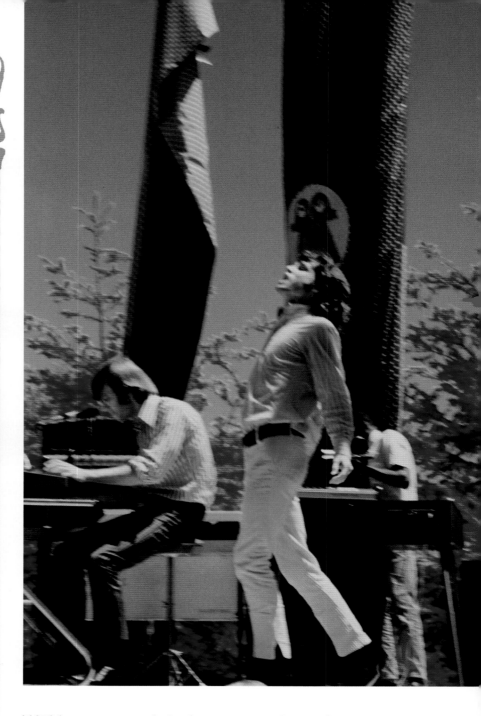

"The amphitheater in the woods was really great and the intimacy of the whole event [had] a spirit of a fair around it."

—JANN WENNER

Awakening

Carlos Santana

"The Summer of 1967. It was about awakening. Away from the Man. Away from the Pope. And away from the presidents and politicians, too. It was through music and doing what Jesus did at the mountain with bread and fish. It was gluten free and mercury free. [Laughs.]

"San Francisco to my knowledge is where the United Nations was born. And where Haile Selassie gave an important speech about war, from which Bob Marley created the song.

"Here's the word: *consciousness revolution.* It did not come from Liverpool or New York. I think it came from San Francisco. The psychedelic shock. Haight-Ashbury. When I first walked on it, I was like, 'Man, this is like being inside one of Bob Dylan's songs or something—"Desolation Row."'

"I'm very grateful that my timing with my mom and dad was perfect for being in San Francisco when it all hit: the Doors, Grateful Dead, Ravi Shankar, Coltrane. There was an explosion of consciousness that made you question authority. Black power. Rainbow power.

"FM radio in 1967. It blew my mind when I found it on KSAN. They played the whole songs of Vanilla Fudge, Country Joe and the Fish, the long version of Traffic's 'Smiling Phases,' the long version of 'Light My Fire.' 'Wow. This is really, really cool.' . . .

"For me, being right out of high school, and listening, really listening, it gave me a vast awareness of "Where do I belong in all this?" And I looked at B. B. King on my left and Tito Puente on my right. . . . [I saw] 'You can do both. You can be both.'"

BELOW: The band Santana, c. 1968. Carlos Santana on far left.

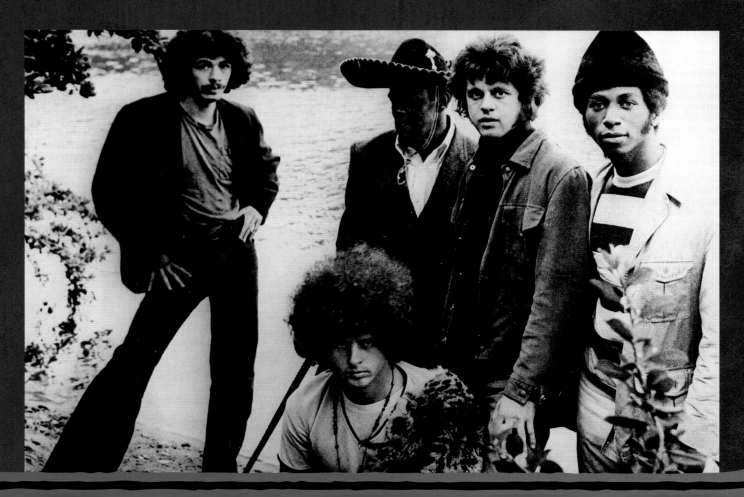

While the *Sounds Like . . . Herb Alpert & the Tijuana Brass* album earned the No. 1 *Billboard* spot in early June, climate continued to play a part in defining the Summer of Love, particularly on the West Coast and in the Southern California basin.

Everything had to do with freedom and greater possibilities. And if you lived in New York, then and now, you know that between October and March you are not free of weather, which is an absolute that no one can do anything about.

In 1967, the California Air Resources Board was established from a merger of the California Motor Vehicle Pollution Control Board with the Bureau of Air Sanitation.

The Mulford-Carrell Air Resources Act was signed into law by then–governor Ronald Reagan.

The federal Air Quality Act was also enacted in 1967. Guidelines were fixed for defining "air-quality control regions" based on meteorological and topographical factors of air pollution. The state of California was granted a waiver to set and enforce its own emissions standards and have more stringent controls for new motor vehicles.

By year's end, there would be clearer skies in the Southern California basin and a drop in "smog days" declared by officials of the Los Angeles Unified School District.

LEFT: Herb Alpert (foreground) and the Tijuana Brass, photographed by Guy Webster, from a photo shoot for their 1968 album *The Beat of the Brass*.

JAMES CUSHING

"I do remember that the Summer of 1967 was very smoggy. And that is the only aspect of it that I remember. I remember looking out my window . . . in the Hollywood Hills when I was listening to the Byrds' *Younger Than Yesterday* and the first album from the Doors and looking out at the Valley and this big carcinogenic tan cloud over the entire San Fernando Valley and feeling how lucky I was being up above it. Even though it was really hot.

"And the light is different in San Francisco. The L.A. light is so beautiful. And the light in L.A. made the planning of the June 16–18 Monterey International Pop Festival possible.

"Can you imagine if the programming was in the hands of the People's Republic of Berkeley? The bands all got together fine. The media created a rivalry that sold papers and created division. Like sports rivalries sell papers."

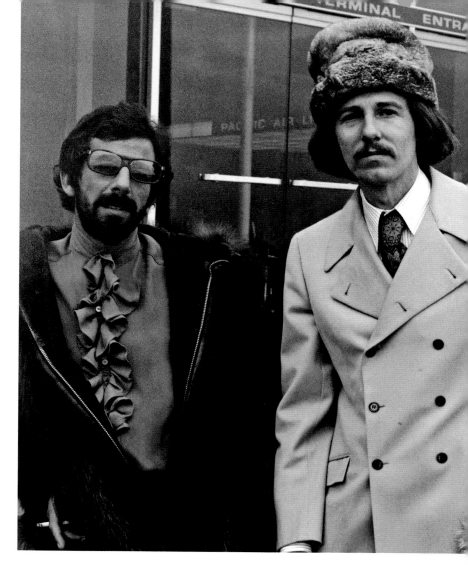

Alan Pariser had Hollywood's coolest pad and the finest stereo system. He also had a hell of an idea, so obvious in retrospect but audacious at the time.

In the best tradition of Mickey Rooney and Judy Garland, Pariser, a young entrepreneur and rock enthusiast who was inspired by the Monterey Jazz Festival, decided to put on a pop music festival that would celebrate the genre's transformation from giddy adolescence into an authentic artistic aesthetic. He partnered first with nightclub impresario Benny Shapiro, who had access to talent.

Pariser quickly recognized that he was swimming in deep waters and turned to pop heavyweights—producer/executive Lou Adler and the Mamas & the Papas' John Phillips—to shepherd the festival to its storied fruition.

That time-honored tarantella of backstage machinations between artist reps and the exigencies of time, space, and budgeting (the festival became a charitable undertaking) were judiciously dispatched.

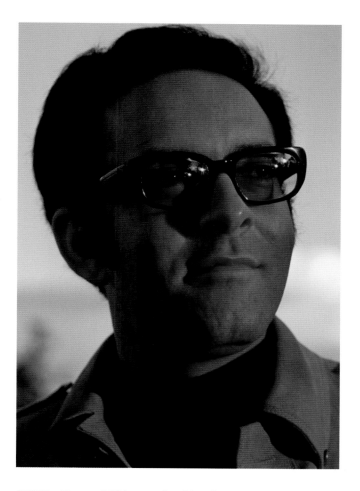

ABOVE: Henry Diltz portrait of Monterey Pop organizer Alan Pariser, August 1967.

From their first production meeting in April until opening night on Friday, June 16, Adler, Phillips, and their crack team whipped together an unprecedented buffet of sights and sounds that continues to resonate like a distant echo of another, more magical time. Cherish, indeed, was the word.

Johnny Rivers, Ravi Shankar, Jefferson Airplane, Grateful Dead, Quicksilver Messenger Service, the Association, Beverley Martyn, Lou Rawls, Big Brother & the Holding Company, the Byrds, Canned Heat, the Mamas & the Papas, Simon & Garfunkel, the Group with No Name, Paul Butterfield Blues Band, the Mike Bloomfield Thing, Country Joe and the Fish, Hugh Masekela, the Steve Miller Blues Band, Moby Grape, the Blues Project, the Jimi Hendrix Experience, Eric Burdon and the Animals, Otis Redding, Laura Nyro, and the Paupers performed during the three-day event.

TOP: Monterey producers Lou Adler and John Phillips of the Mamas & the Papas, photographed by Fred Arellano, c. 1967.

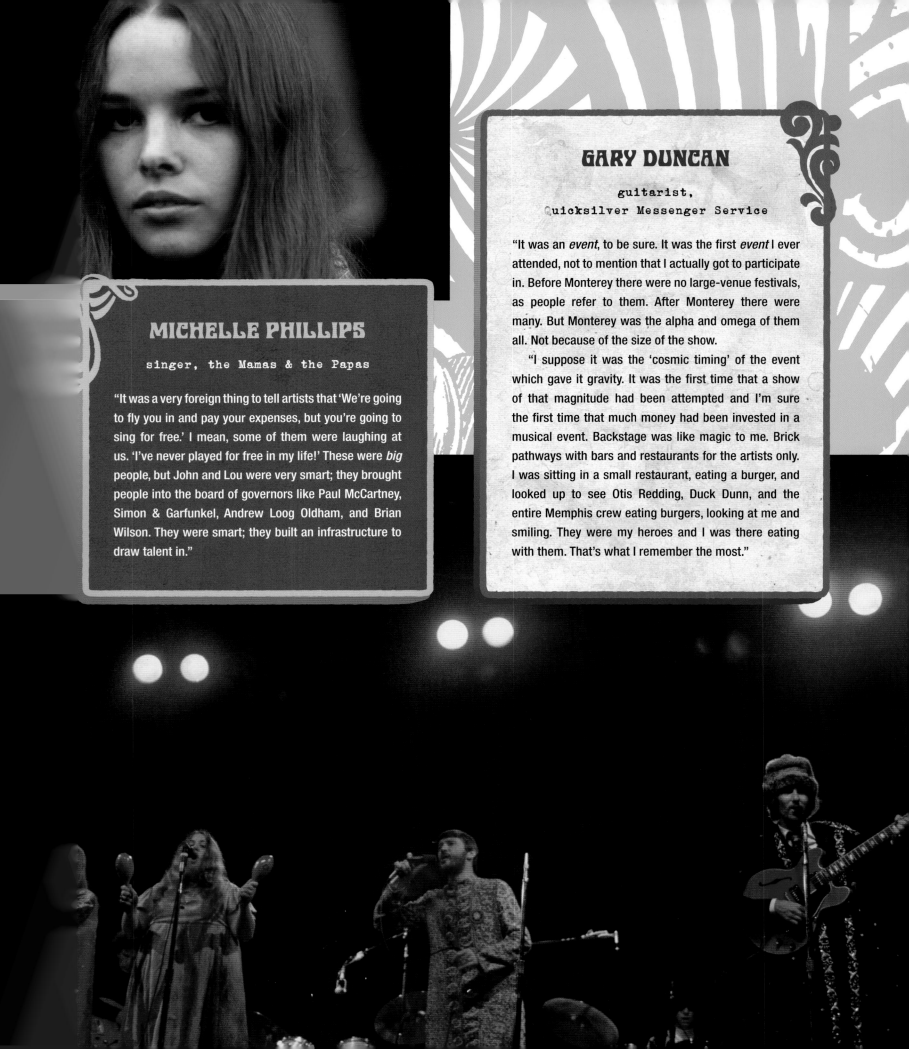

MICHELLE PHILLIPS

singer, the Mamas & the Papas

"It was a very foreign thing to tell artists that 'We're going to fly you in and pay your expenses, but you're going to sing for free.' I mean, some of them were laughing at us. 'I've never played for free in my life!' These were *big* people, but John and Lou were very smart; they brought people into the board of governors like Paul McCartney, Simon & Garfunkel, Andrew Loog Oldham, and Brian Wilson. They were smart; they built an infrastructure to draw talent in."

GARY DUNCAN

guitarist,
Quicksilver Messenger Service

"It was an *event*, to be sure. It was the first *event* I ever attended, not to mention that I actually got to participate in. Before Monterey there were no large-venue festivals, as people refer to them. After Monterey there were many. But Monterey was the alpha and omega of them all. Not because of the size of the show.

"I suppose it was the 'cosmic timing' of the event which gave it gravity. It was the first time that a show of that magnitude had been attempted and I'm sure the first time that much money had been invested in a musical event. Backstage was like magic to me. Brick pathways with bars and restaurants for the artists only. I was sitting in a small restaurant, eating a burger, and looked up to see Otis Redding, Duck Dunn, and the entire Memphis crew eating burgers, looking at me and smiling. They were my heroes and I was there eating with them. That's what I remember the most."

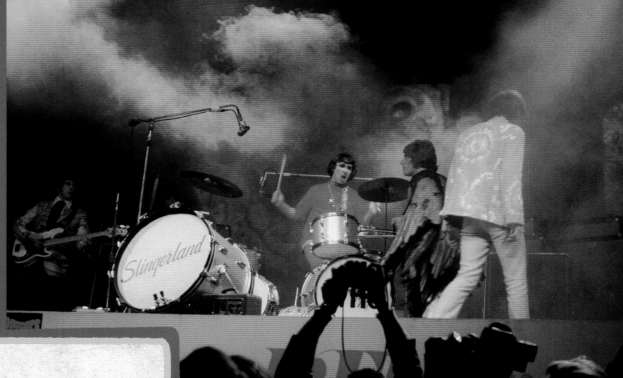

OPPOSITE: Portrait of Michelle Phillips, left, and the Mamas & the Papas performing, below, photographed by Henry Diltz at Monterey Pop.

RIGHT: The Who's raucous performance at Monterey Pop; photograph by Guy Webster.

BOB WEIR

"The first time we went to New York, I met Mark Dronge, the son of the guy who owned Guild Guitars, and we struck up a friendship. He knew that we were going to be playing at the Monterey International Pop Festival, and told me that he was going to be running a booth at the exhibition tent for Guild.

"I went by and found the booth, and he was trying to get together a little jam session. I don't remember everyone who was in the session, but there were two notables. One guy I didn't know or recognize—this black kid with a headband tied around his head. He came after I was plugged in.

"The guy I did know was Paul Simon, who was playing acoustic. I was playing electric and plugged into an amplifier the size of a small refrigerator. I motioned to Paul over the din in that tent that he should grab an electric and plug into my amplifier—there were two channels. But he said no, he was fine, and we would feel the vibrations. I took him at his word. Then the black kid showed up. He grabbed an electric guitar, and I still had that open channel in my amplifier, so he plugged the hell in. And we commenced to making quite a racket. After a little while, I crept up on the amplifier and started feeding my guitar back and the black guy thought this was a good idea, and started doing the same. It got pretty scary. I took down the hearing in my left ear, I guess permanently. It was worth it—it was a lot of fun. We struck up a friendship, although we were never formally introduced. The next day . . . I found out who he was for sure, although I think I'd figured it out the day before."

PETE TOWNSHEND

"We were pretty scared. We'd done a package in New York City with Cream, and it seemed as though we'd missed a beat. We were still displaying Union Jacks and smashing guitars while Cream played proper music and had Afro haircuts and flowery outfits. Jimi had already hit in the UK. . . .

"It was exciting to go to San Francisco for the first time, but also quite strange. The music industry people were pretty whacked out by LSD already in a way that hadn't happened in the UK.

"I remember Brian Jones, sweet as ever. Eric Burdon himself as solid as ever, at least face-to-face he was a good bloke. Jimi was out of his tree. Derek Taylor was frightened to come out of his little box from where he handed out passes.

"The beautiful people gazed at each other. Mama Cass was adorable. John Phillips was too. It was a nice vibe, as we used to say. But we were keen to stay true to our thesis, which was that this is a crock of shit and the war isn't over yet—we meant World War II, not fucking Vietnam. So to say the least we were slightly out of step. The Who was a pretty tough band to be in. I took my girlfriend; we hung on to each other."

Pop Festival

Kenneth Kubernik

"On the morning of June 5, 1967, Soviet Premier Alexei Kosygin reached for the hotline and placed an urgent call to the American president, Lyndon Johnson. Arab armies were massing around lowly Israel, threatening to drag the world's superpowers beneath the heat and dust of grievances, biblical and modern. Thousands of miles to the south and east, America lay stymied in Vietnam's suffocating highlands and oozing lowlands, the president pressured by the 'best and brightest' to double down on a losing hand. . . .

"And then we heard about this 'Pop Festival.' That had an odd ring to it, as 'pop' seemed as if it didn't take the music we loved too seriously. Everything pointed to being there or being left out of something important.

"The festival bill promised an amazing array of stars, some we recognized, others slightly mysterious. And it was to take place in a huge outdoor setting, over several days. This was a radically new concept to us kids raised on rock 'n' roll. We felt that this was our music, and nothing short of death could have kept us away.

"We had no money, no tickets or room reservations. We were

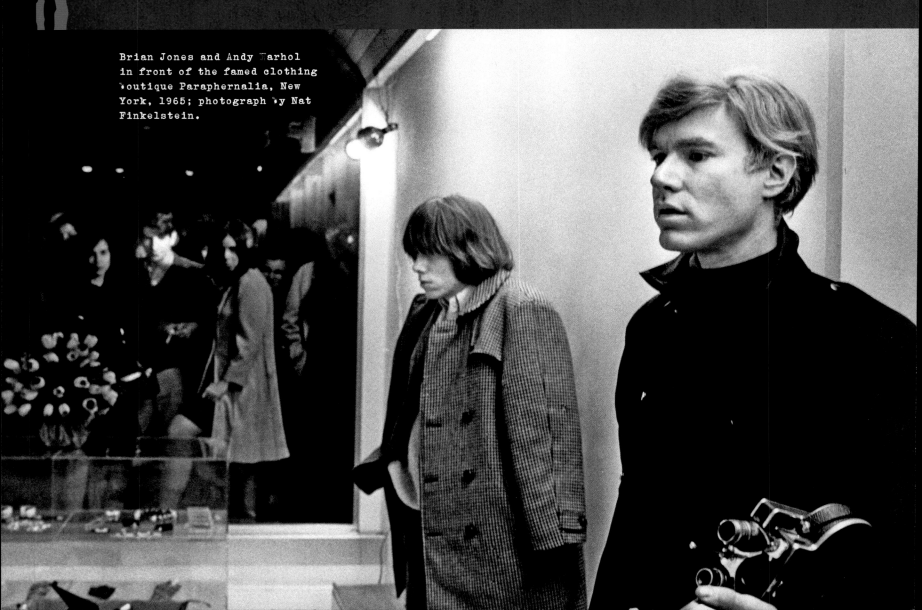

Brian Jones and Andy Warhol in front of the famed clothing boutique Paraphernalia, New York, 1965; photograph by Nat Finkelstein.

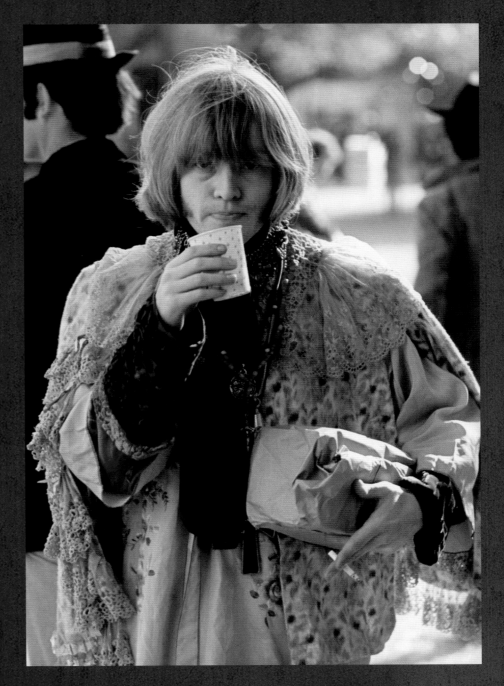

each like the Roy Neary character in the movie *Close Encounters of the Third Kind*; we didn't know why but we HAD TO BE THERE, as so many other young people did that summer.

"It was morning in the sixties, and that long-gestating desire to belong to something so ferociously bigger and better seemed tantalizingly within reach. . . .

"FM was no longer a radio signal; it was a state of mind, conjured under orange skies, on crystal ships, by charismatic Merlins like Rolling Stones founder Brian Jones. With an uncanny talent for serendipity, he was here, there, and anywhere an edge was being cut.

"He was with Dylan in the Village; with filmmaker Donald Cammell in Paris; with collage artist Wallace Berman and actor Dennis Hopper in Los Angeles; with literary/visual innovator Brion Gysin in Marrakech, and with Ken Kesey for the Electric Kool-Aid Acid Test. He was an iridescent 'Happening,' all by himself.

"In an interview with Keith Altham for the *New Musical Express* in October 1966, Jones observed that censorship is still with us in a number of ugly forms. But the days when men like comedian Lenny Bruce and artist Jim Dine are persecuted is coming to an end. Young people are measuring opinion with new yardsticks and it must mean greater individual

freedom of expression. Pop music will have its part to play in all this.'

"In June 1967, Jones boarded a flight from London's Heathrow Airport destined for a quaint waterfront community renowned for its jazz festival and its portrayal in the work of novelist John Steinbeck.

"Accompanied by an unknown black American guitarist scheduled to make his U.S. debut, Jones, the high priest of King's Road, Chelsea, was departing for a place uncharted even by his own psychotropic reckoning. He was destined for Monterey."

Jann Wenner, a recent graduate from UC–Berkeley who had already positioned himself in the vanguard of young journalists intent on chronicling this restive youth movement, wandered like a cub reporter backstage, soaking up all the ambiance with a questing eye. *Rolling Stone* magazine was born that weekend, its first issue out in the fall. Wenner recalled: "This was the first time I saw a lot of people of many groups of all kinds wandering around, smoking, shooting the shit, drinking, obviously a copious amount of drugs around, and just relaxed. Everybody kind of meeting each other for the first time and being in this kind of wonderful setting I kind of remember backstage to be.

"There was a spirit of camaraderie and fellowship. That was the first time that really surfaced at that scale. You had that feeling that the community and the people were joined as one. 'Game changer' is kind of a recent word but [it was] a major step forward. A major evolutionary point. A new plateau, a new kind of thing. All those things, yes. It hadn't been done before."

TOP RIGHT: Ted Bluechel Jr. of the Association on guitar at the festival; photograph by Henry Diltz.

OPPOSITE TOP: Laura Nyro, backstage at Monterey Pop; photograph by Guy Webster.

OPPOSITE BOTTOM: Scott McKenzie, singer of the iconic John Phillips song "San Francisco (Be Sure to Wear Flowers in Your Hair)," spring 1967; photograph by Guy Webster.

TED BLUECHEL JR.

multi-instrumentalist and vocals, the Association

"The Association opened the festival. We were a little bit outside the fold of looking like what most of the artists looked like during that time. We tried to wear three-piece suits and had harmonies.

"High points? Simon & Garfunkel were their usual incredible selves. I loved the way Paul plays guitar. He has the ability to play as an orchestrator.

"Once you listened to the songs on their records and then see it live, it takes you away to a lot of those moments when you are sitting around alone listening to their songs and it takes you someplace."

RIGHT: Simon & Garfunkel at Monterey Pop; photograph by Henry Diltz.

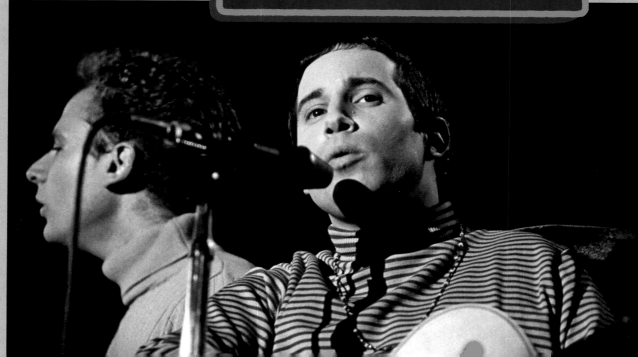

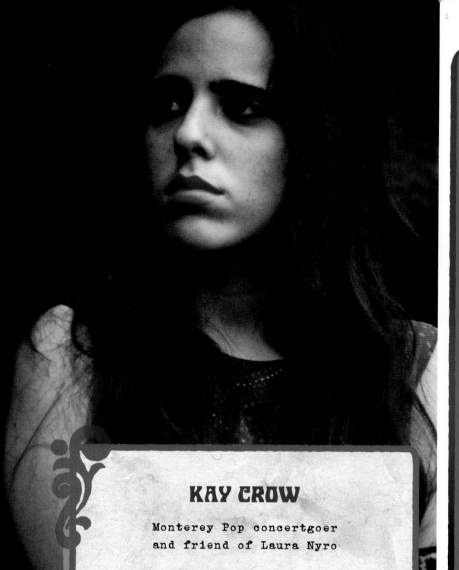

SAM ANDREW

guitarist, Big Brother
& the Holding Company

"I had a lot of fun playing at Monterey, but I must note that the two sets we played there were not the best we ever played.

"Of course the big story for us was the introduction of Janis to the big world. Some of those big-time Los Angeles professionals suddenly knew that they were in deep water when they heard Janis sing 'Ball and Chain.'

"At Monterey we heard a door opening into a whole new world. What had until that time seemed to be a very small scene of people trying to find a way to a new and more just life was now shown to be an international movement. Monterey was where literary San Francisco met hedonistic Los Angeles and both sides won.

"We had a clear idea about what was going to happen there when we signed up for the festival. Monterey was John Phillips deciding that he was going to package that crude San Francisco sound and sell it, Los Angeles–style, to the world. He wrote the theme song ['San Francisco (Be Sure to Wear Flowers in Your Hair')] to the event, which Scott McKenzie sang. This is a typical story. Two people who had nothing to do with San Francisco writing a sugary tune that was not experimental, new, energetic, or revolutionary about a scene that was all of these. Am I glad that Monterey happened? Oh, yes. Thank you, John."

KAY CROW

Monterey Pop concertgoer
and friend of Laura Nyro

"I was in the third or fourth row when Laura Nyro appeared. I do remember the audience was not familiar with her. I wasn't either. The audience was not entirely full at the beginning of her set.

"Then I heard her sing 'Wedding Bell Blues.' She had a 'kick' to the song that caught me right away. I enjoyed that. So did the audience. . . . When I heard 'Poverty Train' it got real quiet. The tempo changed and so did the mood. It was raw.

"Honestly, I think she took everyone by surprise. Most of us in the crowd were, in my opinion, mesmerized from her nontraditional style. Her appearance. She was beautiful. Long black hair, black dress on a dark stage at night. She was vulnerable and exposed, and it seemed the venue was out of her element. But she pulled off a great performance and got cheers from the crowd.

"Although many have claimed Ms. Nyro was booed at the end of her performance, this is simply not true. People were talking about her and asking around if they knew anything about her. She was basically unknown, but so was Janis Joplin until many of us heard her sing."

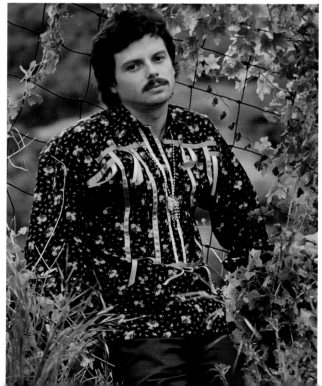

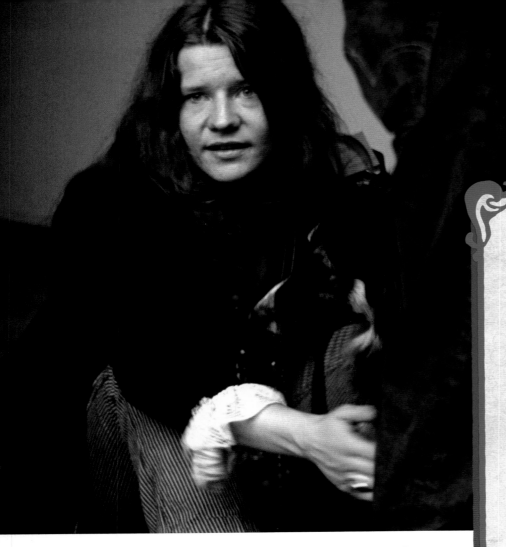

ROBERT MARCHESE

record producer

"I saw Janis before and after her set. She came up to me and I told her to wait until [manager] Albert Grossman saw her. I said to him, 'Well, what do you think? Ten million?' He just busted up. He was standing with that shit-eatin' grin. I liked her and loved the band. I liked Sam, and I loved Jim Gurley. I thought Gurley at the time was the greatest one-note psychedelic guitar player. I thought as long as she was with them she would survive."

JOEL SELVIN

"The thing was the backstage drama: Janis versus the rest of the band. It came as a big surprise to everybody. They had been living in this hunting lodge in the wilds of Marin as a commune. The girls sat around and strung glass beads. It was a very all-for-one-and-one-for-all thing. Nobody had any idea that Janis wanted to be a star. And I don't know if Janis did. Until after that first performance. You know, she wasn't in the center of the stage with Big Brother. Grossman undermined that whole Janis thing. He talked to her backstage. [At first Janis and the band did not want to be filmed. After their first set was so well received, it was decided that they would do another set later, which was filmed.]"

D. A. PENNEBAKER

filmmaker

"Janis Joplin, Big Brother & the Holding Company were the one thing we were told we couldn't shoot for the film [*Monterey Pop*, documentary released 1968]. Although I did shoot a little, but Grossman said, 'I'll pull her the minute I see a camera going on her. All the cameras have to be pointed at the ground.' We went through a whole big drill and it got me really intrigued, you know, with this going on, and then when I heard her, the first song, 'Combination of the Two,' and I said, 'Jesus Christ. . . . This is impossible.' So I went to Albert and I said, 'Whatever it takes. I mean, we got to get her.'

"So he disappeared, and the next thing I knew she came out and she said, 'Oooh, I'm gonna do it again and you can film me this time.' So we did.

"Janis was the staggering thing I saw on the whole show to me. Because I had never heard a woman sing like that. I told her afterwards, 'You're the best female rock singer I've ever heard in my life.' She looked me up and down, smiled, and said, 'You get out much, honey?' . . . I thought it was funny. She was very friendly. I liked her."

—KEITH ALTHAM

AMY BERG

film director,
Janis: Little Girl Blue

"Monterey was her coming-out party. That was her moment. Janis loved being on stage. Everything was based on emotion with Janis. She kicked the doors open, allowing others to follow. There is so much more to Janis."

LAURA JOPLIN

Janis Joplin's sister

"Janis had such good music instincts: She knew what she wanted and where she wanted it. Janis appreciated her audience and her ability to create that. She was creating her sound."

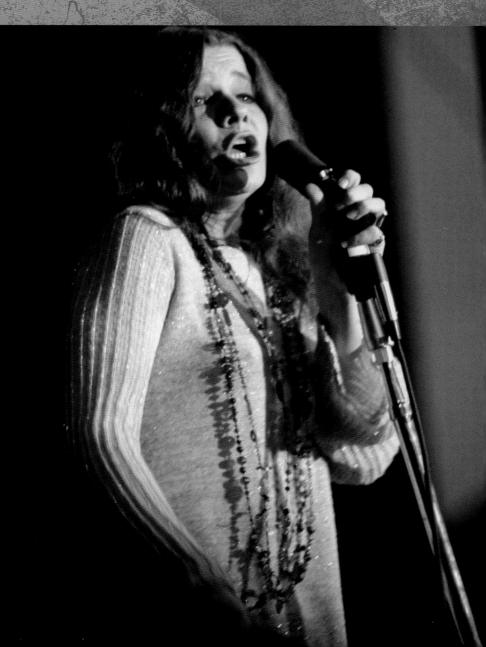

Janis Joplin belting out her groundbreaking version of "Down on Me" at Monterey Pop, captured by Guy Webster.

Jerry Heller is the booking agent who guided the careers of Marvin Gaye, Canned Heat, Van Morrison, and the Standells and later arranged the Pink Floyd and Elton John debut American tours. When he worked for Associated Booking in Beverly Hills, he handled Otis Redding and attended the Monterey International Pop Festival.

JERRY HELLER

"Monterey was the first festival I had gone to, but I had been dealing for a couple of years with Claude Nobs at the Montreux Jazz Festival and George Wein at Newport.

"I was handling Otis and just met him through Phil Walden, a colorful character, who was his manager. Good guy. Several agents went to Monterey. Phil was a fabulous manager. I had never seen Otis live before—only on film from the Olympia Theater in Paris. And Otis was a big man. He was like Aaron Neville. He could just blow you away with his sheer power and intensity of his voice and his lyrics. I've never seen anything like it at Monterey. The reason I was at Monterey with Otis was that I said to Joe Glaser, my boss at Associated Booking, 'This guy can be a major, major pop star. This guy can be a big rock 'n' roll star.'"

WAYNE JACKSON

trumpeter, the Mar-Keys

"We [The Mar-Keys] were in a hotel room rehearsing with Otis for Monterey, and the question of tempos came up. Because tempos had been an important question in Europe. Al [Jackson] said in Europe, 'They were pretty darned fast.' And that was all up to Otis. 'I want to keep them up. I wanna keep 'em jumpin'. I want to keep them up there and hook 'em.' And he knew the songs were better for a live crowd fast because they would jump. Boogie a little harder. The Stax thing was a dance groove and it's not fast. At Monterey, when we were done, they kind of forgot about Jefferson Airplane. And Otis was the man. He really knocked them over. That was a mind changer."

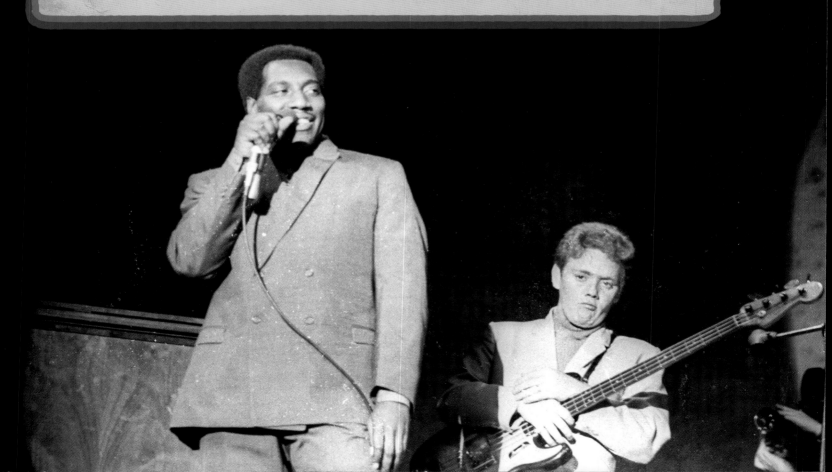

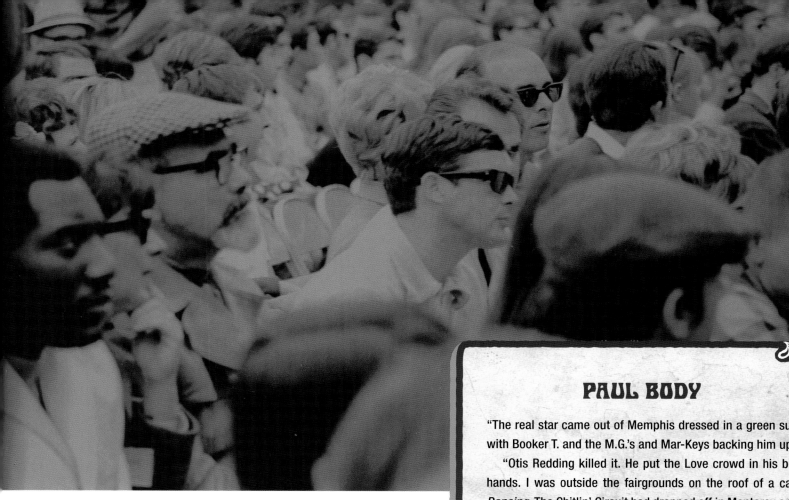

ABOVE: Otis Redding (far left foreground) and producer Jerry Wexler (in plaid cap to Redding's right) in the crowd at Monterey Pop; photograph by Howard Wolf.

"Otis's show nailed that audience of hippies and weedheads in a way that was astonishing to me because that was not his core audience."

—JERRY WEXLER

PAUL BODY

"The real star came out of Memphis dressed in a green suit with Booker T. and the M.G.'s and Mar-Keys backing him up.

"Otis Redding killed it. He put the Love crowd in his big hands. I was outside the fairgrounds on the roof of a car. *Dancing*. The Chitlin' Circuit had dropped off in Monterey and you could almost hear the barbecue sizzling while Otis was playing.

"At this time Otis was on the charts with the *King & Queen* album, the one he did with Carla Thomas that was produced by Jim Stewart, Isaac Hayes, and David Porter. Just back from Europe and he took a page out of Sam & Dave's book—everything was played at lightning speed.

"Taking about Otis and Carla, man, that is one of the greatest duets albums ever done. Their version of 'Tramp' rolls Memphis deep. Carla Thomas matched him pound by pound."

MARTY BALIN

"For me a highlight of the Monterey Pop Festival was Otis. I had been around and he knew who I was. We went on before he went on. And nobody got the crowd moving, but when the Airplane came on we got the crowd moving. We got them excited and got 'em up and dancing.

"I walked off and Otis Redding was standing there and he said, 'Hey man. It's a pleasure to be on the same stage with you.' For me, that was it, baby. Right there. He staggered the crowd."

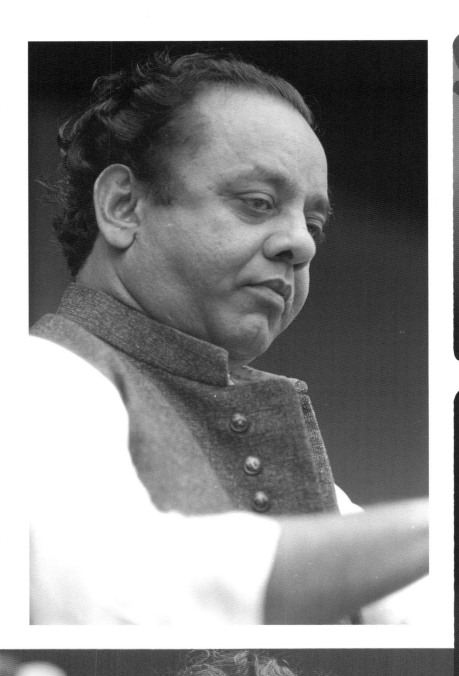

AL KOOPER

songwriter, record producer,
multi-instrumentalist

"Ravi Shankar. My one little thing about his great set. I was sitting in the audience with another artist. And I'm getting an education because I don't know much about it. Don't know much about him, just picked up on him through the Beatles. Like everybody else.

"Watching the musicianship between Alla Rakha and Ravi Shankar killed me. I thought that was amazing when they were trading passages."

RAVI SHANKAR

"On Sunday afternoon, we set up a special section between 1:00 and 3:00 p.m. where there would be no one in front of me and after me. It was cloudy, cool, it had rained a little, and that's when I played and it was like magic. Jimi Hendrix was sitting there. [Jerry] Garcia was there."

"It is one of my memorable performances. I didn't plan for this. I was grateful to God that I was sitting in the atmosphere without anyone disturbing me. It drizzled for a few minutes and then it stopped. So, it was cloudy and there were flowers from Hawaii and, you know, what atmosphere!

"After my set, it was crazy. I have never felt such a commotion of this sort. I was so pure, in spite of the fact that there were many people who were also strong. But it didn't matter, because the whole atmosphere was so clean and beautiful and I could give my best."

Henry Diltz photographs
of Ravi Shankar (left)
and Alla Rakha (above)
at Monterey Pop.

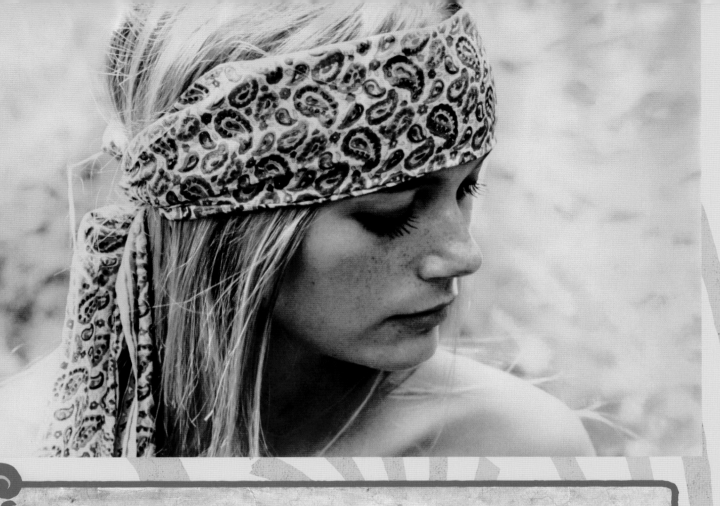

GUY WEBSTER

photographer

"I was the staff photographer at Monterey. What an event! I saw Brian Jones with Nico.

"I knew her from the Velvet Underground and I hung out with her and Brian. We watched Ravi Shankar. I would later do Nico's album cover for *The Marble Index*.

"I had already taken album cover photos for some of the acts at Monterey. Simon & Garfunkel, the Byrds, and the Mamas & the Papas.

"I took a lot of modeling photos of Peggy Lipton, before and after she starred on *The Mod Squad*."

PEGGY LIPTON

actress

"Monterey reached its climax for me that early afternoon. There was a light drizzle and we went to hear Ravi Shankar. I remember I left my body. That was it for me. It was beautiful, peaceful, and chilled everybody out. Ravi transported me. It was gently raining and he transported everybody. We were all taken there. Hearing Ravi Shankar . . . it was like we were put on a spaceship and driven to another planet."

ABOVE: Portrait of Peggy Lipton by Guy Webster, spring 1967.

RIGHT: Monterey Pop bumper sticker.

Music, Love and Flowers
MONTEREY INTERNATIONAL POP FESTIVAL

Jimi Hendrix and the Who

When asked about his experiences at Monterey Pop, Pete Townshend recalled his feelings about Jimi Hendrix: "We [the Who and the Jimi Hendrix Experience] were both competitive. He felt like something of a newcomer, and standard-bearer for black blues, I think—that he may have felt had been plundered by the British sixties bands. But he and I debated about who should go on first. I felt he was a master, a genius. I was not prepared to follow him, not because I was afraid to follow him but because in my old-fashioned showbiz mind the best artists go on latest in the set.

"In the end we tossed for it, and Jimi lost. We went on first; he then announced that if we preceded him, and set the crowd alight with our destruction act, he too would set them alight. So the crowd got two mind-fucking sets."

"I didn't see anyone at Monterey," Roger Daltrey adds. "We were just ushered in and put under the stage a couple of hours before we went on. And then we were kind of escorted out after the set. They weren't best with us because we broke the equipment up and they were very worried about their microphones and all that kind of stuff. [Laughs.] It was

quite funny and we weren't allowed or welcomed to stay. [Laughs.] We reminded them that this world was in a shit state, it wasn't peace and love at all. [Laughs.]

"In August 1965 we played Richmond Jazz Festival with Solomon Burke—a tiny affair with a tent and a cricket pitch. . . . There was a lot of camaraderie at Monterey with the bands, because we didn't know what we were doing. Any of us. No one had written the rules."

BELOW: The Who at Monterey Pop, in iconic guitar-smashing mode; photograph by Henry Diltz.

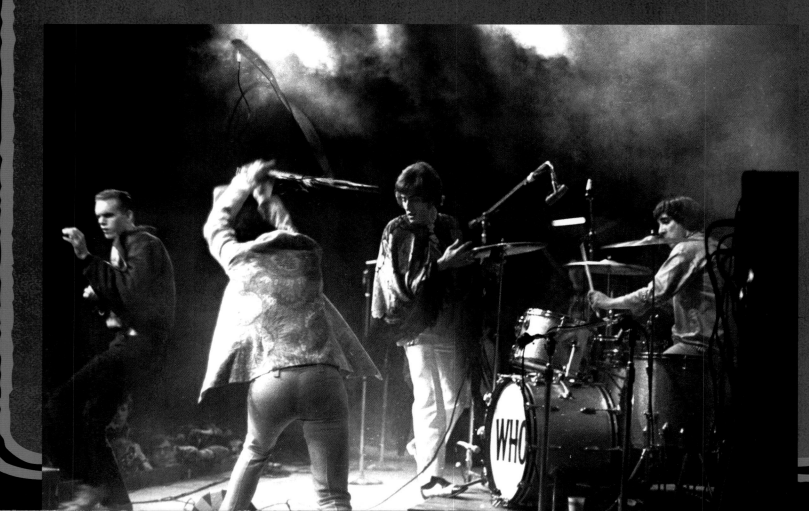

> **"The Who were instrumental in introducing to the American audience the new wave of aggression coming out of the UK. When the Who were done performing, it looked like the aftermath of Saturday night in Kabul."**
>
> —ERIC BURDON

JAMES CUSHING

"Minutes into his set at Monterey, Jimi Hendrix was no longer a complete unknown. Before the event, he could walk around the Monterey fairgrounds pretty much unrecognized; after he got on stage, he couldn't do that.

"It was *A Star Is Born*, 1967 style. Not showing how well you could fit in to the conventions of show business but showing how well you could wrestle those conventions of show business into an act of radical self-expression. The set was partially rhythm-and-blues hucklebuck and partially complete originality, and the blend of them combined with the audaciousness of the moment.

"He opened with 'Killing Floor.' There's a terrible poignancy to that because the last concert he ever played [Isle of Fehmarn Festival, Germany, September 6, 1970], he also opened with 'Killing Floor.' So his first important show and his last show ever, he opened with a Howlin' Wolf classic that has the idea of death in the title. There's a tragic meaning to that opener that nobody could possibly have been aware of."

RIGHT: Jimi Hendrix setting the stage on fire at Monterey Pop; photograph by Guy Webster.

> **"One guy in the press pit with me said after [Jimi] finished, 'What the hell was that?'"**
>
> —KEITH ALTHAM

According to the Animals' Eric Burdon, "The Monterey arrival for Jimi Hendrix was a homecoming. This West Coast Seattle native knew that he had to create an earth-shattering statement to introduce his Reprise Records album in America while simultaneously living up to all the plaudits that he had been receiving in 1967 from his peer group in England."

"Nothing like coming out to Monterey and playing to a large crowd," says journalist Keith Altham. "Probably the largest he'd ever played, too. And seeing that kind of groundswell of interest in progressive rock music gave him hope for the future and an indication perhaps of the direction he might be able to take the music.

"I think, although there wasn't a road to Damascus at Monterey, I think he felt that it was yet another step up the ladder. He knew that was a foot in the door. I don't think it broke Jimi in America. I think it put a foot in the door and brought him to the attention of the mass media in America, and indeed to television and radio exposure, which he had not had yet."

"I wasn't aware of the record business, or music scouts at Monterey, either. We just came to have a good weekend and play, basically. No chains."

–PAUL KANTNER

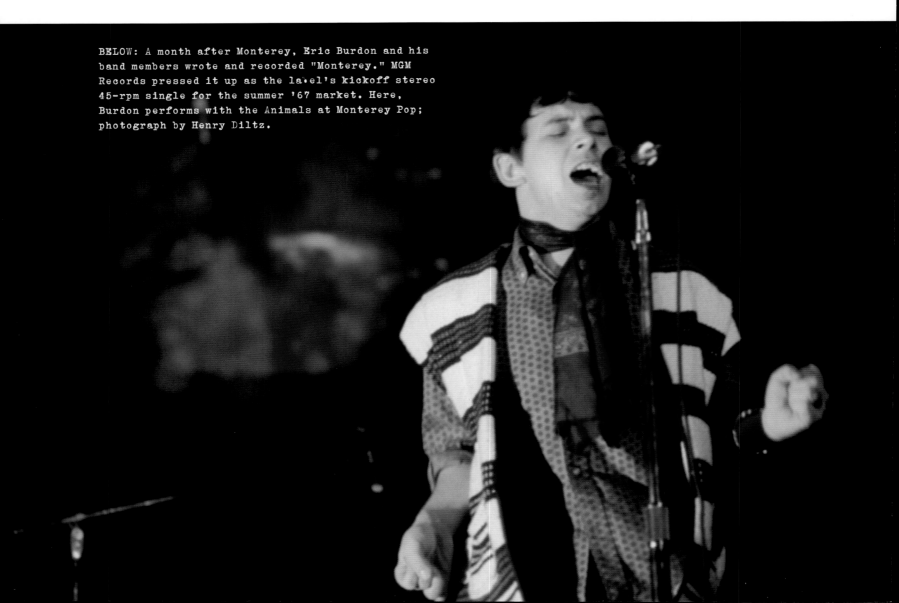

BELOW: A month after Monterey, Eric Burdon and his band members wrote and recorded "Monterey." MGM Records pressed it up as the label's kickoff stereo 45-rpm single for the summer '67 market. Here, Burdon performs with the Animals at Monterey Pop; photograph by Henry Diltz.

CYRUS FARYAR

singer/songwriter and record producer

"Each of us in Group With No Name were impacted [by Monterey Pop] in a certain way.

"The overriding feature of the whole experience was that we were in a situation where there was no judgment. Everybody was there to have a wonderful time. All of the performers gave their all and had a wonderful time. And there was nobody standing in judgment of any of it. There was a spirit of appreciation for the whole event. Whether we were significant or not or contributed noteworthy or not really doesn't matter. We were there. Just like the people in the seats. We were all karmic friends."

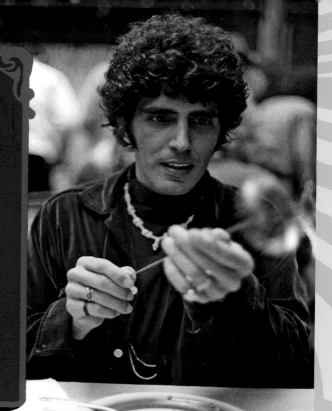

ABOVE: Singer Cyrus Faryar dining backstage at Monterey Pop; photograph by Henry Diltz.

JIM YESTER

vocals, guitar, keyboards,
the Association

"I felt it was a big step in healing the rift between the L.A. and San Francisco bands and it was very cool. I thought it was a great unification thing for all the California groups.

"Monterey was not a cultural sidebar to the 1967 Summer of Love. It was the pivot point of the Summer of Love. It was a pivot point for every act on stage and everyone seated or standing around that seventy-two-hour 'found weekend.'"

PETE TOWNSHEND

"Others may remember it differently. I couldn't see how the Grateful Dead, Janis Joplin, or Country Joe could be taken seriously. Their sound was so ragged, so raw. I was used to a slicker sound. Now I see better what they were doing, and just like the Who it was not just about music, it was about message and lifestyle and change. The three bands I mentioned all had manifestos that were not just about the music. It took me a while to understand that."

JOEL SELVIN

"It was the second weekend of that summer. It was the moment where everything that the Summer of Love sort of came to represent really actually, in a little petri dish, you know, happened.

"Country Joe and the Fish had not been outside of the Bay Area by then. I would think his first album was about to drop by then, or a little later in the summer. Sam Charters had already signed them. They had already done an EP of 'Section 43' that had sold like 10,000 copies in one bookstore in Berkeley. This would be a good thing to move forward with in the record business already.

"Monterey was really a big day for Joe, and being included in the Pennebaker-directed *Monterey Pop* movie was important. The music was fresh. I saw the Monterey International Pop Festival in the long run as the ascendancy of underground rock over Top 40 rock right that weekend."

CLIVE DAVIS

"I really came to Monterey not knowing what to expect, but seeing a revolution before my eyes that became evident.

"All of a sudden seeing Hendrix, Janis Joplin and Big Brother & the Holding Company, and the Electric Flag, and the artists that were there, there was no question that the predominance there was a change in contemporary music. A definite hardening, edgier, rockier amplification that was taking place that truly was signaling a major revolution in rock music.

"The success of the artists I signed at Monterey gave me confidence that I had good ears. I had no idea I had 'ears.' Monterey is without question probably the most vivid memory from a career point of view, from an emotional point of view, from a character point of view, that I've ever had."

Janis Joplin and Big Brother & the Holding Company at Monterey Pop; photograph by Howard Wolf.

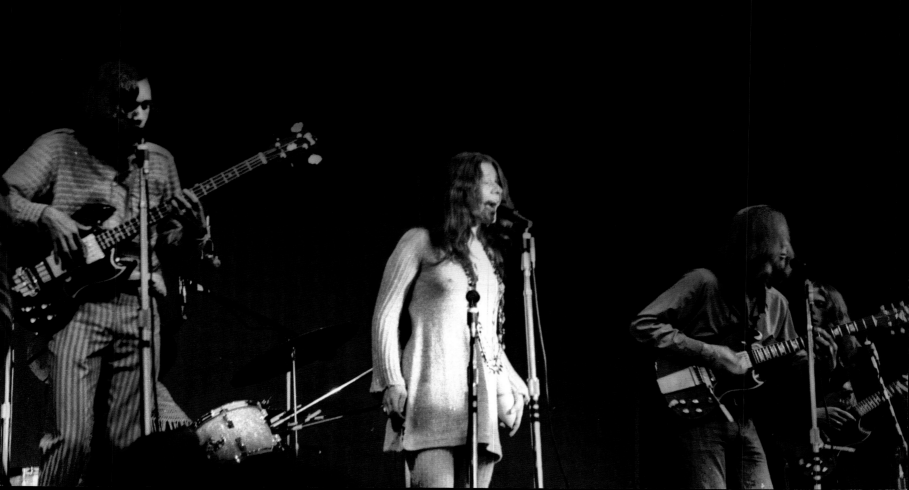

While the audience was feasting on a bounty of musical delights, the music industry vanguard was also listening within earshot. Among the various movers and shakers in attendance were Goddard Lieberson and Clive Davis of Columbia Records (who snared Janis Joplin), Atlantic Records's Jerry Wexler, Richard Delvy from MGM music, World Pacific's Dick Bock, producers Richard Perry and Jim Dickson, Joe Smith from Warner Bros. (who already had drafted the Grateful Dead), and Elektra Records' visionary leader Jac Holzman.

JERRY HELLER

"I think Monterey said to the suits, 'This is the future; you guys better get on the train or you'll be releasing records by jazz acts.' So, Monterey not only was a springboard for acts but a springboard for executives. Remember: It was a nonprofit, and those of us on a different level said, 'OK. Why can't we do this and make money?'"

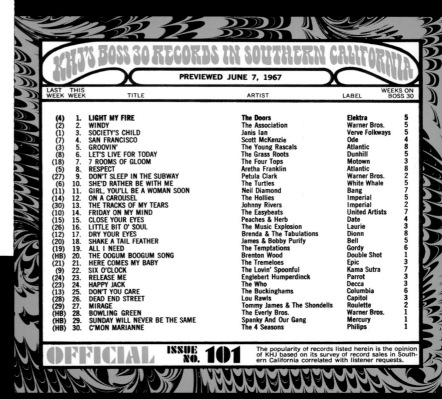

The Doors's "Light My Fire" at the No. 1 spot on the KHJ Boss 30 Records in Southern California chart, the week of June 7, 1967.

"I didn't sign anything [at Monterey Pop]. I had expected the Doors to be invited, but they weren't. But they pissed off everybody anyway because their song 'Light My Fire' was No. 1 in L.A. . . . I thought it was great putting together so many disparate acts and having it blend majestically. The mood was triumph. Rock 'n' roll was here to stay."

—JAC HOLZMAN

Monterey provided the happy ending everyone has pretty much forgotten about. That mystical June weekend let people know there was an audience for bands that in no way fit the operative models for what bands should be like. These were not groups that wore uniforms and tried to be entertainers. This change was not a local thing, but one that happened throughout the Western world, the English-speaking world. Everything was becoming more integrated and blended.

JAMES CUSHING

"The Monterey festival has a much longer and richer and more interesting history behind it than most people had ever seen in print before.

"There was this mixture of trust and suspicion, and warmth and hostility, and the welcoming and the protectiveness between the Los Angeles and San Francisco music scenes. Which added to a drama that was there in the festival, which the music perhaps participated in in some ways. The whole battle between art and commerce was represented."

PETE TOWNSHEND

"It made the Folk Festival and the Jazz Festival format available to pop and rock. Today that is clearly a good thing. Audiences get far more from congregation today than they did when there was no Internet and very little great rock or pop on TV.

"And was there also a flip side? For instance, was it the beginning of off-the-peg hippie culture and—with the major labels swarming over the event—the beginning of the rock 'business' generally? Maybe. . . . The rock 'business' may have been less fun than hippies running their own parties, but at least it allowed ordinary people to be a part, to play a part, and to fit that engagement into their ordinary, responsible working and family lives. Not everyone is a rebel, but that doesn't make them a worm."

ANDREW LOOG OLDHAM

"The festival was incredibly busy, productive, life-changing, exhilarating, and relaxed; I do not think that ever happened again. The focus was incredible; the mission was God-given. We had never been given that type of responsibility before and there was no way our side was going to be let down. Monterey Pop gave service; it still does. I remain oh so proud I was there and was a small part of it. Otis, the Who, Jimi Hendrix—every time I think of the music I remember the sea of faces and the rhythm-of-one of the crowd. These white kids in the audience were in school. We all grew from the diversity presented in those three days."

BELOW: Jerry Garcia and Mountain Girl in the audience at Monterey Pop; Mountain Girl holds her daughter with Ken Kesey, Sunshine. Photograph by Henry Diltz.

MICHELLE PHILLIPS

"But you know what, the Monterey International Pop Festival Foundation fund is still generating hundreds of thousands of dollars. It keeps on giving every year. And it's been managed really well, and you have to give Lou the credit because he has been the one in charge of it. He's been in charge of the money. It's a beautiful thing."

JERRY GARCIA

"I think the United States [in 1976] has changed very visibly in the last ten years. A lot of it had to do with what happened in San Francisco. I really think the scene out here created the possibility for Woodstock to happen. The Monterey International Pop Festival. The thing, the activity, music, and people."

It All Seems Like a Dream to Me Now: Magic Mountain and Making a Concert Poster for Jimi Hendrix

Dennis Loren

"On the evening of June 19, I was hanging a Youngbloods poster I had done for the Matrix on Haight Street. On one corner, I began talking to some Diggers. These guys were really informed about upcoming events in the neighborhood.

"They talked about this 'super cat guitar player' named Jimi Hendrix that had just wowed everyone down in Monterey. They told me that he would be playing with the Jefferson Airplane and jazz guitarist Gábor Szabó at the Fillmore Auditorium all week [June 20–25, 1967].

"They said Jimi was planning to play in the Panhandle during the day of the twenty-fifth and they were going help with the staging. At that moment, it struck me that I should do a poster. I could do just what I had just done for the Matrix. I asked them if they thought it would be all right to make a poster for this event. One of them said, 'Hey man, it's a free concert and you're free—do it, and if anybody asks you who you're doing this for, tell them the Diggers. Besides, Jimi will love it.'

"I had heard 'Purple Haze' on the radio, so I was already aware of Hendrix's music. The real question was, could I do it in time? I had only two or three days at most to draw, design, and get the poster printed. Was it even possible? I would give it my best shot and maybe things would fall into place.

"I gave most of the posters to the Diggers to distribute who had befriended me a few days earlier. I kept about thirty-five copies for myself and to give to friends. I hung about a dozen of those in the Richmond, Cow Hollow, and Marina districts. On Saturday, the concert in the Panhandle was great. My Digger friends introduced me to Jimi and the Experience band members."

LEFT: Poster designed by Dennis Loren for the Jimi Hendrix Experience concert at Golden Gate Park on June 25, 1967.

The Monkees's *Headquarters* occupied the No. 1 position on the LP charts the week of June 24. It was their third album and the first with substantial songwriting and instrumental credits by the group. "Shades of Gray" was a highlight. Written by Barry Mann and Cynthia Weil, it was unusual in that the lead vocals on the recording were shared by Davy Jones and Peter Tork. Says Mann, "We had very little contact or relationships with the Monkees. We just didn't want to be part of the scrambling that went on to have them cut one of our songs. We didn't write the songs for them that they recorded. 'Shades of Gray' was a kind of a Byrds song. That's what the demo felt like."

TOP RIGHT: Peter Tork of the Monkees at RCA Studios, Hollywood, 1967; photograph by Rick Klein.

RIGHT: Monkees producer Chip Douglas of RCA Studios, 1967; photograph by Henry Diltz.

GARY PIG GOLD

"Bright and very early Monday morning, January 16, 1967, Michael Nesmith, Peter Tork, Micky Dolenz, and Davy Jones finally decided to take Monkee matters completely into their own hands. *That* was the day, armed only with three brand-new songs and a Nesmith-anointed ex-Turtle, Chip Douglas, as producer, the freshly liberated quartet began work on what was not just perhaps *their* greatest long-player, but one of that ultra-heady year's absolutely finest audio achievements, period.

"*Headquarters*, as the album became globally known upon release seventeen weeks later [May 22, 1967], can stand as a gigantic accomplishment for *any* band anywhere, let alone for four young singer/actor/musicians whose work before the microphones up to that point had consisted primarily of slapping vocals onto pre-recorded tracks tailored for use beneath Beatle-like 'romps' on *The Monkees* television series. *Headquarters* . . . is not only the stark, dazzling, yet somehow still-wholly-Monkee-around sound of a band finding their sonic legs within RCA's Hollywood studios but—in retrospect especially—an album, thanks in the main to Nesmith's pedal steel, which veers boldly towards that nascent 'country-rock' pigeonhole in ways *Sweetheart of the Rodeo* (still a year into the future, by the way!) should immediately bow down to. . . .

"But, it should be noted here, *no* tracks from *Headquarters* were ever extracted for North American single release; like the Beatles' *Rubber Soul* before it, the third Monkees LP required no Top 40 assistance whatsoever up the charts and was allowed to remain an entity utterly and purely unto itself. . . .

"Alas, after its release, *Headquarters* was allowed but a brief single week atop the *Billboard* album charts (incredibly, the Monkees had already been at No. 1 there for a record 31 of the previous 32 weeks!) before *Sgt. Pepper* came to town, bumping our heroes down to 'only' No. 2 for the next three months. Nevertheless, nitpicking chart and sales data aside, *Headquarters* remains at least one Monkee's fondest of musical memories—yep, all Peter Tork had ever really wanted was to be one quarter of a fully functioning, all-hands-on-deck band—and in *my* record collection, at least, still gets, and deserves, much, much more regular play than that great big Day-Glo Beatles juggernaut from the Summer of Stereophonic Love. So there!"

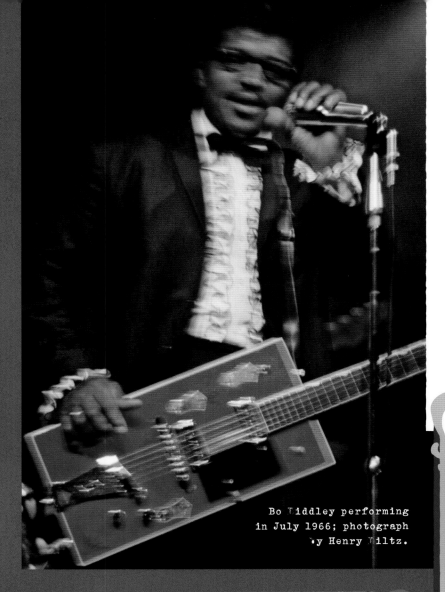

Bo Tiddley performing
in July 1966; photograph
by Henry Tiltz.

No matter how far rock music drifted into the cosmic ether, the muscular underpinnings of the blues—Southern-fried, Chicago-seasoned—remained at its core. For every sunshine superman singing songs of love, there was some blue-jeaned young white boy blowin' harp like the bastard kin of Little Walter, coaxin' that train into the station.

The Monterey International Pop Festival featured no fewer than five hard-down blues bands.

On some turntables in 1967 and in rotation at R&B radio stations and brave FM channels were blues LPs, especially *Super Blues*, a studio album showcasing Bo Diddley, Little Walter, and Muddy Waters. Ralph Bass, known for his work with James Brown, produced it for Chess Records, with Marshall and Phil Chess credited with supervision.

GENE AGUILERA

"As the stoic. blues Chess gods named Muddy Waters, Howlin' Wolf, and Willie Dixon were hitting on all cylinders in the Summer of Love, out comes this young cat out of Chicago named Magic Sam.

"He was a hidden ace that played a new kind of edgier blues and dressed much hipper than the old suits. In the magical year of 1967, Delmark Records released *West Side Soul* (the side of town for cool juke joints), adorned with psychedelic lettering on the cover, intentionally appealing to white blues fans and hippie rockers alike.

"This album heralded in a modern electric sound totally drenched in reverb, and you couldn't help but feel a changing of the guard. You know, there's nothing pretty about the blues . . . it's raw, down, and dirty, but I love it."

MARSHALL CHESS

"I have always considered Bo Diddley to be one of the most creative, innovative, and original of all the Chess artists. From his custom guitars that he built himself to his constant searching for new sounds, he has influenced many recording artists with his originality. He was not afraid to take chances with his music. Chess Records was the perfect place to be, as we were not afraid to experiment with new sounds and ideas. Both Bo and Chess were always ready to push the envelope.

"Little Walter is the truest genius of all the Chess artists, because he invented and perfected a new way to play the harmonica, and did it with tremendous creativity and talent. Very much like Hendrix with the guitar. They're exactly alike. Miles Davis considered Walter a genius. Hendrix considered Walter a genius.

"One of the secrets of the Chess studio was not the studio but our mastering. We had a little mastering room with a lathe. Eventually we had a Neumann lathe. The first one was an American one. We did our own mastering and had these Electro-Voice speakers on the wall. The great part about that room is that when it sounded right in that mastering room, it would pop off the radio. That's what it was all about. And the Rolling Stones, the Yardbirds, and later Fleetwood Mac had to make visits there."

"**Muddy on stage and in the studio was the best. He was organized. He was a fuckin' leader. I always say this. . . . Muddy was the reincarnation of a tribal chief, of a president, of a king. Such a powerful presence. I just loved him.**"

—MARSHALL CHESS

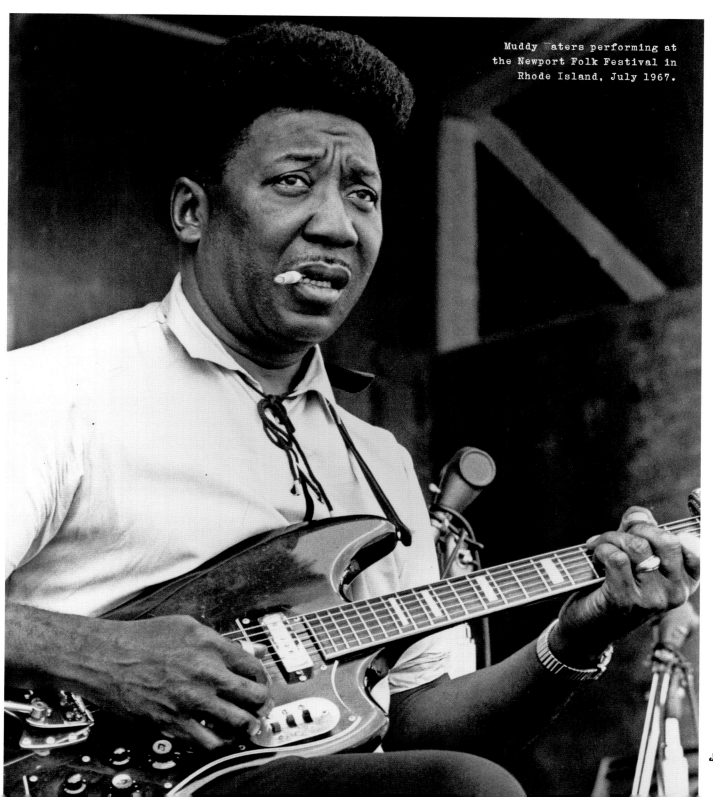

Muddy Waters performing at the Newport Folk Festival in Rhode Island, July 1967.

DENNY BRUCE

"Magic Sam was a client of mine. Sam was dazzling in front of an audience. The Fillmore and the Avalon. Every night he was a crowd-pleaser. . . . Everybody who saw Sam always wanted to know what was he doing with his thumb when he played guitar. And he wouldn't show anybody.

"Sam and I had some California dates, including one at the Bank in Torrance, a bank building turned music concert hall. We were the opening act for the Grateful Dead. They had all their gear on stage, which had wall-to-wall amps. And Sam was guaranteed a sound check.

"We go over, and about the time Sam is ready to plug into his one Fender guitar, Jerry Garcia was on stage with his guitar and walks over. And with that smile on his face, 'Let me plug you into my amp.' And he plugs Sam into his Fender, not much different from what Sam had, but in that wall of speakers there were four Fender amps that were all hooked together. So you're not getting one but getting four amps. Jerry said, 'Let's see how it sounds.' . . .

"Sam did a quick boogie just to see what that sounded like. And he had a big smile on his face. And Jerry said, 'There's your sound of the future.' And I said to Sam, 'Someday you might need more than one amp.'

"Sam's records fit in the new 1967 FM radio format. Albert King's *Born Under a Bad Sign* was already out. Sam wasn't Jimi Hendrix, but he could play better. And as Michael Bloomfield said, who knew Sam from Chicago and they were friends, 'He's got his own thing on guitar, man. And he's the best singer out of all of them. There's nobody like this dude.'"

The seductive "Hip Hug-Her" was released on the immortal Stax label during that glorious June. It was also the title track of Booker T. and the M.G.'s fifth studio album. "Hip Hug-Her" became the group's highest-charting single since their debut, "Green Onions." After the band appeared at Monterey, San Francisco and Los Angeles became even larger markets for radio airplay and sales for the acclaimed instrumental outfit.

JERRY WEXLER

"Booker T. Jones is a musical genius. I love Donald 'Duck' Dunn. Listen, not only did I like Steve Cropper as a guitar player, I consider him a monumental roadwork to a new way of guitar playing. Something he and Cornell Dupree, the only two that I knew that could do it, to play a kind of rhythm and lead at the same time. When he played, there would be a little turnaround, a little obbligato, a little sting, a little fill, and it was single-string, and it was chord and rhythm and lead at the same time without solos."

"The mystery of love and sex was also explored in a brilliant slice of soul, *Hip Hug-Her* by Booker T. and the M.G.'s. This collection of eleven instrumentals blends originals with some known hits like 'Get Ready' and 'Groovin',' and the arrangements and committed performances create an image of unified musical coherence every bit as convincing as the Beatles."

—JAMES CUSHING

June 25 found the Beatles performing "All You Need Is Love" for the Our World satellite television broadcast. That same day, a new LP entry into our heads was *Flowers* by the Rolling Stones, produced by Andrew Loog Oldham.

KENNETH KUBERNIK

"*Flowers*, a risible title for this ungainly collection [a patchwork assemblage of B-sides, outtakes, and the detritus of a years-long recording regimen that produced more chaff than wheat], featured the all-seeing cover photography of Guy Webster; each band member's head shot pinned to the top of a lonely stem, Brian's alone leafless, a premonition perhaps of his self-destructive fate. Nonetheless, the album has its share of unexpected delights amid the repackaging of such recent hits as 'Ruby Tuesday' and 'Let's Spend the Night Together.'

"There is one real revelation on this album: 'Ride On, Baby.' Recorded during those Homeric sessions for *Aftermath* in Hollywood, it was originally conceived as a demo for Chris Farlowe, an Immediate Records artist who charted with his version in 1966. The Stones' take builds with a churning, controlled fury, Charlie Watts stoking the rhythm with the supple restraint of Earl Palmer. Jack Nitzsche furnishes the surprising textural note, his rhapsodic keyboard driving the chorus to its furious release. For those old enough to remember, 'Ride On, Baby' was that rare album track which many AM DJs (at least in Los Angeles) rode like whip-strapping jockeys to the finish line. I can still hear Humble Harve on KBLA intoning in his basso profundo, 'The *Stones* with "Ride On, Baby" . . . ride on . . . ride on . . . ride on. . . .' Three and a half minutes that shook my world."

ANDREW LOOG OLDHAM

"There's incredible clarity to what they were doing. It was like a linear thing. Filmic. They were vivid, and the key to that vividness was Brian Jones. The organ on 'She Smiled Sweetly' by Brian is just amazing. I like 'She Smiled Sweetly' more than 'Lady Jane' and 'Ruby Tuesday.' 'Sweetly' was boy/girl, living on the same floor. Whereas both those other songs have a 'to the manor born' quality to them. Trying to write and evoke. I love 'Out of Time.' On the initial recording it's Mick Jagger pulling off Jimmy Ruffin.

"*Between the Buttons* and *Aftermath*, without a doubt, quite a few harried moments. And we did it in Hollywood at RCA Studios. . . .

"When I produced the band at RCA, to make them feel comfortable, I shrunk and lit the room for them. I was doing set design even then. [Laughs.] There you are. I do dreams, not business."

Guy Webster image of Brian Jones at Monterey Pop.

The Hollies

Manchester's the Hollies, whose entire sound and sensibility were drawn directly from such American forebears who toured Britain in the fifties and sixties as Buddy Holly, the Everly Brothers, Jerry Lee Lewis, and Chuck Berry, were not immune to the commercial allure of psychedelia. Recording across the hall from the Beatles at Abbey Road, the Hollies dappled their distinctive harmonies with fuzzy ruffles and faintly Indian sonic oddments.

Two 1967 releases, *Evolution*, in June (which boasted a cover too tripped out not to border on parody) and *Butterfly*, in November (the last major contribution Graham Nash made before decamping for the emerald highlands of Laurel Canyon and another, more fateful musical incarnation), documented the band's commitment to remaining *au courant*.

The U.S. edition of *Butterfly* was retitled *Dear Eloise/King Midas in Reverse*.

"The Hollies were playing a gig in Split, in the old Yugoslavia . . . sunny days indeed. I was feeling strange about how 'everything was turning to gold' in my life but how, at the same time, life was giving me lemons. 'King Midas in Reverse' was my statement about how my life was unfolding. How odd that I wrote 'I Used to Be a King' several years later about the 'king' I used to be. . . . I believe that the sales of the record we made of my song failed to impress the rest of the band, and I felt that they were done with trusting me and my writing. Coming to Los Angeles after leaving the Hollies was a geographic rebirth. They [the Hollies] passed on 'Teach Your Children,' 'Lady of the Island,' 'Marrakesh Express,' and 'The Sleep Song.'"

—GRAHAM NASH

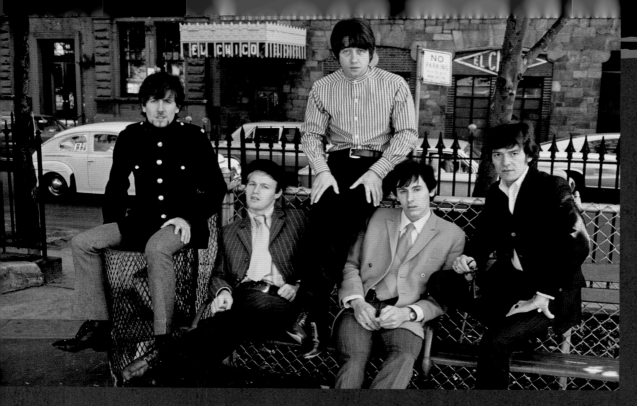

"*Rubber Soul* drew a definite line in the vinyl; then *Revolver* upped the audio ante even higher," claims Big Beat historian Gary Pig Gold. "Consequently, as 1966 concluded, the original British Invaders had to choose between either rolling with the flow—and all that entailed in the wardrobe and even after-hours recreational departments—or simply keep Gretsch guitars high-on-the-strap mooning 'n' Juneing in Scouse for as long as a dwindling marketplace would allow.

"There was at least one member of Manchester's very own Hollies, however, who most definitely did not envision a future spent playing golden oldies on the dreaded cabaret circuit, aspiring instead to greatness of, if not Lennon/McCartney, then at least Townshend or maybe even [Ray] Davies caliber.

"The result was several shimmering singles and two albums, *Evolution* and *Butterfly*, that in 1967 showed the Hollies more than ready, willing, and positively able to move into extra mature avenues of, and I quote, 'elevated observations.' While careful not to alienate totally their long-standing moms-and-dads fan base, this brave new fisheye Day-Glo aesthetic manifested itself not only lyrically (e.g.: the pure pop parable of 'King Midas in Reverse') but across the mission controls on their Ron Richards–supervised Abbey Road mixing console as well.

"While not exactly *Axis: Bold as Love* or, of course, *Sgt. Pepper's*, *Evolution* in particular showed the Hollies now taking a decidedly pot as opposed to pot-pie approach to their career.

"But this changing of ways did not sit entirely well with the entire band, especially when 'King Midas' stalled at a comparatively anemic No. 18 on the UK charts.

"So as 1968 saw our heroes rally back to the Top 10 with the jolly sing-along 'Jennifer Eccles,' then threaten to record an entire LP of Dylan songs to boot, Graham Nash finally packed up his joss sticks and bailed ship into the welcoming arms of his newfound hipster pals Crosby and Stills way over in Laurel Canyon. Pity.

"But it still never hurts to exhume the Hollies's quaint pair of lysergic long-players from '67 and note that they more than continue to hold quite their own alongside *Satanic Majesties* or even Chad and Jeremy's *Of Cabbages and Kings*."

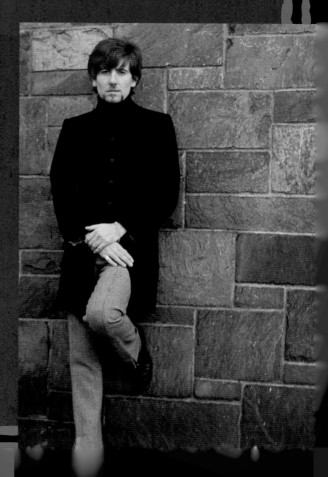

THE RAVE NEW WORLD

The Beatles's *Sgt. Pepper's* lodged itself at No. 1 on the album charts on July 1 during that sweltering summer of '67. The following week, *Time* magazine published a cover story, "The Hippies: Philosophy of a Sub-Culture."

On July 5, 1967, the first of the Schaefer Music Festivals was held in New York City at Central Park. The lineup consisted of singer/songwriter Len Chandler, the Young Rascals, and the Jimi Hendrix Experience. The same day, the song "Windy," by the Association, reached the top of the hit parade. Author Daniel Weizmann explains why: "'Windy' was written by a young folksinger named Ruthann Friedman from the San Fernando Valley. Jimmy Yester of the Association brought a reel-to-reel of twenty of Ruthann's songs to engineer/producer Bones Howe, who cherry-picked 'Windy' and fashioned it into a giant frolicsome hit, with the one

and only Hal Blaine on drums and an unforgettable recorder solo by Terry Kirkman.

"What a cheery, groovy song! But more importantly, a beautiful example of the way an original species of American spirituality had trickled down from Emerson and Whitman, through Henry Miller and the Beats, and into the popular culture—a 45 about a kind of spirit nymph, floating through urban chaos. Not a book of poetry or prayer, not a treatise or an essay. A little vinyl 45. You could buy it at Wallichs Music City in Hollywood for under a buck.

"Is Windy a real woman? Is she the breeze itself? She delivers rainbows, flashes storms against falsehood,

hides under stairways, sweeps through the city, and takes flight above the clouds, above everything. And that's not all: Her main recurring maneuver is that she 'reaches out to capture a moment.' She is the eternal now, the *shechinah*—the divine presence that, even in the mad modern city, brings satori.

"This is what makes '67 such an unusual year—a never-before and never-since year. Such ideas about cosmic consciousness were always present among kooks and intellectuals, but in '67 they had infiltrated the machine, traded by teenyboppers and filtered through transistor and car radios by way of little spinning Trojan horses."

"That gentle spirit was riding airwaves . . . Donovan . . . Scott McKenzie. . . . Even Frank and Nancy were singing 'I love you.' . . . Windy is a wind nymph, a trickster, elusive, ancient, and therefore always contemporary. She's a border figure, suggesting the possibility of change, of another way of living. . . . Yet Windy's function in the song is the recurring chorus-answer to the song's verse-question. It's a little like 'Blowin' in the Wind' really. An answer song?"

—DANIEL WEIZMANN

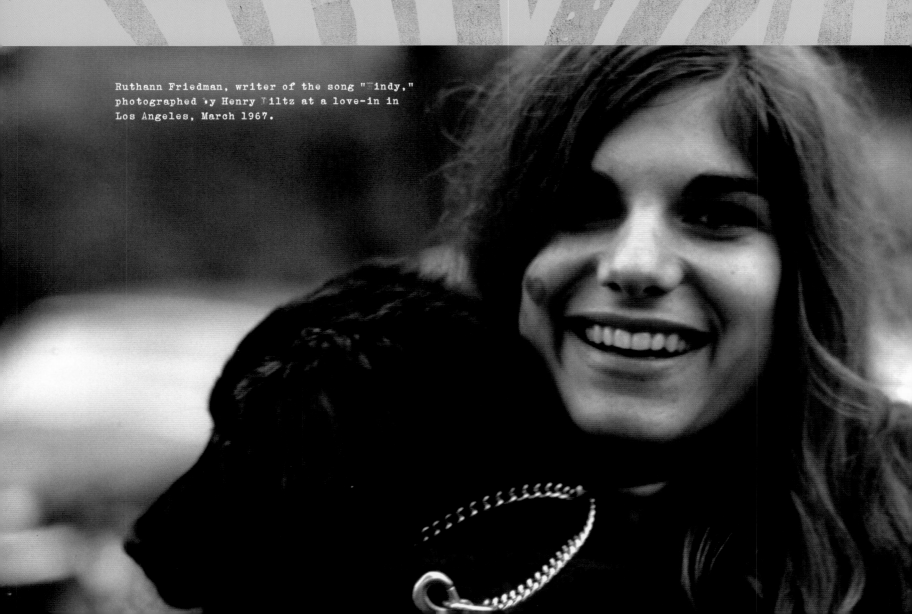

Ruthann Friedman, writer of the song "Windy," photographed by Henry Diltz at a love-in in Los Angeles, March 1967.

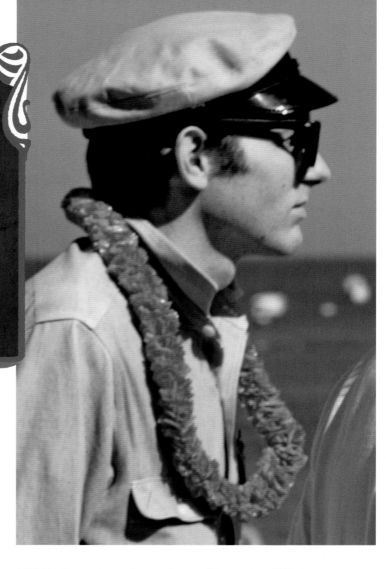

BONES HOWE

record engineer and producer

"When I engineered Ornette Coleman for Atlantic, which Neshui Ertegun produced, [the musicians] were so close to each other they could reach out and touch each other. That was the format. Same way I always produced my sessions. Like the Association. And using the directional qualities of the microphones and as little baffling as possible but sometimes between the bass and drums. Just to let it be free and let the music be in the air, instead of people being all the way across the room from somebody."

In 1967, besides songs for the Association, Hal Blaine's drumming was on many popular tunes by Johnny Rivers, Frank and Nancy Sinatra, Paul Revere & the Raiders, the Grass Roots, the 5th Dimension, the Mamas & the Papas, the Monkees, and Scott McKenzie, as well as "The Happening" from the Supremes.

Under his own name, Blaine recorded the 1967 cult classic album *Psychedelic Percussion*. "Flashes," "Hallucinations," "Flower Society," "Trippin' Out," and "Tune In–Turn On" are just a sampling of the track selections.

ABOVE: Record engineer Bones Howe at a KHJ luau, June 1966; photograph by Henry Diltz.

LEFT: Drummer Hal Blaine, photographed by Henry Diltz at the RCA Studios, Hollywood, 1967.

HAL BLAINE

drummer

"We [Local 47 Musician's Union members] could lock in with anybody. When we finished we had to go out and do another session. I might have had two other gigs that day. Our job was making hit records, and we loved it. We were doing a job. We used to say: TTMAR. Take the money and run."

Wining and Dining in '67

Keyboardist and top session man Don Randi was all over transistor radios and record machines in 1967, including studio efforts in Hollywood with Buffalo Springfield, Tim Buckley, the Monkees, Lee Hazelwood, Love, the Stone Poneys, and Gary Lewis & the Playboys, as well as on Nancy Sinatra's "Sugar Town."

Randi headed the house band at Sherry's Restaurant cocktail bar on Sunset Boulevard from 1957 to 1970 and revealed the culinary habits, favorite watering holes, and nosh spots frequented by instrumentalists after they cut hit records:

"We worked all day and evenings," says Randi. "We socialized. [Arranger] Jack Nitzsche and I would go out to places like the Gaiety Delicatessen. Once in a while Harry Nilsson would come to our table. He was still working at the Crocker-Citizen bank as a teller or had a job there. He might have made a record then.

"We loved Musso & Frank Grill on Hollywood Boulevard and Johnny's Steak House. That was my savior. I didn't have a fuckin' dime and I could go and have a three-dollar meal in there with a rib eye, you know. Can't forget the Brown Derby. We went to Aldo's—great hamburgers. Sonny and Cher dug that place, Canter's, and once in a while, a coffee shop called Huff's. Taco-rama, and Pink's Hot Dogs on La Brea. Another tasty stop was the Dog House on Hollywood, where you sat on stools right on the street.

"There was Young China, two doors down from radio station KFWB, for fantastic Chinese . . . the best wonton soup. The Italian restaurant Miceli's on Las Palmas.

"Dennis Wilson of the Beach Boys loved Ah Fong's restaurant. Delicious Chinese-American food. Gene Norman owned the Marquis restaurant on Sunset Strip, along with his Crescendo and Interlude clubs. I liked the Villa Capri. Phil [Spector] and I went to the Cock'n Bull. The trout was incredible.

"The record company promo men all went to an Italian spot named Martoni's. Label owners [Verve Records] like Norman Granz enjoyed the Pacific Dining Car. Barney Kessel and his wife B. J. Baker requested their New York steaks cooked medium at Diamond Jim's in Hollywood.

"Myself, Jack, Neil [Young], and Denny Bruce also liked to eat at the House of Pancakes on La Cienega and Sunset Boulevard.

"We all went to the Hollywood Ranch Market. Are you kidding? The tater tots and the chicken gizzards! In the late fifties they had a doughnut machine there! [Laughs]. I saw Lucille Ball one night after a session. In a full fur mink coat! She gave me the biggest smile. Rock bands, hookers, actors, and hippies were always at the counter. Especially when there was a live music show in '67 at the Kaleidoscope or Hollywood Palladium."

LEFT: Iconic L.A. hot dog stand Tail o' the Pup in 1967. Designed by architect Milton Black, the stand opened in June 1946. Photograph by Henry Diltz.

As technical advances inside recording facilities were advancing from 4-track to 8-track in 1967, there were a number of established musical equipment stores (selling what is now considered highly prized vintage gear) that were still vital to the sound of '67.

Manny's Music in New York City (1933–2009) had been located in the same building as A&R Recording since 1959. Buddy Holly, Johnny Cash, George Harrison, Al Kooper, Bob Dylan, and Pete Townshend were visitors and customers.

UK-based music makers in 1967 frequented a slew of stores in the Soho district that were the bedrock of their studio experiments and roadwork.

The Selmer Shop, which was on 114–116 Charing Cross Road in London, sold Fender and Gibson guitars to the Shadows and the Who. Their salesmen included two interesting guitarists: pre-Free Paul Kossoff and pre-Fotheringay Jerry Donahue (son of U.S. saxophonist Sam Donahue). Eric Clapton and Peter Green bought their Les Pauls there. Founded in 1958, Macari's, on Charing Cross Road, sold Vox amps as well as guitars. Sound City across the street sold Fender guitars to Jimi Hendrix and Jeff Beck.

Rose Morris, a big store also on Shaftesbury Avenue, had an exclusive deal with Jim Marshall to sell and distribute Marshall amplifiers worldwide. There was Chas E. Foote's drum shop in Golden Square. And Drum City, founded in the 1950s by Ivor Arbiter (who designed the Beatles logo on Ringo's Ludwig bass drum) on Shaftesbury Avenue, that was patronized by Cream's Ginger Baker and many others. For brass and reeds there was Take Five on Shaftesbury Avenue as well as Bill Lewington for brass, reeds, and woodwind. The place where the likes of Sonny Rollins would go when playing a week or two at Ronnie Scott's, one hundred yards away.

Wallichs Music City in Hollywood (1940–78) carried records and stocked equipment. In the sixties, both Micky Dolenz and Frank Zappa worked there. Keith Richards purchased his Gibson Maestro Fuzz-Tone distortion device in 1965, which was utilized when the Rolling Stones recorded "Satisfaction" literally next door on Sunset Boulevard at RCA Studios.

ABOVE: Acclaimed blues and jazz drummer Earl Palmer at Capitol Studios on Sunset Boulevard, in November 1967, photographed by Henry Diltz.

In Los Angeles, there was Saul Bettman's Music in Larchmont Village. Then–Buffalo Springfield member Neil Young bought a Fender Deluxe amp there in 1967 and eventually used it on his solo album *Everybody Knows This Is Nowhere*. Hogan's House of Music on Hawthorne Boulevard in Lawndale was where the Pendletones (later renamed the Beach Boys) rented gear in 1961 for their first recording session at World Pacific Studios on Third Street in Los Angeles. Stein on Vine, across the street from the Local 47 Musicians Union since the 1940s, is a Hollywood institution for professionals and technicians. Jazz greats like Ray Brown, Billy Eckstine, Benny Goodman, Phil Woods, and Stan Getz would hang out and jam before the mid-sixties rock crowd located the action.

Earl Palmer, Hal Blaine, Jim Gordon, and Jim Keltner, heard on many '67 sessions, would constantly visit Professional Drum Shop and Drum City in Hollywood for kits, sticks, and pedals.

Another destination was Mike Marotta's ABC Music Center, located in Monterey, California, on the Central Coast.

Legendary jazz guitarist, pop and rock session man, and record producer Barney Kessel opened Barney Kessel's Music World in Hollywood that July. Located across the street from Capitol Records on Vine Street, Kessel's room quickly became a destination stop for players, pickers, tour managers, producers, and songwriters. Kessel was rated the No. 1 guitarist in *Esquire*, *Down Beat*, and *Playboy* magazine polls between 1947 and 1960. His recording résumé is dotted with the names Elvis Presley, Ricky Nelson, Sam Cooke, Ike & Tina Turner, Frank Sinatra, Phil Spector, Julie London, the Monkees, the Beach Boys, and John Lennon.

You are cordially invited to attend
an open house celebrating the opening of
BARNEY KESSEL'S MUSIC WORLD
FRIDAY, JULY 7th, 1967
7 P.M. UNTIL MIDNIGHT
Free Parking opposite Hollywood Palace

R.S.V.P. HOLLYWOOD 2-0758
REFRESHMENTS

1770 N. VINE STREET
AT YUCCA
HOLLYWOOD, CALIFORNIA

An invitation to the opening of Barney Kessel's Music World in Hollywood on July 7, 1967.

STEVE HOWE

guitarist, Yes

"Long before I joined Yes in 1970, Barney Kessel was the first American jazz guitarist I ever related to. I started playing when I was twelve in 1959. I bought all the LPs he made when he was the leader. I also liked him in support roles. And there was something mysterious about his equipment.

"I read Barney's column, a few times, in *Guitar Player* magazine. One important thing to me is that Barney Kessel is the first guitarist I ever saw who said, 'You need eight guitars to be a session guitarist.' I only had about four at the time. And when I saw his 'eight guitars' quote I kinda read what he meant. Like having a 12-string. Barney put something very influential in my head about the multi-guitar idea when he mentioned eight guitars including 12-string and mandolin. That well-rounded idea that obviously affected me when I went into doing *Guitar Monster of Rock* [album] goes back to Barney Kessel."

DAN KESSEL

multi-instrumentalist
and record producer

"In 1967 my dad hired Milt Owen to be the in-house luthier and repairman at Barney Kessel's Music World, which, along with Wallichs Music City, was one of the top music stores in Hollywood at the time, and Milt was pretty much the top guy in Hollywood. Neil, Stephen, and Richie of the Springfield as well as Frank Zappa, the Byrds, the Association, Eric Clapton, George Harrison, and John Lennon came in to buy guitars and amps and to have Milt do fix-ups and modifications on their equipment.

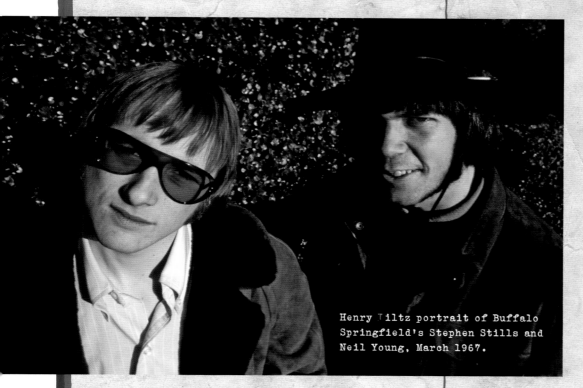

Henry Diltz portrait of Buffalo Springfield's Stephen Stills and Neil Young, March 1967.

"During the Summer of Love, in San Francisco, I was with my dad and we were at Don Wehr's Music City, a music shop that was having a grand opening.

"I noticed the Buffalo Springfield there, plugging guitars into amps. I'd just seen them at the Fillmore West the night before. I got excited and told my dad who they were and that I liked them a lot. He recognized the name Buffalo Springfield but didn't really know a lot about them or their music at that point. Soon, they were kind of looking at him, talking among themselves. Apparently, they knew who he was. Then Stephen walked over, introduced himself and the band, saying they were going to

jam a bit, and asked my dad if he would consider jamming with them. My dad shot me a quick look. I nodded yes.

"He was, musically, on a different planet. He'd jammed with guys like Charlie 'Bird' Parker, Dizzy Gillespie, and musicians of that caliber, on songs with dozens of chord changes and modulations and with polyphonic harmonic structures. But he could dig that they were a hip-looking, young ensemble and was both intrigued and pleased that they would ask him to jam with them. He grabbed a Rickenbacker 12-string off the wall and plugged into a Fender amp. Neil nodded and smiled approvingly. 'Why don't you guys go ahead and start,' my dad said. 'I'll listen for a minute while I tune up this 12.'

'OK,' they said, and started into the beginning of a jam that was in essence a form of 'Bluebird.' Neil's guitar was resonating in a deep D-modal tuning, which is great for raga rock and worked well against Stills and Furay in standard tuning. However, Furay was using a capo, which allowed him to play in different patterns but still be in the key of D, so they had, in essence, three distinct guitar tunings/patterns, in addition to their individual guitar sounds. . . .

"When my dad finally entered the fray they were ready for each other. He had decided that his best approach to adapt to their sound was to add rhythmic sound textures with modal improvisations within the pentatonic scale, à la Miles Davis and John Coltrane. . . . The crowd in the store was definitely digging the action. If only someone had been recording it!

"'That's the first time I've ever played in one key for that long [about ten minutes],' my dad remarked after they ended the jam. The guys said they totally dug what he'd been laying down. When the smoke cleared away, he was pleased to have been asked to jam with these young rockers.

"My dad and I also had friendly encounters with Michael Bloomfield, Country Joe McDonald, Big Brother & the Holding Company, and some other bands, but Buffalo Springfield is the one band he did any serious jamming with in San Francisco that summer."

Guitarist Eddie Willis was a part of many of the hits at Motown Records that were the declarative and seductive soul music backdrop to many emotional and physical encounters occurring during 1967.

Willis's imaginative rhythm playing and flourished fills were a vital component in the Funk Brothers sound. He can be heard on the Temptations' "The Way You Do the Things You Do" and Stevie Wonder's "I Was Made to Love Her."

The Temptations With a Lot O' Soul album classic was spun at every party that July, too.

"That's me on the lead guitar on 'I Was Made to Love Her.' That was a thrill. I knew at the time within a couple of weeks I would hear it on the radio. I could not wait for that song to come out. It jumped out of the AM car radio."

—EDDIE WILLIS

BERRY GORDY

"We didn't look at album tunes as such. We would pick tunes that were hits, and that's why they would go on albums, and pull out a hit here, a hit there, you know? So it didn't impact us that there were albums and we had departments and all that stuff. But as far as recording, unless there was a concept album and things like that, we would say there are no album tunes. We'd say that all the time."

Drummer Uriel Jones was born in Detroit in 1934. He worked with Sarah Vaughan, Billy Eckstine, Mahalia Jackson, and Dakota Stanton, and joined the Motown session band in 1964 after a period as part of Marvin Gaye's touring group. His sticks propel musical backing tracks by the Temptations, including "Ain't Too Proud to Beg" and "I Can't Get Next to You."

URIEL JONES

"I did most of the Temptations stuff with producer Norman Whitfield. We knew all of the producers and knew their styles. We knew that they would be doing something along the lines of the previous hit they had. So, when the producer came in with something, we just about knew what he wanted. 'Cause you knew his style. You needed a hint what it was going to be like. We took it from there. The musicians did a lot of the so-called arranging ourselves. Because they would come out there with just lead sheets. Every now and then someone would come in with an arrangement. But most of the time, for chord or lead sheets they'd rely on us."

PAUL BODY

"In the summer, KGFJ used to play that Tempts song 'You're My Everything,' in which David Ruffin and Eddie Kendricks traded licks and sounded like they were in the amen corner. Spring–summer, things were rocking.

"Meanwhile, the Whisky a Go Go on Sunset Strip had started their new over-age-twenty-one policy in January. Mostly soul music was now featured, which was cool, but I couldn't get in. I did catch Otis Redding in 1966, and I do remember seeing the seven-man *Da Capo* version of Love at the Whisky at what turned out to be one of the last shows that I could legally attend when you only had to be eighteen.

"In 1967, the Impressions, Martha and the Vandellas, the 5th Dimension, Brenda Holloway, and the Temptations were on the marquee. Some friends of mine saw Smokey Robinson and the Miracles earlier in January and actually heard the announcer say, 'And now, ladies and gentlemen, some green-eyed soul from Smokey Robinson and the Miracles.' By the very late summer, the Whisky returned to age-eighteen admission, and in the fall I was able to see Cream and Procol Harum."

DAVID RUFFIN

"The Temptations were individuals who happened to sing together. I never regretted any of the songs we did, and even the choreography on stage has been widely copied. I liked the dancing part of that group. Then you couldn't just stand there and sing. The audience was moving and you just reflected what was going on. If anything, I'd like my association with the Temptations to be remembered as that we gave something. We helped young artists get in a position."

The Temptations with Ed Sullivan,
November 19, 1967.

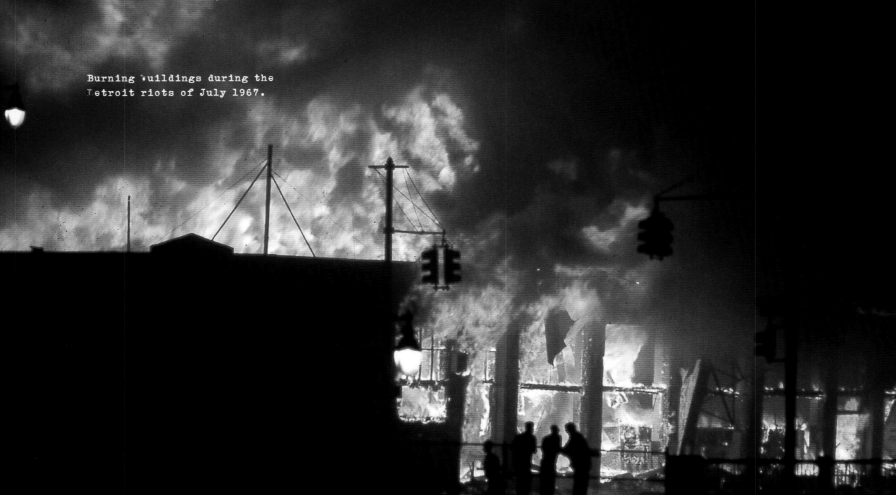

"The blast furnaces roar, melting down the iron ore, and blow black clouds of smoke out of the stacks. The fallout glistens from the particles of graphite suspended in the air below where I walk with a shovel over my shoulder along the railroad tracks on Zug Island. It's the summer of 1964. Across the river from Detroit in Canada, the 50,000-watt CKLW-AM pumps Martha and the Vandellas' 'Dancing in the Streets' through the transistor radio in my hip pocket and makes the walk down into the pit momentarily transform with the sonic medicinal of Motown."

—MICK VRANICH, POET AND MUSICIAN, DETROIT, 2009

Burning buildings during the
Detroit riots of July 1967.

On July 23, 1967, while a love-in was being held in Hollywood at Griffith Park, there was a week-long race riot in Detroit, Michigan, that ended with forty-three dead, over a thousand people injured, and an estimated $80 million in property damage.

During the long, hot summer of '67, those formative streets in Motown were roiling in racial discord, those funky backbeats and imperishably supreme melodies replaced by the sounds of heads cracking and glass breaking: an atonal symphony of youthful aspiration drowned out by the siren song of uniformed authority. And yet, amid the mayhem, Hitsville, U.S.A. retained its vital focus, providing the airwaves with some kind of wonderful.

MARY WILSON

vocalist, the Supremes

"We always had a social consciousness. It was traumatic watching the riots in Detroit in 1967. We're talking about things that were of race. We were a black America. But we were still black first. And it was tragic. But we viewed it just like everybody else. Thank God we were doing things that were helpful to the community. There are all different flavors and colors of black people. And so we were just another flavor but still fighting for the same cause.

"Thank God, Berry Gordy steered us into doing political things. We were there with Robert F. Kennedy. We did some shows in Los Angeles, Century City, he was speaking in. We did a lot of NAACP things. Along with Berry Gordy, we hung out with Martin Luther King Jr. In 1968, we were even in the front row at his funeral after he was assassinated.

"We were always helping the community. We lent our voices and faces to the cause. We had the same feelings as most Afro-Americans then. 'We got to make a difference. We got to make a change.' Everyone was doing what they could in the way they could.

"We did 'Reflections' with Holland-Dozier-Holland in the summer of 1967. It fit right in with all the other things on the radio dial. The record company, thank God, they had marketing in mind, and knew which way and what to catch on to. And what was new. They had that and I'm so happy they did. So, for me, H-D-H, thank God, they gave us those ten No. 1 million-selling records. That's what made us who we are in history.

"We played at the Flamingo Hotel in Las Vegas in July. We were in gowns and always a little different than most everyone else. That's what kind of set us apart. I'm not saying better. But different. Because rock 'n' roll was rock 'n' roll. We were in rock 'n' roll but we were pop. We were glamorous. We were just the other side of what was going on. Even though we were right alongside of it. It was part of the change. My brother said, 'Mary. Why don't you girls wear Afros?' Some people march and chant. But we do ours a different way."

Venues

In writer Kirk Silsbee's interview with choreographer Cholly Atkins in the *Los Angeles Reader*, January 20, 1995, "Cholly Atkins: The Man Who Taught Motown How to Dance," Atkins discussed one of the reasons the Supremes weren't booked anywhere near hippie halls in 1967. "The Supremes . . . seldom did anything more extroverted than extend their gloved arms forward for 'Stop! In the Name of Love,' Atkins observed, clarifying: "The Supremes required another approach; you had to emphasize their feminine side. I used a lot of physical drama and incorporated it with nice rhythmic moves." Was that because they were being groomed for the high-profile venues? Atkins nodded. "Berry didn't want any funk bags for the Supremes."

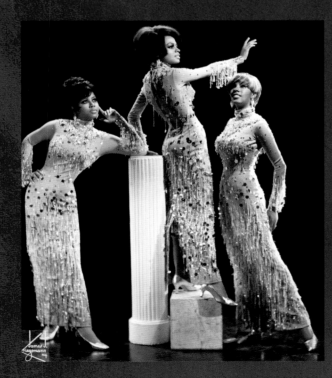

Rob Bowman, an esteemed ethnomusicologist, music writer, and Stax expert, explains further: "If you look at the venues in 1967—the Fillmores in San Francisco and New York, the Grande Ballroom in Detroit, the Tea Party in Boston, the Electric Factory in Philadelphia, all the various psychedelic ballrooms, if you will, the rock circuit had blues players like Albert and B. B. King and Muddy Waters. Because, of course, they were heroes of the rock stars that were playing there. They tended to never have Motown artists. Otis Redding played the Fillmore twice. The circuits were different.

"Although they had big hit records, Motown artists were getting booked into different places like the Hollywood Bowl, mainstream theaters, the O'Keefe Centre in Canada. [Berry Gordy directed his Motown artists during May 1967 into prestigious venues like the Ambassador Hotel's Cocoanut Grove in Los Angeles and the Copacabana Club in New York City.] Yes, those records crossed over. Everyone had hit records high on the charts.

"All the major acts [were] on local and network television shows like *Ed Sullivan*. Motown and Stax artists didn't have lyrics that tied into the hippie subculture, although everyone was hearing their music on the AM radio dial. There was just this separation of cultures. Despite the fact that AM radio . . . [was] playing the shit out of those Motown records, and the odd record on Stax.

"In 1967 the FM stations in San Francisco like KMPX and KSAN became the rage of the hippie subculture, who might be spinning Albert or B. B. King but a whole lot less of Otis Redding and virtually no Motown.

"Culturally what the Motown and Stax artists were singing about, how they presented themselves, and this applies to wardrobe as well, was quite removed from what the so-called hippie culture was all about.

"In fact, it was culture shock for Booker T. and the M.G.'s in 1967 at the Monterey festival seeing what the West Coast looked like. Seeing women wearing different kind of clothes, and people smoking dope openly. They had gone to Mars. . . .

"Motown, and I really believe this, was 'too commercial' and 'too pop,' when weighed against the Grateful Dead and new groups like Cream who were seen as 'hip' and 'underground,' the way the Supremes and the Temptations were not."

The Supremes pose for a portrait in New York, c. 1967.

s August loomed, Paul Revere & the Raiders prepared their own *Revolution!*

"Although already struggling that year to maintain all-American pop-rock supremacy in the wake of the Monkees's arrival, Paul Revere & the Raiders had a revolution of their own to face come 1967," reveals lifelong Raider rooter Gary Pig Gold.

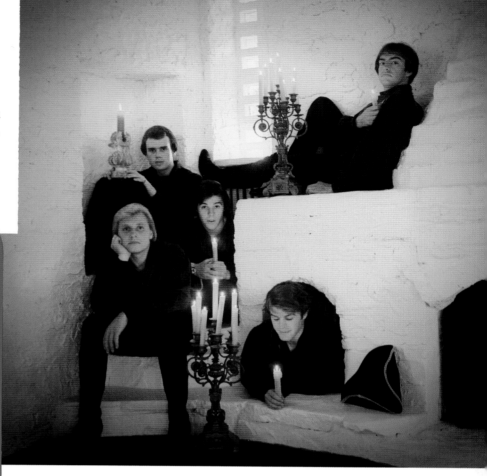

ABOVE: Paul Revere & the Raiders photographed by Guy Webster at his studio in Beverly Hills, from the 1966 photo shoot for the *Midnight Ride* album cover.

BELOW: Portrait of Terry Melcher, who produced records for Paul Revere & the Raiders, the Beach Boys, and the Byrds, among others. Photograph by Guy Webster, 1965.

GARY PIG GOLD

"Following sessions on their gold-certified *Spirit of '67* LP [November 1966], a near-crippling mutiny saw veteran Raiders Jim ["Harpo"] Valley, Phil ["Fang"] Volk, and Mike Smith suddenly jump ship. Harpo, Fang, and Smitty or *no* Harpo, Fang, and Smitty, though, Columbia Records' biggest-selling group had little choice but to bravely soldier onward and upward, instigating a new operating system that saw leader Revere oversee the band's onstage (and backstage) goings-on while vocalist Mark Lindsay, alongside producer Terry Melcher, assumed complete and full control of all activities in and around the recording studio.

"The first result of this astute arrangement saw the magnificent Lindsay/Melcher–composed Buck Owens/ Buckaroos (!) knockoff 'Him or Me (What's It Gonna Be?)' hit No. 5 that spring, while sessions for the *Revolution!* album [August 1967] got underway featuring the cream of Melcher's studio crop—Van Dyke Parks and Ry Cooder, for instance—mixing chops with those of Wrecking Crew members Glen Campbell plus, of course, Hal Blaine.

"Now, while tracks such as 'Mo'reen' and especially 'Ain't Nobody Who Can Do It Like Leslie Can' nodded not so reverently a'tall towards the slappy-go-lucky, Dick Clark–approved Raiders of *Action* years, 'Gone—Movin' On' sported a royal chorale break of near *SMiLE* pedigree while the Summer of Love hit-that-*should*-have been, 'I Had a Dream,' and then 'Tighter' even more boldly, demonstrate Melcher's 8-track wizardry in ways his much-ballyhooed Byrd work, for instance, only hinted at."

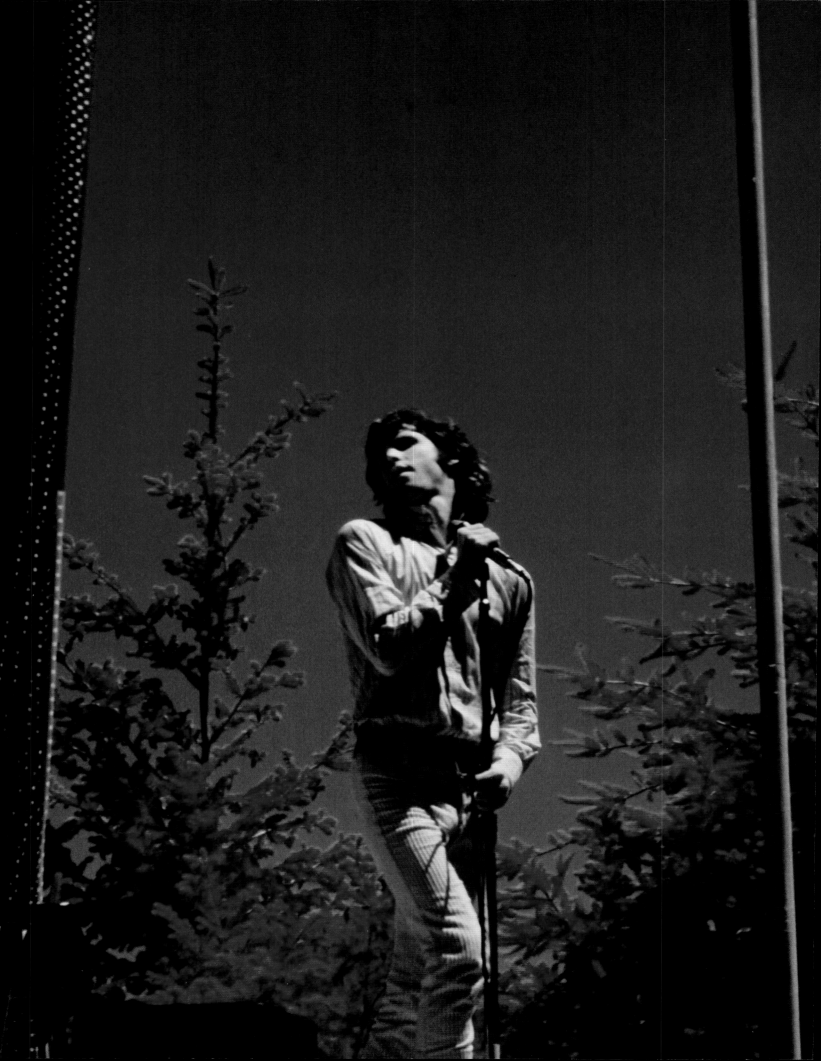

THE REALM OF THE POSSIBLE

In 1964, grad film student Ray Manzarek met an undergrad film student named Jim Morrison in Westwood, California, while both were attending UCLA's prestigious film school. After graduation in 1965, Manzarek encountered Morrison again on the beach in Venice, California.

During '65, Manzarek's group, Rick & the Ravens, recorded for the Aura label, and the head of the company, Richard Bock, suggested to Ray that he visit the Maharishi Mahesh Yogi's 3rd Street Meditation Center in Los Angeles.

It was there that Manzarek initially talked to drummer John Densmore and guitarist Robby Krieger. Ray later invited the duo to his parents' home in Redondo Beach, where they met Morrison around a Rick & the Ravens rehearsal in the garage.

Manzarek, Morrison, Densmore, and Krieger subsequently formed the Doors, and by 1966 were signed to Elektra Records.

On August 5, 1967, "Light My Fire" by the Doors was the No. 1 record on assorted singles charts in the U.S. The song, from their self-titled debut album of January 1967, was released as a single in May 1967.

"I loved the Doors," says Ram Dass. "Sure. 'Light My Fire.' Of course. Some Eastern influences in their music. Jim Morrison was a poet. . . .

"I liked the level of reality he played with. I like people pushing the edge and getting out of the linearity. I love that. And not in a kind of clever, studied way, but in an ecstatic experiential way. That's what I love better. That's what he tried to do."

OPPOSITE: Jim Morrison, onstage at the KFRC Fantasy Fair and Magic Mountain Music Festival at Mount Tamalpais, Marin County, California, June 1967. Photograph by Helie Robertson.

RAY MANZAREK

"Robby [Kreiger] was a different sort of lyric writer. Robby might be the secret weapon of the Doors. We get this great guitar player who plays bottleneck, and all of a sudden he comes in and plays 'Light My Fire,' the first song he ever co-wrote with Jim."

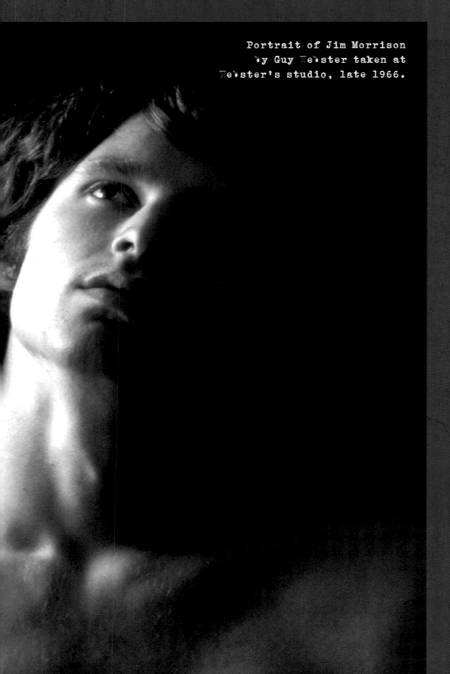

Portrait of Jim Morrison by Guy Webster taken at Webster's studio, late 1966.

JOHN DENSMORE

"Jim had an astounding baritone. Unschooled. It was luck. It was fate. He never sang before I saw him in the garage. It was kinda squeaky in the early days. He just was afraid to open up. How audacious. 'OK. I've never sung and I'm gonna be the lead singer of a rock band.' . . .

"It was Greene and Stone, Sonny and Cher's management team, who made the initial suggestion to cut down 'Light My Fire' for radio since it was 6 minutes and 50 seconds. Their suggestion was to put one half of the song on one side of a 45 and the rest on the flip side. That was cute. Subsequently, Robby and I went over to a local DJ's apartment, Dave Diamond from KBLA-AM, and he said it was a hit but mentioned, 'You have to edit this down [for airplay].'

"So, we pressed [producer] Paul Rothchild, and he just whacked at it, and all of us felt the cut was kinda brutal. But then, we became the darlings of the FM radio stations who played the long version. And that jumpstarted the whole FM underground 'We're cooler' scene. Which was very cool."

KIM FOWLEY

record producer and songwriter

"John Densmore was a jazz drummer. You also had a jazz keyboardist and a jazz guitarist all playing the blues with a real great poet and actor fronting it. It was tremendous. It was theater. Jim Morrison was . . . better than Elvis. Better than Jagger. Because he did what Howlin' Wolf and Lawrence Olivier did. He did it all at the same time. He did William Shakespeare and gutbucket [barrelhouse] together. . . . The Doors were not a rock 'n' roll band but gave you a rock 'n' roll feeling. And the only [other] band that did that was the original King Crimson. . . . When you heard 'Court of the Crimson King' [1969] and Pink Floyd [in] 1967, they were the only bands who had some Wagner with a rock 'n' roll attitude."

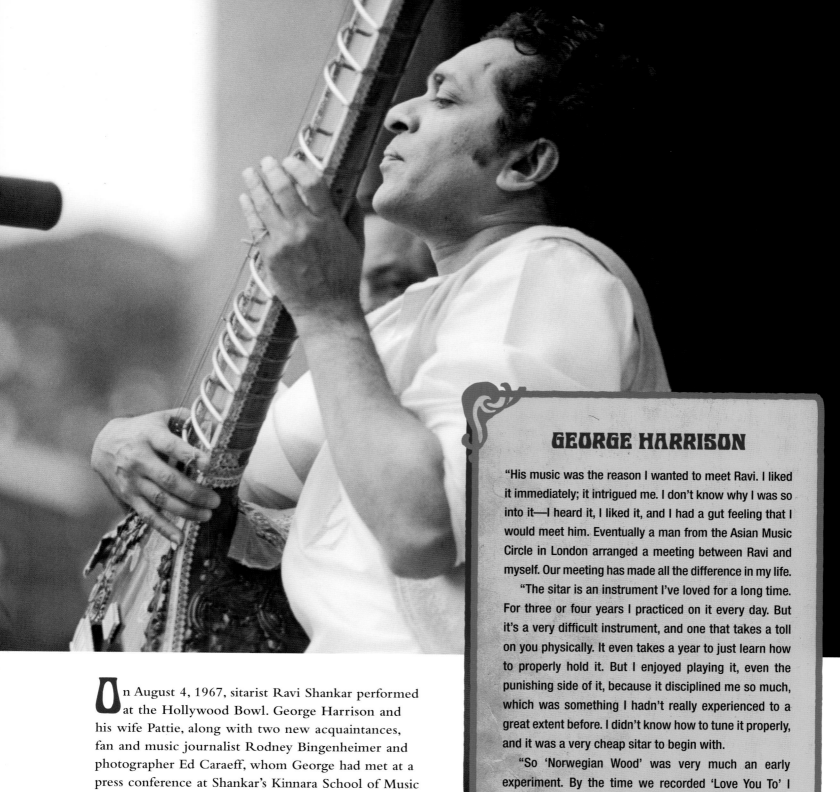

On August 4, 1967, sitarist Ravi Shankar performed at the Hollywood Bowl. George Harrison and his wife Pattie, along with two new acquaintances, fan and music journalist Rodney Bingenheimer and photographer Ed Caraeff, whom George had met at a press conference at Shankar's Kinnara School of Music in L.A., were in attendance.

In 1997, I interviewed George Harrison and asked him about Ravi Shankar.

ABOVE: Ravi Shankar performing on the sitar at the Monterey Pop Festival, June 18, 1967. Photograph by Henry Diltz.

GEORGE HARRISON

"His music was the reason I wanted to meet Ravi. I liked it immediately; it intrigued me. I don't know why I was so into it—I heard it, I liked it, and I had a gut feeling that I would meet him. Eventually a man from the Asian Music Circle in London arranged a meeting between Ravi and myself. Our meeting has made all the difference in my life.

"The sitar is an instrument I've loved for a long time. For three or four years I practiced on it every day. But it's a very difficult instrument, and one that takes a toll on you physically. It even takes a year to just learn how to properly hold it. But I enjoyed playing it, even the punishing side of it, because it disciplined me so much, which was something I hadn't really experienced to a great extent before. I didn't know how to tune it properly, and it was a very cheap sitar to begin with.

"So 'Norwegian Wood' was very much an early experiment. By the time we recorded 'Love You To' I had made some strides. That was the environment in the band; everybody was very open to bringing in new ideas. We were listening to all sorts of things, [Karlheinz] Stockhausen, avant-garde music, whatever, and most of it made its way onto our records."

JAMES CUSHING

"This 1967 disc [*Born Under a Bad Sign*] may rival *The Velvet Underground & Nico* for influence on other musicians.

"Just for starters, Cream copied the title track on *Wheels of Fire* and Zeppelin quoted 'The Hunter' near the end of their epic debut. Part of the reason for the album's strength is that it's also a Booker T. and the M.G.'s album; that great Southern soul-groove quartet does for King what they did for Sam & Dave or Otis Redding.

"Another part is the choice of songs. 'Born Under a Bad Sign' brings out the blues feel that was always there in Jack Bruce's voice, but the guitar solo has an inevitable structure that establishes King's as the superior version. Speaking of guitar solos, 'Personal Manager' provides a perfect lesson in structure and balance and suspense and soulfulness. It may be the ideal representation of King's style. Album closer 'The Very Thought of You,' by no means an obvious choice, seems to belong more to the world of Tony Bennett than to the blues, but it proved that a bluesman could 'get over' to the larger audience without compromising."

Writing about Albert King's album *Born Under a Bad Sign*, released in August 1967 on the Stax label, the perceptive music historian Michael Point hailed it as "the great divide of modern blues, the point at which the music was rescued from slipping into derivative obscurity."

Providing the accompaniment to lead guitarist and vocalist King were the in-house Stax recording session band, Booker T. and the M.G.'s, along with the Memphis Horns.

LEFT: Albert King performing at the Santa Monica Civic Auditorium, April 1970, photographed by Henry Diltz.

In 1967, rock 'n' roll morphed into rock, the art form, bubbling up from the subconscious of an emerging counterculture that demanded and deserved a form of expression. An outgrowth of the Beat sensibility and the political and social movements of the sixties, rock in 1967 found musicians turning away from commercial formulas and feeling their way into experimentation and genuine creativity.

Bob Dylan had made records before then, but he was primarily considered a folk artist until late summer 1965. And myriad jazz and folk records were made from a place of pure expression, art for art's sake, but that didn't extend to pop music.

RIGHT: The KHJ-Boss Top 30 Survey on August 16, 1967, included songs by the Supremes, Buffalo Springfield, and the Mamas & the Papas. The Beatles' "All You Need Is Love," at No. 5, included harpsichord, violin, woodwinds, and accordion, among other instruments.

KHJ'S BOSS 30 RECORDS IN SOUTHERN CALIFORNIA

PREVIEWED AUGUST 16, 1967

LAST WEEK	THIS WEEK	TITLE	ARTIST	LABEL	WEEKS ON BOSS 30
(3)	1.	ODE TO BILLIE JOE	Bobbie Gentry	Capitol	3
(6)	2.	GIMME LITTLE SIGN	Brenton Wood	Double Shot	4
(8)	3.	REFLECTIONS	Diana Ross & The Supremes	Motown	3
(4)	4.	SILENCE IS GOLDEN	The Tremeloes	Epic	6
(2)	5.	ALL YOU NEED IS LOVE/ BABY YOU'RE A RICH MAN	The Beatles	Capitol	5
(1)	6.	SAN FRANCISCAN NIGHTS	Eric Burdon & The Animals	MGM	5
(7)	7.	MERCY, MERCY, MERCY	The Buckinghams	Columbia	7
(5)	8.	HAPPY	The Sunshine Company	Imperial	5
(12)	9.	BABY I LOVE YOU	Aretha Franklin	Atlantic	5
(14)	10.	THERE IS A MOUNTAIN	Donovan	Epic	3
(23)	11.	BROWN EYED GIRL	Van Morrison	Bang	2
(30)	12.	THE LETTER	The Box Tops	Mala	2
(27)	13.	THE LOOK OF LOVE	Dusty Springfield	Philips	2
(13)	14.	WORDS/PLEASANT VALLEY SUNDAY	The Monkees	Colgems	6
(10)	15.	IT'S THE LITTLE THINGS	Sonny & Cher	Atco	4
(16)	16.	YOU'RE A VERY LOVELY WOMAN	The Merry-Go-Round	A & M	4
(11)	17.	BLUEBIRD/MR. SOUL	The Buffalo Springfield	Atco	7
(20)	18.	CARRIE ANNE	The Hollies	Epic	4
(22)	19.	SOUL FINGER	The Bar-Kays	Volt	3
(9)	20.	HEROES AND VILLAINS	The Beach Boys	Brother	4
(21)	21.	I TAKE IT BACK	Sandy Posey	MGM	4
(25)	22.	YOU'RE MY EVERYTHING	The Temptations	Gordy	2
(26)	23.	FAKIN' IT	Simon & Garfunkel	Columbia	3
(24)	24.	YOU KNOW WHAT I MEAN	The Turtles	White Whale	2
(28)	25.	I DIG ROCK AND ROLL MUSIC	Peter, Paul & Mary	Warner Bros.	2
(29)	26.	HYPNOTIZED	Linda Jones	Loma	2
(HB)	27.	TWELVE THIRTY	The Mamas & The Papas	Dunhill	1
(HB)	28.	MY MAMMY	The Happenings	B. T. Puppy	1
(HB)	29.	COME BACK WHEN YOU GROW UP	Bobby Vee	Liberty	1
(–)	30.	COLD SWEAT	James Brown	King	1

OFFICIAL ISSUE NO. **111** The popularity of records listed herein is the opinion of KHJ based on its survey of record sales in Southern California correlated with listener requests.

GARY STEWART

"Prior to 1967 (with some infrequent exceptions in 1966), everything under the banner of rock 'n' roll was made for money for sheer purposes of commerce . . . not for art.

"That changed with the emergence of the Doors, Love, the Grateful Dead, Quicksilver Messenger Service, Jefferson Airplane, and the Velvet Underground. They took this rock 'n' roll beyond its three-minute limit and added eastern Indian sounds, jazz tones, folk, and elements of classical in search of something beyond the hit single. Even though most of them didn't know what they were doing at the time—in the best sense of the word.

"I look at the rock 'n' roll of the sixties as puberty. The birth of the form happened in the fifties, and that was great, but the most interesting phase and the richest period of any movement comes after that formative period when the possibilities inherent in growth exploration and experimentation get realized.

"That's what happened after the Beatles and the British Invasion. And by 1967, many of those that might have sought purity in poetry, jazz, folk, other credible forms of expression, found those possibilities in rock 'n' roll, and this extends to soul music."

"In came the sitar, the horns, jazz, and classical elements and Tin Pan Alley, along with ideas, forms, and concepts that were previously or primarily relegated to jazz, folk, or other forms that were practiced as art. And you have this room to grow that you haven't seen since then. Because you can't. That's that one great period in 1967 that marks rock as art form, and a focus on the Summer of Love."

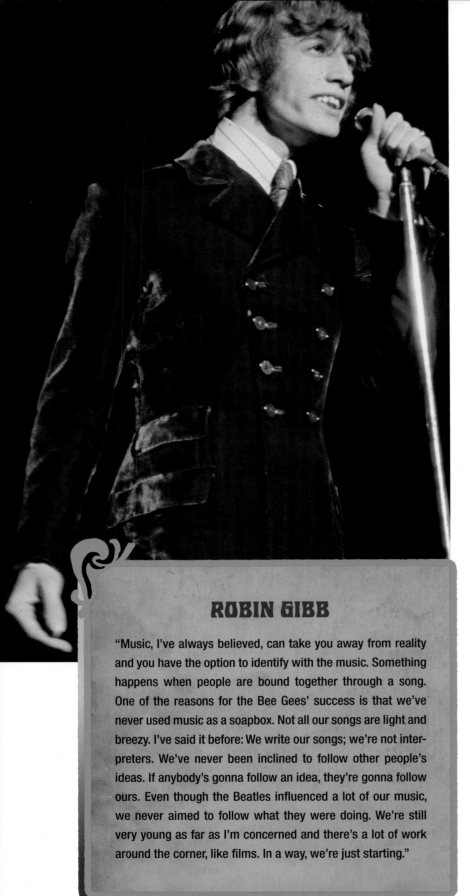

ROBIN GIBB

"Music, I've always believed, can take you away from reality and you have the option to identify with the music. Something happens when people are bound together through a song. One of the reasons for the Bee Gees' success is that we've never used music as a soapbox. Not all our songs are light and breezy. I've said it before: We write our songs; we're not interpreters. We've never been inclined to follow other people's ideas. If anybody's gonna follow an idea, they're gonna follow ours. Even though the Beatles influenced a lot of our music, we never aimed to follow what they were doing. We're still very young as far as I'm concerned and there's a lot of work around the corner, like films. In a way, we're just starting."

ABOVE: Robin Gibb onstage during a Bee Gees concert at the Anaheim Convention Center, January 1968. Photograph by Henry Diltz.

Bee Gees' 1st is the third studio album by the Bee Gees and their initial international product. It was released on July 14, 1967, in the United Kingdom, and on August 9, 1967, in the United States.

In case anyone missed out on discovering the *Bee Gees' 1st* album: It placed no fewer than five songs in heavy rotation on the AM dial. From the mournful "New York Mining Disaster 1941" and the plaintive toll of "Holiday" to the neo-soul styling of "To Love Somebody" (written by Barry and Robin Gibb for Otis Redding) and "I Can't See Nobody," the Bee Gees demonstrated a preternatural command of songwriting and arranging. Child stars in Australia, the Brothers Gibb were an immediate force to reckon with, mindful of their contemporaries but fully equipped to summit the hurly-burly of pop music on their own terms. I interviewed Robin Gibb for *Melody Maker* in Los Angeles in 1978.

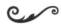

The Piper at the Gates of Dawn is the debut studio album by the English band Pink Floyd. It was pressed on the Tower/Capitol Records label in the States with "See Emily Play," a successful UK single, added to the American version. Led by the deeply troubled, fascinating front man Roger "Syd" Barrett, this quartet from Cambridge rode into the London music scene.

As multicolored liquid light projections enveloped the music's benign expansiveness, it became clear that Floyd had stumbled onto a format that would fuel one of the most exalted careers in rock history.

Their trajectory towards that luminous lunar landing, though, like the Apollo program, experienced its own share of colossal heartbreak, none more mourned than the dimming of their north star, Barrett. With his devastating good looks and air of artistic sophistication, Syd had quickly emerged as a major pop talent, but by 1968 had split from the band after having suffered a mental breakdown, possibly from schizophrenia exacerbated by drug use.

The Piper at the Gates of Dawn provided real evidence of his capacity for innovation. Barrett wrote nearly all the material, toggling between those dreamy vapor trails that highlighted their live shows—"Astronomy Domine" and "Interstellar Overdrive" have become acid-head anthems—and a litany of ear-teasing whimsies that left little doubt that "Strawberry Fields" was the touchstone for much of his inspiration.

Former Beatles engineer Norman Smith, who departed after completing *Rubber Soul*, served as producer.

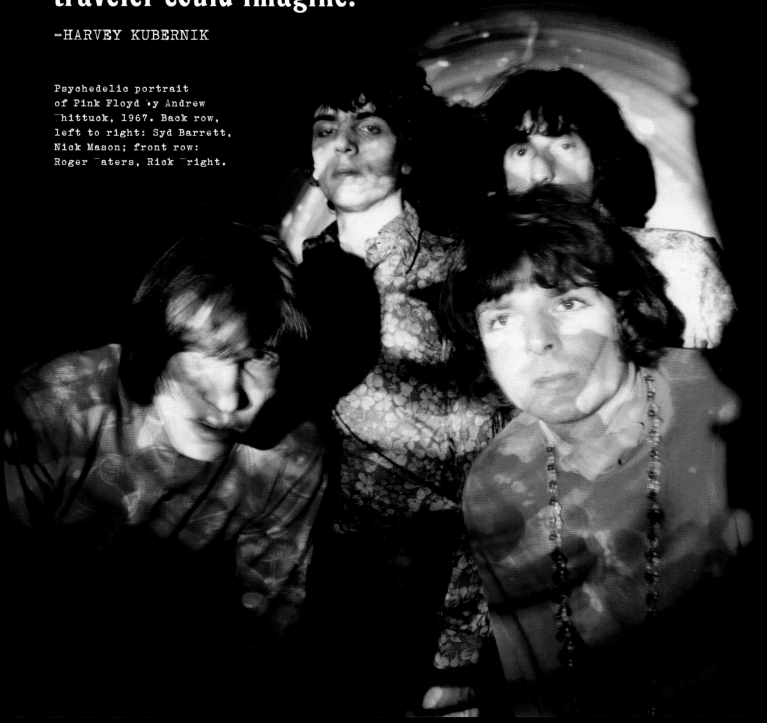

"While it's easy to fixate on Syd, keyboardist Rick Wright added his own distinctive seasoning to the songs, glissandos of reverberant, fuzzed-out organ that enlivened the virtues of a band on the brink of breaking up——Barrett's imminent exit——and breaking through, to a level of success not even the most excitable astral traveler could imagine."

—HARVEY KUBERNIK

Psychedelic portrait
of Pink Floyd by Andrew
Whittuck, 1967. Back row,
left to right: Syd Barrett,
Nick Mason; front row:
Roger Waters, Rick Wright.

The second week of August 1967 found the Beatles' "All You Need Is Love" atop all U.S. music trade magazines and constantly heard over AM and FM signals. On August 25, the Beatles traveled to Wales to study transcendental meditation with the Indian guru Maharishi Mahesh Yogi. He would become their spiritual adviser for a brief period from 1967 to 1968.

The Maharishi originated the Transcendental Meditation (TM) movement in 1957. He landed at the Honolulu airport in 1958 with a game plan to spread Transcendental Meditation as a global practice.

I was present at a 1974 press conference in Beverly Hills when George Harrison discussed Maharishi Mahesh Yogi, saying: "I have a lot of respect for him. He gave me help and plugged me in to a method of being able to contact that reservoir of energy which is within us all. Pure consciousness. I experienced it. He showed me how to reach that. Everything else is just words; beyond the intellect is to have an experience you have to have in order to know."

ABOVE: Photograph of Maharishi Mahesh Yogi, in Los Angeles at the Wilshire Ebell Theatre; photographed by Henry Diltz, May 11, 1967.

KENNETH KUBERNIK

"On the twenty-seventh of August, at age thirty-two, Brian Epstein died of an apparent overdose of barbiturates inside his Belgravia home—a tortured soul lost in a miasma of personal and professional disintegration.

"He left his charges, the Beatles, without their manager, their closest confidant, their steadfast bulwark against the madding tribulations of unimaginable success and its equally ruinous pitfalls. At that very moment, the group, along with various wives, girlfriends, and celebrated associates, was in Bangor, Wales [with] the impish Maharishi Mahesh Yogi. When word came of Epstein's passing, they turned to him for spiritual guidance. . . .

"Epstein's death would quickly become a footnote in the Beatles' epic saga. But he deserves better; it was his passion and uncommon decency in the cutthroat arena of pop music that kept the Beatles aloft. It was a more innocent time; there wasn't any precedent for turning a scruffy, skint quartet of . . . rock 'n' rollers into a titanic cash cow."

ANDREW LOOG OLDHAM

"I lived around the corner from Brian for a while. I think he lived on Chapel Street, whilst I lived in Headfort Mews, the one that was all car places. Anyway, we did not socialize. Fear and background, not any loathing. I liked him but I'm not really sure that he liked himself. Vanity must rule until you get a life that manages you and you get up daily for. I'm not sure that Brian would have thrived any better in today's gay-as-normal world. Either you are happy inside your own skin or you're not.

"Anyway, as I've said before, we all owe Brian a huge debt for getting the Beatles their recording contract. I mean, we would not be chatting now had the only UK hits in America been the Tornados, Petula Clark, and Acker Bilk."

In a rare and revealing interview with the *New Musical Express*'s Mike Hennessey shortly before his death, Epstein spoke candidly about loneliness, about a life without the promise of marriage and children, and the prospects of his only "family," the Beatles, leaving him behind. No longer touring, resolute in their studio endeavors, they had scant need for his long, enveloping shadow. Between the lines one could sense a weariness that some interpreted as a suicide note. He admitted that he'd considered it but the thoughts had passed.

"Asked about the frustration over finding his own creative outlet in the face of the Beatles's surreal stature, he said, matter-of-factly: 'I have learned to live with the idea that I'm the Beatles manager. I'm a creative person to a degree, but the biggest thing that has ever happened to me is the Beatles. I have overcome the feelings of frustration, but the Beatles always make an effort to involve me in what they are doing. And they do involve me.'"

Andrew Loog Oldham had left Epstein's employ in 1963 to pursue his own foolhardy fetish—managing, producing, and creating publicity for the Rolling Stones.

BELOW: The Beatles arriving in London after a trip to the Philippines and India, with Brian Epstein at far left, July 8, 1966.

Boston Tea Party

Travis Pike

"The Summer of Love did not spur the youthful, free sex, drug-induced revolution in Boston that it did in Haight-Ashbury or the East Village, but the homegrown psychedelic music coming from the West Coast, coupled with the psychedelic music coming across the sea from Great Britain, was mind-altering—even without embracing the associated drug culture it trumpeted. . . .

Flyer for Travis Pike and the Boston Tea Party, 1967.

"We Bostonians were big on patriotism and our place in American history. At the beginning of 1967, I formed Travis Pike and the Boston Massacre, a rock group taking its name from the pre-Revolution incident in 1770, nearly two hundred years before the Summer of Love.

"By that summer, our everyday jargon had become laced with phrases imported from the drug culture. I was 'turned on' by the Carnaby Street fashions at the Freaque Boutique in downtown Boston. . . .

"As for the Summer of Love's impact on Boston, of the many college students in my fan base, none ever expressed interest in Dr. Timothy Leary to me. There were pot smokers among them, to be sure, but it might be that my songs didn't appeal to hard-core druggies. Or maybe it was because I was an ex-GI who didn't attend anti-war rallies, advocate drugs, or disrupt traffic to call attention to my special interests. . . .

"Toward the end of that summer, when I learned we were being denied bookings because some venues feared that hiring 'The Boston Massacre' might incite riots, I changed our name to Travis Pike's Tea Party, still in keeping with our Revolutionary roots. I knew 'tea' was a euphemism for marijuana, but that summer, Jefferson Airplane had a huge hit with 'White Rabbit.' I loved Lewis Carroll's *Through the Looking Glass*, Grace Slick's performance, and the lyrics. I even incorporated the 'Unbirthday Song' from Disney's *Alice in Wonderland* as our Tea Party break song. I convinced myself that my clever use of double entendre to connect with my audiences was harmless.

"In my opinion, Boston gave the Summer of Love a miss, but it was nigh impossible to escape the drug culture that came with it. That summer, the music scene was shifted to the West Coast. San Francisco had Jefferson Airplane, Grateful Dead, and Big Brother & the Holding Company with Janis Joplin, but Hollywood had the Byrds, the Mamas & the Papas, the Association, the Beach Boys, and all the major record companies.

"I decided it was time to split, so I packed us up after the Summer of Love and set out to L.A. to make my California dreaming a reality."

JAMES CUSHING

"While it lasted, Donovan's moment was sweetly tender and deeply feminine . . . and the music on these records continues to delight the 14-year-old girl who lives and dreams inside all of us, regardless of our age or gender. The organ-jazz influence on the first disc of *A Gift* pushes the sound toward an adult sophistication, yet the words cherish tiny private feelings. On the second disc, all original children's songs with simple arrangements, Donovan offers a British answer to Pete Seeger's Folkways LP *American Folk Songs for Children*."

Portrait of Donovan on stage at the Hollywood Bowl, April 1966, by Henry Diltz.

KEITH ALTHAM

"Donovan is left out of the conversation. And he was very important; certainly in England, he was the high priest of flower power. I was kind of right there with him. Always liked him a lot. Particularly early on when he was getting kicked around for being a kid copy of Bob Dylan."

And some folks discovered or reinvested their ears into the world of Donovan that sweltering summer of '67.

Donovan's gently jazzy rhythmic bounce and memorable melodic gifts blossomed on his two 1967 releases, *Mellow Yellow* (March, U.S. only) and the two-LP box set *A Gift from a Flower to a Garden* (December, both on Epic). These albums flew independently of that year's hit singles "Epistle to Dippy" and "There Is a Mountain," suggesting the extent to which 1967 was Donovan's Moment. (His Anaheim Convention Center concert in September 1967 was the basis for the following year's *Donovan in Concert* release as well.)

That August, the Seeds' album *Future* was shipped to retailers. "March of the Flower Children," "Travel with Your Mind," "Flower Lady and Her Assistant," and "A Thousand Shadows" continued the Seeds' psychedelic path.

Near the end of the month, Big Brother & the Holding Company's eponymous maiden-voyage record on the Mainstream label followed.

James Cushing remembers his impression on first hearing the album: "Twenty-four minutes of lameness even Joplin's voice can't salvage. I remember how ripped off I felt in 1967 when I paid $3.49 for the first album by the band that, I had been led to believe, made as big an impression as Jimi Hendrix at the Monterey International Pop Festival.

"My very conservative father heard side one coming from my room: 'So, son,' he said, smiling, 'you're moving away from that rock 'n' roll junk into country-western now, I see.'

"I didn't play the record many times after that. It sounds like rough demos. It was what they were able to do with the amount of time and money given to them. Some of Janis's genius shines through. There was a poster of Janis where she is wearing a robe and the robe is open showing one breast. I got a much stronger vibe from her from that poster than I did from that record."

On August 27, 1967, the Peace Torch from Hiroshima arrived and traveled to Washington, D.C., where it was viewed at an anti–Vietnam War demonstration.

August 29 was the date on which the last network episode of *The Fugitive* aired on NBC-TV. Arranger Pete Rugolo did the musical score for producer Quinn Martin's series, which starred David Janssen. For many years, that finale was the most watched program in television history.

ROGER STEFFENS

"It was mandatory viewing for everyone. It was essentially a program about escape, as many people were trying to first do in 1966 and '67 and all during the Summer of Love.

"Science fiction played a huge role in sixties consciousness and the Summer of Love. We were able to accept the alternate universes and other dimensions of reality we are being prepared for. And then LSD came along and gave us the tool.

"In 1967 we still had *The Twilight Zone* on TV and *The Outer Limits*. Great programs. Rod Serling's *The Twilight Zone* made playlets out of stories I had read as a kid in the fifties in *Fantasy & Science Fiction* magazine. Ray Bradbury and Harlan Ellison had *Twilight Zone* screen credits. Serling's scripts were about fear, betrayal, paranoia, lust, censorship, and cosmetic surgery. He was the showrunner of a program about the movie and music business now. [Laughs.] Serling and Paddy Chayefsky were the great screenwriters for TV. They sounded more alarms more righteously than anybody else.

"Serling had a vision that connected with thinkers and musicians. In 1985, theme music for a new *The Twilight Zone* remake series was composed by Jerry Garcia and recorded by the Grateful Dead.

"*The Twilight Zone* first aired from 1959 to 1964. The shows made deep impressions. Then the first reruns started happening. And in 1967, remember, not everyone had color TV sets, so it was great and cool to still watch a series in black-and-white while the world, and especially Haight-Ashbury and Hollywood, was all going color."

ABOVE: Actor David Janssen, star of *The Fugitive*, photographed by Guy Webster, 1968.

Sundays Would Never Be the Same: Gary Pig Gold Drives Down His Summer of Love

Gary Pig Gold

"Once a week throughout the entire sixties, Dad would transport Mom and I all the way from our little suburban bungalow into the Big City of Toronto to have Sunday dinner with Grandma Creighton. Her turkeys really weren't bad at all, and when things got too boring—or should I say when the dessert cookies ran out—I'd sneak off to the kitchen, tune in to 1050 CHUM-AM, and bop my little feet away.

"Come '67, however, I would often be able to convince the adults to allow *The Smothers Brothers Comedy Hour* on Grandma's television when no one else was looking. But pretty soon that summer an entirely new form of, um, entertainment reared itself: 'Dad? Can we? Can we *please* on the way home tonight?' I'd plead, and if he was in the mood we'd take an extra few minutes to pilot the family Austin on a detour down none other than Yorkville Avenue. Yes, straight down *that* block or so where the Toronto *Globe and Mail* was anxiously reporting 'Police

Beat Up Hippies During Yorkville Sit-In! Protest Brings Kicks, Judo Chops.' Yep, this sounded even more action-packed than watching Tommy and Dickie bring the Who onto the local CBS-TV affiliate!

"Of course, this being O Canada, unlike their rebel-rousing comrades in tie-dye on the Haight, the Yorkville youngsters' idea of 'protest' consisted mainly of tossing sandwich wrappers defiantly onto the sidewalk rather than placing them into the proper receptacles, while horse-mounted Ontario Provincial Policemen tsk-tsk'd, 'You kids better start heading home. Don't forget the streetcars stop running early on Sundays.' Nevertheless, as Dad inched our way ever cautiously down the avenue, reminding Mom and I to 'keep your windows rolled all the way up and your doors locked—just in case,' I would view with a deep mixture of fascination, which quicker than later turned into envy, all of these brightly garbed, recklessly long-haired and—Wow! Just like

Donovan!!—guitar-playing boys and girls laughing and lounging all over the steps of the Purple Onion, El Patio, and Penny Farthing. All to the chilling accompaniment of the Lords of London's 'Cornflakes and Ice Cream' blaring comfortably that week from its No. 2 spot on the CHUM Hit Parade.

"But all sweet things *do* come to an end, and suffice to say those Lords, Grandma Creighton, and even Yorkville itself are long, long gone. Replaced, in the case of the latter, with an ironically ultra-chic shopping district full of well-to-do neighborhood retirees and American film stars exercising their credit cards between takes. Nevertheless, a half-century later, whenever I find myself strolling this particular area of Toronto the Good, what's left of my mind immediately drifts back to fastidious turkey dinners lovingly digested whilst cruising the couple hundred yards down the once and possibly forever hippiest street Canada *ever* produced."

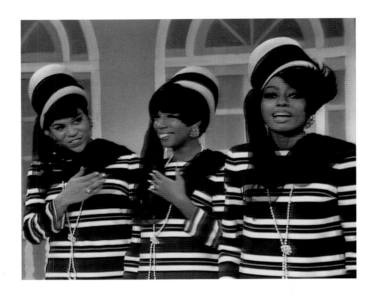

The 1967 International and Universal Exposition, or Expo 67, was a World's Fair held in Montreal from April 27 to October 29, 1967.

The Ed Sullivan Show had been broadcast live on May 7 and May 21 from the Expo 67 venue. Spotlighted were the Supremes from America, the Seekers from Australia, and Britain's Petula Clark.

Visiting the location that year were Queen Elizabeth II, U.S. president Lyndon Johnson, New York senator Robert F. Kennedy, Jacqueline Kennedy, Princess Grace of Monaco, Bing Crosby, Harry Belafonte, French president Charles de Gaulle, and Maharishi Mahesh Yogi.

On the exhibition's premises and entertaining the crowds were Tiny Tim, the Tokens, the Grateful Dead, Jefferson Airplane, and Thelonious Monk.

ABOVE: The Supremes, performing on *The Ed Sullivan Show* broadcast live from the Expo 67 in Montreal, back in May 1967.

BELOW: A present-day image of the American Pavilion, a geodesic dome designed by architect and inventor Buckminster Fuller for Expo 67, now an environmental museum called the Montreal Biosphère.

In February 1967, a psychedelic symposium called Perception '67 had been held at the University of Toronto. Timothy Leary was invited (but was not able to attend). Canadian philosopher Marshall McLuhan was on faculty at the university, and his influential book *The Medium Is the Massage*, co-created with graphic designer Quentin Fiore, was published in 1967. French Dadaist Marcel Duchamp and American avant-garde composer John Cage later appeared together at Ryerson University, Toronto's polytechnical college, at the SightSoundSystems Festival, where in March 1968 they played a game of "musical" chess. Andy Warhol movies were shown on Toronto's Yonge Street, where head shops and black-light posters were now more evident in that city.

BELOW: Toronto's CHUM-AM Top of the Charts, the week of August 21. Compare the Top 10 with the U.S. KHJ-Boss chart from the week before on page 167— they share only three songs: "Ode to Billie Joe," "All You Need Is Love," and "Reflections."

LARRY LeBLANC

music journalist, writer, radio broadcaster

"Bill Graham brought a week of shows, 'The San Francisco Scene in Toronto'—from July 31 to August 5, 1967—to Canada with Jefferson Airplane and the Grateful Dead, including [a show at] the O'Keefe Centre in Toronto with Luke and the Apostles.

"On a Saturday, he had the bands play a free show at Toronto's City Hall Square. That changed Toronto and Canada forever. Killed R&B bands that dominated Toronto until that date. . . ."

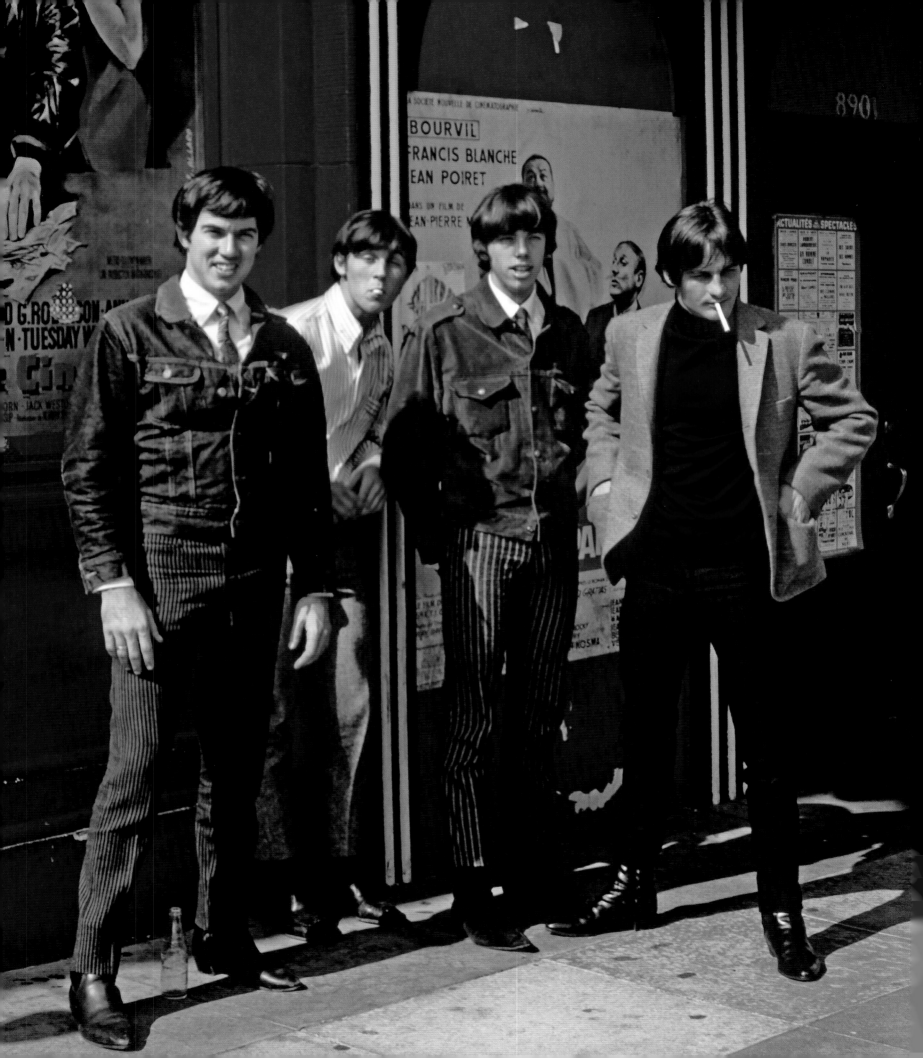

BAREFOOT IN THE PARK

Not content to be overshadowed by their pop music confederates, in 1967, filmmakers were also challenging the strictures of storytelling and subject matter. Two movies, released in late August/September of that year, in particular stood out as cinematic equivalents to *Sgt. Pepper's* boldly innovative, game-changing effect.

Bonnie and Clyde, written for the screen by David Newman and Robert Benton and directed by Arthur Penn, took the shopworn scenario of Depression-era gangsters, a trope as tired as a Cagney impersonation, and reimagined it as a sublime interior melodrama—Ibsen on the run. As played by damaged heartthrob Warren Beatty and the predatory Faye Dunaway, these tormented desperados mirrored a culture in free fall; their mad, inchoate impulse to violence, choreographed into a bullet-ridden ballet, echoed America's pathological preoccupation with guns, a kind of theater of delusion, catharsis without a satisfying climax. "The Ballad of Bonnie and Clyde," recorded by Georgie Fame, would hold the No. 1 UK singles chart listing in January 1968 alongside Top 10 placement in the States.

In the Heat of the Night, directed by Norman Jewison and written by Stirling Silliphant, explored another monster lurking in America's anxiety closet: race. Violence played out as a tribal dance, a mindless instinct condoned by a feckless authority unwilling or unable to act with conscience, good or bad. Starring Sidney Poitier, Rod Steiger, Warren Oates, and Lee Grant, the film had a musical score by Quincy Jones and a title tune sung by Ray Charles.

Hollywood has always been filmic. And now the "In" sound being heard around this town had become more cinematic as well.

When the seminal Whisky a Go Go venue opened at the beginning of 1964, it signaled a change that wiped the beatnik coffeehouses off the Hollywood map. It quickly became a mecca for beehive hair and sharkskin suits.

OPPOSITE: The short-lived L.A. band the Gene Clark Group, photographed in 1966 in front of the Whisky a Go Go by Henry Diltz. From left to right: Chip Douglas (ex-Modern Folk Quartet, Turtles, soon-to-be Monkees producer), Bill Rinehart (ex-Leaves), Joel Larson (ex-Grass Roots), Gene Clark (ex-Byrds).

"**With the white-booted go-go girls Frugging in overhead cages and Johnny Rivers bringing in the likes of Steve McQueen, Jayne Mansfield, and the Beatles doing the Watusi and the Swim, it was the hottest place on the Strip. And a room in 1967 where rock 'n' roll thrived.**"

–HARVEY KUBERNIK

KIRK SILSBEE

"As early as '65 . . . headliners [at the Whisky] included: Paul Butterfield, the Rascals, the Leaves, Love, the Mothers of Invention, the Beau Brummels, Otis Redding, the Gentrys; by the end of that year, *Los Angeles* magazine pronounced the club 'the inviolable center of What's Happening.'

"In the spring of '66, at the urging of Byrds bassist Chris Hillman, owner Elmer Valentine installed Buffalo Springfield as the Whisky's house band. It quickly established them as the next important milestone in the Hollywood Renaissance—after the flowering of the Byrds and Love. Vito Paulekas and his twirling, snaky dance troupe invaded the dance floor, and Genie the Tailor, the legendary rock couturier, caught Neil Young's eye. A flashing strobe light roused Young's violent ire and he screamed for the light man to cut it, lest his epilepsy be triggered. The after-party attracted Hollywood A-listers like salon owner Jay Sebring and *L.A. Times* scribe Pete Johnson.

"Whisky booker Ronnie Haran ducked next door to the nothing-happening London Fog [club] and decided to take a chance on the [Doors, who had been playing there], whose lead singer had been sleeping on the beach. She helped the Doors get some better clothes and join Local 47, and, of course, gave them their first big break. A week of opening for Them culminated in the last night with both bands onstage and two Morrisons singing 'Gloria.' Whisky dancer Michelle Angelo came out of her cage to become the most prolific skin model in Hollywood for a couple of years—including an iconic shot in psychedelic body paint for *Playboy*. . . .

"Near the end of 1967, the over-twenty-one policy restriction had been relaxed to age eighteen [see page 29]. Sunset Strip soul dovetailed with locals Peanut Butter Conspiracy, the Gene Clark Group, Kaleidoscope, Sweetwater, and a San Francisco jolt via Jefferson Airplane, the Grateful Dead, Moby Grape, Big Brother, and Country Joe.

"The Whisky was the most important pop showcase and the next year saw a booking surge of British bands, beginning with the first SoCal appearance of John Mayall's Bluesbreakers. Mayall considered the sunshine, the bucolic serenity of nearby Laurel Canyon, the graciousness of Frank Zappa and Canned Heat, and thought: *This is heaven*."

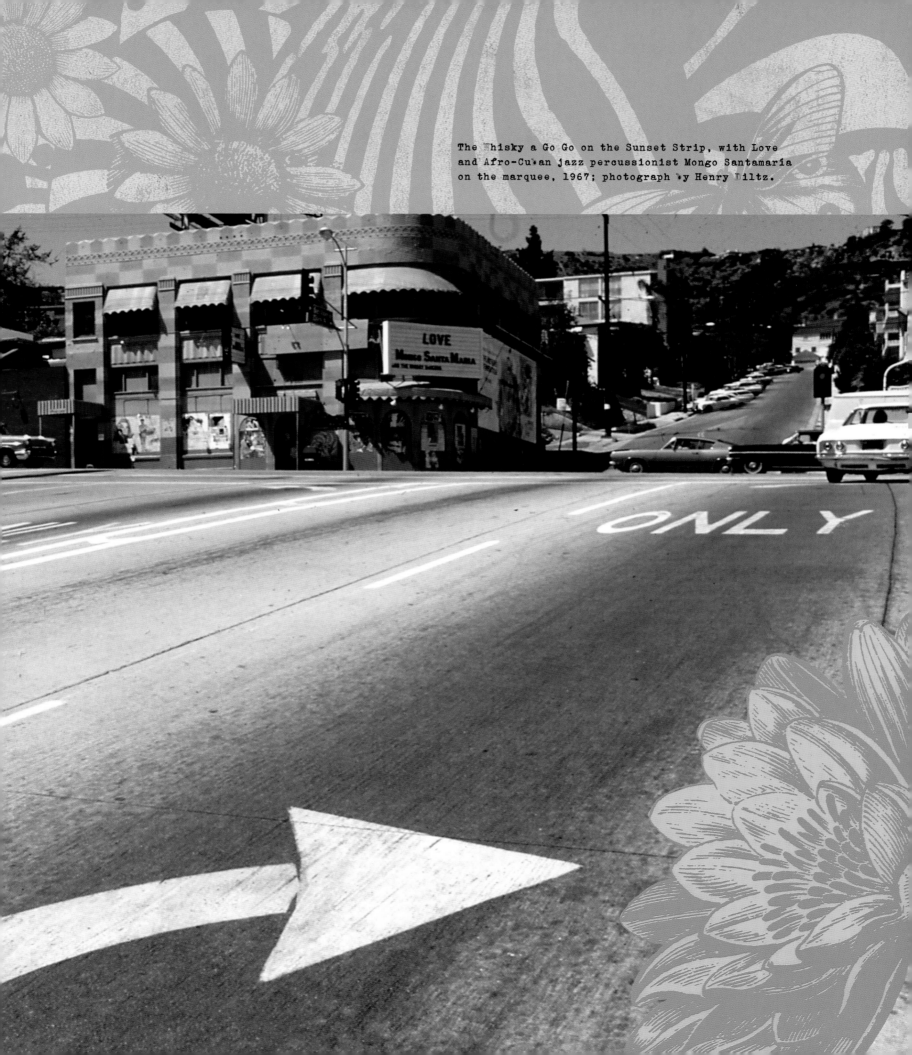

The Whisky a Go Go on the Sunset Strip, with Love
and Afro-Cuban jazz percussionist Mongo Santamaría
on the marquee, 1967; photograph by Henry Diltz.

JOHN MAYALL

"After the guys left to form Fleetwood Mac, I hired Mick Taylor for the guitar position and decided at that time to add horns to the lineup, which broadened the scope of the songs we played live and enabled me to extend the blues catalog. Horn players usually have a jazz background, and this was a helpful element to add to the quartet format.

"The British musical press at this time wasn't giving enough attention to some of the American great bluesmen, and I wanted to give the fans clues as to where to broaden their knowledge of great but some-times neglected performers. It was a way also to make the British press aware of what was going on under their noses.

"First of all, I don't hold auditions for anyone I hire. I generally go by gut instinct, and in Mick Taylor's case, I had heard him play a year or so earlier when he sat in at a club gig on a night when Eric Clapton didn't show up. Mick also got on very well with a horn-section direction in my band. . . .

"I was of course aware that stations were playing my records, which all helped to spread the word about what I was doing for the blues. Probably helpful for me to be in demand enough to do my first U.S. tour in January 1968."

Chicago-style blues, an urban brew laced with a Southside electric charge and a loamy, relentless pulse, invaded England with the same sense of shock and awe as did British beat bands when they appeared on America's shores.

John Mayall, musical vagabond and blues purist, almost single-handedly pushed his interpretation of the black American musical vernacular into Britain's consciousness. In July 1966, his album *Blues Breakers with Eric Clapton* (aka *The Beano Album*—Eric Clapton is reading *The Beano*, a British comic, on the album cover) improbably crashed into the UK Top Ten. The Bluesbreakers' guitarist, the unassuming if equally passionate Slowhand, left to form his own blues-based outfit, Cream, that same month. With his fourth album, *Crusade*, issued in early September 1967, Mayall dramatically expanded his musical palette, adding horns, rousing orchestration, and the scintillating licks of his latest guitar discovery, the nineteen-year-old future Rolling Stones member Mick Taylor. *Crusade* was more than a powerhouse reimagining of an often over-familiar idiom—it was an article of faith for this lionhearted champion of the blues realm.

The 1967 music and Summer of Love commercial and cultural validation event in Southern California took place on September 15, 1967: *Bill Graham Presents the San Francisco Scene* at the 18,000-seat Hollywood Bowl with Jefferson Airplane, the Grateful Dead, and Big Brother & the Holding Company.

According to Bill Graham, "There was never a San Francisco sound or a Boston sound. They may do the same thing to an audience, though, which is to give them pleasure.

"In the long run it's the public that has to get the good energy from them. I really sincerely feel this. Those of us who live in the Bay Area have always had the same goal: We want to turn people on and we want them to have a good time."

TOP: Portrait of John Mayall by Guy Webster, 1968.

OPPOSITE: The Grateful Dead in one of their famed live performances, at the Monterey Pop Festival in June 1967; photograph by Howard Wolf.

"I like the live experience. That's where it counts. That's when music is real. It's real in that situation. That's the situation that I feel I have the greatest sense of personal responsibility about. I don't mind putting out a bad record, but I really hate a bad concert. That really is depressing. I just hate personal failure, being on stage and going through the changes and playing bad because I'm either not well, tired, too stoned, whatever. To me it's an aversion therapy thing. It's the reason I've been able to survive."

—JERRY GARCIA

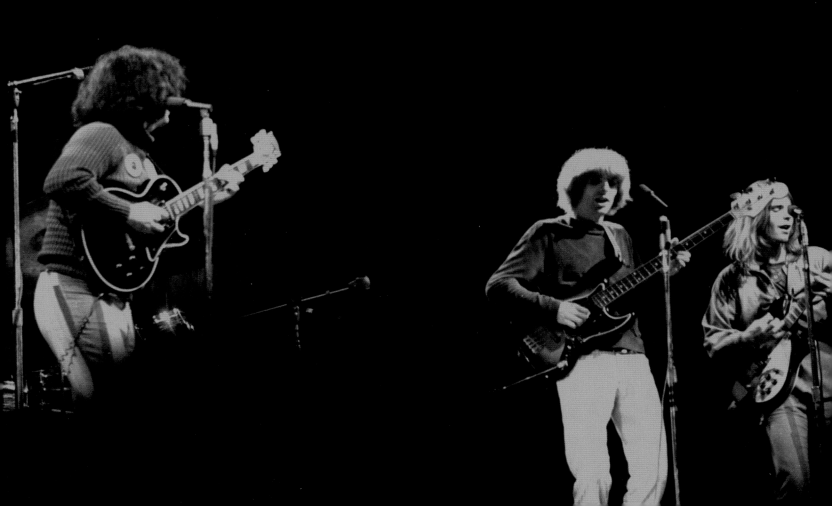

DENNIS McNALLY

author, music historian, publicist

"It's the relationship between the audience and the band. It's so tightly bound that it's like a force field. That is what the Grateful Dead is all about.

"There's no audience in the [recording] studio! They did something very interesting, a flawed masterpiece in *Anthem of the Sun* [July, 1968], and progressively they got less and less interested in the studio. I greatly admire [former Warner Bros./Reprise] record executive Joe Smith. I think the Grateful Dead were incredibly lucky to have him then."

BILL WALTON

NBA MVP and Grateful Dead aficionado

"There are a lot of similarities between the Grateful Dead and a basketball squad. Creativity, teamwork, speed. You don't know what's gonna happen from one moment to the next. It's not scripted. . . Brilliance in performance is the main similarity. Commitment. Passion for work. Jerry Garcia is not one of those guys who sits around thinkin', 'Gee . . . I just can't wait for this to be over.' He just wants to work every day. For people like Garcia and [Larry] Bird, there's never enough."

L ed Zeppelin founder and guitarist Jimmy Page called the L.A.-based Kaleidoscope "my favourite band of all time—my ideal band—absolutely brilliant." Their debut LP *Side Trips* was a companion item to the Summer of Love. Initially released in June, it garnered the first radio airplay and wider distribution by September.

Despite its 26-minute total playing time, *Side Trips* stands out as one of the most daring, confidently eclectic releases of 1967, a "folk-rock" statement the equal of *Fred Neil* and the Byrds' *Younger Than Yesterday*.

BELOW: Solomon Feldthouse, Chris Darrow, and Chester Crill of Kaleidoscope, performing at a love-in in California, 1967; photograph by Pamela Lauesen.

JAMES CUSHING

"A first-time listener would be forgiven for thinking that the album [*Side Trips*] was a compilation of different bands—the variety is so wide. The music draws on historical and international traditions: hokum blues ('Come On In'), psychedelia ('Keep Your Mind Open,' 'Pulsating Dream'), Cab Calloway's swing ('Minnie the Moocher'), even Middle Eastern instruments like the oud and vina ('Egyptian Gardens,' 'Why Try'). Best of all, the group's humor and sheer delight in playing these tunes keeps the music from any pretention at High Art."

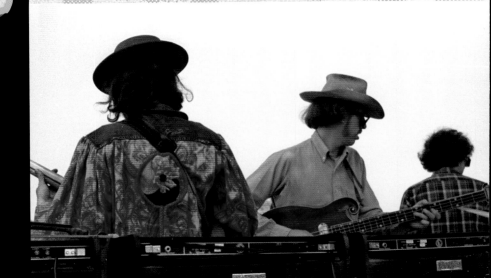

A major factor behind the West Coast–birthed Summer of Love music scene was a meeting that approximately sixty managers and artists from San Francisco requested with Chet Helms and with Howard Wolf, the talent buyer from 1966 to 1971 for San Francisco's Avalon Ballroom and Family Dog.

Howard Wolf explains: "[The San Francisco-based music groups] were really dissatisfied with artists from Los Angeles' being presented at the Avalon and coming into their San Francisco scene. This goes back to 1966 with the Grass Roots. And now the Doors are at the Avalon. The problem was one-sided. Los Angeles and Hollywood loved San Francisco. But San Francisco didn't love Los Angeles.

"After I asked [the San Franciscan] artists where they were born, and how long they had actually lived in San Francisco, it was apparent that virtually no one was born and raised in San Francisco. They had migrated from other cities like San Diego, Chicago, or Detroit.

"I asked them if they would like to perform in other cities across the country. They virtually all said yes. 'How do you think you could do that?' I asked. I then explained one of the reasons they could, is that I would bring artists from the city they were from, and put the San Francisco artists on the bill, and both would be on the poster. When the poster went back to that city, that's how they would be recognized.

"A year later the Doors are No. 1 all summer and fall with 'Light My Fire.' Just before they had a hit record, I arranged for the Doors to play the Avalon over a weekend. It was a big step in setting up the Los Angeles-music-to-San Francisco pipeline. These are the artists I brought up in 1966 from L.A.: Love, Sons of Adam, Leaves, Grass Roots, Captain Beefheart, Buffalo Springfield. In 1967, I also brought up Lee Michaels, Sparrow, Other Half, Doors, Chambers Brothers, Taj Mahal, and Canned Heat.

"Record labels and an act's agent would always send me their new LP releases and tell me to buy them and that they would all be stars after the album was successful."

JAMES CUSHING

"Blues was the default sound of much 1967 rock, and while the Captain's debut LP is certainly blues-based, it does not display white baby boomers in search of authenticity. Rather than recreate a borrowed Delta or Chicago sound, the Captain goes for his native surrealist poetry, and the Magic Band—especially guitarist Ry Cooder and drummer John French—create rhythm patterns (especially 'Abba Zaba' and 'Electricity') that fit into no contemporary paradigm. . . . *Safe as Milk* was one of John Lennon's favorites of that year—he was photographed more than once with the souvenir 'Safe as Milk' bumper sticker visible in the background."

Captain Beefheart and His Magic Band's *Safe as Milk*—released by Buddah Records in September 1967, and produced by Richard Perry and Bob Krasnow—belongs in a rarefied category. Like *Songs of Leonard Cohen* or *The Velvet Underground & Nico*, *Safe as Milk* was not a hit in 1967 but became enormously influential on later artists, and all three albums stand today as revealing starting points for great careers (Beefheart was also successful record producer Richard Perry's first production).

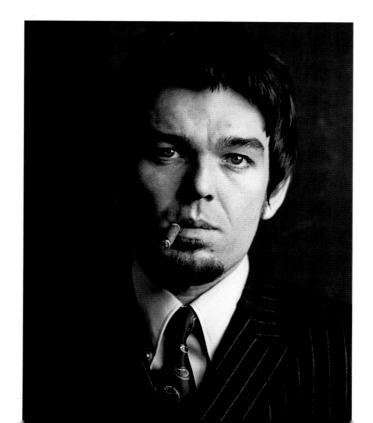

RIGHT: Portrait of Don Van Vliet—Captain Beefheart—by Guy Webster, 1968.

"The studio was a place where we could really experiment. We could put on our lab tech coats rather than coming in with our mod outfits. It's almost as if we put on our glasses. I felt like I was in a 1932 German science-fiction movie. And we were preparing this strange concoction called *Strange Days*. Jim got his chops together.

"And by then, he could sing, man. That throat had opened up and that man was singing."

—RAY MANZAREK

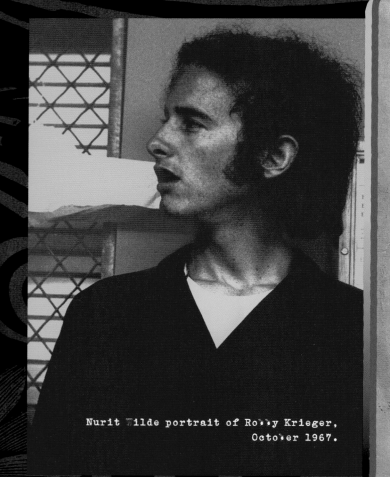

Nurit Wilde portrait of Robby Krieger, October 1967.

ROBBY KRIEGER

"The last song we did on the *Strange Days* album was 'When the Music's Over.' We had been doing it live a lot, and it was fun because it was different every night, kind of like 'The End.' Lots of improvising.

"So the night before we were to record, the phone rings about 4 in the a.m. I knew who it was. Jim says . . . 'Robby, Pam and I took too much acid, man, you gotta come over. You gotta help us.' I got out of bed and drove over there, fearing the worst. They were like helpless babies, not on a bummer, but more just bored. I immediately knew what to do. When on acid, always seek nature! They wanted me to take some but I refused. I said, 'Let's go across the street to Griffith Park. It'll be great!' 'Yeah, yeah,' they were excited! As they started out the door, I said, 'Shouldn't you get dressed first?' They agreed and out we went. They were freaking out, having a great time, so I figured they were okay.

"I said, 'Jim, remember we're recording tomorrow.' 'I'll be there.'

"Of course he wasn't. Probably asleep, we assumed. What to do? Ray said, 'Let's just do the track, and leave spaces where Jim does his thing.' We decided it was worth a try, so we laid it down, trying to imagine where Jim would come in, and other such improvisations that were different every time we played it. Finally Jimbo shows up eight hours late, pretending to have forgotten the 2 p.m. start time. . . . He got it in one take. Amazing!"

On September 17, 1967, the Doors were booked for *The Ed Sullivan Show*. Before the appearance, they had a meeting with a producer who demanded that the word "higher" be changed in the lyrics of "Light My Fire."

Jim Morrison was angry about this request imposed on him, but the group relented. The Doors informed the executive they would change the lyric as he requested. However, as soon as the producer left the premises, Morrison allegedly declared, "We're not changing a word."

After the Doors' live slot was finished, Sullivan chose not to shake hands with the group, contrary to his stage custom; Ed and his cameras went straight to commercial. Backstage, the show's producer was furious and told the band, "Mr. Sullivan wanted you for six more shows, but you'll never work *The Ed Sullivan Show* again." To which Morrison replied, "Hey, man. We just *did* the Sullivan show."

On September 25, 1967, the Doors' second album, *Strange Days*, was released. Recorded at Sunset Sound Studio, with Bruce Botnick engineering and producer Paul Rothchild manning the helm, *Strange Days* was a sparkling follow-up to their audacious debut album from January.

ROB HILL

journalist, writer, magazine editor

"It was a continuation of the eerie underworld they had created on the first album: the three-minute 'Strange Days' kicks the album off with pure paranoia—Morrison's guttural voice buried in the mix like he's singing from underwater; 'You're Lost Little Girl' oozes sweet alienation; and 'Moonlight Drive' is a bewitching ode to an evening on the shores of the City of Angels with your lover. It also contained another epic eleven-minute song to end the album, 'When the Music's Over,' a staple during their live shows. All the songs were written during the summer of '65–'66 and had been fine-tuned and cooked by playing them night after night on the Sunset Strip."

The Doors giving their infamous performance of "Light My Fire" on *The Ed Sullivan Show*, September 17, 1967.

What it lacked in a defining moment like "Light My Fire," it more than made up for in the consistency of the material, adventurous use of the studio—the introduction of an 8-track recorder opened new musical vistas—and the confidence of a band finding its footing as a cohesive unit.

Rothchild, the "fifth Door," encouraged them to explore new sonic territory; the use of the Moog synthesizer on the title track and "Horse Latitudes," and the use of tango rhythm on the impressionistic "Moonlight Drive," showcased their changeling character. There is nothing comforting about their music; like the country's own spiral into a dark wood, they embraced confrontation with a theatrical flourish that portended strange days, indeed.

8-Track Sound

Technology wasn't just affecting the way musicians performed and recorded—it was also transforming the way the listener experienced the music. During 1967, there was a big increase in headphone advertising and product availability, which enabled further discoveries in the new audio-stereo world.

Consumers were being introduced to a variety of playback systems guaranteed to enhance their pleasure, none more "hip" than the 8-track tape cartridge. Kind of clunky—just a big chunk of plastic—it suggested access to the quality of sound reproduction used during the initial taping process. It didn't.

"I was working for Ampex Tapes as their national sales manager in New York," says Howard Shapiro, at the time an executive in sales and distribution for Ampex tapes. "The company were in early with Bill Lear of Lear Jet Corporation, who developed the 8-track cartridge. Inventor Earl 'Madman' Muntz in Hollywood had created the Muntz Stereo 4-track tape

cartridge especially for car installation [see page 110].

"By 1967, car manufacturers made the 8-track a factory optional item. You could now hear your albums in your car. At Ampex we did very well all through the sixties with reel-to-reel tapes. Not everyone had a tape player at home. By 1967, the listener was no longer stationary. The options were the transistor radio, the car

radio, and now the mobile 8-track cartridge machine.

"8-track really spread the music to the younger generation. Rack jobbers and sales staff would also stock the 8-track unit in new outlets like car washes."

BELOW: View inside a 1967 AMC® Ambassador two-door sedan with its 8-track tape player.

While the world was waiting for a new Beach Boys album in 1967, it should be noted that a handful of U.S. DJs—Roger Christian and Bob Dayton at KBLA, Mark Lane in Las Vegas on KENO, and Murray the K on WOR-FM—instead spun "My World Fell Down" by Sagittarius, a Columbia Records studio collective headed by Gary Usher in conjunction with production partner Curt Boettcher.

Usher had co-written the Beach Boys songs "409" and "In My Room" with Brian Wilson. In 1967, he also produced the Byrds' *Younger Than Yesterday* LP. The musicians were Local 47 L.A. session players, and the vocalists on the alluring track included Glen Campbell, Bruce Johnston, and Terry Melcher.

With the Beach Boys riding the crest of critical acclaim (though not commercial success) with *Pet Sounds*, expectations were running high for their next album. Capitol Records, hungering for hits, set a January '67 release date for the new recording, initially titled *Dumb Angel* but changed to *Smile*. Brian Wilson, the band's tormented, creative heart and soul, was toggling between genius and mental breakdown during this period.

When he was "on," Brian produced "Good Vibrations," then the most expensive single ever recorded (approximately $50,000 in studio costs), which commanded charts around the world in the fall of 1966. Was there another magnum opus lurking within that mercurial mind? While the band went off to tour Europe, Wilson returned to the studio; ever restless, he moved between Columbia, Western, and Gold Star, among others, in search of the miraculous.

He was accompanied by a young singer/songwriter named Van Dyke Parks, who, as their collaboration decreed, occupied an often heroic, somewhat mysterious, and important role in the overwrought Wilson mythology.

Brian soon succumbed to his demons, months of recording sessions devolving into a fractious pastiche of their fabled harmonies, with tantalizing hints of something grander, more operatic, left in both the studio vaults and the perfervid imaginations of the group's most earnest enthusiasts.

Capitol, pushed to the brink of their corporate patience, finally issued a simplified version of the album, *Smiley Smile*, in September. In the wake of *Sgt. Pepper's* and a raft of other luminous recordings making memorable waves, the Beach Boys suddenly sounded lost at sea.

BELOW: Brian Wilson on a motorcycle in California, c. 1967; photograph by Guy Webster.

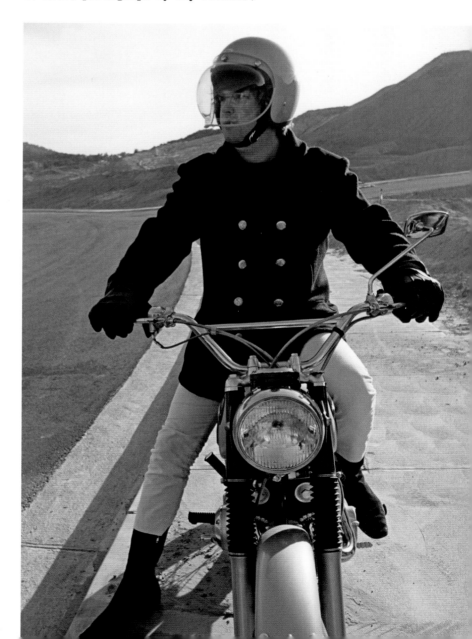

AL JARDINE

singer, songwriter, guitarist,
the Beach Boys

"Brian wanted everything to be about doing a home movie. What we did, really, is start making home movies. And he got a big old Baldwin® organ from the company and he loved it. And he obsessed over that organ, and that became the centerpiece of our *Smiley Smile* album. A very peaceful album. We would later open concerts with it: 'Heroes and Villains.' And, for some of our sessions, we were using our PA mikes on *Smiley Smile*."

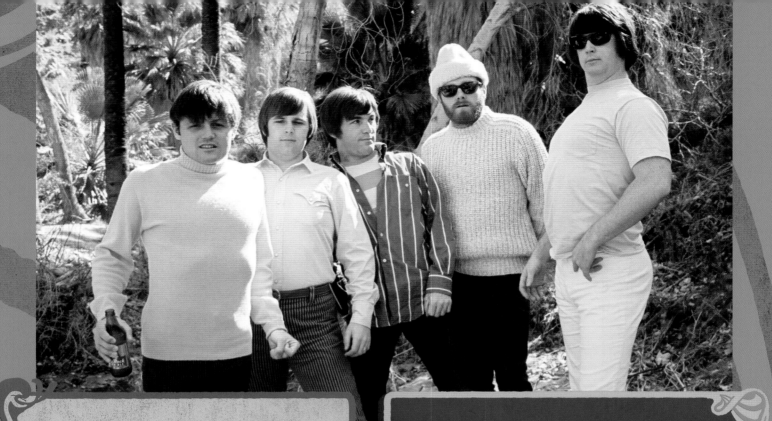

MIKE LOVE

singer, songwriter, musician,
the Beach Boys

"Like, when I first heard the track of 'Good Vibrations,' I said, 'Wow. How are the people in Omaha gonna take this?' I loved the tracks on 'Good Vibrations.' Here's my frame of reference. 'Good Vibrations' was the chorus Brian and I came up with and the lyrics I wrote went to No. 1. Thank goodness. And that was fabulously successful, phenomenal, and the biggest hit of the sixties for us. And we had some pretty good-size hits.

"I just remember the tracks that Brian did were incredible. 'Heroes and Villains' reminded me and made me think of the *William Tell* Overture. You know, it's so dynamic and powerful. And 'Wonderful' is so beautiful and sensitive. Makes you cry. And although I didn't agree with Van Dyke's lyrics on every single thing, I thought he did a marvelous job on that. 'Wind Chimes' . . . I mean, give me a break. That is so beautiful."

BRIAN WILSON

singer, songwriter,
multi-instrumentalist, the Beach Boys

"I was tired of the pop-song structure. For 'Good Vibrations,' I wanted it to be different and a departure. I liked writing in pieces. That was easier for us. I would say when it was time to write a section, 'Hey, here's a rhythm pattern.' Overall we couldn't get through a whole song. Mike's voice on it was the thing that sold me on it. Mike's bass-part singing got us famous. Because his voice has a quality to it that goes hand in hand with the song. He was the appropriate singer for the song."

"If ever an album was created for headphones listening, this release should be placed at or close to the top of the list.

—ELLIOT KENDALL, WRITER, ARCHIVIST, MUSICIAN

In the celebrated summer of this most celebrated year, one song stood above all others, its Everest-like status conferred by no less than John Lennon and Paul McCartney, who were enthralled by the Chaucerian wordplay and heavenly Baroque accompaniment. "A Whiter Shade of Pale," by Procol Harum, galvanized a congregation of disaffected youth dismissive of traditional religion but anxious to achieve spiritual salvation.

Recorded in March under the critical ear of producer Denny Cordell, the song's galvanic ascent up the charts led to one of those arcane U.S./UK album release anomalies so common at the time.

"A Whiter Shade of Pale" was included on the group's eponymous debut LP released in September in the States, predating the British version, which did not include the hit—owing to the band's desire that fans not pay twice for the song, inasmuch as everyone bought the single.

RIGHT: Procol Harum, photograph by Guy Webster, 1966.

OPPOSITE: The Beach Boys, photographed by Guy Webster in c. 1967; from left to right: Bruce Johnston, Carl Wilson, Dennis Wilson, Mike Love, and Brian Wilson.

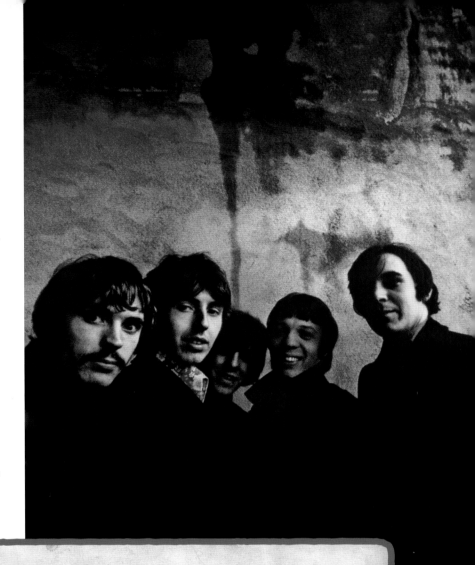

KENNETH KUBERNIK

"Procol Harum's inscrutable tale of light fandangos and vestal virgins was the product of a fortuitous encounter between two talents in search of pop's holy grail—a hit record.

Singer/pianist Gary Brooker worked the bruising R&B circuit from London to Leeds, pounding the keys for the Paramounts. A fortuitous encounter with Keith Reid, whose wire-rimmed, bookish countenance seemed better suited to a Hogwarts lectureship than jobbing pop lyricist, resulted in an unlikely musical partnership—Reid's penchant for literary allusiveness fitting neatly into Brooker's stout arrangements. The air of distinction, though, fell to the celestial gravitas of Matthew Fisher's Hammond® organ. A stalwart presence in jazz and blues, the organ was beginning to mark its territory in pop. . . . Fisher's transposition of Bach—the Lutheran solemnity, the stately keyboard pirouettes—with grand tidal surges of block chords conveyed a sense of moral uplift more identified with the black American church, echoing the sing-out, praise-be soulfulness of Curtis Mayfield and

Percy Sledge. It was 'hallelujah!' for a pale-faced generation.

"Since Procul Harum were more an idea than a fully functioning band, the record's outsize success (six weeks straight at No. 1 in the UK charts) required an immediate follow-up, let alone an album's worth of material. . . . Brooker recruited guitarist Robin Trower and drummer B.J. Wilson from his Paramounts days to join him, Fisher, and bassist David Knights on stage.

"Under producer Denny Cordell's mindful direction, Procol Harum's eponymously titled first album proved that they were no one-hit wonder. Yes, there was a dash of Dylan throughout; the free-wheelin' piano/organ colloquies on 'A Christmas Camel' and 'Something Following Me' were kith and kin to the thin man's left-handed balladry. . . .

"Procol Harum enjoyed a ten-year run, appealing to the most discerning of rock music listeners. Apropos for a band named after a friend's cat, they were by design and temperament regal and enigmatic. And their one imperishable contribution to the canon endures, well beyond the feline allotment of nine lives."

My Summer of Love 1967

Marina Muhlfriedel

"Some cloudy February afternoon. 1967. A funky green car pulls up at our family's Spanish Westside duplex. For some reason, I'm outside in the front yard. Maybe I'm on my way home from school. Leaping from the backseat, my sister Leslie grins knowingly. Hands me a sealed envelope. 'Give this to Mom and Dad,' she says. And, like that, runs away to Haight-Ashbury.

"It was heartbreaking to see my parents so devastated, but, at thirteen, there was a part of me who thought Leslie's fleeing L.A. for San Francisco's flower power vortex was the most magical thing ever. The letter declared to Mom and Dad, 'Your world isn't my world anymore,' and so on. A few months later, *Sgt. Pepper's* would be released and the Beatles' song 'She's Leaving Home' would echo through my life.

"From the start, I was awed by how Leslie was always at the heart of the hippest music scenes. From the East Village to San Francisco to San Diego and more than anywhere, to the Sunset Strip, where she hung with Love, the Leaves, the Seeds, the Byrds, Iron Butterfly, Frank Zappa, Buffalo Springfield, Taj Mahal, the Doors (then the Doors of Perception), and so on, while I chased the crumbs, begging to go to weekend shows at Bido Lito's and the Cheetah. . . .

"[I] got an acoustic guitar and learned to play Phil Ochs, Woody Guthrie, Peter, Paul & Mary, and Richard and Mimi Fariña tunes. I bought my first single, 'For What It's Worth,' and waited in line at a tiny record store on Pico to buy the Doors' *Strange Days*. I fell in love with Tim Buckley's *Goodbye and Hello* and later the *Songs of Leonard Cohen*, probably the two most influential albums of my life, unleashing a love of poetry and an insatiable drive to write. . . .

"Leslie, meanwhile, moved into an apartment at the corner of Haight and Broderick, and like many other flower children, by day worked a job at the U.S. Post Office and, by night, tripped into the thick of San Francisco culture. She bought me a subscription to *Royal's World Countdown* music paper and sent cards from the Fillmore, with mind-twisting couplets on the back. I knew as much as one could about the San Francisco music scene without actually being there.

"I remember one still-vivid summer afternoon, just after turning fourteen. A slightly older friend and I hitchhiked, as you then could, to a Griffith Park love-in. We wore our flowing Renaissance Faire dresses. I had a daisy painted on my cheek and brought bubbles and glitter to throw in the air. . . . Sunshine came softly and the festival frothed with peace, love, happiness, sensuality, color, dance, and music. An effervescence outside of time. Something birthing new and free. Crazy fun. No rules. No hassle. Freaks danced alone in wild abandonment while an ever-widening ring of smiley people spontaneously materialized around them. I was pulled in by a tall, long-haired, shirtless guy and needed to skip my fastest to keep up with the churning circle. I felt my feet leave the ground. It was a perfect moment. . . .

"1967 never entirely left me. Its explosion of freedom, possibility and happiness, infused with an unending soundtrack of monolithic songs, continued to inhabit that magic-believing corner of my being.

"These days, as a writer and sometime musician, I recognize how much of my creative soul still dwells in the surge of passions that conjured the Summer of Love. Had Leslie not paved the way, I might have never noticed their existence and life could have taken a whole other turn."

Marina Muhlfriedel and her sister Leslie, c. 1967.

Summer and Fall 1967 found record stores, black-light poster shops, hip music venues, and retail spaces in Los Angeles, Encino, Hollywood, and Westwood named the Infinite Mind, the Third Eye Head Shop, the Groove Company, Wallichs Music City, and Headquarters carrying rolling papers, water pipes, psychedelic-inspired albums, and *Winds of Change*, released in September 1967 by Eric Burdon and the Animals.

BELOW: Flyer for the Groove Company record store in L.A., c. 1967.

BACKGROUND: Psychedelic slide, courtesy of Roger Steffens.

THE GROOVE COMPANY
RECORDS/TAPES

1446 N. CRESCENT HEIGHTS/LOS ANGELES, CALIF. 90046 □ 654-3131

DAVID KESSEL

"I bought *Winds of Change* in Southern California at Ray Avery's Rare Records in Glendale. It's a definite nod to hallucinogenic drugs and a serious departure from the American-inspired rhythm & blues the Animals had been integrating into their original sound. The album is very 1967 with the production by Tom Wilson in Hollywood at TTG Studios in early spring of that year. An LP trying to send you on a 'trip,' while Eric Burdon gets all introspective-poet with his lyrics and Shakespearean vocal delivery.

"The song 'San Franciscan Nights,' inspired by a Burdon evening with Janis Joplin, really captures the mood going into the Summer of Love. I was in San Francisco that summer as a young teenager and it really has the vibe that was going on. My dad, Barney Kessel, was playing the El Matador jazz club. I also attended an Electric Flag band rehearsal in nearby Sausalito before their gig at the Monterey International Pop Festival.

"The song 'Good Times' is a reflection of the change Eric is experiencing during this phase of his career and human development. The album *Winds of Change* is a unique piece of art that's pretty outta-sight psychedelic stuff."

With a melody as hummable as any crafted by Cole Porter and a lyric as divinely evocative as one written by Larry Hart, the Kinks' "Waterloo Sunset" suspended time and space in three magical minutes, a standout single (out in May 1967) in a year festooned with defining musical statements. Released as their first "true stereo" recording in early May, this Ray Davies–written and –produced snapshot of nocturnal London, seen through the gossamer eyes of the imperishable "Terry and Julie," captured that evanescent quality most associated with literature.

Davies had led the Kinks from its rousing, rock 'n' roll beginnings into a period of deep personal inquiry, so much so that he was reluctant to give this song to the group.

While the world was nervous and on edge in 1967, "Waterloo Sunset" was a calming, reflective staple on FM radio stations in the United States and peaked at No. 2 on the UK charts. ("You Really Got Me,"

"Tired of Waiting for You," and "Sunny Afternoon" had all hit UK No. 1 earlier.) It sparked an immediate outpouring of critical plaudits; Pete Townshend called it "a masterpiece." Fans obsessed over the identity of the song's protagonists—could they be modeled on Chelsea's swingingest actors, Terence Stamp and the gobsmackingly sublime Julie Christie?

Was there ever a more *English* band than the Kinks? Their remarkable *Something Else* LP (September 1967, produced by Shel Talmy and Ray Davies) was a masterpiece—a terrific follow-up to the AM—and now FM-radio playlists of America that included the Kinks' *Face to Face* 1966 classic.

By the time of *Something Else*, chief songwriter Ray Davies had developed the character-driven narrative song into a high-modernist genre of its own, delivering a baker's dozen portraits of an England very unsure of what was looking back in its national soul's mirror.

SHEL TALMY

"The UK technical people didn't think I was weird. They thought I was different because I was pretty much the first American producer there. The first place I went to was IBC studio on Phil Yeend's recommendation. That's where Phil worked. I worked for Phil earlier at Conway Studios in Los Angeles. And they were way ahead of everybody else. In terms of gear, they had young engineers who were willing to experiment. Glyn Johns. And then Olympic. Initially it made my life easier. Glyn Johns and Eddie Kramer, who I used twice. Gus Dudgeon was my assistant at Olympic with Keith Grant. I preferred Pye No. 2, the small band studio, to No. 1. It was better acoustically and, of course, as I was doing bands, not orchestras, a lot cozier. The gear was not quite as good as IBC but close, and they did have a large quantity and range of mikes. I insisted on being present at the mastering of anything I did.

"I always felt the song was 75 percent of the record. Always. Ray Davies was one of the most prolific writers I have ever met. I have been saying for years that Dave Davies is probably the most underrated guitarist in rock 'n' roll. A damn good guitarist. He's also a very good songwriter. He's not as good as Ray, but then again, very few people are. Ray was in a class by himself.

As was Pete Townshend. Lennon and McCartney. Dave was one small step beneath that in terms of how good he was. But he wrote some damn good stuff. 'Death of a Clown' and 'Love Me Till the Sun Shines.'

"Keyboardist Nicky Hopkins. . . . with the Who and the Kinks. I found him real early. Nicky was one of my favorite people. A really nice guy. Easy to work with. A heavy-duty talented musician. I had him playing live with all these people, by the way. I didn't bring him in for overdubs. I don't know how to describe him. When you hear something that's undefinable but you know it is brilliant—that's what I saw with Nicky Hopkins. All the bands loved him that I introduced him to."

ANDREW LOOG OLDHAM

"Shel Talmy arrived in London in 1962 from California to make his way as a record producer. Two years later there were four musical groups in town, making a musical cause and effect all over the world. Sir George Martin produced the Beatles, I managed and produced the Rolling Stones, and Shel Talmy produced the other two—the Who and the Kinks. That was 50 percent of what's going on!"

"The schoolboy envy of 'David Watts' and the family jealousies in 'Two Sisters' or 'Situation Vacant' belong more to the James Joyce of *Dubliners* than to any utopian, revolutionary acid vision. Yet the range of music these songs represent equals *Sgt. Pepper's.*"

-JAMES CUSHING

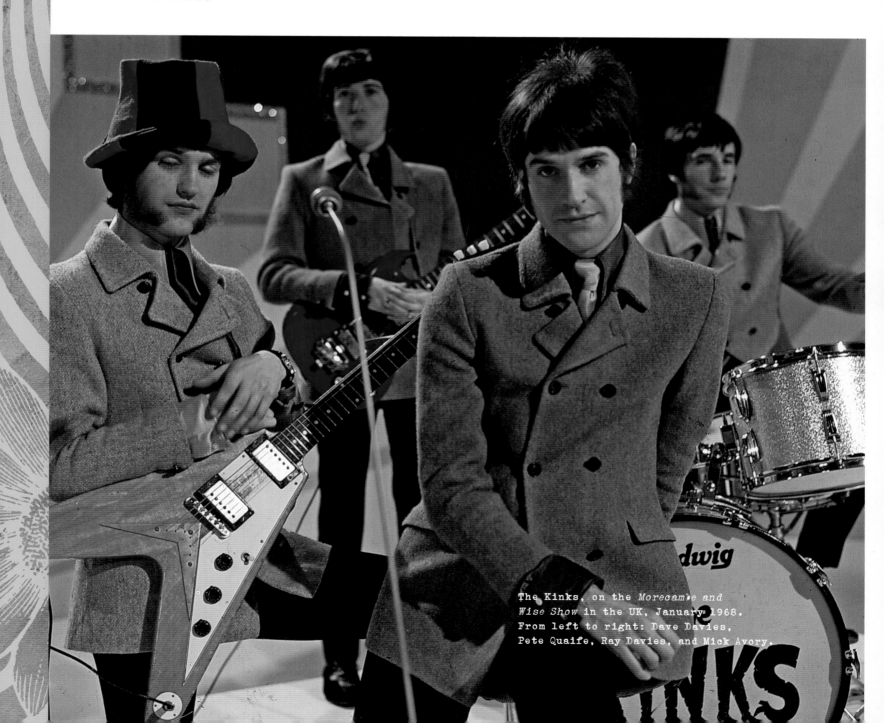

The Kinks, on the *Morecambe and Wise Show* in the UK, January 1968. From left to right: Dave Davies, Pete Quaife, Ray Davies, and Mick Avory.

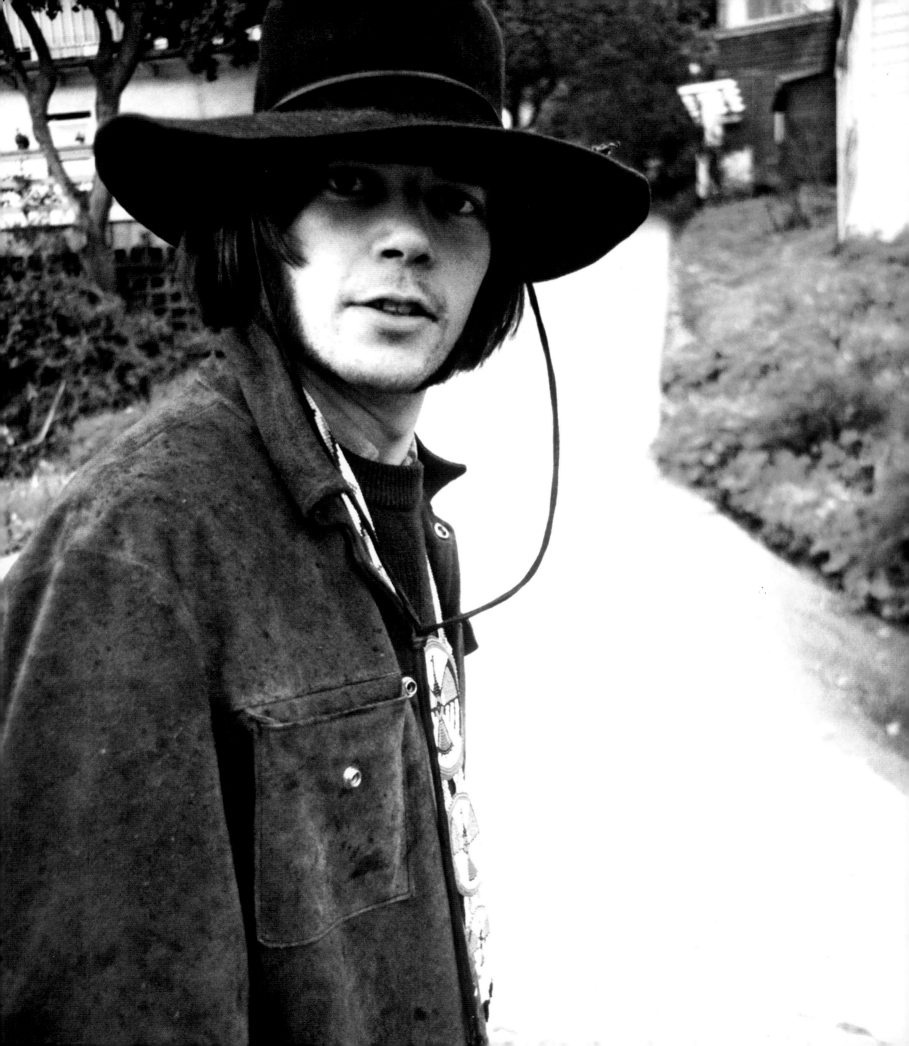

AN AUTUMN SHADE OF PALE

While San Francisco and London were reaping most of the media's attention as the cynosures of miniskirted rebellion, Los Angeles, long the entertainment-industry center and therefore dismissed as "plastic," mounted a rearguard movement within its own thriving community of artists and backlit renegades, roosting most prominently in the higher climes of Laurel Canyon.

In one fabled instance, a couple of journeymen musicians from the frosty Canadian north crossed paths with a hair-triggered "Southern Man," and their resulting fireworks produced some of the defining music of 1967.

Buffalo Springfield Again (October), the group's second album, was the rigorous distillation of the disparate but ultimately complementary qualities of Stephen Stills' pugnacious twang, Neil Young's rousing insolence,

Richie Furay's lonesome harmonies, the reliable pocket of drummer Dewey Martin, and Bruce Palmer, whose Motown-inspired work on the electric bass drove the Stills-and-Young–penned tunes into your ears.

OPPOSITE: Neil Young of Buffalo Springfield, photographed by Henry Diltz in California, March 1967.

Although no more stable than the San Andreas fault, the band, with the inerrant support of arranger Jack Nitzsche, culled their influential sound from the soulful strains of the deep South, the folky drift of the High Plains, and the contagious lift of contemporary pop and rock.

Buffalo Springfield Again was a bright, shining rebuke to the notion that L.A. was a cultural wasteland: There was gold in them glittering hills high above Hollywood. You just had to work harder, want it more than everyone else.

RICHIE FURAY

singer and songwriter, Buffalo Springfield

"We were always comfortable singing someone else's song early on. I know we tried 'Mr. Soul' with everybody singing and it sounded best with Neil. The individual members brought their own take on what was being presented to the song. We liked the Beatles with John and Paul singing harmony. Stephen [Stills] and I did a lot of that unison singing. That, we picked up from the Beatles, but then there was a lot of experimentation."

JAMES CUSHING

"Neil's 'Broken Arrow,' the Beatles' 'A Day in the Life' and 'I Am the Walrus,' along with Brian Wilson's 'Good Vibrations' and 'Heroes and Villains,' are audacious experiments. And some of Frank Zappa's music, like 'Brown Shoes Don't Make It' or the whole of *Freak Out!* And when I hear 'Broken Arrow,' when I think of this song, with this very small elite group, we hear in these that thing that makes art exciting.

"The sense of an artist or a single artistic mind made up of several people, Neil, Lennon, a single mind directly and dramatically in the moment of transcending its own previously accepted limits in a natural and organic way."

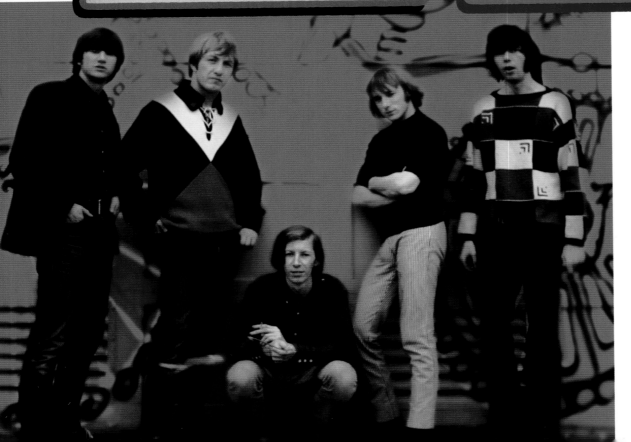

TOP LEFT: Portrait of Richie Furay by Henry Diltz, June 1966.

LEFT: Buffalo Springfield, photographed by Henry Diltz in Redondo Beach at the third i club, October 1966. From left to right: Richie Furay, Dewey Martin, Bruce Palmer, Stephen Stills, and Neil Young.

"Neil wrote cinematically and Jack [Nitzsche] arranged his own records cinematically. I loved Neil's music. This guy's writing . . . I thought everybody and their mother was gonna try and start doing his songs. I knew he was a songwriter. Some of the tunes were movies. They were scripts."

—DON RANDI

Buffalo Springfield at the Hollywood Bowl, April 1967; photograph by Henry Diltz.

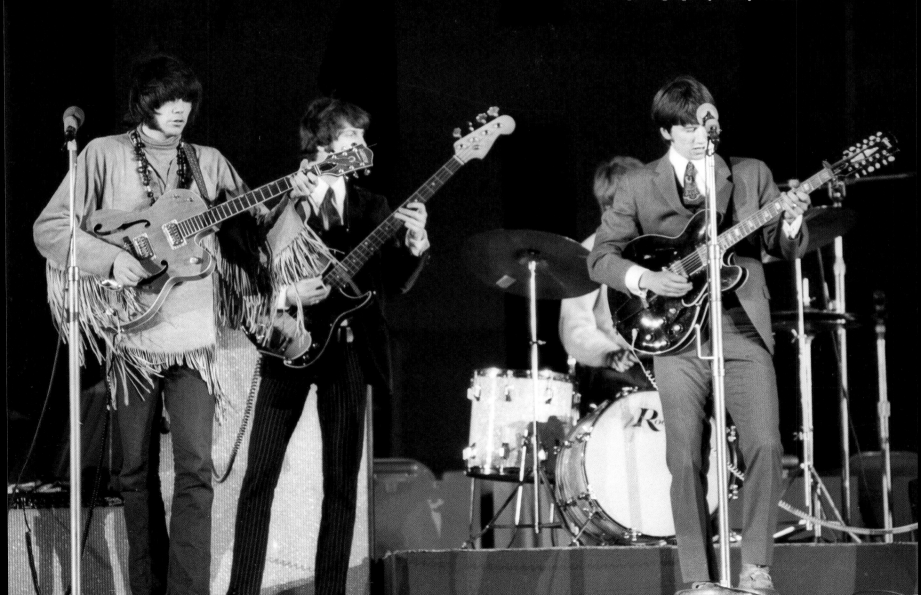

ABOVE: Playful portrait of Neil Young by Henry Diltz, 1967.

BELOW: Henry Diltz portrait of Stephen Stills in Chicago, July 1967.

KIRK SILSBEE

"There's a sense of musical adventure in *Buffalo Springfield Again* that you don't hear on many albums of the period—either coming out of Hollywood or anywhere else. Each one of the Springfield members was asserting his own identity as writer, musician, and conceptualist; they all stretched their wings and tried new things. At that moment in Hollywood, the Springfield, the Doors, and Love were raising the musical bar awfully high.

"There was nothing like 'Expecting to Fly,' even from the Beatles. It was an out-of-tempo art song, and there had never been anything like that in pop music. Neil's voice was high-pitched and odd, and though we knew his singing, the recording used that haunted quirkiness to full advantage. His disembodied vocal floated over Jack Nitzsche's spacey string chart, so that Neil sounded ghostly on this otherworldly tune.

"*Buffalo Springfield Again* allowed the writers, in particular, to stretch. 'Mr. Soul' was a departure if you only knew the first, eponymous album, which had a fair amount of country rock and folk-derived material. 'Mr. Soul' was psychedelia wrapped in tension and fear. If Bob Dylan had written that song it wouldn't have been a bad day for him. Otis Redding was canny enough, marketwise, to want to record it. 'Bluebird' by Steve Stills used folk vocal harmonies, tempo changes, and interludes. The vocals and nonstandard song form presaged 'Suite: Judy Blue Eyes.' Like 'Mr. Soul' and 'Expecting to Fly,' it was a statement that Stills was a substantial writer, and 'For What It's Worth' was just a beginning."

When Doug Weston moved his influential Troubadour club in Los Angeles from La Cienega Boulevard to Santa Monica Boulevard in 1964, the club sharpened its booking policy. Unlike the other folk clubs, Weston needed names with marquee value. Like the Ash Grove six blocks away on Melrose Avenue, the Troubadour brought jazz, blues, and bluegrass to West Hollywood. Weston was more than happy to let the Ash Grove's Ed Pearl bring in Lightnin' Hopkins, the Kentucky Colonels, Mance Lipscomb, and Doc Watson.

Weston's schedule, complete with mandatory options for return bookings (for artists' next regional appearances in the market), further solidified the venue as a prominent national showcase for an eclectic mix of touring artists who headlined in 1967.

ABOVE: Portrait of Troubadour owner Doug Weston by Henry Diltz, 1972.

KIRK SILSBEE

"Weston needed names with more marquee value: Bud & Travis, Oscar Brown Jr., Roger Miller, Nina Simone, the Chad Mitchell Trio, Olatunji, the Stoneman Family, Judy Collins, Joe & Eddie, Buffy Sainte-Marie, Barry McGuire, Glenn Yarbrough, the Association, and the like.

"Several currents ran through the Troub. Jazz pianist Horace Tapscott had a long residency; while he sowed the seeds of his Pan-Afrikan Peoples Arkestra in Watts, Ava Gardner sipped scotch to his trio.

"Monday night hootenannies drew scores of hopefuls, from Ruthann Friedman (who would write 'Windy' for the Association) to the Peanut Butter Conspiracy.

"By 1967, the club was also *the* meeting place for folk and country musicians who were interested in starting rock bands (the Byrds formed there) or just trying to find like-minded colleagues. Stage manager Dickie Davis became the first manager of Buffalo Springfield, and the band played one of its first gigs there. The Flying Burrito Brothers, Dillard & Clark, Rick Nelson's Stone Canyon Band, and others all got together at the Troubadour, just as the Eagles would a few years later.

"One singer who haunted the Monday night hoots was not so terribly long out of her native Arizona. She was a hippie girl who . . . [wore] peasant blouses and went barefoot. Her money was short, so she and her friends went to downtown L.A. to buy cheap antique clothing at Zsa Zsa's in Grand Central Market. The club was an important conduit for Linda Ronstadt's career.

"The '67 Troub saw offbeat comics like Brother Dave Gardner, Pat Paulsen, Dick Davy, Vaughn Meader, and Larry Hankin in opening slots. It was Nina Simone casting a spell with 'I Loves You Porgy,' the Nitty Gritty Dirt Band bringing bluegrass filigree to pop music, Joe and Eddie's gospel fervor, Rod McKuen's greeting-card poetry, guitar innovator T-Bone Walker's Texas shuffle blues, the first L.A. airing of Laura Nyro's Bronx soul, the Muddy Waters Blues Band—twice in two months, Tim Buckley's I-think-I-know-where-I'm-going songs, flower power rock from the Sunshine Company, Bob Lind's literate folk ballads, Arlo Guthrie's first SoCal date, and the searing professionalism of the Butterfield Blues Band.

"Weston made the Troubadour the essential launching pad for the singer-songwriters of the early '70s, but he did it by building his venue the hard way—week by week for a decade."

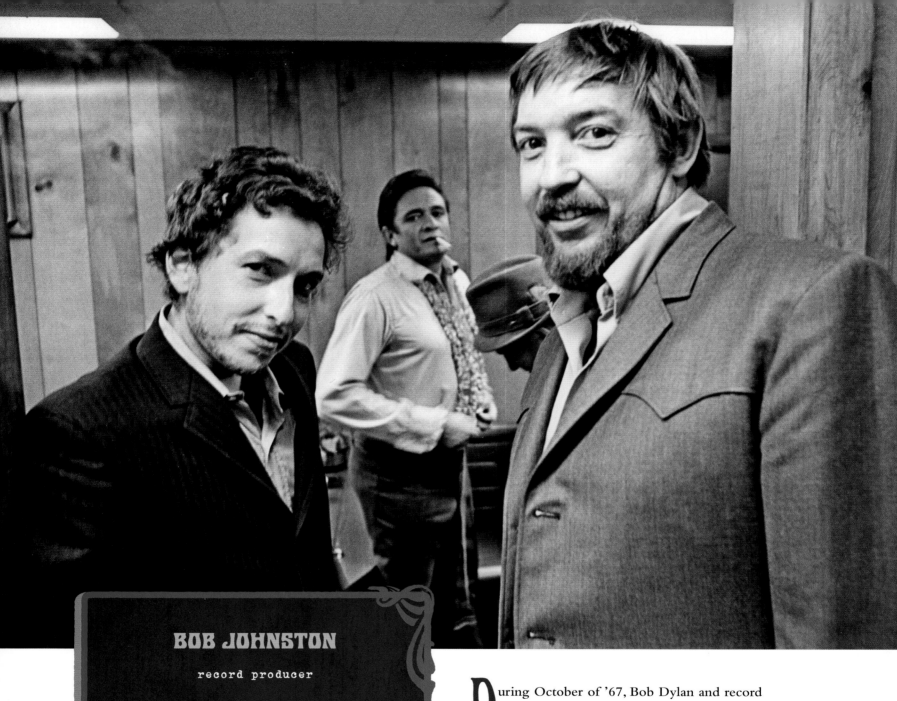

BOB JOHNSTON

record producer

"I would place glass around Dylan for recording. He had a different vocal sound. I didn't make his different vocal sound. He always had different sounds on. I never wanted to be [Phil] Spector . . . and while the rest of the world was doing an album as big as *Blonde on Blonde*, which everybody was—the more musicians they could get, the better it was. But we went in with four people . . . in the middle of a psychedelic world!"

ABOVE: Bob Dylan, Johnny Cash, and Bob Johnston, on set at the debut episode of *The Johnny Cash Show*, June 7, 1969; photograph by Al Clayton.

During October of '67, Bob Dylan and record producer Bob Johnston met at a Ramada Inn in Nashville, Tennessee, before starting an album to be called *John Wesley Harding*.

John Wesley Harding was recorded in Columbia Music Row Studios by Dylan in six weeks, from October 17 to November 29 of 1967. To promote intimacy and allow the musicians to stay in visual contact, Johnston—as he had done previously in the Nashville sessions for Dylan's *Blonde on Blonde* in 1966—removed the studio acoustic baffles, space-dividing devices used to prevent microphone leakage and the instruments of the musicians from bleeding into one another's separate sound booths during the sessions.

Glass was placed around Dylan in the center of the room to isolate his vocals from the musical tracks.

The Bang label was formed by Bert Berns in 1965 with Atlantic Records partners Ahmet Ertegun, Nesuhi Ertegun, and Jerry Wexler, which produced such hits as "Hang On Sloopy" (written by Wes Farrell and Berns, with the iconic version recorded by the McCoys) and early Neil Diamond efforts "Solitary Man" and "Cherry Cherry." Berns also founded Shout Records in 1966, for rhythm and blues, which made an impact with Freddie Scott's "Are You Lonely for Me."

Ritchie Yorke recalls that "in a business where track record is the beginning and the end of the holy gospel, Berns seemed assured of success. He'd co-authored the Isley Brothers' million-seller 'Twist and Shout,' subsequently revived by the Beatles, the royalties from which must have topped the quarter-million-dollar figure for publisher and composers. . . .

"'Hang On Sloopy' . . . achieved hit status three times, with singles by the Vibrations, Little Caesar and the Consuls, and the McCoys. In addition, he'd produced and written a top-selling single with Them. In short, Berns had the wherewithal to write and produce hit singles for the AM Top 40 radio medium."

One memorable 1967 moment was the Bert Berns–produced and Brooks Arthur–engineered Van Morrison "Brown Eyed Girl" session, which popped off the AM dial with the fizzy ardor of an instant classic. Berns had access to the first-call musicians in New York, including Eric Gale (bass); Al Gorgoni (guitar); Hugh McCracken (guitar); Gary Chester and Herbie Lovelle (drums); and Cissy Houston, Dee Dee Warwick, Myrna Smith, and Jeff Barry (background vocals).

Morrison's lead vocal was brusque, snarling—many listeners thought they were hearing Jagger and a new Stones single. It was another brooding, sensual presence, about to begin one of rock's most illustrious solo careers. Van Morrison, the former front man of Belfast's baddest band, Them, introduced himself with this imperishable hit, fittingly released on Bang Records. "Brown Eyed Girl" was released as a single in June 1967 and on Morrison's debut album *Blowin' Your Mind!* in September. The song charted at 10 on *Billboard* in late September, and spent sixteen weeks on the Top 100. Van Morrison describes his relationship with Berns and the production of "Brown Eyed Girl" here in an interview conducted by music journalist Ritchie Yorke.

BELOW: Van Morrison (left) at a Bang Records recording session with Bert Berns (right) on March 28, 1967, in New York.

VAN MORRISON

"I'd rather have worked with Bert than some other guy with a bigger record company. From that angle, it was spectacular because Bert was somebody that I wanted to work with. . . .

"They put out publicity around that time to the fact that ['Brown Eyed Girl'] was written specifically about somebody I knew, but it wasn't. Originally it was called 'Brown Skinned Girl' when I wrote the song. I just thought 'Brown Eyed Girl' sounded better or something. I guess it really wouldn't have made much difference, but 'Brown Skinned Girl' was the original title. After we'd recorded it, I looked at the tape box and didn't even notice that I'd changed the title. That's how spaced out it was. I looked at the box where I'd laid it down with my guitar and it said 'Brown Eyed Girl' on the tape box. It's just one of those things that happen. Obviously it was a Top 40 record, but I didn't think it was that well produced."

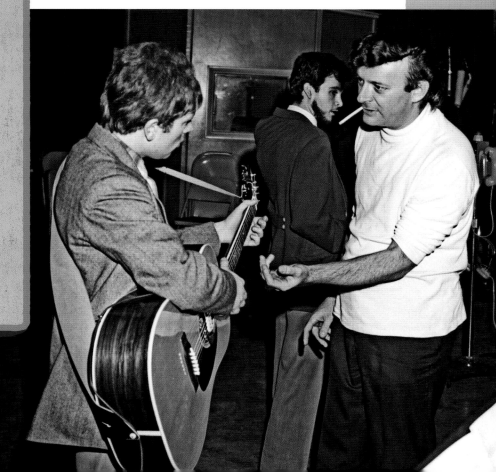

Tower Records

The business of record retailing was about to experience its own revolution. Like so much else roiling the marketplace, the wants and needs of avaricious young consumers demanded a bold, extravagant response.

Traditionally, records were sold mostly in mom-and-pop stores catering to local clientele and regional tastes. In bigger cities, the advent of the "big box" store allowed for a broader if indiscriminant range of titles.

Los Angeles, being the music entertainment capital, had those options plus Wallichs Music City (see page 155). Situated at the corner of Sunset and Vine, it wasn't just one-stop shopping for all your record and instrument needs; it was also a rite of passage into the world of professional music-making, given its proximity to the many studios and record labels clustered around it in Hollywood.

But that was all about to change with the first planned expansion in 1967 of Sacramento-based Tower Records, whose distinctive canary-yellow and cherry-red outlets would soon deliver a cornucopia of musical delights diverse enough to leave even the most vinyl-addicted spinning. Tower founder Russ Solomon made multiple trips to San Francisco during 1966 and '67, where Tower had a warehouse. He initially saw a vacant building in San Francisco when staying over one night and quickly made a deal to lease the property. The San Francisco store opened in 1968, and the Hollywood store in 1971.

Russ Solomon, founder of Tower Records, explains that "You gotta look at the timing. We [Tower Records] really hit it at exactly the right time. We had all that experience of selling music that came out after World War II, 1946 to 1967. Then the Summer of Love happened down at Monterey, *Rolling Stone* started in 1967, and we really got going in 1968.

"Before then, all through those formative years, the kids in Sacramento were going into San Francisco on the weekends. They were dressing up in what would now be called hippie clothes, and hanging out and bringing back the whole culture that was happening down there. Sacramento was not that at all; it was hanging on to the coattails of a previous time. Tower and many of us moved into San Francisco and became part of the new swirl. I like to say that we got onto the wave and rode the damn thing until it went ashore.

"And it could not have been a more perfect spot, from a standpoint of timing. It was an accident. The combination of Bill Graham, the Fillmore, *Rolling Stone*, and us; in the very beginning, for a little while, we were their number one sales outlet. They could put a whole pile of magazines in and they'd all get sold.

"Tower was a destination stop. People saw one of Bill Graham's Fillmore shows, then went into the store and got an album—not from the headliner but [from] one of the opening acts."

Inspired by a visit to Bill Graham's Fillmore Auditorium, Detroit DJ Russ Gibb decided to bring a taste of the Bay Area's music madness to the Motor City. He located a slightly decrepit theater in a rough-and-tumble neighborhood that was certain to entice a young rock audience to kick out the jams and to incite paranoid fear in their parents while inspiring the local music scene to become part of a larger cultural conversation. The Grande Ballroom opened with the potency of a souped-up muscle car—in your face and in your ears.

OPPOSITE: Poster designed by noted graphic artist Gary Grimshaw for a Cream show at the Grande Ballroom in Detroit, October 15, 1967.

KENNETH KUBERNIK

"Cream ended their first American tour in mid-October with a three-night stand at Detroit's Grande Ballroom. Bootlegs of these shows registered Richter-scale intensity; guitarist Eric Clapton, bassist Jack Bruce, and drummer Ginger Baker pushed the limits of a blues-based vernacular into the heady realms of free improvisation, a loud, imperious assault that transformed Coltrane's 'sheets of sound' into a thunderous wallop that, as these performances attest, took no prisoners.

"Ostensibly playing the venerable I-IV-V chord progressions set down in Mosaic tablets by their saw-toothed elders—the King boys, especially Albert and Freddie, Skip James, Willie Dixon, et al.—Cream played fast and loose with the tradition, adding a dash of psychedelic coloratura to their strange brew of weeping lead lines, train-time rhythms, and bad-luck lamentations.

"Not surprisingly, it was in San Francisco, at the Fillmore Auditorium, that they first found traction for their decisively 'unflowery' approach. As the audience sat transfixed by the dizzying light show onstage . . . Cream ignited. 'When we got to America we were supremely confident—and there's nothing like confidence to get you really playing,' said Baker.

"Cream never lacked for self-regard; their name, picked by Clapton, was a tacit acknowledgement that they represented the 'cream' of the British music scene. Clapton's apprenticeship with the Yardbirds and John Mayall's Bluesbreakers earned him the embarrassing sobriquet 'God.' Jack Bruce was a bit of a prodigy, studying cello and composition at the Scottish Royal Academy of Music and Drama. . . . Baker, a devoted jazzer and junkie with the constitution of a Welsh coal miner, had long established his bona fides as a rhythm machine with the locomotive drive of his hero, Elvin Jones. 'We never told Eric we're a jazz group,' Bruce explained years later. Listeners might not have been hip to the influence; what they heard were three free radicals rollin' and tumblin' through a heritage that satisfied their brave souls."

"Surrounded by a Hadrian's wall of Marshall amplification, Cream stripped away the sweetly endearing shimmy that gave pop music its distinctive 'roll'; what remained was *rock*, a sound not so much played as hewed like marble from an ancient quarry. Their music was 'heavy, man.'"

—KENNETH KUBERNIK

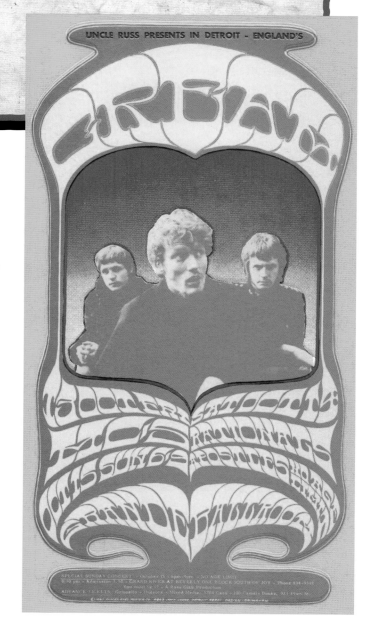

Read All About It

Playboy Magazine's reporting on the contemporary music scene of 1967 helped broadcast the counterculture revolution to a wide audience. Their Jazz & Pop Poll ballot of October 1967 reflected the impact of then-current audio culture.

In the Male Vocalist category, Marty Balin, Jimi Hendrix, Otis Redding, John Mayall, Scott McKenzie, and Johnny Rivers were now listed with Frank Sinatra, Gene Pitney, Sammy Davis Jr., Al Martino, and Mose Allison. The Female Vocalist listing now found Janis Joplin, Cass Elliot, and Grace Slick right alongside Dionne Warwick, Julie London, Anita O'Day, Jackie DeShannon, and Eartha Kitt.

Besides showcasing and advertising state-of-the art '67 home audio equipment, *Playboy* gave ink to well-established and emerging FM-radio-playlist recording artists. Summer of Love turntable favorites Charles Lloyd and Ravi Shankar were both profiled in a fall '67 issue. Moby Grape, Brenton Wood, and Chris Darrow of the Kaleidoscope now shared the glossy pages with Bill Evans, Oliver Nelson, Andre Previn, and Chico Hamilton—further proof that *Playboy*'s former reputation as "only a skin magazine" was now forever gone. A psychedelic-themed front cover graced its '67 Gala Christmas issue.

Meanwhile, music weeklies and monthlies continued to highlight and tout the vibrant music of 1967; they included *Hit Parader*, *Teen Set*, *Datebook*, the *KRLA Beat*, the *KYA Beat*, *HiFi/Stereo Review*, *DownBeat*, *Jazz & Pop*, *Cheetah* (which debuted in October '67), and *RPM Weekly* and the *Georgia Straight* from Canada. In the UK, *Disc*, *Melody Maker*, *New Musical Express*, and *Beat Instrumental* were still highly influential in showcasing European and American pop and rock music.

The first issue of *Rolling Stone* was on the newsstands in November 1967. The November 9 newspaper format featured John Lennon and the film *How I Won the War*. The periodical had been inspired in 1966 by Greg Shaw's *Mojo-Navigator Rock 'n' Roll News*. "*Rolling Stone* publisher and editor Jann Wenner learned under Ralph J. Gleason, *Rolling Stone*'s 'spiritual adviser,'" James Cushing explains. "Gleason seemed to understand the connection between jazz and the new rock, both in the sense of using improvisation and in the sense of the existential-humanistic philosophy of life the boppers enacted rather than theorized about. And the same is true for the people of '67. They enacted the philosophies rather than representing them.

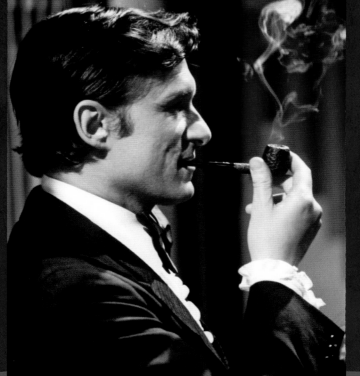

"The underground newspapers, the *Los Angeles Free Press*, the *Oracle*, the *Berkeley Barb*, the *Kaleidoscope* in Milwaukee and the *Seed* in Chicago were very important, as were the glossy *Ramparts* and a little eccentric outsider, Paul Krassner's *The Realist*. The mainstream press thought these new media outlets were dangerous or silly, but they really presented balance and exposure."

LEFT: Portrait of *Playboy* magazine founder Hugh Hefner by Henry Diltz, March 1970.

Monterey Pop reverberated into October as Mike Bloomfield's Electric Flag played one of its first SoCal gigs at the Cheetah. Opening for the Flag was Clear Light, the Elektra-signed band with two drummers that never quite made it. New Year's Eve at the Cheetah featured Buffalo Springfield, the Seeds, and the Lollipop Shoppe—an auspicious close to a good year.

The Aragon ballroom, erected where the Venice and Santa Monica beaches meet, had been a big-band outpost in World War II. In the 1950s, it became Lawrence Welk's home base, then briefly served as a residence for Dick Dale's surf guitar in the early sixties. The owner of New York's wildly popular Cheetah Club, Oliver Coquelin, expanded his reach and opened a West Coast branch there in February 1967.

RIGHT: Cheetah flyer, 1967.

"**Weird scenes took place inside that pulsating goldmine: Playmate of the Month Angela Dorian was photographed Frugging for her September '67** *Playboy* **spread, and Strawberry Alarm Clock was filmed for the movie** *Psych-Out.* **Buffalo Springfield and the Watts 103rd Street Rhythm Band shared an improbable bill. Arizona transplants the Spiders became the house band. They changed their name to the Nazz, before they changed it to Alice Cooper."**

—KIRK SILSBEE

KIRK SILSBEE

"The Cheetah was a short-lived and prescient chapter in Los Angeles rock history. A psychedelic ballroom with acres of dance floor, multiple couches, a corrugated metal wainscot, and two four-foot-high stages that sat side by side, it had as its only competition the Sunset Strip's Kaleidoscope club. The considerable distance from Hollywood and subsequent attendance falloffs were a continual problem.

"The bills included the Young Rascals, Eric Burdon and the Animals, Hamilton Streetcar, Jefferson Airplane and the Doors (in the same show), the Byrds, Love, the Chambers Brothers, Iron Butterfly, the Grateful Dead, Kaleidoscope, Clear Light, Bo Diddley, Smokestack Lightnin', the Seeds, James Brown's Revue, the Turtles, Captain Beefheart, Larry Williams and Johnny 'Guitar' Watson, Big Brother & the Holding Company, Ike & Tina Turner. . . . Country Joe and the Fish, Pink Floyd, Traffic, Ten Years After, and Creedence Clearwater all played their first SoCal bookings at the Cheetah.

"The Cheetah was where Pink Floyd played the second and last night of its aborted first American tour. Frizzy-haired Syd Barrett . . . is said to have poured a tub of hair gel over his head and gobbled a handful of barbiturates before taking the stage."

RODNEY BINGENHEIMER

"I worshipped the Cheetah. I went to the opening. Some rock fans and people from Hollywood didn't like going out to the beach too often. Very few people had cars, and it took three buses to get there and no buses after midnight. So sometimes you could see an act in Hollywood one night and then a booking at the Cheetah the next evening. It was a real happening place in 1967.

"I went with Jeff Beck and Mary Hughes to catch Ten Years After. The sound system was incredible and there were a lot of couches to sit [on] and watch the bands as well as plenty of dance floor space.

"It was definitely a spot where the new FM radio bands of 1967 were coming, and not just the rock groups from 1966 who just had big AM singles. A lot of 1967 rock music was previewed and tested at places like the Cheetah before being heard anywhere else."

HOWARD WOLF

"One other reason why the rock music of 1967 found an initial live audience on the West Coast that turned into a record-buying element was—98 percent of the people going to the Avalon, the Fillmore, the Kaleidoscope in Hollywood, the Cheetah at Venice Beach, and shows at the Los Angeles Shrine Exposition Hall in 1967—was that tickets were sold night of the event at the door and early-evening walk-up purchase from a girl in the window at the box office.

"There might have been a few handwritten names on a backstage-band and equipment-entrance list, but ticketing was impulse and trust. No one had reservations or things like 'will call' weeks in advance, and parking wasn't an issue. No music-business list for admission.

"This is a world before record labels provided tour support and thought in three-album deals. There might have been one or two record stores selling tickets or a psychedelic head shop selling tickets where posters had been dropped off. There were devoted people paying $2.50 or $3.50 a ticket to see and discover these bands; many didn't have major-label record deals."

One popular October offering was Judy Collins' *Wildflowers* on Elektra, arranged by Joshua Rifkin and produced by Mark Abramson. Jac Holzman notes, "There are a couple of other albums that contributed to the ambience of the label that sold well, although they didn't score in the Top 10 of the charts. Judy Collins' *Wildflowers*, which was a whole different sound for Judy; the Incredible String Band's *5,000 Spirits or the Layers of the Onion*; and *The Zodiac: Cosmic Sounds* are all part of that Summer of Love." Another important fall 1967 album was Phil Ochs' *Pleasures of the Harbor*, released October 31.

"The music and the vinyl messages that Phil Ochs sent out in 1966, '67, and '68 were very inspirational," Roger Steffen recalls. "Phil's *Pleasures of the Harbor* 1967 LP, produced by Larry Marks—he is undeservedly forgotten. Here was a guy who sang 'I Ain't Marchin' Anymore' and 'Outside of a Small Circle of Friends.' Very crucial for the movement and us hippies."

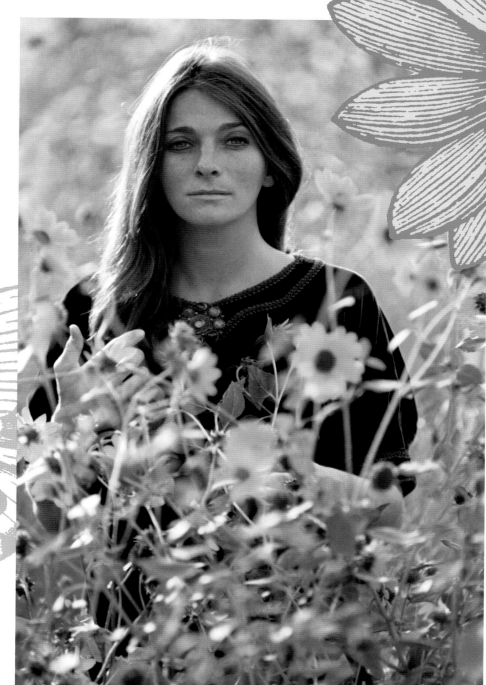

Outtake of the photoshoot for Judy Collins' *Wildflowers* album cover, by Guy Webster.

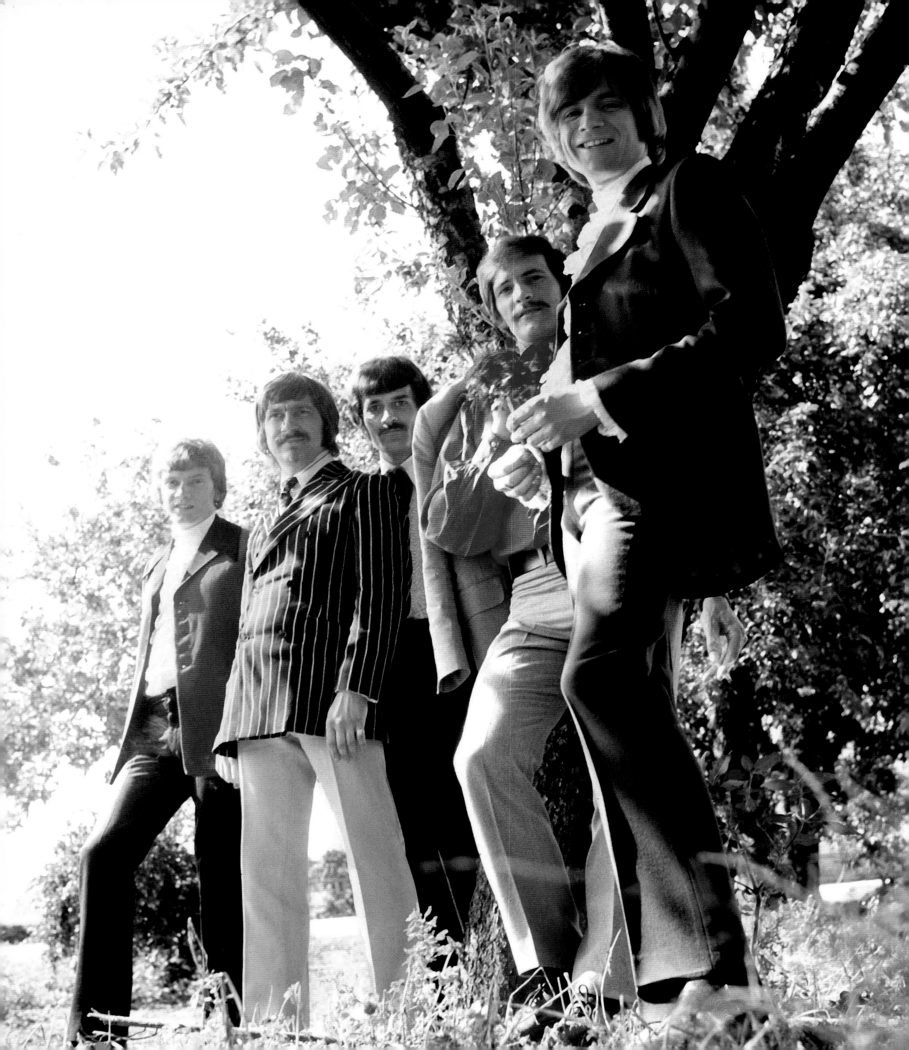

WITH APPROPRIATE FLASHBACKS

The Moody Blues, who as part of the original English Invasion scored a surprising hit with their reading of Bessie Banks' soul-stirring "Go Now," entered 1967 with new personnel and a new musical identity. Keyboardist Mike Pinder replaced his straight-eighths piano parts with the ersatz orchestral posturing of the Mellotron.

A year prior, singer, guitarist, and songwriter Justin Hayward had replaced the departing Denny Laine. Hayward penned "Fly Me High," a Moody Blues Decca single in 1967, and then "Leave This Man Alone," and he collaborated with Pinder on his "Love and Beauty," the first Moody Blues record to incorporate the Mellotron.

Evoking Heathcliff on the moors or a Lake District idyll with the turn of a knob, a swooning Mellotron flourish transformed the chirpy pleasantry of "Tuesday Afternoon" into something bold and strikingly hip. Love-beaded, Nehru-jacketed, the Moody Blues became the face of yet another emerging musical genre—progressive rock—and their album *Days of Future Passed*, released in November 1967, became a template for any number of young bands eager to traipse in Elgarian pomp and circumstance.

OPPOSITE: Moody Blues, photographed in Germany by Petra Niemeier, 1967.

Drastically rethinking their musical approach, the band began to compose new material in a uniquely different style. Decca asked the Moody Blues to record a rock version of Dvořák's *New World Symphony* to demonstrate a new stereo system they were launching, known as "Deramic" (Decca Panoramic) sound. Instead, the band, along with producer Tony Clarke, used the orchestral settings for a suite of their own songs, which resulted in *Days of Future Passed*—a record that was as ground-breaking as any of that era and featured "Nights in White Satin." They recorded the album with the London Festival Orchestra, conducted by Peter Knight. Hayward's principal songwriting contribution, the haunting and memorable "Tuesday Afternoon," was coupled with John Lodge's "(Evening) Time to Get Away" to form "Forever Afternoon (Tuesday?)." Another Hayward song from the same period, "Cities," is an early ecology-themed tune.

JUSTIN HAYWARD

singer, guitarist, songwriter,
the Moody Blues

"We had the idea for a stage show and then it really came from Mike, who had written a song, 'Dawn Is a Feeling,' which I really loved. And then we got round to sort of thinking about, *This would be quite a good idea for a sort of thematic stage show about a day in the life of one guy.* And I just sort of chose: 'I'm gonna do the afternoon.' And I had already done 'Nights in White Satin,' written and recorded.

"So I went back to where my parents lived in the west country in England with a guitar and went out that afternoon, sat in the side of the field and smoked a joint, and then came back with 'Tuesday Afternoon.' That was about it. I thought it was kind of a cheeky little song that wouldn't really mean much.

"But I have to say, the single version of 'Tuesday' and the single version of 'Nights in White Satin' does not have any orchestra on it. It's just a Mellotron. But I was at the session when they did the orchestra sessions. And they did it in one take. They had already laid out the songs on a 4-track machine and they were bouncing to another 4-track. And so they did one run-through with the orchestra and then the take itself. And so I was astounded when I heard this stuff. And Mike had already done the spoken-word stuff. So it was astounding to listen to that."

"But in truth, I thought we were making a kind of arty album——that I might get invited to a cocktail party and might meet some nice lady from the *Observer* and that's about it. That was as far as a thought. So I wasn't completely overwhelmed by it. I thought it was a limited-appeal album."

-JUSTIN HAYWARD

Another well-received platter on both the East and West coasts, particularly in college dormitory rooms, was singer/songwriter Tim Buckley's *Goodbye and Hello*, produced by Jac Holzman and the Lovin' Spoonful's Jerry Yester. The front-cover album photograph was snapped by Guy Webster.

RIGHT: Tim Buckley, photographed for the album cover of *Goodbye and Hello* by Guy Webster, 1967.

"We hung out. Tim and I were a lot alike. Elektra sent him to me. I wanted to do something completely different with him. We did it at the beach. He was handsome. So I put a bottle in his eye and it relaxed him. He went for it and smiled. And I caught it. And had the blue sky on one cover and yellow sky on the other. We were hippie friends. Never saw him play live but listened to the music. He was an iconoclast, and that appealed to me."

—GUY WEBSTER, PHOTOGRAPHER

DANIEL WEIZMANN

"Fritz Perls, the father of Gestalt therapy, who came to Big Sur in '63, warned the sunny new free-spirited generation arriving at Esalen that there were no instant answers to man's real dilemmas, that no hippie sugar cube escapade or communal freak-out would easy-fix troubled lives. So high were the times that the kids didn't want to hear it.

"Just four years later, on *Forever Changes*, Love had the same stark message. Most praising their '67 release focus on the adventurous music, the way it blends high orchestra and low garage. But equally unusual is the record's lyrical p.o.v.—aggressive dis-illusion in the original sense of the word. *Forever Changes* is the only album of the Summer of Love that is totally anti-utopian. . . .

"In song after song, Love test the limits of 'pop life,' its inability to save souls. . . .

"It's been said that *Forever Changes* is a timeless album, one that rises above its specific environment, et cetera. Maybe. But I find it hard to separate these dark portraits from Los Angeles in the middle of the sixties. Here in the petri dish of ultra-modernism and counterculture, Love touched the edge of the '60s vision first. They were vanguards of a whole new kind of dismantling. The radio was blasting songs about marmalade skies and peppermints and strawberries back then—yummy fantasias for affluent children. *Forever Changes* unmasked the loneliness, the alienation, and the dread that TV dreams seek to hide.

"The title itself, which can be read about eighteen different ways, also turns the idea of limitlessness on its head. There's something tragic about it, something resigned, and something grown up."

PAUL BODY

"*Forever Changes* altered the mind—didn't need any dope, just close your eyes. It was my favorite album from that Summer of Love year. The only drag was that [the band] Love was on the verge of falling like stars out of the skies. 1967 was crazy; it was the time of Superspade, LSD, hippies, incense, wearing flowers in your hair."

Immaculately produced and engineered by Bruce Botnick, with exquisite string and horn arrangements from David Angel, *Forever Changes* was recorded at Sunset Sound and Western Recorders studios in Hollywood.

Peter Piper, now a professional surfer, served as the parking lot attendant in 1967 for the Sunset Strip's Old World restaurant and the nearby Whisky a Go Go. Piper watched Love many times at the formative club. He offers his description of the landmark disc: "Right in the middle of all this 1967 Hollywood peace, love, and sunshine–created music, there was Love, who reminded us that their alluring, romantic, and menacing sound with *Forever Changes* really captured the darkness of our town."

It was an unexpected vinyl gift that arrived like a TNT explosion in your bedroom. Many were further introduced to the ongoing reality of the Vietnam War by this musical audio report. Underground FM–radio DJs spun the deeply meaningful platter that reached disenfranchised teenagers and adults along with veteran rock 'n' roll listeners.

"I was drafted into the army during the Vietnam War and sent to Saigon," remembers Roger Steffens, SSG U.S. Army, ret. "I was originally ordered into frontline combat operations broadcasting prerecorded surrender messages to the Communist troops from an eighty-pound loudspeaker backpack. I was all over the country, from the DMZ to the Delta.

"When I arrived in November '67, Jimi Hendrix was the soundtrack and you heard his records on AFVN over our headsets. Very late in '67 and all through 1968, we then heard Love's *Forever Changes* . . . When the sky would be exploding. Soldiers were dying on many hillsides, there were countless blood transfusions, and the general feeling about the Vietnam War could be summed up in Love's song title "Bummer in the Summer.'"

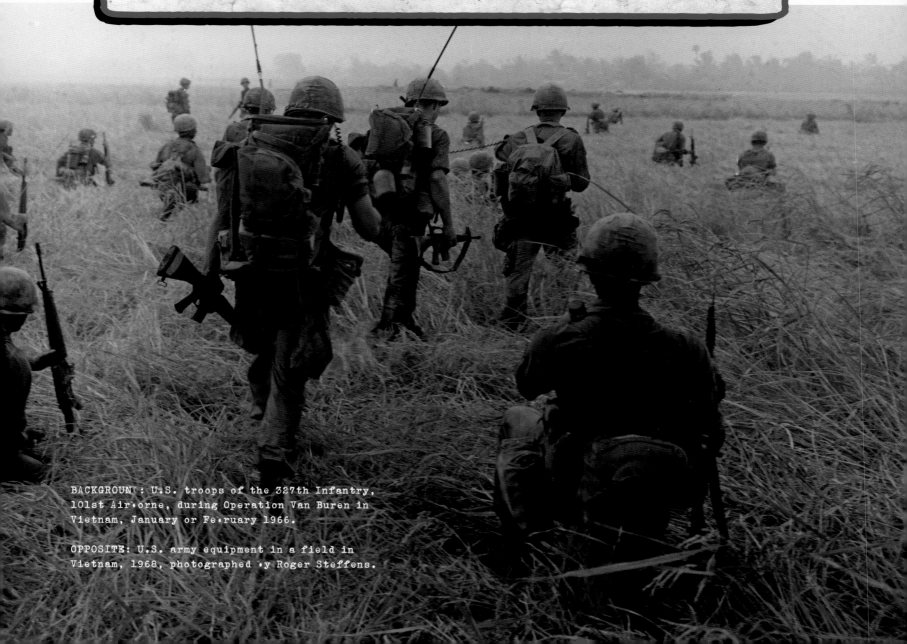

JOHNNY ECHOLS

guitarist and co-founder, Love

"[*Forever Changes*] was influenced by *Sgt. Pepper's*. Arthur [Lee] was writing some phenomenal lyrics. Listen to 'A House Is Not a Motel.' I knew what those words were, having been with Arthur when a Vietnam veteran came back to talk to us when Love was . . . in San Francisco when we were playing with Janis Joplin. He mentioned these kids were dying in the fields and nobody can get to them. And they're calling out their mother's name, calling out God's name, or someone's name.

"And Arthur is listening to him. We go back and put the song together and want the music to reflect what somebody felt when they were out in that field by themselves. You know, listening to bombs explode around them and all of the stuff that is happening. Because we wanted to have something that was spontaneous but also reflecting the chaos that was going in people's lives.

"So that's one song. And there are others that speak to the insecurity of people, speak to the animosity that is happening to the kids growing up not trusting anyone [other] than people their own age. All of this stuff is going on at the same time. . . .

"I have heard it all. . . . It's deep. One of the kind of prevailing things I've heard is, 'This is the soundtrack of my life.' And I think that is the best definition of it. A soundtrack of the life. Because *Forever Changes* was a soundtrack of the times. The music reflected the times we were living in."

BACKGROUND: U.S. troops of the 327th Infantry, 101st Airborne, during Operation Van Buren in Vietnam, January or February 1966.

OPPOSITE: U.S. army equipment in a field in Vietnam, 1968, photographed by Roger Steffens.

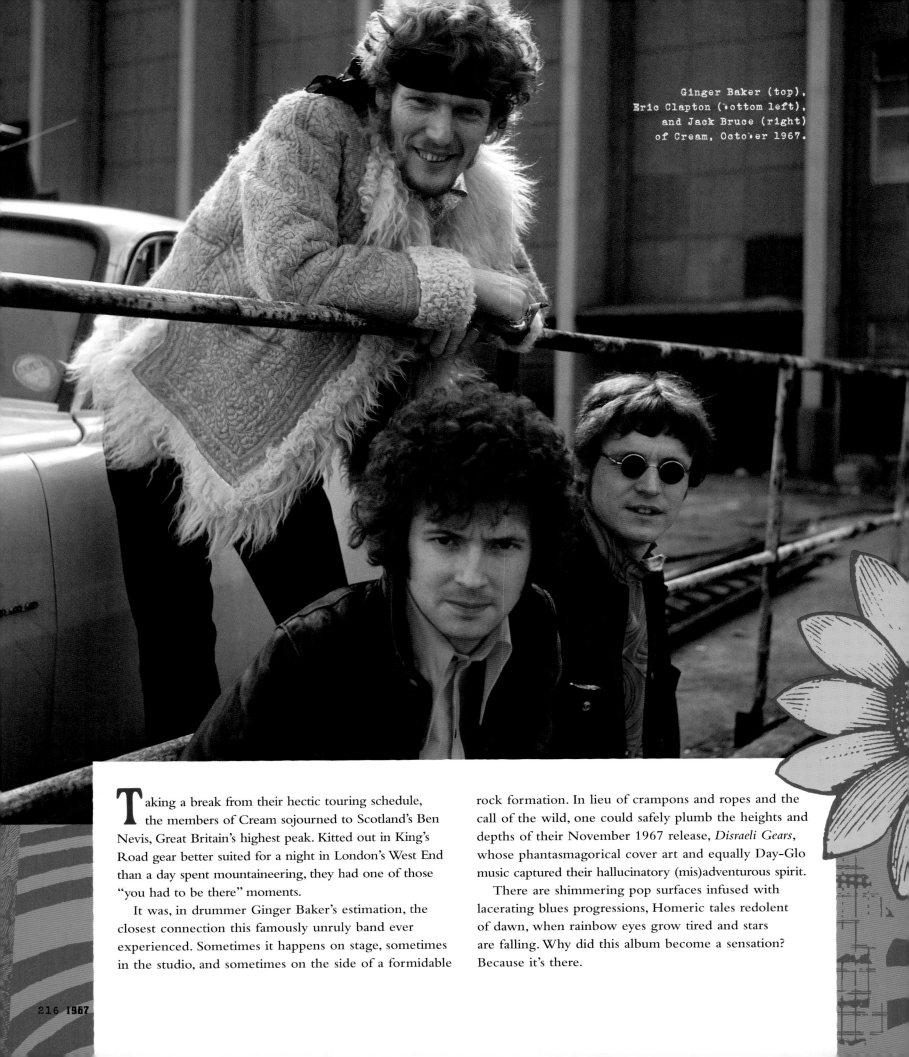

Ginger Baker (top),
Eric Clapton (bottom left),
and Jack Bruce (right)
of Cream, October 1967.

Taking a break from their hectic touring schedule, the members of Cream sojourned to Scotland's Ben Nevis, Great Britain's highest peak. Kitted out in King's Road gear better suited for a night in London's West End than a day spent mountaineering, they had one of those "you had to be there" moments.

It was, in drummer Ginger Baker's estimation, the closest connection this famously unruly band ever experienced. Sometimes it happens on stage, sometimes in the studio, and sometimes on the side of a formidable rock formation. In lieu of crampons and ropes and the call of the wild, one could safely plumb the heights and depths of their November 1967 release, *Disraeli Gears*, whose phantasmagorical cover art and equally Day-Glo music captured their hallucinatory (mis)adventurous spirit.

There are shimmering pop surfaces infused with lacerating blues progressions, Homeric tales redolent of dawn, when rainbow eyes grow tired and stars are falling. Why did this album become a sensation? Because it's there.

Almost seven years to the day after its original November 1967 American release, John Lennon admitted during a 1974 radio interview, "*Magical Mystery Tour* is one of my favorite albums. Because it was so *weird*." Several dozen years and countless thousands of plays later, that adjective continues to fit like a Technicolor dream glove and then some. Gary Pig Gold agrees: "Although quickly cobbled together in expanded fashion for North American eyes and ears, Capitol Records' *Magical Mystery Tour* added the Beatles' stray 1967 singles to the band's half-dozen *MMT* soundtrack selections, zoomed the entire package—including its gorgeous accompanying 'twenty-four-page full color picture book'—from seven inches all the way to twelve, and voilà! A magically mysterious package to compete with [the other] long-play stocking stuffers of choice that Christmas. . . .

"[All the] tracks on both original vinyl sides were sequenced and edited tightly together (delicate *Pepper's*-type segues completely undone, most unfortunately, on its twenty-first-century digital incarnations) and featured in 'Strawberry Fields Forever' and especially 'I Am the Walrus'—the absolute twin peaks of J. Lennon/G. Martin's mad creative genius."

JAMES CUSHING

"*Magical Mystery Tour* is the first 'visual' album, in the sense that all the songs functioned both on the radio and as elements in a film. All of side one worked in a single film, and the singles on side two had videos to go along with them. . . . But the video the Beatles made for 'Strawberry Fields Forever' . . . was like nothing else in the pop-visual world in March 1967, and it provided evidence that the acid sensibility was an established fact in the world of popular arts. How many people had their heads turned around by these backwards-dancing, smashed-piano-painting Beatles? Something of the wildness of that gesture imbues every cut on *MMT*.

"*MMT* shows the group's moods at their most extreme: John's surreal acid visions ('Walrus,' 'Strawberry'), Paul's nostalgic evocations (the title song, 'Your Mother,' 'Fool on the Hill'), George's mysterious Hollywood Hills mantra, and the only instrumental they ever recorded as stars, 'Flying,' which for me epitomizes the whole LP: an instantly memorable, shimmering guitar phrase leads to a series of elaborations, some funny (the la-la-la chorus), some suspenseful, then the song ends with synthetic bird cries that come out of nowhere (the Mellotron?) and leave us hanging, delighted, in midair. That is the essence of psychedelia, right there—to hang, delighted, in midair and talk about it afterwards."

DAVID KESSEL

"*Disraeli Gears* is a real solid venture into psychedelic blues and poetry art rock. These heavyweight blues cats were channeling the vibe coming out of London, L.A., and San Francisco during the buildup to the Summer of Love.

"The production by Felix Pappalardi is very much like what Chas Chandler did for Jimi Hendrix. No matter how many crazy things are on the songs and recordings, it's all tight pop productions, making for great records and a great album. The principal singing by both Eric Clapton and Jack Bruce is excellent and inventive with the vocal arrangements. . . . The thundering rhythm section of Ginger Baker and Bruce, supporting and weaving the songs along with Clapton's newfound psychedelic blues rock, forged some new ground. 'Tales of Brave Ulysses' was one of the very first records where a wah-wah pedal was used. A wise radio edit would make 'Sunshine of Your Love' Cream's biggest hit, and it was one of Atlantic (ATCO)'s biggest-selling singles ever at the time.

"*Disraeli Gears* sounds like you're stumbling into an underground Cockney music hall that becomes an LSD blues rock poetry beatnik club."

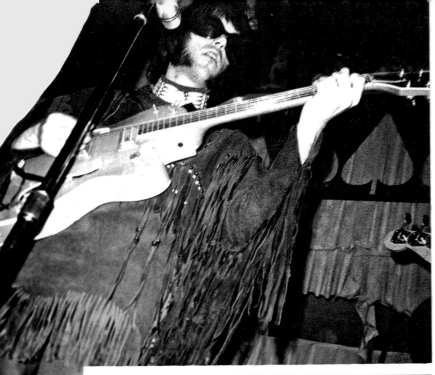

Within its Moorish architectural façade, rich in cultural and community fellowship, the Shrine Auditorium near downtown L.A. has played host to just about every music, movie, and media extravaganza devised to sate the appetites of audiences eager to swallow sensation whole. The Grammys, the Emmys, and the Oscars have all enjoyed the spotlight at this landmark institution.

By 1967, the building had become just shabby enough to open its doors to rock 'n' roll. Acoustically suspect, it nonetheless became a critical stop for bands working the Fillmore or the ballroom circuit.

The adjacent Shrine Exposition Hall, dubbed the "Pinnacle," featured a dance concert series with names like Buffalo Springfield, the Grateful Dead, Jimi Hendrix, and Traffic.

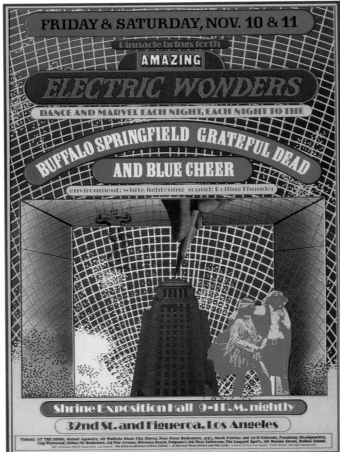

TOP: Neil Young at the Shrine Exposition Hall, during a Pinnacle Dance concert event in late 1967, photographed by Heather Harris.

BOTTOM: Poster designed by John Van Hamersveld for the Electric Wonders concerts, November 10 and 11, 1967, at the Shrine Exposition Hall, aka the "Pinnacle."

JOHN VAN HAMERSVELD

"Creating the *Electric Wonders* for November 10 and 11 was planned at my Coronado studio There is where we talked with agents of rock groups. My roommates were Caleb Deschanel, a film student at University of Southern California, who worked with George Lucas, and Barry Le Va, an art student at Otis Art Institute. We collaborated in setting up light and fog for the floor of the Shrine Exposition for an art happening.

"I [was] traveling to see [artists] Rick Griffin and Victor Moscoso in San Francisco and going to the Avalon Ballroom. . . . But I came up with the name 'Pinnacle' on my way to the studio in L.A.

"As a fan and concert promoter with Pinnacle, often the music and the event posters created in 1967 were the backdrop to all media, clothing, and record stores. . . .

"Working for Capitol Records as an art director during 1965 to 1968, I designed the American cover of the Beatles' *Magical Mystery Tour* album.

"Many albums of 1967 would be telling stories in the lyrics in an abstract way as to what was happening. The concert poster promoted the shows, and also you would remember the shows through having and looking back at the poster—remember what you experienced. Like an album cover, you could smell them, read them, and remember them."

DENNIS LOREN

"John Van Hamersveld's works for the Shrine posters were very subtle in his approach to color. His Shrine posters are overlooked, and that's because the focus was on San Francisco, where the poster art sorta came to bloom there; but it doesn't diminish the work of Gary Grimshaw in Detroit or John in L.A. Of all the psychedelic artists, John is the most minimalist."

DENNY BRUCE

"November '67. Pinnacle dance concerts. I went to all of them, including the two in 1967. I only stuck around for the Buffalo Springfield. I didn't like the Grateful Dead, and Blue Cheer were so fuckin' loud I couldn't stay in the room.

"However as a venue, L.A. needed the Shrine Auditorium and Exposition Hall for rock 'n' roll gigs. Somebody came up with the bright idea, 'Why don't we have a Fillmore in Los Angeles?'"

Remembering Janis

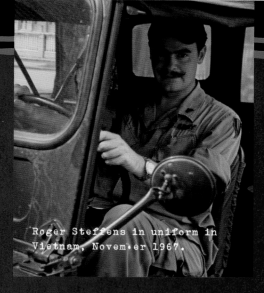

Roger Steffens in uniform in Vietnam, November 1967.

Destined to become the world's foremost authority on Bob Marley and all things reggae, Roger Steffens was nurtured in the fertile soil of sixties counterculture, finely attuned to rampant tremors in music, psychedelic expeditions, politics, and social dishevel roiling the country. He was auditioning, unbeknownst to him, for his role as one of the most astute chroniclers of a world in changes, set to an irresistible island rhythm. Here, Steffens recalls seeing Janis Joplin before leaving for Vietnam:

"On November 2, 1967, the night before I shipped out for Vietnam, three Army buddies and I drove out of the Oakland Army Terminal across the bridge to Winterland in San Francisco.

"It was to be the debut of a new English band, Pink Floyd, but we were there to see the opening act, Janis Joplin and Big Brother & the Holding Company. I had grown up in the fifties in New York City and had seen almost all the major figures of the era in Alan Freed's big stage shows. But not since Jackie Wilson had I seen a performer of such soul-searing power as Janis that night. She was like an exposed nerve ending with a voice, and I felt totally drained emotionally after her startling set.

"Then Richie Havens appeared in the middle of the huge dance floor, alone on a stool with his acoustic guitar, encircled by a couple of thousand kids. He held us in the palm of his hands for the next hour, after which Bill Graham came out onstage looking very apologetic. 'I know you all came here tonight and paid three dollars to see three acts, but Pink Floyd can't get out of customs in time. So I went to the [local club] and got the current group there to fill in. Ladies and gentlemen, please welcome Ike & Tina Turner!'

"Janis raced out of the dressing room clutching a full bottle of [bourbon] and worked her way to the foot of the stage, right beneath Tina, whooping and hollering encouragement all through Tina's outlandish, heart-racing set, draining the bottle in the process.

"After that, Janis decided to do an unannounced second set, and to this day it remains my most precious musical memory. Indescribable, except to say it was twice as good as her astounding opening set—our minds [were] completely blown. A few hours later I was on a plane to Saigon and the war, leaving the States with a vow that if I made it through the war alive, I would come back and live in the Bay Area. I did, and I did."

Standing firm in the face of the psychedelic onslaught, Motown Records in Hitsville, USA, remained its vital, vibrant self, rolling out new models that were steeped in tradition but mindful of the social and cultural discord that demanded a visceral edginess. Detroit, itself, had been feeling the blunt force of racial unrest, culminating in street riots in July. Amid the city's burning, the Funk Brothers, that band of jazz masters who generated all those joyful grooves, continued to lay down the sound of young America.

On October 28, 1967, *Diana Ross and the Supremes: Greatest Hits* began a five-week run atop the Billboard album chart, solidifying their supremacy as the queens of chiffon pop.

"Reflections" by the Supremes raced up the charts that year, its pumping bass hook and airtight arrangement keeping the trio a part of the current musical conversation.

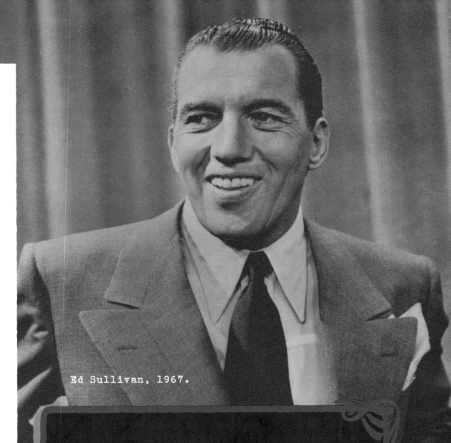

Ed Sullivan, 1967.

BARNEY ALES

Motown Records executive

"It was really a battle in those days to get black artists on network television in prime time. Sammy Davis Jr. and Nat Cole were about the only ones—anyone else, they just weren't accepted. But when the Supremes broke through, we knew we had an opportunity. They looked so great, as well as sounding great. And [producer] Harvey Fuqua and [talent agent] Maxine Powell did a wonderful job, grooming the girls, getting them ready for prime time.

"*The Ed Sullivan Show* was the real breakthrough. Sunday nights, millions of people watching. Once Sullivan took to the Supremes, we knew we were on the right track. And album sales picked up like crazy whenever they were on, so we always made sure to tell the distributors they needed to check their inventory. After the Supremes, we got everyone on Sullivan's show: Stevie, Gladys, the Temptations. We had a good relationship with the producer, Bob Precht. He liked Motown, and Esther, Berry's sister, used to take the dressing room keys afterwards as souvenirs. They're probably somewhere in the Motown Museum to this day."

ANDREW SOLT

producer, director, screenwriter

"The relationship between Berry Gordy's Motown label and *The Ed Sullivan Show* made music and television history. Soon after the Supremes' debut on *Sullivan* (December 1964), it was clear that showcasing the latest Motown releases on CBS on Sunday nights (35 million viewers was average) until 1971 was a way to expose the record company's newest hits and boost the show's ratings. Sullivan introduced nearly all the Motown acts, including the Supremes, the Temptations, Stevie Wonder, the Four Tops, Smokey Robinson and the Miracles, Marvin Gaye, Gladys Knight and the Pips, and the Jackson 5."

MARY WILSON

"Our songs from 1964, '65, and '66 were heard in 1967. Berry Gordy and the Motown A&R department knew what was happening. And we didn't have to think about that. But we were happy for it. And [for us] as a group, 'Reflections' took us into areas we wanted to go. Which is great."

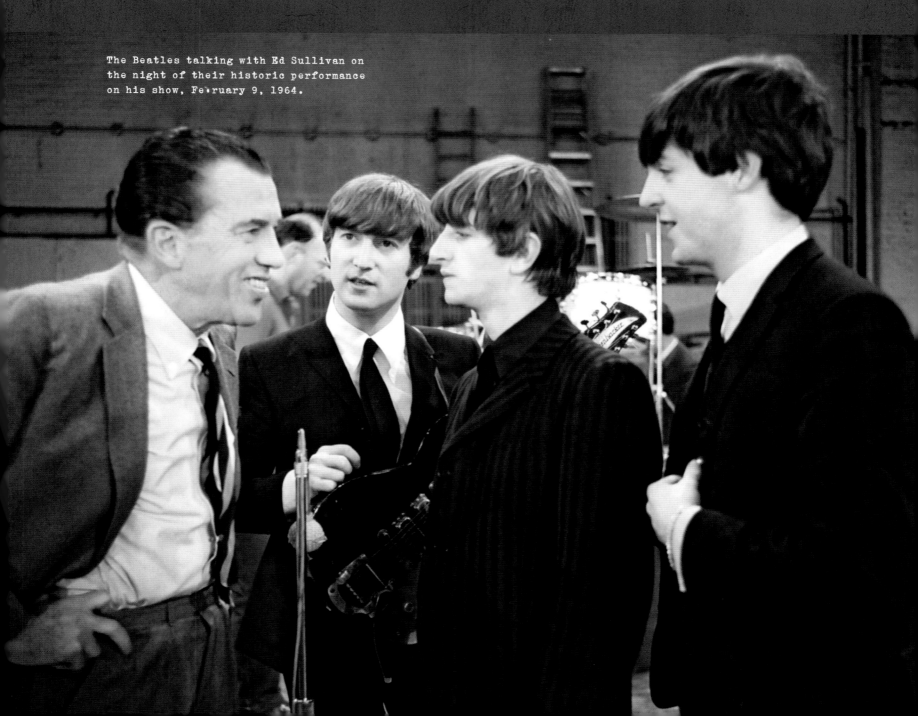

"Ed Sullivan was a true American phenomenon. . . . His musical booking decisions opened the eyes and ears of America and created a legacy/library for all future generations. And he's the only dude I know who made the Rolling Stones change their lyrics."

—ANDREW LOOG OLDHAM

The Beatles talking with Ed Sullivan on the night of their historic performance on his show, February 9, 1964.

MARY WILSON

"For us, being on [Ed Sullivan's] show was so much more than record sales. It wasn't about promoting us. It was about that we had grown up watching *The Ed Sullivan Show*. We had grown up watching shows where you didn't see a lot of black people starring on those shows. For us, we were like every other family in America who spent hours watching *Ed Sullivan*. So for us, being on the show was such a great honor. Because we were there to see the world changing. To see America changing. We were excited. 'We're on *The Ed Sullivan Show*!'

"We came from a time when a whole family of all different colors didn't sit around watching black people on television. The Dick Clark tours—where before us there were segregated hotels. For us, that is what it was all about. We were part of that change. We were part of helping America to see black people, black women, being proud, beautiful, and successful. It wasn't just us. Many people before us. But they didn't have the television to expose them to that wide range of people as we did at the time when we came. We were lucky. And we stood on a lot of shoulders. But we were there when the doors opened."

ANDREW SOLT

"Ed may have been the heart of his celebrated variety show for most of the *Sullivan Show*'s twenty-three-year run, but when it came to the music of the mid- to late sixties, Bob Precht, the show's producer—Ed's son-in-law—was the pivotal guy who knew what was happening. Bob was of the era, considerably younger than Ed, of course, and he genuinely enjoyed and loved the music that was percolating throughout the world, and especially, across the Atlantic.

"The Beatles made their historic U.S. TV debut on the Sullivan stage on February 9, 1964, as we know. It was after that 'big bang moment' that the floodgates totally opened.

"One wouldn't think of Ed as being particularly hep, but in a weird way he was. His instincts led him to give talent he respected a break. He had always been that way. He marveled at the gifts shown by Broadway and cabaret stars from his earliest years. When it came [time] to decide whom to book, he was much more open than one might think. Bob Precht may have been a strong influence as the years went on, but before Bob was around, Ed had already shown his stripes. . . .

"Ed loved introducing African Americans on his stage, and most of all he enjoyed giving people big breaks and the most desired gift: national TV airtime. Ed liked his role as showbiz kingpin, and he knew he was very fortunate to be such a powerful arbiter of American taste. He took pleasure in influencing our culture and acts that would make us gasp and swoon. He was an unlikely hero.

"The home brew served as a platform for musical guests and philosophies being cooked up by the Byrds, the Lovin' Spoonful, James Brown, the Rascals, the Mamas & the Papas, the Doors, the West Coast's reliable Beach Boys, and so many more talented songsters. . . . The impressive creativity of our favorite musical artists was reaching new heights, and their output when it came to breakthrough albums and historic tours was reshaping the way rock would roll for decades to come. Ed was part of this story."

Released in the very late fall of '67, Traffic's *Heaven Is in Your Mind* (later changed to *Dear Mr. Fantasy*, making the original copies rare and very valuable) was, if they did say so themselves, "like, where it's at, man!" With its promiscuous embrace of all the grooviest new sounds—that lumbering Mellotron, Beatlesque sitar, whizzing saxes, and fluttering flutes—Traffic delivered a dizzyingly panoptic view of the British music scene in all its super-saturated glory.

KENNETH KUBERNIK

"Two distinct personalities saddled the band's direction: guitarist Dave Mason's whimsical if finely detailed Top 40 predilections versus the baby-faced soulfulness of keyboardist/singer Stevie Winwood. . . . Winwood was a young musical prodigy, guiding the Spencer Davis Group through a raft of chart successes. When he left, many understandably viewed Traffic as solo Winwood with backing band, a perception that drove Mason to leave and return with fitful irregularity.

"Grievances aside, Traffic's musical template—a loose aggregate of heavy rock, English folk song, a jazzman's instinct to improvise, and a healthy regard for a hook-laden chorus—struck an immediate critical and, to a surprising degree, commercial chord. The hippie anthem 'Dear Mr. Fantasy' is the ur-text for the burgeoning jam-band phenomenon, stretching out over a languorous rhythmic pulse, allowing both players and audience to coordinate their 'flight paths' in harmony."

KEITH ALTHAM

"I interviewed Stevie Winwood for the October 7, 1967, issue of *New Musical Express* back then when he was forming Traffic. He was enormously talented. I mean, a multi-instrumentalist. Really, I think if he cared about being famous a bit more, which I don't think he did, I think he would have been a huge star. I mean, he was big. I think he would have been mega. I don't think he cared about it enough. He didn't care enough to be in love with being a star. He was kind of more in love with the music and being a musician."

LEFT: Dave Mason, Chris Wood, Jim Capaldi, and Steve Winwood of Traffic, London, 1967.

Jefferson Airplane's song-cycle concept LP *After Bathing at Baxter's*, produced by Al Schmitt, was released on November 27 by RCA.

The twelve songs were combined into five "suites" that suggested the band was starting to think in terms of larger structures. This level of seriousness prefigured that of the progressive bands that would follow a few years later.

The genre-shattering undertaking retained the band's zaniness, as evidenced by Paul Kantner's opening composition "The Ballad of You & Me & Pooneil."

Grace Slick's singing throughout this album, especially on "Rejoyce" and "Two Heads," remains one of the most erotically compelling rock performances on record. These two songs aren't about sex, not in any obvious way, but the steely command in her voice isn't about anything else.

Jefferson Airplane at Monterey Pop, June 1967; photograph by Howard Wolf.

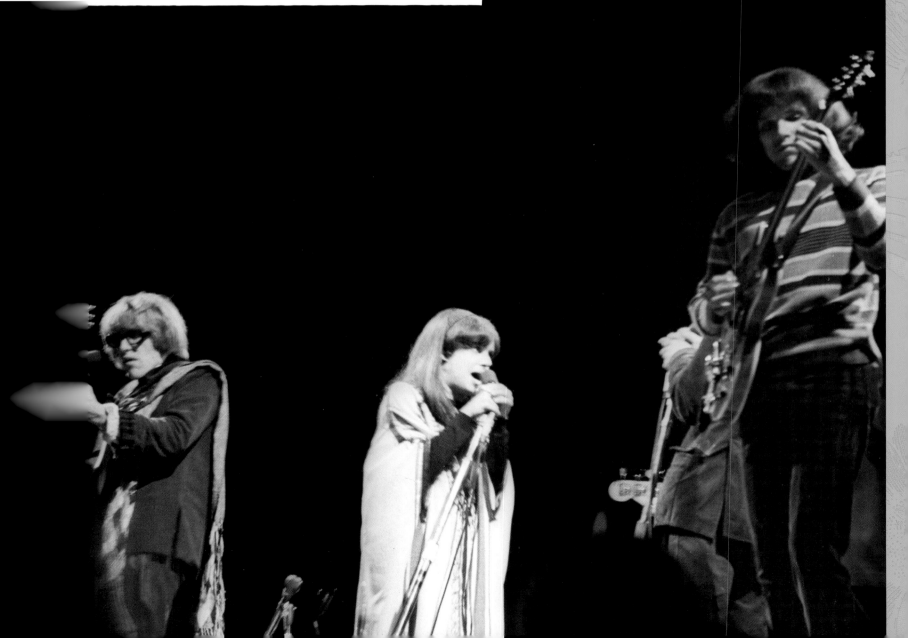

"**I know how I feel emotionally. The music is from inside of me. We all tend to do pretty much what we please and that has nothing to do with sales. We make songs. We communicate with people. I think music touches a lot of people.**"

–GRACE SLICK

PAUL KANTNER

"I wrote just regular songs and then got a little out there like we all did on *After Bathing at Baxter's*. Still one of my favorite albums just for the stretch that went from *Surrealistic Pillow* to *Baxter's*. We just went to the nth degree. As such, it is a rather difficult and faulted [record] . . . but the push and the drift is what I enjoy about that album. There's all sorts of stuff on it. Mistakes become part of the arrangement, as jazz people used to say. Or as Jorma used to say, 'When you make a mistake on a guitar, repeat it.' Everybody thinks it's part of the arrangement.

"I like things going out connecting with other things. I'm very much on collaboration as a writer and a player. I like collaborating. I like the friction that happens and the fire that occurs as a result of that friction that comes out in music in another way that comes from collaborating in other levels. I like bouncing ideas off people who like to work together. There's a little magic in a band when people decide to put their heads and minds to one thing and it works. It becomes more than the people involved."

JAMES CUSHING

"*After Bathing at Baxter's* is the strongest single album from the San Francisco psychedelic scene. Not even side one's opening roar of feedback prepares the listener for the variety of sounds to come: the stoned hilarity of 'A Small Package of Value Will Come to You, Shortly' [and 'Rejoyce,'] Grace Slick's tribute to Joyce's *Ulysses*; side two's nine-minute 'stealth jazz' jam called 'Spare Chaynge'; and [other] songs with memorable melodies and lyrics that invite one to a 3-D picture of enlightened innocence. . . .

"Jefferson Airplane's masterpiece presents the psychedelic experience ('bathing at *Baxter's*') in its best possible light: as a sweet adventure of the innocent imagination, a small package of value that comes to you gently. Is this a simplistic notion? Yes—but on Paul Kantner's 'Won't You Try/Saturday Afternoon,' it's completely convincing. At one level, it invites you to a Be-In at Golden Gate Park; at another, it beckons you to another knowledge of reality."

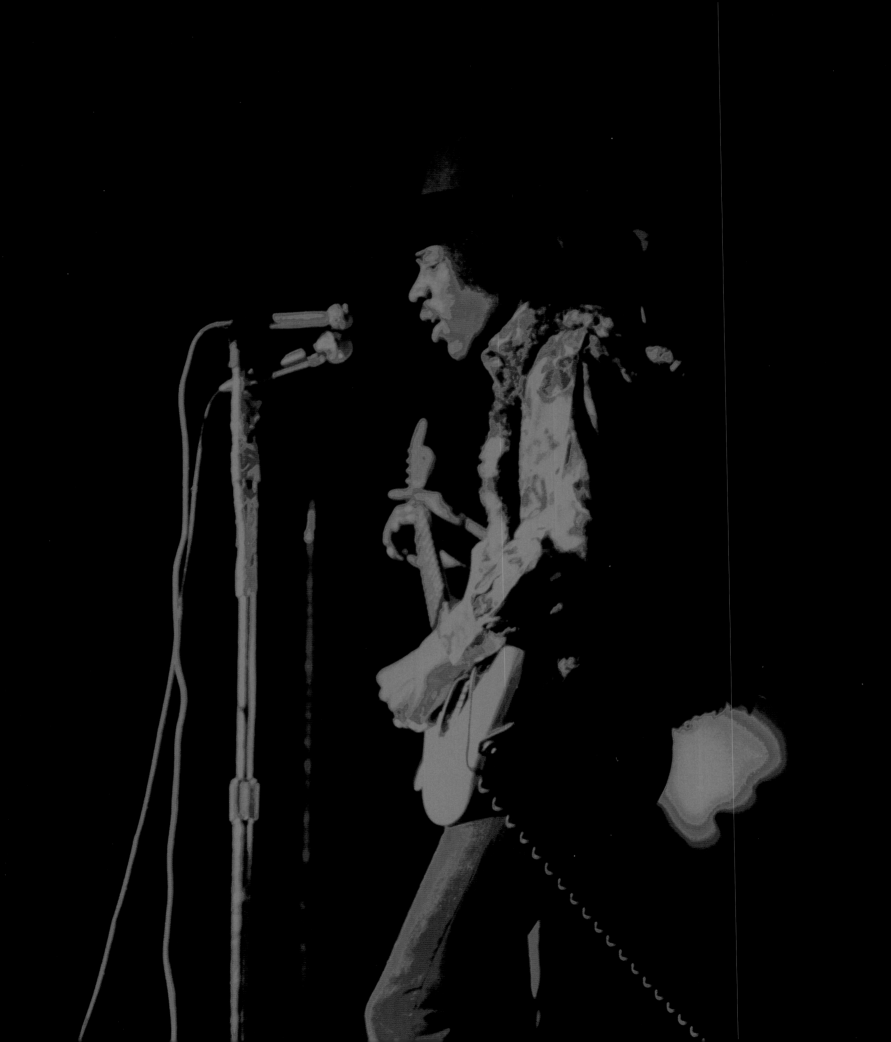

PSYCHEDELIC SUPERMARKET

Jimi Hendrix ignited the year with his brazen, blues-rock attack, his electric showmanship, and an intuitive command of the prismatic forces bending and shaping the musical landscape. His second album, *Axis: Bold as Love*, released on December 1 on the UK Track label (Reprise Records in early 1968 in the States), concluded a whirlwind race to the summit of pop superstardom.

From the moment he "combusted" onstage at Monterey, Hendrix demonstrated that he was not simply an artist but a magic man shrouded in a nimbus of fuzzy swirls, who stirred his cauldron of darkly alluring potions with his trusty Stratocaster.

He was also a thoughtful, soft-spoken, well-mannered professional, possessed by the need to push his creative impulses to their unknowable limit, which made the journey even more rewarding for him and his audience.

As Kenneth Kubernik notes, "With *Axis*, the production is leaner, the riffs meaner, the psychedelic flourishes more textural, less 'groovy,' the lyrical flights finding their poetic thrust in an . . . admixture of Dylan, Blake, and a few too many encounters of the sugar-cubed kind. . . . But I don't mind."

OPPOSITE: Jimi Hendrix at the Anaheim Convention Center, February 9, 1968; photograph by Henry Diltz.

JAMES CUSHING

"*Axis*, as the semi-comprehensible title suggests, occupies a multicolored area all its own. It's Jimi's second LP, but first *album* in the *Sgt. Pepper's* sense of providing forty minutes of unified organic flow. The songs show an unexpected and ongoing obsession with death, departure, termination—as though the Jimi Hendrix Experience, having achieved stardom, could now only think of it as a prelude to an early farewell: 'Now, if you'll excuse us, we must be on our way.'

"Is this why eleven of these thirteen brilliant songs were never performed in concert—even the obvious stadium anthems like 'If 6 Was 9' or 'Wait Until Tomorrow'? Certainly the album joins Butterfield's *East-West* and the Blues Project's *Projections* in the stealth jazz category. After Mitch Mitchell's bop drumming on 'Up From the Skies,' the straight 4/4 of most rock just sounds less bold."

EDDIE KRAMER

"As an engineer, I started with Jimi in January of 1967. I wasn't there for everything, unfortunately, but I was there for the majority in the sense of all the albums. I think he was fascinated with . . . the recording process whether it [was] live or in the studio. . . .

"But Mitch [Mitchell] was the little-known genius, you know, who just sort of fiddled around the kit and did the most spectacular thing that would spark Jimi's imagination. And he was able to stay with Jimi and always land on the downbeat, even though he would do the most outrageous fills. You'd think, 'There's no way in hell he's gonna land on one.' But he did. . . . Musically, I think Noel [Redding] is very underrated and I think he did a tremendous job."

December 5, 1967, brought the theatrical release of Murray Lerner's *Festival!* movie, a documentary of the 1963 to 1966 years of the Newport Folk Festival. Footage of Bob Dylan, the Paul Butterfield Blues Band, Buffy Sainte-Marie, Donovan, Pete Seeger, Son House, Judy Collins, Mississippi John Hurt, Joan Baez, Johnny Cash, and Peter, Paul & Mary could now be seen on the big screen in national cinemas.

MURRAY LERNER

documentary film director and producer

"I think electric music gets into your body, and enters into your nerves quite deeply, and almost puts you into a trance. It's hypnotic. I've always felt this, and this was the feeling I had when I watched Bob Dylan. And I was excited by it. I not only appreciated the changes, I loved it! I really was mesmerized and hypnotized by 'Maggie's Farm' on many levels. As I was filming it, I knew it was a gateway to a new culture in the form of, based on, the older culture, and I thought this was it. And it was quite a moment with Dylan playing with this band.

"The other part to me which is fascinating is the message of those songs. 'Maggie's Farm' and 'Like a Rolling Stone' were very much in tune with what the kids really felt. They expressed their feelings. But they didn't understand that. They were reacting to something else. 'Maggie's Farm' was about work and drudgery. 'Rolling Stone'—the feeling of alienation was very common in those days."

JOHNNY CASH

"I became aware of Bob Dylan when the *Freewheelin'* album came out in 1963. I thought he was one of the best country singers I had ever heard. I always felt a lot in common with him. I knew a lot about him before we had ever met. I knew he had heard and listened to country music. I heard a lot of inflections from country artists I was familiar with.

"I was in Las Vegas in '63 and '64 and wrote him a letter telling him how much I liked his work. I got a letter back and we developed a correspondence. We finally met at Newport in 1965. It was like we were two old friends. There was none of this standing back, trying to figure each other out."

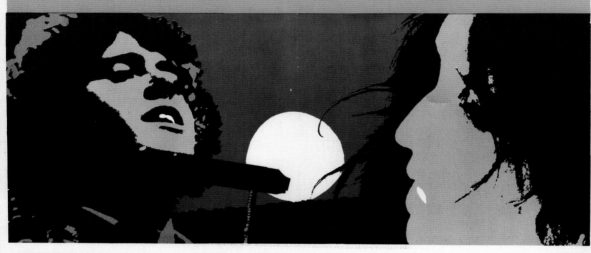

Newport is an oasis of beautiful music—
and beautiful people...
who take the
high road
to

"FESTIVAL!"

A FILM
BY
MURRAY LERNER
·
FILMED
AT THE
NEWPORT
FOLK FESTIVAL

"FESTIVAL!" FEATURING JOAN BAEZ · BOB DYLAN · PETER, PAUL & MARY · DONOVAN
JUDY COLLINS · MIKE BLOOMFIELD · PAUL BUTTERFIELD BLUES BAND · SON HOUSE · THEODORE BIKEL · ODETTA · MIMI & DICK FARIÑA
MISSISSIPPI JOHN HURT · JIM KWESKIN JUG BAND · HOWLIN' WOLF · PETE SEEGER · BUFFY SAINTE-MARIE · SPIDER JOHN KOERNER
VENICE FILM FESTIVAL PRIZE WINNER · RELEASED BY PEPPERCORN-WORMSER FILM ENTERPRISES, INC.

The poster for *Festival!*, a documentary by Murray Lerner on the Newport Folk Festival.

MURRAY LERNER

"On stage Paul Butterfield came alive. I interviewed Mike Bloomfield in *Festival!* talking about Butterfield. I wanted to show in the movie that this was a movement for white kids and white people to get into the blues. Bloomfield and Butterfield were iconic figures in my mind."

STEVEN VAN ZANDT

"I talk a lot about Bloomfield. One of the greats. The single most unsung guitar hero. Really right there alongside the holy trinity of Clapton, Beck, and Page. Probably next in line as far as influence and importance would be Mike Bloomfield in our early youth growing up. Extremely important."

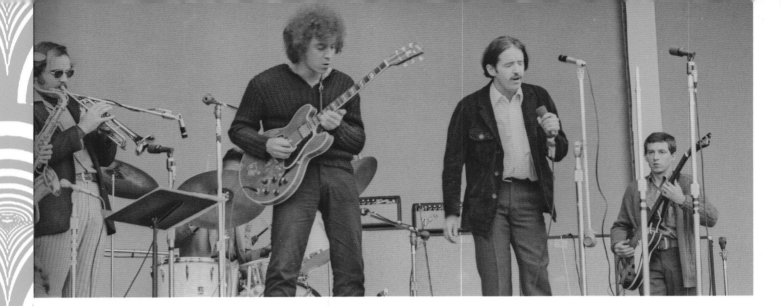

Paul Butterfield's 1966 masterpiece *East-West* documented one of the greatest twin-guitar blues-rock bands ever. But by 1967, soul was making inroads in Butterfield's sound, and a lot of bright people in rock were starting to remember that saxophones and trumpets sounded good with guitar. Mike Bloomfield had left Butterfield to form the horn-dominated Electric Flag, and Bloomie's buddy Al Kooper had started another horn-based outfit, Blood, Sweat & Tears.

Butterfield beat both to the record racks with the whimsically titled *Resurrection of Pigboy Crabshaw*, an album by a one-guitar, three-horn version of his band that was released in December. Elvin Bishop took the guitar solos, but the backbone of the music was the horn section: Keith Johnson on trumpet, Gene Dinwiddie on tenor sax, and, in one of his first appearances on record, Dave Sanborn on alto sax. Six of the LP's nine cuts are long blues covers, with Butterfield essaying usual suspects Otis Rush, Albert King, Bobby Bland, and Little Walter.

By 1966, weekly network music television series *Hullabaloo* and *Shindig!* had been canceled. But the saving grace of live televised rock 'n' roll weekly music shows in the United States was *Upbeat*, a Herman Spero–produced, syndicated, one-hour program hosted by Don Webster in Cleveland, Ohio, on WEWS-TV 5 that was broadcast in more than one hundred markets from 1964 to 1971.

ABOVE: The Paul Butterfield Blues Band at the Monterey Pop Festival, June 1967; photograph by Howard Wolf. From left to right: Keith Johnson (trumpet), Billy Davenport (drums), Elvin Bishop (lead guitar), Paul Butterfield (vocals, harmonica), and Bugsy Maugh.

DAVID SPERO

radio pioneer and music manager

"*American Bandstand* had one or two live acts that lip-synched, and dance music the rest of the show. My father wanted eight or ten live acts per show. One day could be Dizzy Gillespie and Gene Krupa alongside the Box Tops, Tommy James and the Shondells, and Aretha Franklin, the Temptations, Otis Redding. . . .

"We were fortunate to have so much music coming through [Cleveland]: Jackie Wilson, Love, and Simon & Garfunkel, who debuted on *Upbeat*; the Velvet Underground. . . . We had a place called Leo's Casino, and the only white group that ever played there was Wayne Cochran & the C.C. Riders. It was all Motown and Stax."

ABOVE: David Spero, far left, holds cue cards on the set of *Upbeat*, c. 1964; Herman Spero, David's father and the show's producer, is on the right.

On November 22 in Memphis, Tennessee, Otis Redding recorded "(Sittin' On) The Dock of the Bay"—a tune he co-wrote with Steve Cropper. Overdubs were added by Redding and Cropper on December 8. Tragically, two days later, Otis Redding died with four members of his backing band the Bar-Kays when his private airplane crashed in Lake Monona, Wisconsin, when the musicians were on their way to a show near the University of Wisconsin. Otis and the group had just taped the *Upbeat* TV program in Cleveland. Trumpeter Ben Cauley survived the accident.

Singers Johnnie Taylor and Joe Simon were among the pallbearers at Redding's funeral in Macon, Georgia. Booker T. played organ to the grieving congregation and Jerry Wexler provided the eulogy.

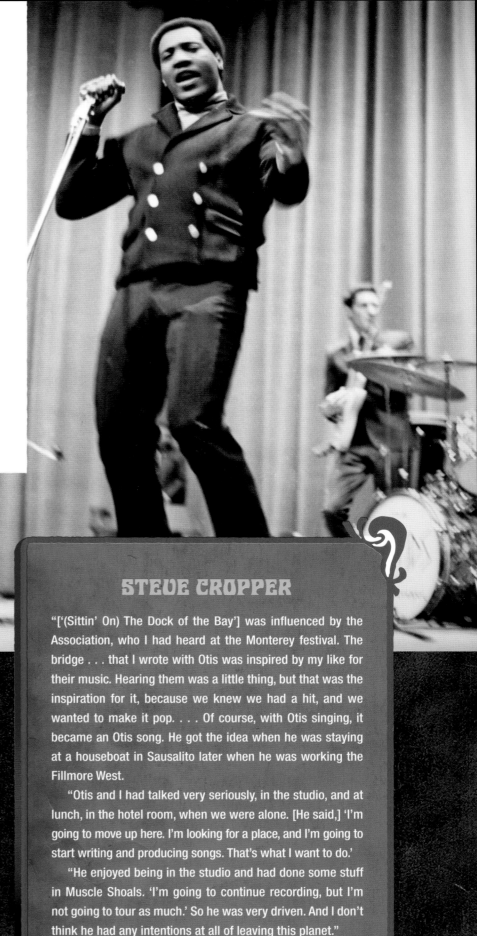

RIGHT: Otis Redding and Steve Cropper performing at Hunter College in New York, January 21, 1967.

WAYNE JACKSON

trumpet player in the Mar-Keys

"My luck was that good and God was that good to me to put me into that situation as an eighteen-year-old. I was there the whole time and thrilled the whole time. I loved Otis and he loved me. We were big friends. 'Cause we all liked to laugh, and we were all young and the testosterone levels were out of this world. That's what you heard in that music.

"Otis used a guitar to write songs and would use open key. So he could just bar it, put a bar on his finger and play up the scale and chords. He could easily write with it. But outside of the farm he didn't think of nothing but his career. Otis did an amazing body of work in the six years he was recording."

EMPEROR ROSKO

"I was on the air, French Radio Luxembourg. The news broke. I broke. Even now I break up. He [Otis] had that effect. I just put his album on."

STEVE CROPPER

"['(Sittin' On) The Dock of the Bay'] was influenced by the Association, who I had heard at the Monterey festival. The bridge . . . that I wrote with Otis was inspired by my like for their music. Hearing them was a little thing, but that was the inspiration for it, because we knew we had a hit, and we wanted to make it pop. . . . Of course, with Otis singing, it became an Otis song. He got the idea when he was staying at a houseboat in Sausalito later when he was working the Fillmore West.

"Otis and I had talked very seriously, in the studio, and at lunch, in the hotel room, when we were alone. [He said,] 'I'm going to move up here. I'm looking for a place, and I'm going to start writing and producing songs. That's what I want to do.'

"He enjoyed being in the studio and had done some stuff in Muscle Shoals. 'I'm going to continue recording, but I'm not going to tour as much.' So he was very driven. And I don't think he had any intentions at all of leaving this planet."

DAVID SPERO

"Otis had been on the show six or seven times. He was like a member of the family. He was the first person I knew who died. Otis performed at Leo's Casino that night after doing the *Upbeat* show. He was leaving on Sunday. He had played cards with my dad on Friday or Saturday night. I do know I have a copy of the check; he signed it on the back because he had lost $209 to my dad playing cards, and everyone playing cards, and endorsed the check to my dad. Which is why it wasn't in his pocket when he died. I literally spent four or five hours with Otis the day before. He was a young guy. He seemed much younger than he was."

JONATHAN GOULD

writer

"As for Otis' planned tour schedule in December 1967, he played a fraternity dance at Vanderbilt in Nashville on Friday, December 8, flew that same night to Cleveland in time to catch the Temptations' last set at Leo's Casino, played the *Upbeat* and Leo's on Saturday night, and left for Madison, Wisconsin, on the afternoon of December 10 to play at a club called the Factory. His plane crashed on its final approach to Truax Field in Madison. . . . There only would have been one more weekend between the fateful gig in Madison and his bookings on the West Coast."

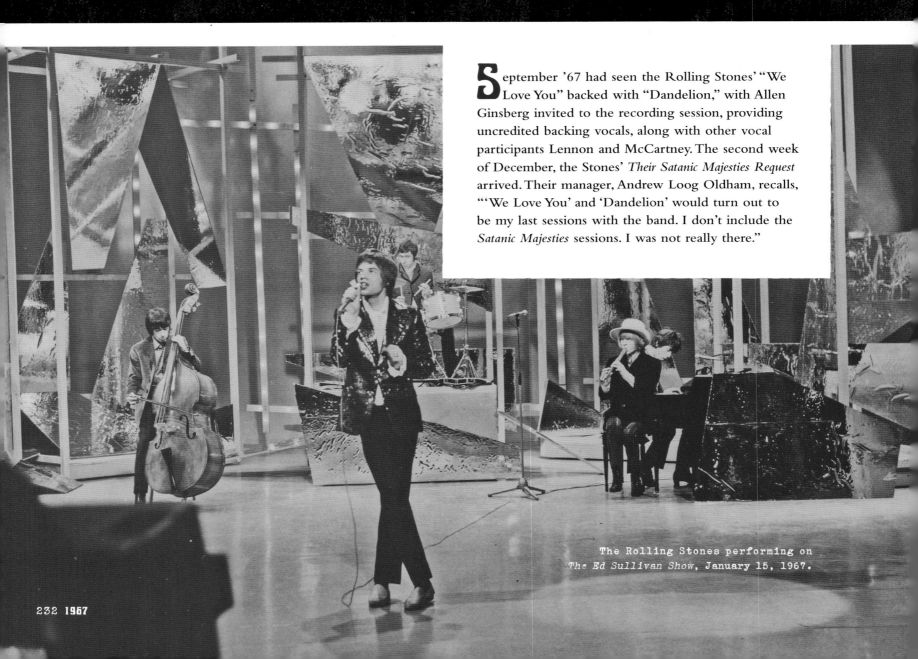

September '67 had seen the Rolling Stones' "We Love You" backed with "Dandelion," with Allen Ginsberg invited to the recording session, providing uncredited backing vocals, along with other vocal participants Lennon and McCartney. The second week of December, the Stones' *Their Satanic Majesties Request* arrived. Their manager, Andrew Loog Oldham, recalls, "'We Love You' and 'Dandelion' would turn out to be my last sessions with the band. I don't include the *Satanic Majesties* sessions. I was not really there."

The Rolling Stones performing on *The Ed Sullivan Show*, January 15, 1967.

Destination: Far Out

Kenneth Kubernik

"'The Stones' . . . year began with that little dustup at Redlands—the bust heard 'round the world—that canonized Mick and Keith as the baddest of Peck's bad boys. Brian Jones was equally heedless, drifting in and out of courtrooms and airport lounges in search of some ineffable respite that drugs or travel seemed to prescribe. . . .

"[Jones] had one last creative gasp within him and it would define their next, and most controversial, album, *Their Satanic Majesties Request*. Recording began in July at Olympic Studios, Glyn Johns at the mixing console. Their guileful manager/producer, Andrew Oldham, had been experiencing his own Walpurgisnacht and slipped inconspicuously from sight. The Stones were left to conduct themselves without any adult supervision. . . .

"In a conversation years later with Roy Carr, [Jagger] observed that the music always reflected 'the mood of the times' and that 1967 was rife with 'flowers, beads, and stars on your face.' For his bedside reading, Mick reached for *The Secret of the Golden Flowers*, a critical text about the Chinese philosophy of Taoism. Indeed, the lyrical imagery throughout *Satanic* is suffused with references to light, color, night, flight, weightlessness, drowsiness, time ebbing and flowing, all denoting the free fall of consciousness under the delirium of acid. . . .

"The album has a distinct beginning, middle, and end, an implicit narrative that some ascribe to the Stones aping *Sgt. Pepper's*. The music bleeds together in a similar suite-like structure, furthering the indictment. But if there is a surface correspondence, it's no more akin than describing the Beatles' work as a piquant Haydn symphony and the Stones countering with 'Carmina Burana,' unruly, indulgent, revelatory. It begins with pianist Nicky Hopkins' Brahmsian chords to the overture, 'Sing This All Together.' 'Citadel' follows, its wrought-iron riff and leering, seesaw backbeat showcasing Richards' genetic command of the power chord. 'In Another Land,' Bill Wyman's loopy minuet, is salvaged by Jagger's rim-shot harmony, which snaps the song's inherent slackness into something that sort of rocks.

"'She's a Rainbow (She Comes in Colors)' is highlighted by Hopkins' partita-like accompaniment, aided and abetted by John Paul Jones' (yes, Led Zep's JPJ) chiaroscuro string arrangement. . . . And then there is '2000 Light Years From Home,' a fantasia for the cosmic explorer in all of us. Pitch perfect to its time, the song seizes on the culture's appetite for fantastic voyages into inner and outer worlds, the longing for home while striving to reach escape velocity.

The Space Age will reach its creative zenith with Kubrick's *2001: A Space Odyssey*, which was already in production in '67. . . .

"The record ends . . . with another excuse for dance hall frippery. 'On With the Show' is a tea cozy of a tune, part Vaudevillian ditty, part South American rumba, a possible homage to the anarchic silliness of BBC Radio's *The Goon Show*, bringing the curtain down on this deeply misunderstood, deeply undervalued album.

"And how 'bout that cover—the boys looking all mysterioso, like some bizarro-world genre scene in kaleidoscopic 3-D, photographed by their fellow traveler, Michael Cooper (who, Beatle conspirators note, also took the cover photo of *Sgt. Pepper's*)."

After the hot, sticky Summer of Love, there was a gifting to come from the Beach Boys: *Wild Honey*. Following the debacle of *Smiley Smile*, it was decided that a return to their earlier, collaborative approach was the only real option, and they quickly produced a number of desultory performances that were gathered together as *Wild Honey*.

Released in December, it features at least one song that delivers a winning blast of their signature melody and harmony: "Darlin'," composed by Brian, which had initially been considered for singer Danny Hutton's new band, Redwood (soon to be renamed Three Dog Night), but instead became a hit for a band desperate to remain relevant. Well served by younger brother Carl's caressing vocal and buoyant backbeat, "Darlin'" proved that Brian still had the ability to touch the teenage heart.

In a 1974 interview for *Melody Maker*, Mike Love told me, "The biggest change the group has gone through is Brian's retirement from live touring. I'd like to point out, in the past, Brian was the overwhelming dominant creative force in the group just by virtue of his influence on his brothers, myself, and his friends. That, along with a personal growth program, Transcendental Meditation, has been very helpful in unfolding our individual capacity for creativity.

"We met the Maharishi Mahesh Yogi in December 1967 when we did a United Nations show in Paris. The whole group now meditates. Al and I are teachers. Any group is only as strong as its members. I don't think I'd be in the group if it wasn't for meditation."

ABOVE LEFT: Portrait of Brian Wilson by Guy Webster, fall 1966.

ELLIOT KENDALL

"The title track is an ideal showcase for Carl Wilson's R&B vocal stylings, as is the classic 'Darlin',' a song that began melodic life as a 1964 Brian Wilson–produced track, 'Thinkin' 'Bout You Baby,' sung by Sharon Marie and co-written by Wilson and Mike Love. 'Wild Honey' was also co-written by Wilson and Love and features Paul Tanner playing his custom-made Electro-Theremin."

"I know music was more than people applauding and buying records. The most amazing comment I got [was] from one guy who said, 'That [*Pet Sounds*] is the most spiritual album I've ever heard.'"

—BRIAN WILSON

Not every hitmaker of the period was festooned in paisley. Composer Burt Bacharach and lyricist Hal David emerged a generation earlier from the Brill Building's songwriting factory. Having enjoyed some success with a clutch of R&B/soul exercises for artists like the Drifters and the odd novelty tune, they made their songs increasingly idiosyncratic, mixing the craft of Broadway standards with the harmonic palette of modern classicism.

Bacharach grew up listening to the New York Philharmonic and later studied composition and theory with Darius Milhaud and Henry Cowell. He was equally enamored of the scintillating sound of bebop, and his writing was often inflected with unusual rhythmic displacements and sophisticated harmony not associated with pop music.

Bacharach composed and arranged the soundtrack of the 1967 film *Casino Royale*, spotlighting "The Look of Love," performed by Dusty Springfield, and the title tune, an instrumental Top 40 hit for Herb Alpert and the Tijuana Brass.

It was at a New York recording session in 1964 that Burt first encountered a young backup singer working on a Mike Stoller and Jerry Leiber track—Dionne Warwick. The magic of Bacharach's music, David's enchanted lyrics, and Warwick's interpretive grace reached its creative zenith in 1967 with the release of "Alfie," the title song to Michael Caine's breakthrough portrayal of an irrepressible bounder in Swinging London. Bacharach introduced a radical take on the conventions of verse/bridge/chorus that entailed soaring vocal leaps and abstruse chord substitutions more fit for a Bill Evans session than for a single from a mainstream feature film. "Alfie" became an instant classic, confirming that even in this most turbulent of years, the poetry of loss and longing, in words and music, remained hauntingly timeless.

In 1967, Bacharach, David, and Warwick also recorded "Do You Know the Way to San Jose" at Bell Sound, and in August 1967 the partnership had another hit with "The Windows of the World."

BELOW: Burt Bacharach at the piano in his Hollywood home, 1969.

BRIAN WILSON

"Burt Bacharach. What a writer. What a songwriter. Hal David, what a lyricist. Oh God, yes. Of course. 'Let's Go Away for Awhile' [on *Pet Sounds*] was influenced by Burt Bacharach. Because the chord structure—if you follow the chords, you can trace the roots back to Burt Bacharach. I like going up and down the keyboard. He is probably one of the greatest songwriters of the whole century, including Gershwin, in my opinion."

BURT BACHARACH

"No demos, no rehearsals. I like to believe we know basically that we know what we've got and what's going to work and what's not going to work before we hear it. For me, it's always—if it can work, if you have the song, and you have it intimate, then you have the capacity to explode on a level that is very wide-scope. Nothing is crowded. But then our intent was not to be crowded in the composition, or crowded in what was gonna be jammed in on the color, the orchestration, things that would be too busy behind."

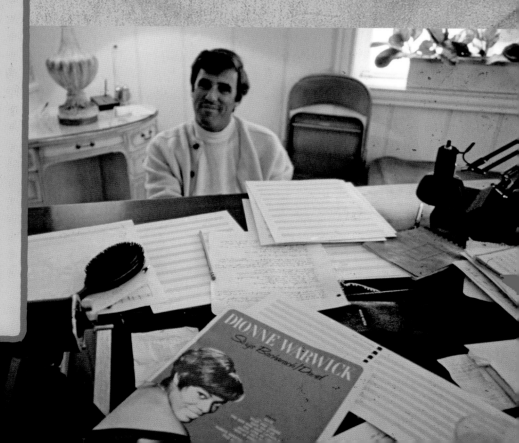

CHRISSIE HYNDE

"I sang a version of 'The Windows of the World' for the film *1969*. I was always a fan of the Bacharach and David team ever since I heard them. Dionne Warwick was always one of my favorite singers, so, naturally, those were the songs of the late sixties. They were like the great melodic songs; they weren't just records."

ELVIS COSTELLO

"I have a perspective on Bacharach and David that some- one of my years probably shouldn't have. I always heard Burt's tunes in cover form first. And that was important. It's very natural for me because I grew up also with my mother being a record salesperson and really know- ing the catalog backwards in a day when being a record salesperson was closer to being a librarian than it is now.

"I've told Burt he always got his hits stolen out from under him in England. I'm sure from Burt's point of view, making killer records on these songs with Dionne Warwick and having somebody copy them, ya know."

ABOVE: Dionne Warwick performing at the KFRC Fantasy Fair and Magic Mountain Music Festival at Mount Tamalpais, Marin County, California, June 1967; photograph by Helie Robertson.

Many AM and FM radio stations playlisted Lee Hazlewood and Nancy Sinatra's easy-listening/ psychedelic-soaked 'Some Velvet Morning.' Their collabo- ration made the Top 30 singles chart in the United States in the last month of the year.

All through 1967, Los Angeles continued to have a very active pulse in the R&B world of 45-rpm singles. Radio stations XERB, KGFJ, and KDAY, the major R&B outlets in Southern California, were very supportive of the Loma label, a subsidiary of Warner Bros. Records.

From 1964 to 1967 more than one hundred singles and a handful of albums featured the logo of Loma, a company run and guided by Bob Krasnow, Russ Regan, and Jerry Ragovoy. Several Loma discs were spun on the pop stations up and down the West Coast: J.J. Jackson's 'But It's Alright,' Linda Jones' 'Hypnotized,' the Enchanters' 'I Paid for the Party,' the Apollas' 'You're Absolutely Right,' and Ike & Tina Turner's 'Somebody (Somewhere) Needs You.'

Visiting English acts at the Southland record shops Flash Records and Dolphin's of Hollywood devoured Loma soul-glow plastic from the Olympics, Lorraine Ellison, the Mighty Hannibal, and Bobby Freeman.

BELOW: Portrait of Nancy Sinatra, 1966, by Guy Webster.

RUSS REGAN

record executive

"Gene Page and H.B. Barnum arranged for the Loma label. Loma was supposed to be the R&B division of Warner Bros. Records. I had a history with Motown and Scepter Records. Joe Smith hired me to understand R&B and sign acts. Jerry Ragovoy brought Lorraine Ellison to me. I produced a live Redd Foxx album at Western Recorders.

"I remember the day in 1967, just before the Monterey International Pop Festival, when Joe Smith called me into his office and played me an acetate of Jimi Hendrix. Reprise had signed him for North America. I heard 'Purple Haze' and said to Joe, 'This record will do absolutely nothing or go all the way.'"

JOE SMITH

record executive

"After Monterey I took out the first Hendrix album to our independent distributors, and I would make the pitch. And I'm in Chicago with all our distributors from the Midwest and the South. And I said, 'This is the music that will change the world. Now, you've been listening to Frank Sinatra and Sammy Davis Jr. records here; this is what we're going to be dealing with for many years.' And our deal used to be with our distributors that they bought seven and they got one free. And then I looked at the order from Minneapolis and they ordered seven records. I called them in. 'This is the future!' And I added three zeroes. 'You just bought seven thousand of this fuckin' album and you'll get a thousand free.'"

ANDREW LOOG OLDHAM

"The audience and record business changed in 1967. Along came an audience, now pretty high on a regular basis, that was going to be around for a while and could be targeted and marketed to. The BBC tried to fight the pirate radio successes into sinking by employing anyone with hair long enough to look like they might enjoy a spliff.

"Quite frankly, I was more than a little lost with this change of events, though fortunately most of the acts I worked with, in particular the Small Faces, were not, and they held my hand through this change of events.

"Of course, everything goes in cycle, and one of the cycles that somewhat ended with the Summer of Love, the 12-inch LP replacing the 45-rpm single as the sales chip, and the public desire for a more real intimacy with and from its artists, was the life of the Svengali producer, the writing teams, the puppet artists, and that whole syndrome.

"The fight in '67 was different. Even though the likes of Nancy and Frank Sinatra and Petula Clark dominated the charts [early in the year]. . . in the second half of the charts came the Beatles, the Who, Jim Hendrix, and the rest."

I n 1967, following in the tradition of relocated Brit DJs Lord Tim Hudson on KFWB and Tommy Vance on KHJ, radio station KRLA in Pasadena hired another British DJ voice, journalist and former Beatles publicist Derek Taylor, who aired English import records weekly on his Sunday night shift, including Traffic's "Paper Sun," Procol Harum's "Homburg," Dusty Springfield's "Give Me Time," the Flower Pot Men's "Let's Go to San Francisco," Lulu's "To Sir With Love," and the Small Faces' "My Mind's Eye."

In the fall, the Small Faces from England had a huge U.S. hit with "Itchycoo Park," on Andrew Loog Oldham's Immediate Records label. It was introduced stateside by program director Les Carter on Pasadena-based KPPC-FM and subsequently received hitbound airplay on KHJ-AM, the Ron Jacobs–programmed RKO chain outlet in Los Angeles. Both stations would occasionally spin "Itchycoo Park" right next to Jackie Wilson's "Higher and Higher."

RIGHT: Soul singer Jackie Wilson's hit album *Higher and Higher*, released by Brunswick Records in late 1967.

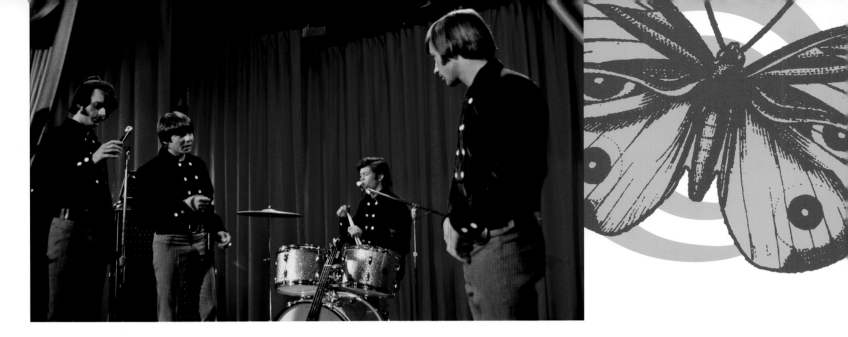

After the success of his *Where the Action Is* weekly music program that ran from June 27, 1965, through March 31, 1967, Dick Clark's new *Happening '68* taped four episodes that were filmed on December 16, 1967, in Hollywood, co-hosted by Mark Lindsay and Paul Revere. The Saturday afternoon weekly show followed Clark's *American Bandstand* on ABC-TV and would debut on January 6, 1968. (The color TV show was eventually so popular and influential that the ABC network added a weekday spinoff Monday–Fridays from July through October 1968.)

The December 1967 musical guests lip-synched to their current repertoire. Most notably, Etta James' "Tell Mama," Strawberry Alarm Clock's "Tomorrow," and John Fred and His Playboy Band's "Judy in Disguise," which would dislodge the Beatles' "Hello, Goodbye" from the *Billboard* No. 1 chart position for a couple of weeks in January 1968.

Clark conducted interviews with the talent and provided a viable exposure and showcase platform as 1967 concluded and 1968 loomed. Dick Clark explained that he "never relegated the lip-synch to a lower form of entertainment. Lip-synching is an art unto itself. A lot of people can't do it. Jazz singers, improvisational singers just can't pull it off. Our interviews with the artists were short. Give them the courtesy of allowing them to get their plug in and then get what you want out of it. It's a very symbiotic relationship. We are using one another."

In mid-December, principal photography of the Monkees' second season of their television series wrapped. 1967 episodes featured a variety of guest cameo appearances: Donna Loren, Frank Zappa, Liberace, Tim Buckley, Charlie Smalls, Jerry Blavat, Deana Martin, Rupert Crosse, and Godfrey Cambridge.

For five weeks, starting on December 2, the Monkees' *Pisces, Aquarius, Capricorn & Jones Ltd.* album topped the *Billboard* charts.

ABOVE: The Monkees, photographed in April 1967 by Henry Diltz.

JOSEPH MCCOMBS

music journalist

"After proving in early summer with *Headquarters* that they were capable of playing on an entire album and writing a good share of it, the Monkees made the sensible decision for their follow-up to let the experts at their disposal do what they do best. So *Pisces, Aquarius, Capricorn & Jones Ltd.* utilized the talents of 'Fast' Eddie Hoh on drums, Chip Douglas on bass, Douglas Dillard on banjo, and electronic jazzman Paul Beaver playing Micky Dolenz's Moog synthesizer, reputedly the third such in existence. . . .

"Whereas *Headquarters* had lacked a single, *PAC&J* had the breezy Carole King ode to suburbia 'Pleasant Valley Sunday,' which had promptly soared to No. 3 prior to the album's release. Here, Micky once again staked a claim to being one of King's most effective and affecting vessels. The fourth and final No. 1 album for the Prefab Four is their finest and most consistent effort from start to finish and provides ample evidence of their Rock and Roll Hall of Fame worthiness."

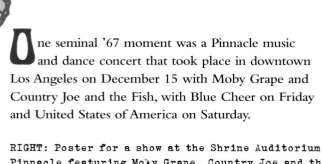

One seminal '67 moment was a Pinnacle music and dance concert that took place in downtown Los Angeles on December 15 with Moby Grape and Country Joe and the Fish, with Blue Cheer on Friday and United States of America on Saturday.

RIGHT: Poster for a show at the Shrine Auditorium's Pinnacle featuring Moby Grape, Country Joe and the Fish, Blue Cheer, and the United States of America, December 15-16, 1967.

BELOW: Concertgoers milling around after a show at the Pinnacle c. 1967; photograph by John Van Hamersveld.

JOHN VAN HAMERSVELD

"So the rumor went out in the rock scene and it turned out San Francisco fans loved the Pinnacle idea, created in L.A. The second show with Moby Grape, Country Joe and the Fish, with Blue Cheer, went well, and the light show expanded using Hugh Romney and the Hog Farm Family's psychedelic light show. We hired Thomas Edison Lights and film students Caleb Deschanel, Taylor Hackford, and George Lucas from the University of Southern California Film School, and Pat O'Neill and Burt Gershfield from the UCLA Film School."

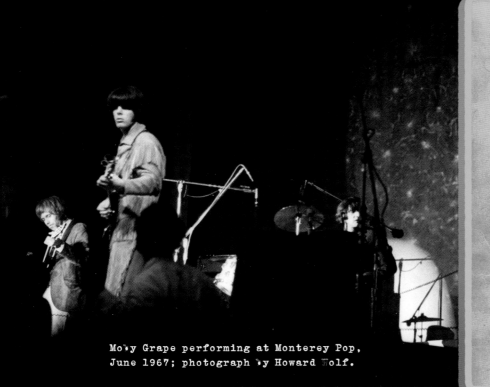

Moby Grape performing at Monterey Pop, June 1967; photograph by Howard Wolf.

PETER LEWIS

"They call it the Summer of Love. And, as a member of Moby Grape, I've talked to Peter Fonda about this, who said, 'When you guys showed up, it changed everything.' It wasn't so much that the words were depressing or about darkness or anything, but the music just sounded a lot different. It was real aggressive. It sort of was a signal that things were changing in general.

"Moby Grape was involved on this ride, not just about us, but the whole generation and not thinking about show business. We didn't make political statements. We were just trying to document our experience with our songs. Trying to talk to each other through them. We felt like we were supposed to be examples of what it was like to be a cool hippie. We did find ourselves in that position."

LEONARD COHEN

"I came to New York and was unaware of what was going on at the time. I had never heard of Phil Ochs, Bob Dylan, Judy Collins, or any of these people, and I was delighted, overwhelmed, and surprised to discover this very frantic musical activity. Hammond was extremely hospitable and decent. He took me out for lunch at a place called White's on 23rd Street. It was a very pleasant lunch, and he said, 'Let's go back to your hotel room, and maybe you can play me some songs.' So he sat in a chair and I played him a dozen songs. He seemed happy and said that he had to consult with his colleagues but that he'd like to offer me a contract. . . . I don't have any reservations about anything I do. I always played music. When I was seventeen, I was in a country music group called the Buckskin Boys. Writing came later, after music. I put my guitar away for a few years, but I always made up songs. I never wanted my work to get too far away from music.

"My tunes often deal with a moral crisis. I often feel myself a part of such a crisis and try to relate it in song."

Songs of Leonard Cohen, recorded in the summer and fall of '67, was officially released on December 27, 1967. Columbia A&R staff producer John Hammond signed Cohen to the label. He had read his poetry and heard Judy Collins' cover version of Cohen's "Suzanne."

On the very same December 27, 1967, date, Columbia Records also issued the Bob Johnston–produced Bob Dylan *John Wesley Harding* long player.

GREIL MARCUS

author and music journalist

"The first thing a friend said when we first heard the album, on the radio, late one night on KSAN-FM: 'I think we'll be listening to this for a long time.'"

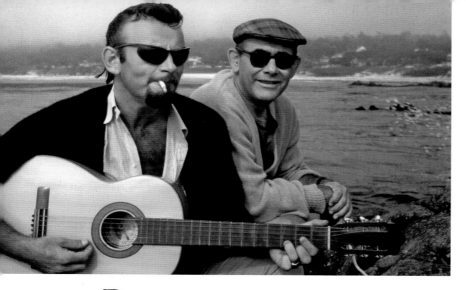

December 30 brought the news of the death of songwriter and record producer Bert Burns in New York City from a heart attack.

Berns penned "Piece of My Heart" with Jerry Ragovoy; it was first recorded in 1967 by Erma Franklin, and later in 1968 by Big Brother & the Holding Company, featuring Janis Joplin.

ABOVE: Bert Berns (left) and Jerry Wexler in Long Island, New York, c. 1965.

ROGER STEFFENS

"Among the albums that helped put our shituation in Vietnam into perspective was Van Morrison's 1967 *Blowin' Your Mind!*, produced by Bert Berns. People primarily bought it because of 'Brown Eyed Girl.' But they weren't ready for 'T.B. Sheets.' *Blowin' Your Mind!* was the trailer for *Astral Weeks*."

ANDREW LOOG OLDHAM

"One of the side benefits of America opening its doors to our version of their music was we got to meet our heroes and villains. Bert Berns was a hero."

RICHARD WILLIAMS

author

"Eighteen months was a lifetime in the late sixties, and *John Wesley Harding* ended the longest, loudest silence in the history of rock and roll. No one knew what Dylan was up to. No one knew the truth about his 'retirement.' . . . 'I Pity the Poor Immigrant,' 'I Dreamed I Saw St. Augustine,' and 'All Along the Watchtower' forced us all into a radical reconsideration. The album was a blast of clean air—not just for us, but for Dylan, too. And it still sounds pristine."

MICK FARREN

author

"The weight of anticipation that was loaded upon the release of *John Wesley Harding* was probably more than any artist should be expected to shoulder. How in hell was Dylan going to follow something as monumental as *Blonde on Blonde*? And when the answer turned out to be relaxed, controlled, and even reserved, conflict broke out between those who just wanted more, just *B-on-B 2*, and others who were frankly baffled and studied the cover photo for mystic clues. Dylan had constructed cottages: neat formal songs that smelled of Jerry Lee Lewis, Sam Phillips, Hank Williams, and A.P. Carter. He had edited and simplified, and in so doing had created tunes that, down the years, proved to be of incredible durability."

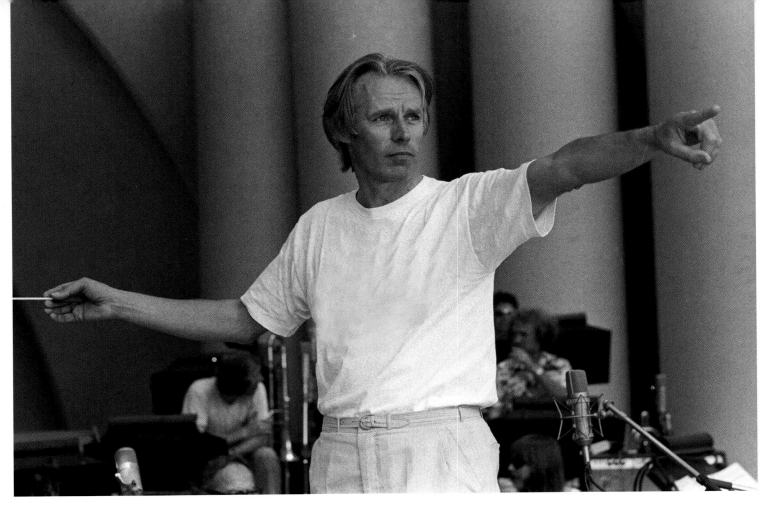

"The group did a lot of quality material. Pretty good stuff, don't you think?"

—GEORGE MARTIN

Having introduced the magical, mysterious year of 1967 with the revelatory psychedelia of "Strawberry Fields Forever" and the filmic "Penny Lane," it was only fitting that the Beatles closed it on December 31 with yet another epochal tune that pushed the boundaries of pop music to its outer limits. "I Am the Walrus" is an e-ticket passage through a funhouse mirror. With its mischievous marriage of Wagnerian excess and *The Goon Show*, it is John Lennon's cheerio to a year of living lysergically.

The flip side, "Hello, Goodbye," is closer to Paul's cheeky embrace of English music-hall temperament, an infectious if inconsequential melody gussied up under George Martin's sterling production. The Beatles set another benchmark, leaving the rock music community to ponder.

ABOVE: George Martin conducting the symphony at the Hollywood Bowl, 1975; photograph by Henry Diltz.

No previous moment—not the bobby-soxers clamoring for Sinatra in '47; not the poodle-skirted screamers pining for Elvis in '57; not even the first salvos of the British Invasion in '64—had prepared listeners young and old, square and hipster, for what flew out of 1967's sonic cuckoo's nest.

Artists were energized by the radically new means of expression available to them: Moog synthesizers and Mellotrons, innovations in multitrack recording, and all manner of sound manipulation. The studio itself was becoming an instrument to be mastered. Correspondingly, stereo would shortly replace mono as the music industry standard; and with it, the album, forty minutes of aural bliss, a modestly priced unit that could take you "out" and have you home in time again for the family dinner, relegated bite-sized 45s to the sugary appetites of little brothers and sisters.

This enraptured new audience was as heavily invested in the music as the musicians themselves, leading to a mutual heightening of expectations. Pop music— rock—was no longer a fad, a passing fancy, a marketing ploy that drew no distinction between hustling plastic toys and the Boss Radio Top 30. Rather, beneath the enveloping purple haze of this star-spangled generation, there was a manifest hunger to hear and be heard. Wherever you went, the music rode shotgun, had your back.

1967, the year of living impetuously, was coming to its terminus, the long, strange trip a glimmer, a faint promise to live on a higher, more enlightened plane.

The new year would start promisingly; *The Graduate*'s Benjamin and Elaine, guileless and lost, headed out in search of a more redemptive America. What they and the rest of us would later discover in 1968 was the awful truth—outside a Memphis hotel, inside the kitchen corridor of L.A.'s Ambassador Hotel. And there would be music, to console the hurt, to embolden the fight, to sing out in the name of love.

BELOW: Photograph by Henry Diltz, July 1967. A memorial in the window of Lucy's El Adobe restaurant in L.A., July 1968, a month after Robert F. Kennedy was assassinated on June 5. The famed eatery was across the street from RFK's California headquarters.

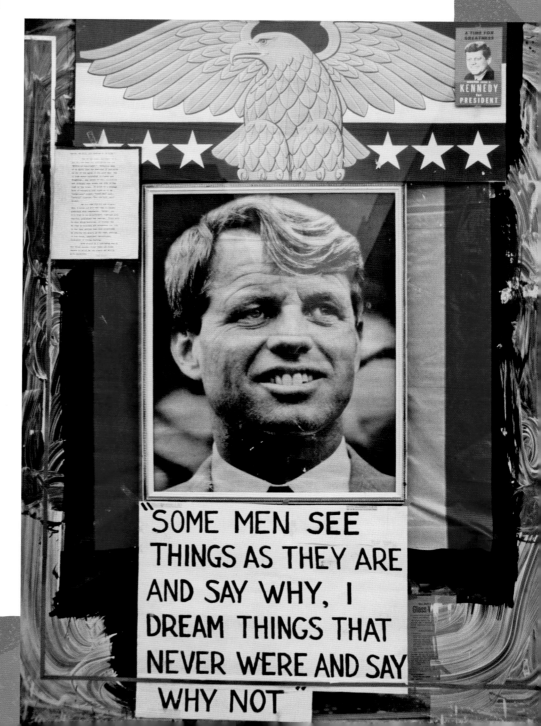

"SOME MEN SEE THINGS AS THEY ARE AND SAY WHY, I DREAM THINGS THAT NEVER WERE AND SAY WHY NOT"

FIFTY YEARS ON

In 1967, the Census Bureau estimated the U.S. population at 197,863,000. As of this writing, it's 324,700,000. In terms of age, most of the young people who listen to music now were born in the 1990s or later. Yet while not as calamitous as 1914 or as (literally) revolutionary as 1956, 1967 remains an indelible "hinge year" of the twentieth century, when so many aspects of popular culture—the arts, fashion, politics, foreign entanglements, race, women's rights, reproductive rights, drug laws, etc.—came into visceral focus.

The push/pull between the "greatest generation" and their impertinent offspring put paid to the *Ozzie and Harriet* vision of Middle America; in its stead was a raucous, unpredictable splash of creative indignation that spilled out like an unhinged oil well whose cleanup and consequences remain (deliriously) uncertain.

The musicians, wordsmiths, and cultural creatives first heard a half a century ago left their aural footprints in the Summer of Love's sonic soil. Those echoes continue to endear and endure.

PAUL BODY

"Forget the Summer of Love, it was the Summer of Otis and the Beatles. The Beatles seemed to be everywhere that summer. Live broadcast of 'All You Need Is Love.' Epstein dying. 1967 was a long way from 1964.

"Summer of 1967. Soul was alive and moving down the dial. . . . Soul music was turning into the Boogie disease; it was everywhere.

"For me the song that caught that summer was Joni Mitchell's 'The Circle Game,' sung by Buffy Sainte-Marie. It was a song about the past, growing up and leaving the childish things alone."

ERNIE ISLEY

guitarist and songwriter,
the Isley Brothers

"My older brothers can tell you a lot of stories about the way it used to be. Things are different now for the black musician. Some people have been knockin' at the door even longer. You can't keep good music down. Eventually it will get heard."

DAVID RUFFIN

singer, the Temptations

"We went through a few mindbenders. Some cats had to buy us food 'cause restaurants wouldn't serve us, mostly in the South. Things are much better today. Yet the musicians and later on all kinds of kids went to our shows. We would rap and sing on the bus ride between concerts and it was a lot of fun."

MARTY BALIN

"As far as the music of 1967, the songs of the year '67 and the Summer of Love still having power and reaching people in 2016? They are good songs that people grew up with, you know. I've had people tell me they were married to one of my songs, their father died the year of one of my songs, some soccer game in Boston played one of them.

"You don't think about whether a song will last. I think about that it still moves me and takes me to the place I want to go. It puts me in a trance. That's the way I write 'em, or why bother to play them then or now for people?"

PAUL KANTNER

"We put it out in the universe and see where it lands. There was a message there, but we didn't blare it out. We just tried to show by example what you could get away with, basically. And enjoying our day. And that's all we tried to put across. Creating another universe, if you will, or at least a semblance of another alternate quantum that worked for us. And God knows why we got away with it 90 percent of the time if not more. We should have been in jail, dead, run over by trucks, and a number of things over the years.

"With the Airplane we thought we could do it all. It was a reaction against the corporate structure trying to impose certain limits on you. We revolted against that, which was the other extreme, which is doing it totally ourselves. And it was like putting a five-year-old in an automobile reeling down the street. It may make it down the street, but the car may get a few dents along the way.

"You can enjoy your day. Hedonistic or Dionysian, on some levels. That existed. And San Francisco was very good, I think, particularly the musicians, at transmitting the goodness of the day, rather than complaining about the badness of the day."

ROGER McGUINN

"The Summer of Love. I just remember the good parts of it. The flowers, the attitude of a lot of people really loving each other. A sense of community. It was a good feeling. Positive things that were planted then have stayed with some people. We believed all the peace-and-love stuff, and I mean, we thought we could change the world. And some things did change for the better. You can't say we didn't do anything. The feeling was a euphoric one. I mean, aside from the substances, we were feeling really good about everything. It was a good time."

CHRIS HILLMAN

"What holds up in that era were melodies. When you heard a new song on the radio, the melody would catch you right away. It worked. It swung. . . . I think that's a big part of it and it was real and so honest. But the record companies were run by music people. People who loved music. It was not a corporate monster. And they'd sign you and you'd be on the label for three or four albums, you know. The sixties were wonderful."

HOWARD WOLF

"I think the downfall of the Summer of Love, and this was evident near the end of 1967 and the rest of the sixties, was harder drugs and the darkness that came with that. The business really changed as well, and money was driving the managers and agents and record companies, and the sense of community was evaporating."

CHRIS DARROW

"The Summer of Love, 1967, brought an end to the organic, peace-and-love temperament that pervaded the early days of the psychedelic era. The Monterey festival brought about a change in the weather, whereby money, power, and management took over for the music and soulful ethic of the early days. Bands, who had before been 'all for one,' changed their tune and looked to the bottom line as the measure of their success. Monterey became the turning point towards a more commercial and jaded look at a movement that started out to change the world through peace and love."

JAMES CUSHING

"So when we look back at 1967 now, the work is often done by people who were not even teenagers at the time. Facts are distorted, and a cut-and-paste mentality is repeated. We focus on the flashy clothes and the drugs and the sex and forget the national confidence that gave rise to those things.

"The artists themselves were in the process of discovering brand-new things and so was a large part of the culture, and what is vibrant is that you are listening to someone in the act of discovering something new, rather than the act of attempting to sell you an image. And that's when the party ended, when people realized that this energy could be corrupted into selling images. . . .

"The musicians of the sixties railed against the conformity of post-WWII American life and made a new life on the basis of artistic and intuitive leaps. How much nervous, worried, self-conscious anxiety about acceptance or value did most of the acts recorded suggest? Almost none. It was implied permission to 'do your own thing.' Long hair still bothered people. Bumper stickers like 'Make Love Not War' that were all over events and love-ins in 1967 did not go over well with many WWII or Korean War veterans, who fought very hard for the protection of American freedoms as they understood them—not as they were being redefined and proudly displayed in front of them. 'Free love' is an expression of enormous confidence."

CELESTE GOYER

writer and poet

The complexities, the responsibilities [of this new culture], were beyond my understanding, but the chaos caused by it in my family was the daily background of life. Just as the invitation of the music was another kind of background. In a way, you could say I packed up 1967 and tucked it somewhere deep, to be unfolded later when I reached the age of choice. I was a latter day hippie by choice, no doubt, after the larger culture had moved on.

JACKIE GREENE

"I think it's really simple that a lot of the music created in 1967 comes from a place of authenticity and it's not bullshit. It's not like some music today, where it's sort of constructed in a lab and given a nose job."

JAC HOLZMAN

"The music from 1967 is reaching a lot of people digitally. And it continues moving further because people can hear it for virtually nothing. . . . But you can afford to be experimental. You don't have to plunk down $10 or $15 for a CD and be disappointed."

ROBIN GIBB

"In 1967, most music was a social outcry, and we never subscribed to that pattern. We didn't jump on trends, and we've seen a lot of them. Flower power, glitter . . . I think the Bee Gees have always realized that there is so much love to bring out in songs. That it is a catalyst to bring people together."

CARLOS SANTANA

"Bill Graham's Fillmore was like a laboratory to try out all things all the time.

"San Francisco was an affirmation to the rest of the nation: 'We don't want to be square. We don't want to be sent to war for somebody to make profit and selling weapons to damning us.' They didn't see the big picture. They call you 'dirty hippie' and 'unpatriotic, traitor.' No. Listen to Country Joe and the Fish. It really tells you what is happening now."

ANDREW LOOG OLDHAM

"In fact, there may be less to celebrate than one imagines to remember. Oh, we all had a great time being irresponsible and responsible with a lot of the music that was made and events like Monterey. If anything, the film business picked up the mantra; the music biz, apart from John and Yoko, had stopped chanting. This is my selective memory. I may be biased."

ROGER STEFFENS

"I was the *Kaleidoscope* Vietnam correspondent for several issues, reporting from Saigon. . . . During the entire time I was in Vietnam, a poet friend, Jerry Burns, taped eight hours of KSAN-FM every week. . . . I probably made a thousand or more cassettes to give to guys going out into the field. And they, in turn, would copy them for their buddies.

"Our only political information, besides the heavily censored AFVN broadcasts (where Pat Sajak was the morning jock who succeeded Adrian Cronauer of *Good Morning, Vietnam* fame) was from *Stars and Stripes*, which was heavily censored. Thank God the KSAN weekly tapes had Scoop Nisker's masterful stream-of-consciousness alternate newscasts to learn what was really going on back in the world. The most chillingly psychedelic reports are in Michael Herr's immortal *Dispatches*. He understood better than anyone that it was a rock 'n' roll war. . . . Because people then were telling the truth, and in joy-filled ways, generally speaking. There was a pervasive feeling of magic as a multitude of social changes were exploding all at once, and for weeks at a time we actually thought the spiritual millennium had arrived. Our fatal mistake was underestimating the enemy."

"THE CITY"

By Harry E. Northup

Why did people flock to San Francisco in 1967 for the Summer of Love? First of all, it's in California, the Golden State, where you could go to college free, live cheaply, swim or surf. L.A.'s the commercial city, the town that makes movies; it's the movie capital of the world. San Francisco is relaxed. Poetry & jazz. A friend of mine who grew up in the Bay Area called San Francisco The City, capitalized, as you capitalize Muse or the Divine Creative. An alluring, glorious, romantic place by the bay. A decade before, the Beat poets, Spicer & Duncan, among others brought new poetry into the San Francisco narrative. Any 14-year-old runaway girl is more important than Jerry Garcia or The Mamas & the Papas, a spokesman for his generation said—about why the Summer of Love happened. Two decades before 1967, America was at its peak: World War II victory, economic buoyancy, GI Bill, houses, cars being consumed by the growing, happy, confident, conformist middle class. Consumers. Materialists. The 14-year-old runaway girl abandoned materialism, abandoned a hunger to buy products: Americans go crazy for products, WCW told us. Love, flowers, a gathering of the tribes, drugs, communes, rice & beans. Music. Golden Gate Park & the Family Dog & Grace Church. Reclining on the grass in Golden Gate Park & smoking a joint. Sharing soda pop, mescaline, homes. Years later, I asked my 7-year-old son, What did the hippies eat? Rice & Beans. What did the hippies like to do? Break things. Where did the hippies go? To work.

11 30 15 | East Hollywood, California

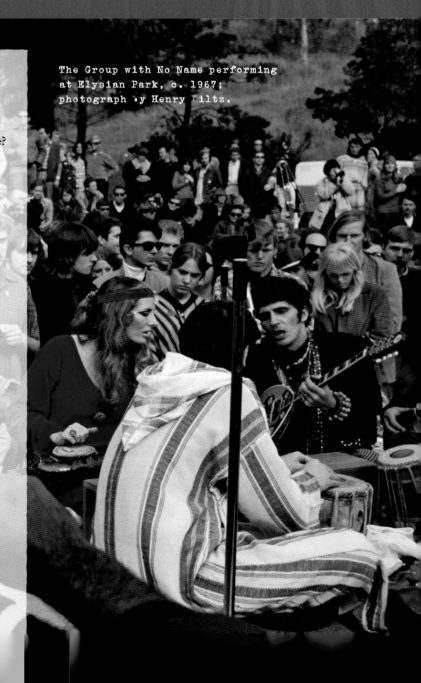

The Group with No Name performing at Elysian Park, c. 1967; photograph by Henry Diltz.

ACKNOWLEDGMENTS

Barbara Berger: A special thanks for initiating this endeavor, and for your acquisition and publishing vision at Sterling Publishing in developing our joint editorial partnership and direction. Your developmental organization, photograph selections, deft editing skills, and passion for this subject-specific 1967 era are very much appreciated. Also at Sterling, thanks go to art director Chris Thompson; Linda Liang and Stacey Stambaugh in the photo department; and production manager Fred Pagan. I am grateful to Phil Yarnall and Allison Meierding for the beautiful design. Thanks as well to Joanie Eppinga for copyediting and proofreading the layouts, via editorial services / gonzalez defino, NY.

Kenneth R. Kubernik: Kudos to younger brother Ken for your work, story observations, tuneful reflections, editorial advice, and poetic offerings that underscored the book's content. They are constant reminders of our 5th Street Summer of Love audio and visual reality from yesterday's life in Los Angeles. It's always a good day when mother Hilda brings home a chocolate cake. Just keep monitoring around Miles Davis, Soft Machine, King Crimson, vinyl on the Impulse label, and KPFK-FM.

Joseph McCombs: Your copyediting and understanding of the year 1967 and the musical documents that were birthed and still remain was very nourishing—not only correcting spelling and grammar, but reinforcing how vital and cosmic '67 was, and still is, to our eyes, ears, and hearts.

Words work best when employed as guideposts.

Gary Strobl: My photo librarian, technician, scanner, and so much more. Your energy, help, voice of reason, whenever needed, at the Henry Diltz studio, often after midnight, really made this book come true. Just like your Chicago Cubs winning the World Series. You also earned the MVP award as Mr. 1967 on AM radio. It was a very important moment when Graham Nash said, "We're all on a path." There were times where I truly felt my dad Marshall and your younger brother Greg's coaching from the third base box, giving the sign to send us home with the victorious run.

Henry Diltz: I left you alone in the '60s and '70s while you were taking pictures at rock concerts and club dates we attended. I am so grateful for your vast photography archive and generosity in participating in this adventure. During production, I would list or vibe out an image, or mention a music show around Hollywood I saw or a memorable hot dog location in L.A. that was my basic nutrition in 1967, wishing I had a regional photo for the devoted readers. The next morning at 1:11 a.m., Gary Strobl would call or email: "Henry's vault has the Love photo from the Whisky a Go Go gig you went to and the hot dog stand on La Cienega." Love can be found anywhere, even inside a yellow box of 50-year-old Ektachrome slides, the Judy's store in Century City, or a yogurt shop in the San Fernando Valley.

Guy Webster: I am very fortunate to have your spiritual being in my life. Your album cover photos for the Rolling Stones, Doors, Byrds, Simon & Garfunkel, the Mamas & the Papas, Taj Mahal, Spirit, Herb Alpert & the Tijuana Brass, and so many other pictorial events captured on film from the West Coast really put me on this journey. Our friendship makes me continue the deep-dive plunge. I guess Krishnamurti does watch everything. Your wonderful assistant, Lisa Gizara, artist and painter, understood the mission behind this book. Thanks to archivist Drew Evans.

A writer could not ask for anything better than to finish a line or a section of a manuscript when the telephone rings in the early morning or an email of literary encouragement arrives from influential author and iconic record producer Andrew Loog Oldham, the singular wordsmith and pop and rock music epicenter of 1966 and '67.

Many people, special friends, and team players provided support on this expedition. They heard and knew the pain and gain inherent in the achievements and permanent memories from 1967 that informed our voyage and group undertaking.

My endless gratitude to:

Chris Darrow and Data Center Services

Gary Pig Gold

Kirk Silsbee

Daniel Weizmann

Gypsy Boots

Paul Kantner

Dr. James Cushing

Celeste Goyer

Howard Wolf Archives

Sherry Hendrick and the Mick Vranich Archives

Gary and Theresa Schneider at Open Mynd Collectibles

John Van Hamersveld and Alida Post at Coolhaus Studio

Rebecca Baltutis

Keith Richards and Ronnie Wood for the guitar picks

Rosemarie Renee Patronette

Charlie Watts

Sherry Daly

Jim Keltner

Steven Van Zandt and Renegade Nation

David Leaf

Eva Leaf

Jac Holzman

Brett and Cassandra Berns

Stephen J. Kalinich

Carol Schofield and MsMusic Productions

Samantha Dolenz

Ritchie and Minnie Yorke, Michael MacDonald, and David N. Pepperell in Australia

Andrew Solt

Greg Vines

Angie Wilson

SOFA Entertainment

The Ed Sullivan Show

Barney Hoskyns

Jeremy Gilien

Ron Lando

Dr. David Wolfe

Edith Wolfe

Robert "Ciggy" Sherman

Bryan Skryha

Ray Randolph and KHJ radio surveys

Jim Roup

Phyllis Pollack

Jensen Communications, Inc.

Tom Cording and Toby Silver at Sony Music

Leonard Cohen

Johnny Cash

Jeff Rosen

Bob Dylan

Al Kooper

Frazer Pennebaker

Grelun Landon, RCA Records

Jim Kaplan and *Record Collector News* magazine and David Kessel at www.cavehollywood.com, where many of my initial interviews in this book first appeared in print

Melody Maker

MOJO

Goldmine Magazine

GNP Crescendo Records

Universal Music Enterprises

Jeffrey Goldman

Santa Monica Press

Elliott Lefko

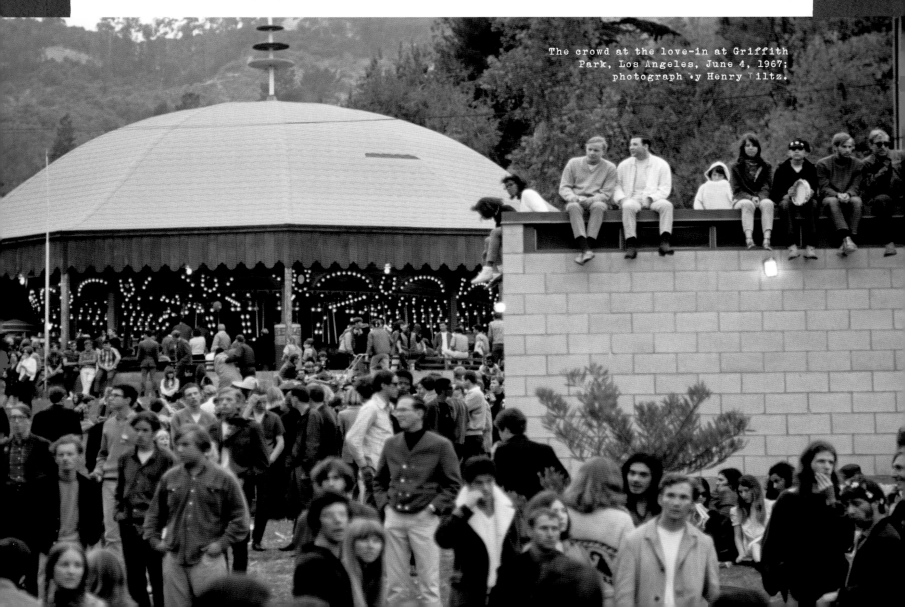

The crowd at the love-in at Griffith Park, Los Angeles, June 4, 1967; photograph by Henry Diltz.

Dan Kessel
Gene Aguilera and his East Los Angeles Library
Elliot Kendall
Crystal Ann Lea
Jeff Gold at Record Mecca
Iconic Images
Richard Williams
Bob Johnston
Tom Wilson
Levi Stubbles
Buddy Collette
Oak Grove School
Leon Russell
Bobby Womack
Wyline and Scott
Travis and Judy Pike at Other World Cottage Industries
David Carr
Larry LeBlanc
David Farber
University of New Mexico Press
Greg Franco
Randy Haecker for arranging the George Harrison and Ravi Shankar interviews
Richard Bosworth
Daniel and Melissa at Whole Foods Market for nosh and herbal supplements
Dr. Cynthia Summers
Dr. Robert Wolfe
Dr. Robert Klapper and *The Weekend Warrior*
Jo Ttanna
Colin Webb
Palazzo Editions
David A. Barmack
Kansas Bowling
Rodney Bingenheimer
Cathy Fuller
The Hollywood Ranch Market
Roger Steffens and his Ark-hives
Jan Alan Henderson
Tom Gundelfinger O'Neal and Molly O'Neal
Peter Piper and your mother Margaret
Jeff Tamarkin

Gregory A. Munford
Ram Dass
Dennis Loren
Laura Grimshaw
The Allen Ginsberg Estate
The Charles E. Young Research Library at UCLA
Keith Altham
Sweet Nurit Wilde
The Frigate
Wallichs Music City
The Music Revolution
The Groove Company
Ray Avery's Rare Records
Rockaway Records
Bob and Tom at FreakBeat Records
Kip at CD Trader
Aron's Records
Tower Records
Amoeba Records
Lewin Record Shop
Pickwick Books
Nancy Rose Retchin
Tim Doherty
Ernie Banks
Ron Santo
Garry Marshall
Peter Barnard
Maribeth Dougherty
Aime Elkins McCrory
David M. Berger
Paul Taranpool at Brunswick Records
Russ Regan
Mark Pucci Media
Roy Trakin
Harry E. Northup and Holly Prado
Dean Dean the Taping Machine
Harold Sherrick
Pinnacle Dance Concerts
Cindy Kona
Heather Harris
Mr. Twister
Lonn Friend
Rob Hill
Frank and Anthea Orlando
Tia at Jerry Schatzberg studio

Gered Mankowitz
Crystal Larson at the Grammy Museum in Los Angeles
A. Bernadicou
Dennis Dragon and The Studio @ Pacifica
Pooch & Tommy
The Ash Grove
Pete Mitchell
Neil Cossar
Warren John Wolfe
Veterans Affairs Hospital
Mike Stax
Getty Images
Paramahansa Yogananda and SRF
Coach John R. Wooden
Kobe Bryant and the Los Angeles Lakers
Dave Roberts and the Los Angeles Dodgers
Sandy Koufax
Jack Nitzsche
Denny Bruce
Bill Maher
Kathleen Scheyer
Lesley Wilk
Joanne Russo
Justin Pierce
David Bowie
The Everly Brothers
Meagen Mendoza and Pasha Balykin
Dr. David James and the School of Cinematic Arts at the University of Southern California
Tony Funches
The West Los Angeles College Library
Clem Burke
Paul Body
Robert Marchese
Gary Stewart and Opinions Galore
Dave Diamond
Godfrey Kerr
Radio stations KHJ, KRLA, KFWB, KBLA, KTYM, KGFJ, KDAY, and KPPC-FM
Shindig! magazine
Vincent Edward "Vin" Scully
Hilda & Marshall Kubernik

PLAYLIST

SONGS

ALL ALONG THE WATCHTOWER: Bob Dylan

ALL MY DREAMS BLUE: The Youngbloods

ANTHEM: The Procession

APPLES, PEACHES, PUMPKIN PIE: Jay & the Techniques

ARE YOU EXPERIENCED?: Jimi Hendrix Experience

ARE YOU GONNA BE THERE (AT THE LOVE-IN): The Chocolate Watchband

ARE YOU LONELY FOR ME: Freddie Scott

BABY, YOU'RE A RICH MAN: The Beatles

BACK ON THE STREET AGAIN: The Sunshine Company

THE BALLAD OF YOU AND ME AND POONEIL: Jefferson Airplane

THE BEAT GOES ON: Sonny & Cher

BERNADETTE: The Four Tops

BOOGALOO DOWN BROADWAY: The Fantastic Johnny C

BORN UNDER A BAD SIGN: Albert King

BOTH SIDES NOW: Judy Collins

BOTTLE OF WINE: The Fireballs

BOWLING GREEN: The Everly Brothers

BREAK ON THROUGH: The Doors

BROWN EYED GIRL: Van Morrison

BROWN SHOES DON'T MAKE IT: The Mothers of Invention

BUMPIN' ON SUNSET: Wes Montgomery

CAN'T SEEM TO MAKE YOU MINE: The Seeds

CASINO ROYALE: Herb Alpert & the Tijuana Brass

CLOSE YOUR EYES: Peaches & Herb

COLD SWEAT: James Brown

COME ON DOWN TO MY BOAT: Every Mother's Son

CORNFLAKES AND ICE CREAM: Lords of London

CREEQUE ALLEY: The Mamas & the Papas

DANDELION: The Rolling Stones

THE DARK END OF THE STREET: James Carr

DARLING BE HOME SOON: The Lovin' Spoonful

DEATH OF A CLOWN: Dave Davies

DIFFERENT DRUM: The Stone Poneys

DON'T GO OUT INTO THE RAIN (YOU'RE GOING TO MELT): Herman's Hermits

DON'T SLEEP IN THE SUBWAY: Petula Clark

DOWN ON ME: Big Brother & the Holding Company

DRY YOUR EYES: Brenda & the Tabulations

ELECTRICITY: Captain Beefheart and His Magic Band

EPISTLE TO DIPPY: Donovan

EXPRESSWAY TO YOUR HEART: Soul Survivors

EVERYBODY'S TALKIN': Fred Neil

FAKIN' IT: Simon & Garfunkel

FLYING ON THE GROUND IS WRONG: The Guess Who

FOR WHAT IT'S WORTH: Buffalo Springfield

FOREST FLOWER: Charles Lloyd

FOREVER AFTERNOON (TUESDAY?): The Moody Blues

FOUR IN THE MORNING: The Youngbloods

FRIDAY ON MY MIND: The Easybeats

FRIENDS OF MINE: The Zombies

FUNKY BROADWAY: Wilson Pickett

GENTLE ON MY MIND: Glen Campbell

GET ON UP: The Esquires

GIMME LITTLE SIGN: Brenton Wood

GET TOGETHER: The Youngbloods

THE GIRL I KNEW SOMEWHERE: The Monkees

THE GOLDEN ROAD (TO UNLIMITED DEVOTION): The Grateful Dead

GOOD TO ME AS I AM TO YOU: Aretha Franklin

GOOD VIBRATIONS: The Beach Boys

GREEN GRASS OF HOME: Tom Jones

GROOVIN': The Young Rascals

HALF PAST MIDNIGHT: The Staccatos

HAPPY JACK: The Who

HAPPY TOGETHER: The Turtles

HAVE YOU SEEN HER FACE: The Byrds

HERE COMES MY BABY: The Tremeloes

HEROES AND VILLAINS: The Beach Boys

HIP HUG-HER: Booker T & the M.G.'s

HIM OR ME (WHAT'S IT GONNA BE?): Paul Revere
& the Raiders

I DIG ROCK AND ROLL MUSIC: Peter, Paul & Mary

I HAD TOO MUCH TO DREAM LAST NIGHT:
The Electric Prunes

I HEARD IT THROUGH THE GRAPEVINE:
Gladys Knight & the Pips

HOMBURG: Procol Harum

THE HUNTER GETS CAPTURED BY THE GAME:
The Marvelettes

HYPNOTIZED: Linda Jones

(I KNOW) I'M LOSING YOU: The Temptations

I NEVER LOVED A MAN THE WAY I LOVE YOU:
Aretha Franklin

I SECOND THAT EMOTION: Smokey Robinson
& the Miracles

I WAS MADE TO LOVE HER: Stevie Wonder

IF YOU'RE THINKIN' WHAT I'M THINKIN':
Dino, Desi & Billy

I'M A BELIEVER: The Monkees

I'M A MAN: Spencer Davis Group

INCENSE AND PEPPERMINTS: The Strawberry Alarm
Clock

IT'S A HAPPENING THING:
The Peanut Butter Conspiracy

IT'S GETTING HARDER ALL THE TIME:
The Mindbenders

IT'S THE LITTLE THINGS: Sonny & Cher

IT'S YOU NEED THAT I NEED:
The Temptations

JIMMY MACK: Martha and the Vandellas

KING MIDAS IN REVERSE: The Hollies

KROME PLATED YABBIE: The Wild Cherries

LAZY DAY: Spanky and Our Gang

LET IT ALL HANG OUT: The Hombres

LET'S LIVE FOR TODAY: The Grass Roots

THE LETTER: The Box Tops

LIGHT MY FIRE: The Doors

LITTLE GAMES: The Yardbirds

LIVING IN A CHILD'S DREAM: The Masters' Apprentices

THE LOOK OF LOVE: Dusty Springfield

LOVE IS ALL AROUND: The Troggs

LOVE IS HERE AND NOW YOU'RE GONE: The Supremes

LOVE ME TWO TIMES: The Doors

LOVE OR CONFUSION: Jimi Hendrix Experience

MAGIC EYES: James Taylor Move

MERCY, MERCY, MERCY: Cannonball Adderley

MIRAGE: Tommy James and the Shondells

MORNING GLORY: Tim Buckley

MR. FANTASY: Traffic

MY OBSESSION: The Rolling Stones

MY WHITE BICYCLE: Tomorrow

MY WORLD FELL DOWN: Sagittarius

NEON RAINBOW: The Box Tops

NEVER MY LOVE: The Association

NOBODY BUT ME: Human Beinz

NOT SO SWEET LORRAINE: Country Joe and the Fish

NOTHING TAKES THE PLACE OF YOU:
Toussaint McCall

ODE TO BILLIE JOE: Bobbie Gentry

OMAHA: Moby Grape

ONCE I WAS: Tim Buckley

THE OOGUM BOOGUM SONG: Brenton Wood

PAY YOU BACK WITH INTEREST: The Hollies

PICTURES OF LILY: The Who

THE RAIN, THE PARK & OTHER THINGS: The Cowsills

REACH OUT OF THE DARKNESS: Friend & Lover

REFLECTIONS: The Supremes

RESPECT: Aretha Franklin

SAN FRANCISCAN NIGHTS: Eric Burdon & the Animals

SAN FRANCISCO (BE SURE TO WEAR FLOWERS IN YOUR HAIR): Scott McKenzie

SAVE ME: Brian Auger & Julie Driscoll with the Trinity

SCARBOROUGH FAIR/CANTICLE: Simon & Garfunkel

SEE EMILY PLAY: Pink Floyd

SHE MAY CALL YOU UP TONIGHT: The Left Banke

SHE'D RATHER BE WITH ME: The Turtles

SHE'S A RAINBOW: The Rolling Stones

SIT DOWN, I THINK I LOVE YOU: The Mojo Men

SIX O'CLOCK: The Lovin' Spoonful

SO YOU WANT TO BE A ROCK 'N' ROLL STAR: The Byrds

SOMETHING ABOUT YOU BABY: Vibrants

SOUL FINGER: The Bar-Kays

SOUL MAN: Sam & Dave

SPICKS AND SPECKS: The Bee Gees

SUNSHINE GIRL: Parade

SWEET SOUL MUSIC: Arthur Conley

TALES OF BRAVE ULYSSES: Cream

TELL IT LIKE IT IS: Aaron Neville

THAT ACAPULCO GOLD: The Rainy Daze

THAT'S HOW IT IS: Otis Clay

THERE IS A MOUNTAIN: Donovan

THERE'S A KIND OF HUSH (ALL OVER THE WORLD): Herman's Hermits

THROUGH MY EYES: The Creation

TO LOVE SOMEBODY: The Bee Gees

TO SIR WITH LOVE: Lulu

TODAY: Jefferson Airplane

TRAMP: Otis Redding & Carla Thomas

TRANSPARENT DAY: The West Coast Pop Art Experimental Band

TRY A LITTLE TENDERNESS: Otis Redding

TWELVE THIRTY: The Mamas & the Papas

UP, UP AND AWAY: The 5th Dimension

VENUS IN FURS: The Velvet Underground

VALERIE (TV-SERIES VERSION): The Monkees

WATERLOO SUNSET: The Kinks

WE HAD A GOOD THING GOIN': The Cyrkle

WESTERN UNION: Five Americans

WHEN I WAS YOUNG: Eric Burdon & the Animals

WHEN SOMETHING IS WRONG WITH MY BABY: Sam & Dave

THE WINDOWS OF THE WORLD: Dionne Warwick

WITH A LITTLE HELP FROM MY FRIENDS: The Beatles

A WHITER SHADE OF PALE: Procol Harum

WINDY: The Association

WHITE RABBIT: Jefferson Airplane

YELLOW BALLOON: The Yellow Balloon

YOU CAN'T DO THAT: Nilsson

YOU GOT WHAT IT TAKES: The Dave Clark Five

YOU KEEP ME HANGIN' ON: Vanilla Fudge

YOU SET THE SCENE: Love

(YOUR LOVE KEEPS LIFTING ME) HIGHER AND HIGHER: Jackie Wilson

YOUR PRECIOUS LOVE: Marvin Gaye and Tammi Terrell

WEDDING BELL BLUES: Laura Nyro

ALBUMS

1ST Bee Gees

ABSOLUTELY FREE The Mothers of Invention

ARE YOU EXPERIENCED? The Jimi Hendrix
　Experience

BETWEEN THE BUTTONS The Rolling Stones

BORN UNDER A BAD SIGN Albert King

BUFFALO SPRINGFIELD AGAIN
　Buffalo Springfield

CRUSADE John Mayall & the Bluesbreakers

DAYS OF FUTURE PASSED Moody Blues

DISRAELI GEARS Cream

ELECTRIC MUSIC FOR THE MIND AND BODY
　Country Joe and the Fish

FOREVER CHANGES Love

HIP HUG-HER Booker T & the M.G.'s

I NEVER LOVED A MAN Aretha Franklin

INSIGHT OUT The Association

JOHN WESLEY HARDING Bob Dylan

*LIVE: RAVI SHANKAR AT THE MONTEREY
　INTERNATIONAL POP FESTIVAL* Ravi Shankar

MELLOW YELLOW Donovan

MOBY GRAPE Moby Grape

MR. FANTASY Traffic

PIPER AT THE GATES OF DAWN Pink Floyd

REACH OUT The Four Tops

SAFE AS MILK Captain Beefheart and His
　Magic Band

SELL OUT The Who

SGT. PEPPER'S LONELY HEARTS CLUB BAND
　The Beatles

SIDE TRIPS The Kaleidoscope

SOMETHING ELSE The Kinks

SOUL FINGER The Bar-Kays

SURREALISTIC PILLOW Jefferson Airplane

THE DOORS The Doors

THE GRATEFUL DEAD The Grateful Dead

THE RESURRECTION OF PIGBOY CRABSHAW
　Paul Butterfield Blues Band

THE YOUNGBLOODS The Youngbloods

VELVET UNDERGROUND & NICO The Velvet
　Underground

WINDS OF CHANGE Eric Burdon & the Animals

YOU GOT MY MIND MESSED UP James Carr

YOUNGER THAN YESTERDAY The Byrds

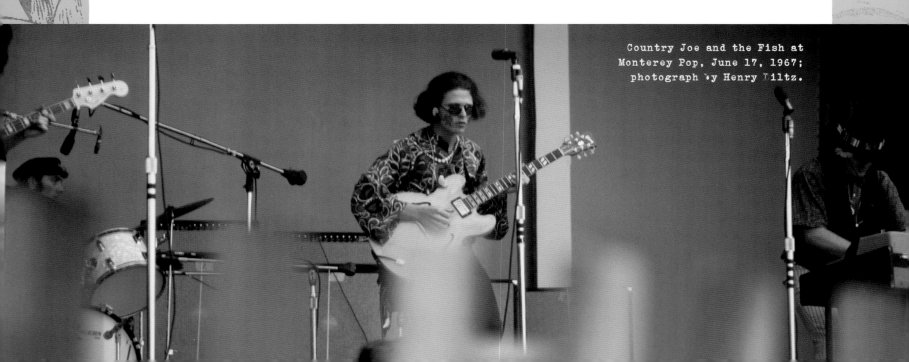

Country Joe and the Fish at
Monterey Pop, June 17, 1967;
photograph by Henry Diltz.

SOURCES

Harvey Kubernik newly conducted 2015–16 interviews for *1967 The Complete Rock Music History of the Summer of Love* and previous Kubernik written and published magazine/periodicals and non-published sources.

All incorporated Kubernik-penned magazine articles and excerpts utilized from the Harvey Kubernik archive except where noted.

PROLOGUE

Kenneth Kubernik: interviews, 2015 and 2016.
Roger Steffens: interviews, 2015 and 2016.
John Van Hamersveld: interview, *THC Exposé* magazine, 2010.
James Cushing: interviews, 2015 and 2016.
Marty Balin: interview, 2015.
Paul Kantner: interviews—*Melody Maker*, 1978; *Record Collector News*, 2012. On writing the song "Today": Harvey Kubernik and Kenneth Kubernik, *A Perfect Haze*. Santa Monica: Santa Monica Press, 2012.
Jack Casady: Courtesy of www.Jackcasady.com.
Carol Schofield: interview, 2015.
Jerry Garcia: interview, *Melody Maker*, 1976.
Robert Greenfield: interviews, 2009 and 2015.
Bill Graham: interview, *Melody Maker*, 1976.
Grace Slick: interview, *HITS* magazine, 2001; *Goldmine* magazine, 2002; excerpted in Harvey Kubernik, *This Is Rebel Music: The Harvey Kubernik InnerViews*. University of New Mexico Press: Albuquerque, 2004.
Abe Jacob: interview, *Goldmine*, 2011.
Chet Helms: Jeff Tamarkin, *Got a Revolution! The Turbulent Flight of Jefferson Airplane*.
Allen Ginsberg: interview, *HITS*, 1997; Harvey Kubernik, *This Is Rebel Music*.
Ram Dass: interview, 1999.
Jerry Schatzberg: interview, 2015.
Timothy Leary: interview, *BAM [Bay Area Music]* magazine, 1996.
Jac Holzman: interview, 2015.
Jac Holzman and Gavan Daws, *Follow the Music: The Life and High Times of Elektra Records in the Great Years of American Pop Culture*. Santa Monica: First Media Books, 1998.
Joel Selvin: interview, 2015.
Derek Taylor: KRLA Presents John Gilliland's *The Pop Chronicles*, 1969. The John Gilliland Collection, University of North Texas Music Library.
Dennis Loren: interview, 2015.
Bill Ham: interview, 2015.

1 JANUARY: ABOARD THE FRIGATE

Kenneth Kubernik: interview, 2015.
Paul Body: interview, 2015.
Ray Manzarek: interview, 2002, and interview, *THC Exposé*, 2013.
Rob Hill: interview, 2015.
John Densmore: interview, *MOJO* magazine, 2007.
Jac Holzman: interview, 2015.
Jac Holzman and Gavan Daws: *Follow the Music*.
Barry Miles: interview, 2015, *Shindig!* magazine, January 2016; used by permission of editor-in-chief Jon "Mojo" Mills.

Daniel Weizmann: interview, 2015.
Rodney Bingenheimer: interview, June 2011, *Shindig!*; and interview, 2016; used by permission of editor-in-chief Jon "Mojo" Mills.
Dennis Loren: interview via e-mail, 2015.
Ram Dass: interview, 1999.

2 FEBRUARY: HEARING A NEW FREQUENCY

Denny Bruce: interviews, 2015 and 2016.
Roger Steffens: interviews, 2015 and 2016.
Micky Dolenz: interview, 2009; excerpted in Harvey Kubernik, *Canyon of Dreams The Magic and the Music of Laurel Canyon*. New York: Sterling, 2009.
Fred Catero: interview, 2013.
Dennis Loren: interview via e-mail, 2015.
Timothy Leary: interview, 1996, excerpted in *BAM*, 1996, and *MOJO*, 2006.
Joe Smith: interview, 2007.
Ram Dass: interview, 1999.
Marshall Chess: interview, *Goldmine*, December 2006.
Denny Bruce: interviews, 2015 and 2016.
Dave Diamond: interview, 2013.
Keith Richards: interview *HITS*, 1997; excerpted in Harvey Kubernik, *This Is Rebel Music*.
Jac Holzman: interview, 2015.
Chris Darrow: interviews, 2015 and 2016.
Paul Body: interview, 2015.
Gary Schneider: interview, 2015.
Emperor Rosko: interview, 2015.
Carlos Santana: interview, *Melody Maker*, 1976; interviews, 2015 and 2016.
Keith Altham: interview, 2015.
Andrew Loog Oldham: interview, *MOJO*, 2008; and interviews, 2015 and 2016.
James Cushing: interviews, 2015 and 2016.
Kenneth Kubernik: "In Between the Buttons"— text by Kenneth Kubernik, 2016, edited by Harvey Kubernik.
Peter Noone: interview, 2015.
Roger McGuinn: interview, *MOJO*, 2007.
Celeste Goyer: interview, 2016.
Paul Kantner: interview, *Record Collector News*, 2012.
Marty Balin: interview, *Record Collector News*, 2015.

3 MARCH: THE RAMIFICATIONS OF INVOLVEMENT

Paul Body: interview, 2015.
Kirk Silsbee: interviews, 2015 and 2016.
Lenny Kaye: interview via e-mail, 2015.
Mary Wilson: interview, *Record Collector News*, 2015.
Berry Gordy Jr.: interview, *HITS*, 1999; and excerpted in Harvey Kubernik: *This Is Rebel Music*.
Lou Reed: Roy Trakin interview with Lou Reed, *HITS*, 1989; © Roy Trakin.
Jerry Garcia: interview, *Melody Maker*, 1976.
Bill Graham: interview, *Melody Maker*, 1976.
Marty Balin: interview, *Record Collector News*, 2015.
Ritchie Yorke: interview via e-mail, 2015.
Wayne Jackson: interview, *MOJO*, 2007.
Emperor Rosko: interview, 2016.
Steve Cropper: interview, *Goldmine*, 2007; and *MOJO*, 2007.
Allen Ginsberg: interview, 1997.
Daniel Weizmann: interview, 2016.

Kenneth Kubernik: interview, 2016.
Henry Diltz: interview, *THC Exposé*, 2013.

4 APRIL: COOL CLARITY

John Hartmann: interview, 2007.
Michelle Phillips: interview, *MOJO*, 2007.
Curtis Hanson: interview, *HITS*, 2000.
Howard Kaylan: interview, *Record Collector News*, 2013.
Barry Miles: interview, 2015, *Shindig!*, January 2016; used by permission of editor-in-chief Jon "Mojo" Mills.
Michael MacDonald: interview, 2015.
David N. Pepperell: interview, 2015.

5 MAY: SOUND AND VISION WITH A MISSION

James Cushing: interview, 2016.
Ray Manzarek: interviews, *Record Collector News*, 2007 and 2013, and *MG* magazine, 2014.
John Densmore: interview, *MOJO*, 2008.
Jimi Hendrix: Keith Altham interview with Jimi Hendrix, *NME*, May 1967; © Keith Altham.
Gene Cornish: interview, *Record Collector News*, 2013.
Steven Van Zandt: interview, *Record Collector News*, 2013.
Kirk Silsbee: interview, 2016.
Felix Cavaliere: interview, *Record Collector News*, 2013.
D. A. Pennebaker: interview, *Goldmine*, November 2007.
Gene Aguilera: interview, 2015.
Alan G. Watts: interview, 2015.
Denny Bruce: interview, 2015.

6 JUNE: STAX OF WAX

Jerry Wexler: interviews—*MOJO*, 2007 and *Goldmine*, 2012; excerpted in Harvey Kubernik, Kenneth Kubernik, *A Perfect Haze: The Illustrated History of the Monterey Pop Festival*. Solana Beach, California: Santa Monica Press, 2011.
Andrew Loog Oldham: interview *MOJO*, 2002; 2007; interviews, 2015 and 2016, excerpted in Harvey Kubernik, *Hollywood Shack Job: Rock Music in Film and on Your Screen*. Albuquerque: University of New Mexico Press, 2006.
Roger McGuinn: interview, *MOJO*, 2007.
John Densmore: interview, *MOJO*, 2007.
Ram Dass: interview, 1999.
Shel Talmy: interview, 2015.
Bobby Rogers: interview, *Melody Maker*, 1974.
Deepak Chopra: interview, *HITS*, 1998; excerpted in Harvey Kubernik, *It Was Fifty Years Ago Today: The Beatles Invade America and Hollywood*. Los Angeles: Other World Cottage Industries, 2014.
Paul Body: interview, 2015.
Bob Mosley: interview, *Goldmine*, 2007.
Tom Rounds: interview, 2012.
Joel Selvin: interview, 2016.
Jann Wenner: interview, 2012.
Mel Lawrence: interview, 2012.
Carlos Santana: interview, 2015.
James Cushing: interview, 2016.
Kenneth Kubernik: "Pop Festival"—interview, 2016.
Michelle Phillips: interview, *MOJO*, 2007; and interview, 2014.
Gary Duncan: interview, *MOJO*, 2007.
Bob Weir: Dennis McNally interview with Bob Weir, 2007; © Dennis McNally.

Pete Townshend: interview via e-mail, *MOJO*, 2007.

Ted Bluechel Jr.: interview, 2013.

Kay Crow: interview, 2015.

Sam Andrew: interview, *MOJO*, 2007

D. A. Pennebaker: interview, *Goldmine*, November 2007.

Robert Marchese: interview, 2007.

Keith Altham: interview, 2016.

Amy Berg: Grammy Museum, Los Angeles, 2015. Q&A stage interview discussion on *Janis: Little Girl Blue*.

Laura Joplin: 2015 Grammy Museum, Los Angeles, 2015. Q&A stage interview discussion on *Janis: Little Girl Blue*.

Jerry Heller: interview, *Goldmine*, 2007.

Wayne Jackson: interview, *Goldmine*, 2007.

Jerry Wexler: interview, 2008.

Marty Balin: interview, *Record Collector News*, 2015.

Al Kooper: interview, 2007.

Ravi Shankar: interview, *HITS*, 1999, and excerpted in *Record Collector News*, 2011.

Guy Webster: interview, 2014.

Peggy Lipton: interview, 2012.

Roger Daltrey: interview, *MOJO*, 2007.

Eric Burdon: interview via e-mail, *MOJO*, 2007.

Paul Kantner: interview, 2012, www.cavehollywood.com.

Cyrus Faryar: interview, 2009.

Jim Yester: interview, *MOJO*, 2007.

Jerry Heller: interview, 2007.

Clive Davis: 2007 interview; excerpts appeared in *Goldmine* and *MOJO*, 2007.

Jac Holzman: interview, 2015.

Jerry Garcia: interview, *Melody Maker*, 1976.

Barry Mann: Gary Strobl interview with Barry Mann, 2015; © Gary Strobl.

Gary Pig Gold: interview, 2016.

Gene Aguilera: interview, 2016.

Marshall Chess: interviews, 2006 and 2009; excerpts appeared in *Goldmine*, 2006.

Denny Bruce: interview, 2015.

Kenneth Kubernik: interview, 2016.

Graham Nash: interview via e-mail, 2015.

6 JULY: THE RAVE NEW WORLD

Daniel Weizmann: interview, 2015.

Bones Howe: interview, 2013.

Hal Blaine: interview, 2008.

Don Randi: interview, 2015.

Richard Williams: interview via e-mail, 2016.

Steve Howe: interview, *Goldmine*, 2004.

Dan Kessel: interview, 2015.

Ravi Shankar: interview, *HITS*, 1997.

James Cushing: interview, 2015.

Kenneth Kubernik: interview, 2016.

Eddie Willis: interview, 2002, excerpted in *BAM* and *Goldmine*, 2002.

Berry Gordy Jr.: interview, *HITS*, *BAM*, and *Goldmine*, 1999.

Paul Body: interview, 2016.

Uriel Jones: interview, *BAM* and *Goldmine*, 2002

David Ruffin: interview, *Melody Maker*, 1976.

Mick Vranich: "the blast furnaces roar" © 2003 by Mick Vranich.

Cholly Atkins: Kirk Silsbee interview with Cholly Atkins: *Los Angeles Reader*, January 20, 1995, © Kirk Silsbee.

Mary Wilson: interview, 2016.

Rob Bowman: interview, 2016.

Gary Pig Gold: interview, 2015.

8 AUGUST: THE REALM OF THE POSSIBLE

Ram Dass: interview, 1999.

John Densmore: interview, *MOJO*, 2007.

Ray Manzarek: interview, *THC Exposé*, 2010.

Kim Fowley: interview, *MOJO*, 2007.

James Cushing: interview, 2015.

George Harrison: interview, *HITS*, 1997.

Robin Gibb: interview, *Melody Maker*, 1977.

Kenneth Kubernik: interview, 2016.

Andrew Loog Oldham: interview, *DISCoveries*, 2000.

Brian Epstein: Mike Hennessey interview with Brian Epstein, *NME* magazine, August 1967; © Mike Hennesey.

Roger Steffens: interview, 2016.

Travis Pike: interview, 2015.

Gary Stewart: interview, 2015.

Larry LeBlanc: interview, 2015.

Gary Pig Gold: "Sundays Would Never Be the Same"—interview, 2016.

9 SEPTEMBER: BAREFOOT IN THE PARK

Kirk Silsbee: interview, 2016.

John Mayall: interview, 2015.

Bill Graham: interview, *Melody Maker*, 1976.

Jerry Garcia: interview, *Melody Maker*, 1976.

Dennis McNally: interview, *Goldmine*, 2003.

Bill Walton: interview, *HITS*, 1992.

Howard Wolf: interview, 2016.

James Cushing: interview, 2016.

Rob Hill: interview, 2016.

Ray Manzarek: interview, *THC Exposé*, 2010.

Robby Krieger: interview via e-mail, 2016.

Howard Shapiro: interview, 2016.

Al Jardine: interview, *Record Collector News*, 2009.

Brian Wilson: interviews, *MOJO*, 2007 and 2011.

Mike Love: interview, *Melody Maker*, 1974; interview, *MOJO*, 2011.

Elliot Kendall: interview, 2015.

Kenneth Kubernik: interview, 2016.

David Kessel: interview, 2015.

Shel Talmy: interview, 2015.

Andrew Loog Oldham: interview, 2016.

10 OCTOBER: AN AUTUMN SHADE OF PALE

Richie Furay: interview, *Goldmine*, 2008; excerpted in Harvey Kubernik, *Turn Up the Radio! Rock, Pop, and Roll in Los Angeles*. Solana Beach, CA: Santa Monica Press, 2014.

James Cushing: interview, 2016.

Don Randi: interview, 2015.

Kirk Silsbee: interview, 2016.

Bob Johnston: interview, *Record Collector News*, 2007.

Ritchie Yorke: interview, 2016.

Van Morrison: Ritchie Yorke interview with Van Morrison, 2015; © Ritchie Yorke.

Russ Solomon: interview, *Record Collector News*, 2015.

Kenneth Kubernik: interview, 2016.

Rodney Bingenheimer: interview, 2016.

Howard Wolf: interview, 2016.

Roger Steffens: interview, 2016.

11 NOVEMBER: WITH APPROPRIATE FLASHBACKS

Justin Hayward: interview, *Record Collector News*, 2012.

Guy Webster: interview, *Treats!* magazine, 2014.

Daniel Weizmann: interview, 2016.

Paul Body: interview, 2016.

Roger Steffens: interview, 2016.

Johnny Echols: interview, 2012.

Gary Pig Gold: interview, 2016.

James Cushing: interview, 2016.

David Kessel: interview via e-mail, 2016.

John Van Hammersveld: interview, *Treats!*, 2012.

Dennis Loren: interview via e-mail, 2016.

Denny Bruce: interview, 2016.

Barney Ales: interview via e-mail, 2016.

Andrew Solt: interview, 2015.

Mary Wilson: interview, 2016, excerpted in *Record Collector News* and www.cavehollywood.com.

Andrew Loog Oldham: interview, *MOJO*, 2007.

Keith Altham: interview, 2016.

Kenneth Kubernik: interview, 2016.

Grace Slick: interview, *Melody Maker*, 1978.

Paul Kantner: interview, 2012, excerpted in *Record Collector News* and www.cavehollywood.com.

12 XII DECEMBER: PSYCHEDELIC SUPERMARKET AND EPILOGUE

Kenneth Kubernik: interview, 2016.

James Cushing: interview, 2016.

Eddie Kramer: interview, *Goldmine*, 2007.

Murray Lerner: interview, *Goldmine*, 2009.

Johnny Cash: interview, *Melody Maker*, 1975.

Steven Van Zandt: interview, *Record Collector News*, 2007.

David Spero: interview, 2016.

Wayne Jackson: interview, 2007.

Emperor Rosko: interview, 2016.

Steve Cropper: interview, 2007.

Jonathan Gould: interview via e-mail, 2016.

Kenneth Kubernik: "Destination: Far Out"—text by Kenneth Kubernik, 2016, edited by Harvey Kubernik.

Elliot Kendall: interview, 2016.

Mike Love: interview, *Melody Maker*, Harvey Kubernik 1974.

Brian Wilson: interview, *MOJO*, 2011.

Burt Bacharach: interview, *Musician* magazine, 1998.

Chrissie Hynde: interview, *Goldmine*, 2002.

Elvis Costello: interview, *Musician*, 1998.

Russ Regan: interview, 2016.

Joe Smith: interview, *MOJO*, 2007.

Andrew Loog Oldham: interview, *MOJO*, 2007.

Dick Clark: interview, *HITS*, 2005.

Joseph McCombs: interview via e-mail, 2015.

John Van Hammersveld: interview, *Treats!*, 2012.

Peter Lewis: interview, *Goldmine*, 2007.

Leonard Cohen: interviews, *Melody Maker*, 1976 and 1978.

Greil Marcus: interview via e-mail, 2007, for *Record Collector News*.

Roger Steffens: interview, 2016.

Richard Williams: interview via e-mail, *Record Collector News*, 2007.

Mick Farren: interview via e-mail, *Record Collector News*, 2007.

George Martin: interview, 2007; excerpted in *Record Collector News*, 2015.

EPILOGUE: FIFTY YEARS ON

Paul Body: interview, 2016.
Ernie Isley: interview, *Melody Maker*, 1975.
David Ruffin: interview, *Melody Maker*, 1976.
Marty Balin: interview, 2015.
Paul Kantner: interview, *Melody Maker,* 1978; and 2012 interview; excerpted in Kubernik, *A Perfect Haze.*
Roger McGuinn: interview, *MOJO*, 2007.
Chris Hillman: interviews, *MOJO*, 2007 and 2014.
Howard Wolf: interview, 2016.
Chris Darrow: interview, 2016.
James Cushing: interview, 2016.
Celeste Goyer: interview, 2016.
Jackie Greene: interview, 2015.
Jac Holzman: interview, 2016.
Robin Gibb: interview, *Melody Maker*, 1977.
Carlos Santana: interview, 2016.
Andrew Loog Oldham: interview, excerpted in *MOJO*, 2007.
Roger Steffens: interview, 2016.
Harry E. Northup: "The City" © 2015 by Harry E. Northup, courtesy of Harry E. Northup.

BIBLIOGRAPHY

BOOKS

Holzman, Jac, and Gavan Daws. *Follow the Music: The Life and High Times of Elektra Records in the Great Years of American Pop Culture.* Santa Monica: First Media Books, 1998.
Kubernik, Harvey. *This Is Rebel Music: The Harvey Kubernik InnerViews.* University of New Mexico Press: Albuquerque, 2004.
———. *Hollywood Shack Job: Rock Music in Film and on Your Screen.* Albuquerque: University of New Mexico Press, 2006.
———. *Canyon of Dreams The Magic and the Music of Laurel Canyon.* New York: Sterling, 2009.
———. *Turn Up The Radio! Rock, Pop, and Roll in Los Angeles.* Solana Beach, CA: Santa Monica Press, 2014.
———. *It Was Fifty Years Ago Today: The Beatles Invade America and Hollywood.* Los Angeles: Other World Cottage Industries, 2014.
Kubernik, Harvey, and Kenneth Kubernik. *A Perfect Haze.* Santa Monica: Santa Monica Press, 2012.
Tamarkin, Jeff. *Got a Revolution! The Turbulent Flight of Jefferson Airplane.* New York: Atria Books, 2003.

POEMS

Northup, Harry E. "The City" © 2015 by Harry E. Northup, courtesy of Harry E. Northup.
Vranich, Mick. "the blast furnaces roar" © 2003 by Mick Vranich.

ESSAYS

Kenneth Kubernik: "In Between the Buttons," "Pop Festival," "Destination: Far Out"—text by Kenneth Kubernik, 2016, edited by Harvey Kubernik.
"It All Seems Like a Dream To Me Now"—text by Dennis Loren, 2016.
"My Summer of Love 1967"—text by Marina Muhlfriedel, 2016.

AUDIO

KRLA Presents John Gilliand's *The Pop Chronicles,* 1969 [Derek Taylor interview]. The John Gilliland Collection, University of North Texas Music Library.
Amy Berg: Grammy Museum, Los Angeles, 2015. Q&A stage interview discussion on *Janis: Little Girl Blue.*
Laura Joplin: 2015 Grammy Museum, Los Angeles, 2015. Q&A stage interview discussion on *Janis: Little Girl Blue.*

WEB SITES

www.cavehollywood.com: Mary Wilson interview by Harvey Kubernik, 2016, and Paul Kantner interview by Harvey Kubernik, 2012.
www.Jackcasady.com.

MAGAZINE AND NEWSPAPER ARTICLES

BAM, 1996. Timothy Leary: Harvey Kubernik interview.
BAM, 1996. Timothy Leary: excerpt of Harvey Kubernik interview.
BAM, 1999. Berry Gordy Jr.: excerpt of Harvey Kubernik interview.
BAM, 2002. Uriel Jones: excerpt of Harvey Kubernik interview.
BAM, 2002. Eddie Willis: excerpt of Harvey Kubernik interview, 2002.
DISCoveries, 2000. Andrew Loog Oldham: Harvey Kubernik interview.
Goldmine, 1999. Berry Gordy Jr.: excerpt of Harvey Kubernik interview.
Goldmine, 2002. Chrissie Hynde: Harvey Kubernik interview.
Goldmine, 2002. Uriel Jones: excerpt of Harvey Kubernik interview.
Goldmine, 2002. Grace Slick: Harvey Kubernik interview.
Goldmine, 2002. Eddie Willis: excerpt of Harvey Kubernik interview.
Goldmine, 2003. Dennis McNally: Harvey Kubernik interview.
Goldmine, 2004. Steve Howe: Harvey Kubernik interview.
Goldmine, 2006. Marshall Chess: excerpt of Harvey Kubernik interview, 2009.
Goldmine, 2007. Steve Cropper: Harvey Kubernik interview.
Goldmine, 2007. Clive Davis: excerpt of Harvey Kubernik interview.
Goldmine, 2007. Jerry Heller: Harvey Kubernik interview.
Goldmine, 2007. Wayne Jackson: Harvey Kubernik interview.
Goldmine, 2007. Eddie Kramer: Harvey Kubernik interview.
Goldmine, 2007. Peter Lewis: Harvey Kubernik interview.
Goldmine, 2007. Bob Mosley: Harvey Kubernik interview.
Goldmine, November 2007. D. A. Pennebaker: Harvey Kubernik interview.
Goldmine, 2008. Richie Furay: Harvey Kubernik interview.
Goldmine, 2009. Murray Lerner: Harvey Kubernik interview.
Goldmine, 2011. Abe Jacob: Harvey Kubernik interview.
Goldmine, 2012. Jerry Wexler: Harvey Kubernik interview.
HITS, 1989. Lou Reed: Roy Trakin interview, © Roy Trakin.
HITS, 1992. Bill Walton: Harvey Kubernik interview.
HITS, 1997. Allen Ginsberg: Harvey Kubernik interview.
HITS, 1997. George Harrison: Harvey Kubernik interview.
HITS, 1997. Keith Richards: Harvey Kubernik interview.
HITS, 1997, 1999. Ravi Shankar: Harvey Kubernik interviews.
HITS, 1998. Deepak Chopra: Harvey Kubernik interview.
HITS, 1999. Berry Gordy Jr.: excerpt of Harvey Kubernik interview.
HITS, 2000. Curtis Hanson: Harvey Kubernik interview.
HITS, 2001. Grace Slick: Harvey Kubernik interview.
HITS, 2005. Dick Clark: Harvey Kubernik interview.
Los Angeles Reader, January 20, 1995. Cholly Atkins: Kirk Silsbee interview, © Kirk Silsbee.
Melody Maker, 1974. Mike Love: Harvey Kubernik interview.
Melody Maker, 1974. Bobby Rogers: Harvey Kubernik interview.
Melody Maker, 1975. Johnny Cash: Harvey Kubernik interview.
Melody Maker, 1976, 1978. Leonard Cohen: Harvey Kubernik interview.
Melody Maker, 1976. Jerry Garcia: Harvey Kubernik interview.
Melody Maker, 1976. Bill Graham: Harvey Kubernik interview.
Melody Maker, 1975. Ernie Isley: Harvey Kubernik interview.
Melody Maker, 1976. David Ruffin: Harvey Kubernik interview.
Melody Maker, 1976. David Ruffin: Harvey Kubernik interview.
Melody Maker, 1976. Carlos Santana: Harvey Kubernik interview.
Melody Maker, 1977. Robin Gibb: Harvey Kubernik interview.
Melody Maker, 1978. Paul Kantner: Harvey Kubernik interview.
Melody Maker, 1978. Grace Slick: Harvey Kubernik interview.
MG, 2014. Ray Manzarek: Harvey Kubernik interview.
MOJO, 2002, 2007, 2008. Andrew Loog Oldham: excerpts of Harvey Kubernik interviews.
MOJO, 2006. Timothy Leary: excerpt of Harvey Kubernik interview, 1996.
MOJO, 2007. Sam Andrew: Harvey Kubernik interview.
MOJO, 2007. Eric Burdon: Harvey Kubernik interview.
MOJO, 2007. Steve Cropper: Harvey Kubernik interview.
MOJO, 2007. Roger Daltrey: Harvey Kubernik interview.
MOJO, 2007. Clive Davis: excerpt of Harvey Kubernik interview.

MOJO, 2007. John Densmore: Harvey Kubernik interview.

MOJO, 2007. Gary Duncan: Harvey Kubernik interview.

MOJO, 2007, 2014. Chris Hillman: Harvey Kubernik interview.

MOJO, 2007. Kim Fowley: Harvey Kubernik interview.

MOJO, 2007. Wayne Jackson: Harvey Kubernik interview.

MOJO, 2007. Roger McGuinn: Harvey Kubernik interview.

MOJO, 2007. Michelle Phillips: Harvey Kubernik interview.

MOJO, 2007. Joe Smith: Harvey Kubernik interview.

MOJO, 2007. Pete Townshend: Harvey Kubernik interview.

MOJO, 2007. Jerry Wexler: Harvey Kubernik interview.

MOJO, 2007, 2011. Brian Wilson: Harvey Kubernik interviews.

MOJO, 2007. Jim Yester: Harvey Kubernik interview.

MOJO, 2008. John Densmore: Harvey Kubernik interview.

MOJO, 2011. Mike Love: Harvey Kubernik interview.

Musician, 1998. Burt Bacharach: Harvey Kubernik interview.

Musician, 1998. Elvis Costello: Harvey Kubernik interview.

NME, May 1967. Jimi Hendrix: Keith Altham interview, © Keith Altham.

NME, August 1967. Brian Epstein: Mike Hennessey interview, © Mike Hennesey.

Record Collector News, 2007. Mick Farren: Harvey Kubernik interview.

Record Collector News, 2007. Bob Johnston: Harvey Kubernik interview.

Record Collector News, 2007, 2013. Ray Manzarek: Harvey Kubernik interviews.

Record Collector News, 2007. Greil Marcus: Harvey Kubernik interview.

Record Collector News, 2007. Steven Van Zandt: Harvey Kubernik, interview.

Record Collector News, 2007. Richard Williams: Harvey Kubernik, interview.

Record Collector News, 2009. Al Jardine: Harvey Kubernik interview.

Record Collector News, 2011. Ravi Shankar: excerpt of Harvey Kubernik interview, 1999.

Record Collector News, 2012. Justin Hayward: Harvey Kubernik interview.

Record Collector News, 2012. Paul Kantner: excerpt of Harvey Kubernik interview.

Record Collector News, 2013. Felix Cavaliere: Harvey Kubernik interview.

Record Collector News, 2013. Gene Cornish: Harvey Kubernik interview.

Record Collector News, 2013. Howard Kaylan: Harvey Kubernik interview.

Record Collector News, 2013. Steven Van Zandt: Harvey Kubernik interview.

Record Collector News, 2015. Marty Balin: Harvey Kubernik interview.

Record Collector News, 2015. George Martin: excerpt of Harvey Kubernik interview, 2007.

Record Collector News, 2015. Russ Solomon: Harvey Kubernik interview.

Record Collector News, 2015, 2016. Mary Wilson: excerpt of Harvey Kubernik interview.

Record Collector News, 2016. Carlos Santana: Harvey Kubernik interview.

Shindig!, January 2016. Rodney Bingenheimer: Harvey Kubernik interview, 2011. Used by permission of editor-in-chief Jon "Mojo" Mills.

Shindig!, January 2016. Barry Miles: Harvey Kubernik interview, 2015. Used by permission of editor-in-chief Jon "Mojo" Mills.

THC Exposé, 2010, 2013. Ray Manzarek: Harvey Kubernik interviews.

THC Exposé, 2010. John Van Hamersveld: Harvey Kubernik interview.

THC Exposé, 2013. Henry Diltz: Harvey Kubernik interview.

Treats!, 2012. John Van Hammersveld: Harvey Kubernik interview.

Treats!, 2014. Guy Webster: Harvey Kubernik interview.

HARVEY KUBERNIK ORIGINAL INTERVIEWS

Gene Aguilera: 2015.
Barney Ales: via e-mail, 2016.
Keith Altham: 2015, 2016.
Marty Balin: 2015.
Rodney Bingenheimer: 2016.
Hal Blaine: 2008.
Paul Body: 2015, 2016.
Ted Bluechel Jr.: 2013.
Rob Bowman: 2016.
Denny Bruce: 2015, 2016.
Fred Catero: 2013.
Marshall Chess: 2006, 2009.
Steve Cropper: 2007.
Kay Crow: 2015.
James Cushing: 2015, 2016.
Chris Darrow: 2015, 2016.
Ram Dass: 1999.
Clive Davis: 2007.
Dave Diamond: 2013.
Micky Dolenz: 2009.
Johnny Echols: 2012.
Cyrus Faryar: 2009.
Allen Ginsberg: 1997.
Gary Pig Gold: 2015, 2016.
Jonathan Gould: via e-mail, 2016.
Celeste Goyer: 2016.
Jackie Greene: 2015.
Robert Greenfield: 2009, 2015.
Bill Ham: 2015.
John Hartmann: 2007.
Jerry Heller: 2007.
Rob Hill: 2015, 2016.
Jac Holzman: 2015, 2016.
Bones Howe: 2013.
Wayne Jackson: 2007.
Paul Kantner: 2012
Lenny Kaye: via e-mail, 2015.
Elliot Kendall: 2015, 2016.
David Kessel: 2015; via e-mail, 2016.
Al Kooper: 2007.
Robby Krieger: via e-mail, 2016.
Kenneth Kubernik: 2015, 2016.
Mel Lawrence: 2012.
Timothy Leary: 1996.
Larry LeBlanc: 2015.

Andrew Loog Oldham: 2015, 2016.
Dennis Loren: via e-mail, 2015, 2016.
Michael MacDonald: 2015.
Ray Manzarek: 2002.
Robert Marchese: 2007.
John Mayall: 2015.
Joseph McCombs: via e-mail, 2015.
Marina Muhlfriedel: 2016.
Graham Nash: via e-mail, 2015.
Peter Noone: 2015.
David N. Pepperell: 2015.
Travis Pike: 2015.
Don Randi: 2015.
Russ Regan: 2016.
Emperor Rosko: 2015, 2016.
Tom Rounds: 2012.
Carlos Santana: 2015, 2016.
Jerry Schatzberg: 2015.
Gary Schneider: 2015.
Carol Schofield: 2015.
Joel Selvin: 2015, 2016.
Howard Shapiro: 2016.
Kirk Silsbee: 2015, 2016.
Joe Smith: 2007.
Andrew Solt: 2015.
David Spero: 2016.
Roger Steffens: 2015, 2016.
Shel Talmy: 2015.
Alan G. Watts: 2015.
Guy Webster: 2014.
Daniel Weizmann: 2015, 2016.
Jann Wenner: 2012.
Jerry Wexler: 2008.
Richard Williams: via e-mail, 2016.
Mary Wilson: 2016
Howard Wolf: 2016.
Ritchie Yorke: via e-mail, 2015; 2016.

OTHER INTERVIEWS

Barry Mann: Gary Strobl interview with Barry Mann, 2015; © Gary Strobl.
Van Morrison: Ritchie Yorke interview with Van Morrison, 2015; © Ritchie Yorke.
Bob Weir: Dennis McNally interview with Bob Weir, 2007; © Dennis McNally.

Note: Page references in parentheses indicate non-contiguous references. References to photos indicate caption location.

PICTURE CREDITS

Front cover: © Howard Wolf (Janis Joplin); © Henry Diltz (Jimi Hendrix)

Alamy: © Heritage Image Partnership Ltd: 2 (background); © Pictorial Press LTD: 73, 216

Allen Ginsberg LLC: 83 right

© **Fred Arellano/www.vintagerock-photography.com:** 77, 119 right

Courtesy of The Bert Berns Archives: 241

© **Paul Body:** 51 left

Chris Darrow: endpapers, 94 top

Courtesy of Dennis Loren Archives: endpapers, 25, 38, 45, 86, 140, 176 top, 205

© **Jim Dickson:** 22

© **Henry Diltz:** endpapers, vi, 2 bottom, 5 top right, 6 top, 16, 28 top, 29, 36, 43, 44, 63, 65, 75, 87 top, 91, 93, 94 bottom, 98, 100, 113 left, 115, 119 left, 120, 124, 130, 131, 132, 134, 135, 139, 141 bottom, 142, 147, 148, 150, 151, 152, 153, 155, 165, 166, 168, 170, 178, 181, 196, 198, 199, 200, 201, 206, 226, 238, 242, 243, 247, 249, 254

© **Nat Finkelstein:** 122

Courtesy of the Gary Pig Gold Archives: endpapers, 177

Gary Schneider Open Mynd Collectibles: endpapers, 2 top, 48, 51 right, 52

Gary Strobl Archive: endpapers, 8, 110, 193, 207

Getty Images: 105, 158; © API/Michael Ochs Archives: 81; © Bettmann: 171, 235; © CBS Photo Archive: 42; © Tom Copi/Michael Ochs Archive: 143; © Ralph Crane/The LIFE Picture Collection: viii; © John Downing: 85, 108; © GAB Archive/

Redferns: 117; © Declan Haun/The LIFE Picture Collection: 158; © James Kriegsmann/Michael Ochs Archives: 160; © Michael Ochs Archives: 20, 26, 78, 231; © Monitor Picture Library/Photoshot: 60; © Petra Niemeier/K & K/Redferns: 210; © Popperfoto: 195; © PoPsie Randolph/Michael Ochs Archives: 70, 203; © Chris Walter/WireImage: 223; © Andrew Whittuck/Redferns: 169; © Baron Wolman/Iconic Images: 88; © Gunter Zint/K & K Ulf Kruger OHG/Redferns: 106

Jeff Gold: 90

© **Gary Grimshaw, courtesy Laura Grimshaw:** 86

© **Heather Harris:** 112, 218 top

© **Iconic Images/Baron Wolman:** 12, 46

iStock: © marcpk: 95, © Massimiliano Pieraccini: 176 bottom

© **Rick Klein/courtesy of Gary Strobl:** 141 top

Harvey Kubernik Archive: endpapers, 47

© **Pamela Lauesen:** 50, 184

Murray Lerner: 229

Library of Congress: 4; Carol M. Highsmith: 68

Courtesy of Michael MacDonald: endpapers

© **Gered Mankowitz:** 59

© **Maria Muhlfriedel:** 192

National Archives: 215

Neil Norman: 71

© **Tom Gundelfinger O'Neal:** 7, 17, 23

Courtesy of Pennebaker Hegedus Films: 104

© **David Pepperell:** 97

Travis Pike: 172

Ray Randolph: endpapers, 37, 137, 167

© **Helie Robertson:** 15, 114, 116, 162, 236 left

Roger Steffens Archive: endpapers, 5 top left and bottom right, 219

© **Jerry Schatzberg Studio:** 18, 57

© **Harold Sherrick:** 62

Courtesy of David Schiller, Sparta Graphics. Used by permission. Poster design Jim Michaelson: 40

Shutterstock: © Antonov Roman: 55

Courtesy of SOFA Entertainment, All Rights Reserved: 54, 67, 92, 103, 156, 157, 176, 187, 220, 221, 232, 233

Courtesy of Sony: 202

© **David Spero:** 230 bottom

© **Roger Steffens:** 19, 24, 35, 113 right, 193, 214

Paul Taranpool: 237

John Van Hamersveld: endpapers, 218 bottom, 239; © 1964, 2016 Bruce Brown Films, LLC: 6 bottom

© **Guy Webster:** 30, 31, 32, 33, 49, 53, 56, 74, 83 left, 87 bottom, 101, 118, 121, 123, 125, 126, 127, 133, 138, 145, 161, 164, 174, 182, 185, 189, 190, 191, 209, 213, 234, 236 right

Courtesy of Wikimedia Commons: Harvey W. Cohen: 39; CZmarlin: 188

© **Nurit Wilde:** 186

© **Howard Wolf:** 3, 128, 129, 136, 183, 224, 230 top, 240